SOCIAL CHOREOGRAPHY

POST-CONTEMPORARY INTERVENTIONS

Series Editors: Stanley Fish and Fredric Jameson

Social Choreography

IDEOLOGY AS PERFORMANCE IN DANCE

AND EVERYDAY MOVEMENT

Andrew Hewitt

Duke University Press Durham and London

2005

© 2005 Duke University Press

Printed in the United States of America on acid-free paper ∞

Designed by C. H. Westmoreland

Typeset in Cycles with Helvetica Neue display

by Keystone Typesetting, Inc.

Library of Congress Cataloging-in-Publication

Data appear on the last printed page

of this book.

Contents

Introduction

SOCIAL CHOREOGRAPHY AND

THE AESTHETIC CONTINUUM

In 1796 Friedrich Schiller—arguably the nineteenth-century's leading proselytizer and disseminator of an idealist aesthetic of bourgeois humanism—chided the tardy contributor of an essay on dance to the following year's issue of *Musenalmanach* for not profiting from "the newly awakened interest in this art."[1] In contrast, by the beginning of the twentieth century Havelock Ellis—a significant champion of dance—could cite as characteristic a contemporary's 1906 evaluation that "the ballet is now a thing of the past and, with the modern change of ideas, a thing that is never likely to be resuscitated."[2] The historical arc traced between these two aesthetic assessments serves nicely to map out the field of the central arguments in this book. A dance historian might wish to demonstrate what "went wrong" with theatrical dance in the years that separate these assessments—and, indeed, to explain why Ellis, a fervent amateur and promoter of dance, would himself in turn so quickly and definitively be proved wrong. This book is not a work of dance history in that sense, however—although it does seek to suggest new interpretive paradigms of interest to dance historians and critical theorists alike. When my consideration here of social choreography does focus on dance in the stricter, or theatrical, sense of

the word, the aim is neither to produce an immanent dance history—examining the emergence of certain forms and codes according to an internal logic—nor, indeed, to locate dance within a broader social history. The historical claims I make in this volume might be said to work in the opposite direction: they are claims for the historical agency of the aesthetic as something that is not merely shaped but also shaping within the historical dynamic. By attempting to reconnect to a more radical sense of the aesthetic as something rooted in bodily experience, I use the category of social choreography as a way of examining how the aesthetic is not purely superstructural or purely ideological. Social choreography is an attempt to think about the aesthetic as it operates at the very base of social experience.

Substantiating such claims might begin by returning to Schiller. Even though the general "newly awakened interest" of which he writes was aroused by performances of theatrical dance, Schiller's own interest lay primarily (although not exclusively) in dance as a *social* phenomenon. In a famous passage from a letter of 1793 to Christian Körner, he writes:

> I can think of no more fitting image for the ideal of social conduct than an English dance, composed of many complicated figures and perfectly executed. A spectator in the gallery sees innumerable movements intersecting in the most chaotic fashion, changing direction swiftly and without rhyme or reason, yet *never colliding*. Everything is so ordered that the one has already yielded his place when the other arrives; it is all so skillfully, and yet so artlessly, integrated into a form, that each seems only to be following his own inclination, yet without ever getting in the way of anybody else. It is the most perfectly appropriate symbol of the assertion of one's own freedom and regard for the freedom of others.[3]

In a sense, it is the history of Schiller's observation that I trace in this book; that is, dance not simply as a privileged figure for social order but as the enactment of a social order that is both reflected in and shaped by aesthetic concerns. The English dance, for Schiller, is not just an *example* of the existing social order but rather a *model* for that order. For him, the force of his observation lies not in the description of an English aesthetic and social phenomenon but in the prescription it entails for his German contemporaries. Schiller gazes at a social dance from the gallery, as if observing a theatrical performance, while with the same regard looking across to England for a model of social organiza-

tion. My central presupposition in this book is that Schiller's project of what I will call social choreography has been dehistoricized and depoliticized by a prevailing modernist understanding of choreography as an essentially metaphysical phenomenon oriented around questions of transcendental subjectivity rather than social and political intersubjectivity. What is at stake in proposing an analysis of social choreography is a threefold determination of the modern: namely, a redefinition of modernism as an aesthetic program; a rethinking of modernization as a social process of rationalization that would not, as is generally assumed, compartmentalize and trivialize aesthetic experience; and, finally, a rethinking of the relationship of two terms—aesthetic modernity and sociopolitical modernity—that have either been taken to be irremediably at odds or assumed to be reducible to each other.

Certainly Schiller's own writing on dance elsewhere—specifically the famous poem *Der Tanz*—does use dance as the figure for a self-transcending aesthetic in which spirit and body are taken up into each other and the subject completed/annulled. This sublation, however, is not itself one that negates historical time. It was only with the symbolists of the late nineteenth century along with their international avatars that the figure of the dancer would be most definitively removed to the realms of the metaphysical. In the writings of Théophile Gautier from the mid-nineteenth century—but most markedly since the end of that century, with Stéphane Mallarmé's famous essays inspired by the dances of Loïe Fuller—the figure of the dancer within the project of aesthetic modernism has generally served to invoke aesthetic experience in its most self-enclosing and immanent yet transcendent aesthetic form. In the moment of the dance, the possibility of a movement beyond the limitations of the body is paradoxically embodied; human potential supposedly resides as much in the vital energies that move and displace the body through space as it does in the contingent materiality of the body itself.[4] In this study, by contrast, I use the term social choreography to denote a tradition of thinking about social order that derives its ideal from the aesthetic realm and seeks to instill that order directly at the level of the body. In its most explicit form, this tradition has observed the dynamic choreographic configurations produced in dance and sought to apply those forms to the broader social and political sphere. Accordingly, such social choreographies ascribe a fundamental role to the aesthetic in its formulation of the political.

This argument for the centrality of the aesthetic to the elaboration of social configurations places the critical project of social choreography in opposition to two alternative approaches to the consideration of dance. If the most obvious polemic is against the critical tradition that takes dance as a physical experience of metaphysical transcendence—that is, against the vocabulary developed in the symbolist and aestheti-cist writings of the late nineteenth century—this study no less reso-lutely resists any reduction to the specific social "determinants" of dance, such as race, gender, or class. My argument here will not be that these categories do not hold with respect to social choreography, but that both in the practice of choreography and in the critical discourses it generated, such categories were themselves being rehearsed and re-fined. The aesthetic thus functions in this study neither as a quasi-metaphysical realm separate from the sociohistorical nor as a practice that can be fully explained in terms of sociohistorical analysis. The aesthetic will function—and here we encounter the importance of the performative within our notion of social choreography—as a space in which social possibilities are both rehearsed and performed.[5] Although this work certainly seeks to situate the moments of its specific analyses within their historical and art historical context, the aim is less a his-tory of the aesthetic than it is the uncovering of the operation—in modern social thought—of a certain aesthetic of history.

In the absence of any detailed consideration of the modes of produc-tion of given dance forms, either theatrical or social, it might seem audacious to make materialist claims for the analysis presented here. As I seek to demonstrate, however, in the debates around dance that took place from the mid-nineteenth through the early twentieth centuries—even as dance as an aesthetic practice fell into decrepitude only to reemerge all the more triumphantly—what was at stake was the ques-tion of defining just what constituted matter and materialism. If Marx famously argued that the materialism of Feuerbach was too invested in the inertia of bodies and lacked the dialectical insight into the dynamic nature of matter, his own position would later be assailed from the other extreme by a tradition of vitalist *Lebensphilosophie* that, in turn, saw nothing *but* energy, and grounded in the "dance of life" itself—to quote the title of Ellis's treatment of choreography—a new and para-doxically embodied metaphysical biopolitics. Because modern dance was from the outset imbued with the terminology of Lebensphiloso-

phie—either explicitly or simply because the language of vitalism was so unavoidably "in the air"—an avowedly materialist critique might be expected to ground that aesthetic ideology in a specific politics and politics itself in the material social conditions of production. Better yet, one might demonstrate how the vitalist ideology derives in its parallel aesthetic and political forms from the exigencies of the economic base. In the first case, a certain agency and intentionality is implicit: "This art reflects this political agenda, which in turn derives from this social and economic situation." In the second case, there is room for what we might call the political unconscious in art: art reflects a social situation directly but may not do so with any explicit political agenda.[6] In this second model art might, of course, reflect social realities in direct opposition to the artist's explicit political stance. Thus, for example, Marx famously claims that Balzac reveals progressive social tendencies despite his own avowed conservatism because the aesthetic imperatives of his realism oblige him to face realities that his political ideology otherwise forces him to obfuscate.[7]

Such models of materialist analysis may be serviceable enough when dealing with an art that consciously reflects a reality external to itself, but they obviously require modification when facing either an abstract or nonfigurative art or an art that foregrounds the performative rather than the mimetic. In the face of abstract or nonfigurative art, the reflection model might still be workably retooled: abstract art "reflects" anincreasingly abstract world, perhaps; or, in a more sophisticated model, abstraction marks the inevitable failure of the bourgeois artist to countenance a social totality that is historically destined to obliterate him.[8] In such accounts, abstraction would be a sort of refusal to represent—or simply an incomprehension; in another, more positive, formulation, abstraction would mark the attempt to distill the essence of a social formation from out of its contingent and confusing manifestations.

These possibilities have been well rehearsed and debated by the Left. In taking dance merely as the most aestheticized form of social choreography, however, I wish to move beyond that debate to ask how we might understand the relationship between the political and aesthetic when the prevailing paradigm for art is performative—that is, when we focus on the dynamics of the "work" of art as a system of production, rather than on the artifact itself. What, precisely, will the politics of

dance, or social choreography, mean in the end? Are we talking meta-phorically, or are there more substantive entailments? How do various notions of choreography correspond with, derive from, or reflect politi-cal ideologies or social conditions? Can we talk of an "aesthetic ideol-ogy" without rooting it in a political one? My argument here will be that dance has served as the aesthetic medium that most consistently sought to understand art as something immanently political: that is, as something that derives its political significance from its own status as praxis rather than from its adherence to a logically prior political ideol-ogy located elsewhere, outside art. In short, we are not talking meta-phorically. When we talk of an "aesthetic ideology" we talk not of an ideology *of* the aesthetic but refer instead to the intrinsic aesthetic component of any ideology that seeks to structure itself in narrative form. Thus, the aesthetic component of ideology is the utopian lure that enables that ideology to operate in a hegemonic rather than a simply coercive fashion.

In making materialist claims at this level of embodiment for a study that seems to open the door to an idealist inversion of the base-superstructure model of ideology by arguing for an aesthetic compo-nent operative at the base, I obviously need to qualify what I mean by "materialist" and explain how this study relates to a more traditional form of history. We need to remember that the problematic term in the traditional characterization of ideology as "false consciousness" was originally "false" not "consciousness." To invoke—in a crassly undialec-tical manner—some putative materiality of the body as guarantee of the materialism for our analysis is the exact opposite of what is proposed here. Although we now have more sophisticated models for thinking about ideology, the most commonly invoked notion of "false conscious-ness" reminds us of how "consciousness" itself has long defined our sense of the ideological. Within this tradition of thought, Fredric Jameson's concept of the "political unconscious" marked an important advance in our understanding of ideology, and it helps us understand what I think is going on in choreography. My challenge to the "political unconscious" model lies in its tendency to abstract ideology from the realm of social performance—that is, from what actually happens.

We need to be clear about what material analysis is *not* in this presen-tation, before we can begin to understand just what it is. To this end, we might invoke debates internal to dance studies to make broader claims

about the terms of a materialist critique. The recent turn, across the humanities, toward cultural studies and away from the text-based models of high theory seems to have favored a reemergence of dance as an object of analysis. Certainly, traditional dance history has been supplemented and enhanced both by a new openness to literary and philosophical theory and by the willingness of scholars to situate dance in its broader cultural and social milieu. The downside of this latter development, however, has been the unfortunate and often merely implicit identification of "the body" with materiality per se, as if—with the move toward cultural studies—that body might guarantee the "reality" or "materiality" of the critical method.[9] As dance scholars have pointed out, however, this by now tiresome return of the ubiquitous body has had little effect in placing dance back at the center of critical cultural analysis. Amy Koritz points out how dance in fact refutes the immanentist fallacy that would see in the body a quite literal "materiality of the signifier," reconciling cultural studies with high theory. "Surely," she writes,

> twenty years of poststructuralism ought to have taught us the impossibility of accessing unencoded experience of any sort. The obsession with the body to the exclusion of dance is perhaps symptomatic of a failure to think beyond the binary opposition between body and mind that seems to hold out the body as the realm where the problems of the mind take on a concrete form that removes from them the stigma of scholarly abstraction. The pervasive absence of dance from cultural studies may well reflect dance's inability to provide the sorts of bodies cultural studies scholars find most engaging. But this, far from being a disadvantage, suggests the importance of what cultural studies has to learn from dance scholarship.[10]

What Koritz seeks to counter is a critical tendency to fetishize the body as the bearer of "the real" in ways that replay some of the more crass ideological pretensions of the early dance pioneers themselves. The "return to the body" in cultural studies bypasses dance because dance locates the social energumen not in bodies but in the dynamic spaces that separate and link those bodies, in dialectical "movement" rather than in brute soma. For this reason, I share Jameson's antipathy to the reemergence of "the body" as a ubiquitous, but undialectical, grounding topos in the cultural turn of recent years.[11]

Of course, simply to displace the body with a fetish of "movement" would itself be to replay the grounding ideological gesture of vitalism: out of the Feuerbachian frying pan and into the fire of Lebensphiloso-phie, so to speak. It is in the uncomfortable encounter and collision of bodies in space that we need to find a model for material analysis. Thus, in this volume, in the chapter on Nijinsky, I provide a model of how this analysis might look by invoking Charles Sanders Peirce's semiotics, not in order to fold bodies into text but to demonstrate how dance brings into doubt the Saussurian privileging of "negative relations" over "pos-itive terms." Nijinsky, and Peirce, provide a model for understanding how acts of signification depend not only on the interplay of signifiers but also on a certain "knocking up against" reality (to use Peirce's description of the icon). Stressing the moment of performance or en-actment in ideology over the ways in which ideology lays down pre-determined social "scripts" clearly has micrological implications for the analysis of dance itself. While I do not seek to present this volume as a work of dance history, the methodological questions it raises are certainly central to the practice of dance historians.[12]

By schematizing somewhat we can distinguish between studies that seek to "read" the body as text and rely on "a vision of the body's movement as an act of writing"[13] and those that argue, with Peggy Phelan, that "to attempt to write about the undocumentable event of performance is to invoke the rules of the written document and thereby alter the event itself . . . The labor to write about performance (and thus to "preserve" it) is also a labor that fundamentally alters the event."[14] Polemically, this study is much closer to the latter position. Although I am trained as a literary scholar I resist attempts to somehow "legiti-mize" performance by subjecting it to a hegemonic epistemology of textual reading. (This "literarizing" gesture is one, for example, that Isadora Duncan made when, in seeking to ground the high cultural credentials of dance, she acknowledged only writers and philosophers as her teachers.) Bodies are not writing. This being said, however, they clearly do signify; the challenge is to understand how they do it. I seek to do so without locating "real" meaning elsewhere (i.e., in the realm of the social) and then tracing the ways in which bodies reference this external stratum of significance.

At the other extreme, Peggy Phelan's insistence on the "undocument-able event" is appealing for two distinct reasons. At the most mundane

level, those performers I do consider in the second half of this book—specifically Isadora Duncan and Nijinsky—refused to be "documented" in the then new medium of film, and the reconstruction of their actual dances is a difficult and painstaking task for historians and choreographers alike. As a literary scholar working unapologetically on various forms of "document"—diaries, reviews, memoirs, and so forth—I do not seek to approach the moment or "event" but rather understand "performance" itself in a very different way. Performance, in this book, needs to be understood along the lines of "ideological work"—as something analogous to the dream work in which Freud (resisting the simplistic schism of latent and manifest meaning) located the stratum of the dream's significance. The "work" of a performance lies as much in what it unleashes as in what it encloses. The second reason for embracing Phelan's position is for its refusal to reduce the aesthetic performance to the level of "document." While cultural studies has taught us to locate aesthetic phenomena within their respective historical and cultural milieus rather than assume their transhistorical validity, it has also tended at times to dedifferentiate different types of ideological performance (aesthetic, political, etc.) by "reading" all as documents. Rather than taking text as a model for reading performance I propose instead to take performance as a challenge to our model of "reading texts." To question the status of a dance interpretation on the grounds that it is, after all, a trope or a certain approximation of interpretive reading strategies is to naturalize the act of reading itself as nonmetaphoric, as the hegemonic medium for the production of meaning. A study of social choreography entails opening up to the many different ways in which meaning is produced in both aesthetic and social arenas.

It is also important, however, to note a danger implicit in this second approach proposed by Phelan—namely, the possible fetishization of the unrepeatable, undocumentable moment of performance itself. Throughout this work I note within the critical discourse of modern dance a tendency to romanticize as moments of "truth" precisely those moments of physical contingency that for a traditionally "metaphysical" discourse were the things that stood in the way of the performance of transcendental truth. For example, if the symbolist celebration of the body's self-transcendence and self-obliteration in the dances of Loïe Fuller is ideological in its metaphysical and transhistorical pretensions, any celebration of the somatic body or of the "laws" of gravity

is potentially no less so. Indeed, I would argue that the latter is all the more dangerous for presuming the translatability of metaphysical longing into physical form. In this regard, I consider briefly in chapter 3, for example, the emergence of racist and eugenic discourse within the writings of early modern dance pioneers.

Our task, then, must be to develop a critical hermeneutic that eschews the undialectical "materiality" of the body on the one hand, and the vitalist celebration of "force" or "movement" on the other. We need a semiotic that articulates their interactions and collisions. The critical challenge is to marry text-based analysis to the analysis of performance; a challenge that is not simply for dance historians but also for those cultural historians who wish to learn from dance and who are dissatisfied with their discipline's tendency to reduce aesthetic phenomena to the status of document, to its simple sociological determinants. As one critic has put it with regard to reading strategies: "If—as has been customary since the sixteenth century—the literary motif can be conceived of in its Latin sense of *motivum*, as a principle of narrative motion that drives the action, it would be tautological to speak of a "motif of motion," since the motif—*by its very definition*—is what "moves" the literary narrative . . . The question as to dance's figurative function therefore necessarily links thematic and rhetorical or textual readings."[15]

Dance, then, is not simply another object onto which text-based "reading" strategies can be projected; it is a motif, a challenge internal to the operation of textuality. One weakness of the high critical tradition that culminated, so to speak, in deconstruction, was its antipathy to any consideration of motif, which it tended to write off as mere "thematic criticism." By insisting on the motivum, I wish to suggest that by criticizing a traditional tendency to enclose critical reading in a consideration of thematic topoi, deconstruction reinforced a certain structuralist synchronization of the reading process. The diachrony of the text suggested by this invocation of the motivum provides a model for thinking across the barricades of high theory and cultural studies. We need not eschew the "textuality" of high theory in order to focus on cultural determinants: the task, instead, is to demonstrate the insufficiency of our prevailing understanding of the text. The opposition of textual and performative paradigms is a false one, and there can be no question here of a paradigm shift from one to the other. Performance is

something that stands not outside the "text" but operates from within it. Consequently, it is a linking of thematic and textual readings that I attempt here.

What I am calling "choreography" is not just a way of thinking about social order; it has also been a way of thinking about the *relationship* of aesthetics to politics. In other words, as a performative, choreography cannot simply be identified with "the aesthetic" and set in opposition to the category of "the political" that it either tropes or predetermines. In the bourgeois era, I argue, choreography has provided a discursive realm for articulating and working out the shifting, moving relation of aesthetics to politics and for thinking about questions of semiotic "motivation" in systems of representation. In this study, then, politics and semiotics work closely together. In his study *The Body in the Mind: The Bodily Basis of Meaning, Imagination, and Reason*, Mark Johnson has proposed the category of "force" as a way of understanding what I have thus far been referring to as motivum in the text. By implicitly arguing for the centrality of a certain rhetoric, he seeks to demonstrate how "through metaphor, we make use of patterns that obtain in our physical experience to organize our more abstract thinking."[16] As I will demonstrate in chapter 2, this argument has precedent in bourgeois political philosophy all the way back to Thomas Hobbes. While I have great sympathy for this critical move, however, it is by way of contrast that I might best describe here what I mean when I say that social choreography is not a metaphor. I seek to counter the prevailing interpretation of a metaphor of dance within modernist poetics. The model of causality here is more structural. An aesthetic form could be judged ideologically not simply because it expresses a clear agenda or because we know its author or choreographer belonged to a certain class or party. *Actions*— not just representations—are ideological.

There are two reasons for this antimetaphorical approach: one methodological and one substantive. This study differs in substance from the writings on the dance metaphor cited in an earlier note by stressing the social and political function of choreography—its disposition and manipulation of bodies in relation to each other—over the metaphysical resolutions that dance offers. Rather than being interested in questions of how the metaphor, or even the practice, of choreography resolves problems of metaphysical subjectivity, this study will concern itself instead with the historical emergence of choreography (within

modernism broadly defined) as a medium for rehearsing a social order in the realm of the aesthetic. Particularly when dealing with a performative genre, moreover, that constantly demarcates its own artistic borders even as it acknowledges what its material (the body) has in common with the extraaesthetic—"metaphor" is an inadequate model for understanding the relationship of aesthetics to politics.

Whereas writing on dance's function (as image) within modernism has tended to stress the movement of self-transcendence as the dancer disappears into the dance, here I envisage instead a more "lateral" transcendence whereby the dancer is integrated into a social organization. Although it will be necessary to look at the ways that social choreography addresses fundamental philosophical questions regarding the relationship of the body to the spirit and the possibility of transcendence, I will consistently situate such reflections within a broader aesthetic and political ideology. In the treatise *On the Aesthetic Education of Man*, for example, Schiller characterizes the play of sensuality and order—the two competing moments in dance—as follows: "The sense-drive demands that there shall be change and that time shall have a content; the form-drive demands that time shall be annulled and that there shall be no change. That drive, therefore, in which both the others work in concert (permit me for the time being, until I have justified the term, to call it the *play-drive*), the play-drive, therefore, would be directed towards annulling time *within time*."[17]

If this insistence on "annulling time *within time*" opens up the possibility of political readings, it also suggests a rather troubling aestheticization of politics. In his study *The Aesthetic State: A Quest in Modern German Thought* Josef Chytry notes how "according to Schiller, dance symbolizes wholeness of the psyche; beauty is developed 'through the free play of limbs' that represents harmony between individual freedom and group order." In other words, dance figures a kind of liberal ideal of freedom of movement rejoined at the level of the articulate body politic. In the Schillerian tradition, dance expresses two levels of harmony: it is, in Chytry's paraphrase of *Über Anmut und Würde*, "the premonition of a grace that expresses humans' inner harmony between spirit and sensuousness. A society of beautiful human beings requires that they be creatures of grace."[18] But it is also the harmonization of individuals within historical societies. The prevailing modernist paradigm for thinking about dance—inaugurated by the romantics and car-

ried through by the late-nineteenth-century aestheticists—has consistently privileged the philosophical, aesthetic, and even religious question of individual "grace" over the politics of social choreography.

What Schiller intends is a temporal sublation—"*within time*"—that reconstitutes rather than negates history. Thus, dance offered him a specifically historical and political model. Commenting on the very passage I cited from Schiller's letter at the opening of this introduction Paul de Man has insisted that we not only restore to the aesthetic the political concerns that have gradually been stripped from it, but also—perhaps more troublingly—that we acknowledge the aesthetic moment in the political itself. "As is clear from Schiller's formulation," he writes, the aesthetic "is primarily a social and political model ethically grounded in an assumedly Kantian notion of freedom . . . The 'state' that is here being advocated is not just a state of mind or of soul, but a principle of political value and authority that has its own claims on the shape and the limits of our freedom."[19]

While de Man might not be the most obvious source for this reminder, his observations do indeed articulate a central axiom of this volume—namely, that philosophical reflections on dance do not simply need to be politicized or historicized by context (although, of course, they may be). They are themselves direct political and social interventions in which the aesthetic is an integral part of the vision articulated rather than a convenient metaphoric medium. This is by no means to suggest that there is no need to offer political and historical context, but rather only that the politics of social choreography are not exhausted by that context. Because choreography takes as its material the human body and its relation to other human bodies, an examination of social choreographies is particularly suited to a presentation of the ways in which political and aesthetic moments shade into each other and delineate themselves with respect to each other. By insisting on an aesthetic continuum, I seek to resist two equally seductive ideologies of the body politic.

First, there is the identification of "choreo-graphy" with the practice of writing per se—an ideological move that sees all physical embodiment as the pre-scripted playing out of determinant social discourses. According to this model, all gesture—albeit unconsciously—would always already be language in the discursive sense. At the other extreme we have an ideology of physical immanence that would take the body as

the final point of resistance to both social and discursive determination. Such a model would stress physical lapses as moments of resistance to discourse, or—in a supreme restitution of the discourse of the subject—as "expressive" gestures indicative of an aesthetic (and, presumably, social) subject. These broadly sketched approaches to the question of ideology replay, in essence, the oppositions in dance criticism that I outlined above. In this book I think of the body as doubled: neither as the brute soma that must resist or conform to a social choreography, nor as the purely discursive construct that it can become in an overzealous new historical reading.

My second challenge to the notion of metaphor is methodological. Greek philosophers explicitly presented musical training in the broadest sense—let us call it "choreography"—as the very foundation of socialization. It was not a metaphor for, but rather a precondition of, social integration. If the idea seems quaint, I nevertheless wish to show how it was adapted by bourgeois aesthetics and exercised considerable power over the construction of art in the postmimetic twentieth century (and earlier). It is in reflections on dance that artists in the bourgeois era have most consistently focused on two key issues: the limits of art (when does a dance cease to be a dance and become mere movement?) and the potential of art to provide models for—rather than mere reflections of—social organization. I am interested here in precisely those instances where art is supposed not to "derive from," "correspond to," or "reflect" the social but rather to shape, determine, or illuminate it. In this introductory chapter—and subsequently throughout the book—I wish to demonstrate how choreography has served not only as a secondary *metaphor* for modernity but also as a structuring *blueprint* for thinking and effecting modern social organization: it is not only a secondary representation but also a primary performance of that order. Couching my argument, for simplicity's sake, in the same rhetorical terms that might lead us to think of choreography as metaphor, I wish to argue instead for the operation of choreography as catachresis. That is, insofar as it appears metaphoric, the critical methodology of social choreography invokes the object of its metaphoric displacement only as a result of that displacement itself. To reflect on catachresis—on what it means to speak of the "leg" of a table, to take the most common example—is to reflect on the ways in which rhetoric serves not only secondary or metaphoric functions. If there is, after all, no "proper"

term for what we "improperly" refer to as a table's "leg," the very referentiality of language itself comes into question. Whereas metaphor makes sense out of what it finds, this catachresis actually brings into being what we might ordinarily presume to have preceded it—its referent. Likewise, choreography is not just another of the things we "do" to bodies, but also a reflection on, and enactment of, how bodies "do" things and on the work that the artwork performs. Social choreography exists not parallel to the operation of social norms and strictures, nor is it entirely subject to those strictures: it serves—"catacritically," we might say—to bring them into being. Thus when in chapter 2, I examine a certain trope of stumbling through political and aesthetic writings from the eighteenth to the twentieth centuries—and when in chapter 4 I trace such stumbles through the choreography of Nijinsky— I do so precisely to demonstrate the instability of metaphor's basic assumptions: the ability of something to "stand for" something else. The logic of catachresis, notwithstanding our example of the table leg, is a logic of stumbling.

How can we be satisfied with establishing a relation of metaphoric causality between aesthetics and politics—linking one term to another— when one of the terms moves and shifts; when it dances? I do not claim that aesthetic forms do not reflect ideological positions: clearly they can and do. But they do not only reflect. My claim, instead, is that choreography designates a sliding or gray zone where discourse meets practice—a zone in which in an earlier era it was possible for an emerging bourgeois public sphere to work on and redefine the boundaries of aesthetics and politics. I will, then, read "choreography" neither as aesthetics nor as politics but rather as articulation—not as one term in a relation but as a discourse, and performance, of that relation. Although I examine how bodies are bounded by textual conventions, I am less concerned with discourse than with practice. At what point, for example, does simple movement become dance? To answer this question by saying that, in the end, all dance is really just movement; or, on the contrary, that all movement is choreographed and, in some sense, pre-scripted ideologically, is simply to dodge the question. The distinction between dance and mere movement is real but contingent. While I do not seek to trace that distinction's history throughout this work, I believe that our conception of "choreography" allows for a focus on praxis rather than metaphor.

A metaphoric relation would imply that choreography is always mimetic (even when it is clearly not mimetic in the strict sense of a *ballet d'action*), the aesthetic reflection of a more fundamental acknowledged reality.[20] This would certainly accord with a materialist tradition of thinking about ideology, placing the aesthetic in the ideological superstructure and "explaining" it with reference to economic realities (perhaps mediated by the category of the political). Thus, for example, the emergence of bourgeois social dance forms—aestheticizing social interaction as a diversionary imperative—might be taken to represent in aesthetic form a political ideology of seamless social harmony that serves as cover for the social antagonisms it unleashes and seeks to contain. I do not question the validity of such models of ideological reflection, but neither do I engage here in the historical work necessary to trace such a history of dance as (mis)representation of social relations. Instead, I will be suggesting the possibility of strategic reversals of this structure of ideology—reversals that locate social and political fantasies within an aesthetic practice that I call social choreography. This choreography is ideological by virtue of what it both produces and instills rather than for what it reflects.

While I do not wish to engage in broad political-historical arguments for which I am unqualified, there is historical precedent for my thesis regarding the role of the aesthetic in the institutionalization and inculcation of the political in bourgeois everyday life. Historians and theorists have demonstrated how it was within the realm of relative aesthetic autonomy that a bourgeois public sphere first negotiated for itself a limited political freedom from within the authoritarian social structures that had characterized the baroque period.[21] As the bourgeoisie sought ideological and political liberty from the tutelage of absolutist states in the eighteenth century, art was guaranteed a degree of freedom at the cost of its disempowerment as a social force. Within limits one could reason freely in art because it was agreed that art was without direct social consequence. Obviously, the emerging class utilized this freedom to rehearse ideas that would only subsequently be set free into a truly political bourgeois public realm. To assume that protopolitical ideas developed within one sphere of discourse, with its own norms and traditions—in this case, the aesthetic realm—would be completely unmarked by this period of gestation, seems counterintuitive. The (aesthetic) form of expression allowed to the politically emergent

bourgeois class cannot have been without effect on the content of the ideas that were developed under its protection. Thus, aesthetic concerns entered from the very beginning into bourgeois political calculations. More specifically, here I wish to argue that dance—as an aesthetic form that had yet to fully establish its autonomy as something other than a social observance or entertainment—was a particularly "porous" membrane of communication between the aesthetic and sociopolitical realms.

With the emergence of the relatively autonomous bourgeois aesthetic realm—generally traced to the eighteenth century—we might think of choreography in terms of "rehearsal"; that is, as the working out and working through of utopian, but nevertheless "real," social relations. My argument is that discourses around dance—in the bourgeois aesthetic and public spheres—have tended to recognize choreography as a form that not only exemplifies a certain ideological relation of aesthetics to politics but also reflects on and/or performs that relation. Dance's overt choreographing and conventionalizing of the body has allowed it to serve as a performative reflection on social choreography in the broader sense. In other words, if the body I dance with and the body I work and walk with are one and the same, I must, when dancing, necessarily entertain the suspicion that all of the body's movements are, to a greater or lesser extent, choreographed. This may sound, once more, like the thesis that dance reveals the ideological functions of the body as mere text. But an aesthetic continuum such as this is not a simple chain of cause and effect—rather, it runs both ways. Dance also serves to demonstrate how the "textual" acquires significance as social choreography only when embodied. This complicates the operation of any critique of ideology.

My task in this book is to demonstrate the scope and limits of embodied experience as an indicator of the operation of ideology rather than to trace the social relevance or derivation of specific forms of choreography. To take an example from the work of Isadora Duncan, one of the central figures discussed in this book: recognizing that ballet conventions and positions are historically and politically determined on the one hand, and physically debilitating on the other, is a form of critique of ideology. That critique might be articulated intellectually, but it is experienced by the body itself. Physical experience is a crucial component of this critique of ideology. To this extent, one can follow

Isadora Duncan in her rethinking of the operation of ideology. However, if the body can serve as a marker of what is wrong in ideology, it becomes ideological itself when taken as the arbiter of what should be "set right." Here I contend that the body that "experiences" critique—ballet is "wrong" because it hurts, as Isadora Duncan would pithily argue—cannot serve as the locus of an experience of "truth," as Isadora would go on to argue. An entire tradition of modern dance thinking about the body—from François Delsarte through at least as far as Martha Graham—shares this belief that the body cannot lie. Such a belief is the very essence of ideology. Pain might serve as the embodiment of a critique of ideology but its absence can never mark a position of nonideological truth, for the reification of the body necessary to disentangle it from the social milieu it "critiques" involves an ideological gesture. This rejection of the body's normative claims may sound like a resignation to the fashionable cultural platitude that everything is just ideology, that there is no nonideological space from which a critique of ideology might be launched. Not so. In the performance of dance itself—not in any act of representation—it is the physical experience of pain that tells us that ballet posture might be "unnatural." This experience has not necessarily passed through consciousness. Where the implicit critique itself becomes ideological, however, is in its movement out of the performative and into the mimetic, for the body thereby becomes the arbiter of "true" consciousness.

It is one thing to envisage (as Isadora Duncan did) a dance form that did not involve pain, but it is another to assume (as she also did) that the performance of that dance would adequately represent the experience of joy, thereby providing a model for social order. In combating the pain that physically marks the ideological fallacy of ballet, for example, it is tempting to celebrate the merely somatic—the seamless experience of embodiment—as the truth. Nothing could be more ideological: for without some pain of alienation, some schism within the embodied subject, no experience is possible. Experience is a category of consciousness, and consciousness becomes unconscious and irrational when the body is celebrated as at once brute soma and immanent truth. The operation of aesthetic ideology relies on the suppression of the contingencies that structure experience, and to ontologize the body itself as a minimal resting place of untrammeled, noncompromisable subjectivity is to engage in the worst form of aesthetic ideology.[22] To

counter such tendencies, a truly materialist analysis can only be a social and historical analysis, in which even the category of "history" itself cannot be granted immunity from critique.

The choreography I invoke throughout this book operates along an aesthetic continuum and does not only find expression in dance or in forms of movement we might recognize as "aesthetic" in and of themselves. Only in the second half of the book does my focus move to instances of theatrical and social dance to demonstrate specific ways in which they inculcate ideology. In the first half of the volume, by contrast, a critical choreography traces the movement of bodies through social space and further examines the ways in which an idealized body negotiates that space according to bourgeois political and aesthetic theory. Chapter 2, for example, focuses on the minimally "aesthetic" achievement of walking and on the significance of stumbling in bourgeois theories of community, and subject, formation. My task here is to follow this aesthetic continuum, noting how and where, historically, a threshold of the aesthetic was established to differentiate the aesthetic continuum into categories of "art" and "experience." In focusing on a continuum of bodily movements—from simple walking, to "taking a stroll," to the most highly conventionalized balletic forms, and even to such "subsocial" phenomena as convulsive vomiting (see chapter 3)—I wish to suggest a different relation of aesthetics to politics. Rather than tracing aesthetic effects to their social and political causes, I will suggest throughout this book that a certain codification of the aesthetic both predates and serves as a threshold to society. Rather than simply reading the body as trope we need to observe a double agenda in this work: dance as the production and presentation of social order; and dance as the articulation and disposition of bodies at both work and play. To examine choreography thus is necessarily to follow two trajectories: one tracing the ways in which everyday experience might be aestheticized (dance aestheticizes the most fundamental and defining motor attributes of the human animal); and another tracing the ways in which "the aesthetic" is, in fact, sectioned off and delineated as a distinct realm of experience. This is what I mean by the aesthetic continuum of social choreography.

I must acknowledge also slippages inherent in my use of the term "aesthetic"—slippages I take as fundamental to the category of choreography as something both social/political and aesthetic. By working

with the notion of an aesthetic continuum—a scale of experience that would extend from apparently (but only apparently) somatic experiences of the body through to the most formal and conventional aesthetic forms in the more limited sense—I do not simply invert a causal relation of aesthetics and politics. It is not simply a question of saying that, in certain instances, aesthetics determines politics, rather than the reverse. By positing an aesthetic continuum—within which more limited and conventional concepts of "art" arise and shift at given historical points—I wish to stress the relational nature of the category of the aesthetic. Again, this relationality will not be examined in a strictly "historical" manner. I will trace only as background the institutional shifts that mark and define the changing boundaries of aesthetic discourse.[23] I focus primarily on two extremes of the aesthetic continuum—apparently presocial, "accidental," or somatic experiences of the body on the one hand, and clearly delineated theatrical dances on the other. (This book is also organized, to some extent, on this principle: theatrical dance per se becomes the focus only after more philosophical considerations on the nature and history of embodiment are given in the first half of the book.) Indeed, this is a second sense in which the term aesthetic continuum is crucial to this study: it denotes not only a scale of bodily experiences but also a scale operative within the aesthetic realm itself—a scale extending from clearly theatrical forms of choreography to forms of social dance. Thus, while I shall begin by considering Schiller's important reflection on the social dance forms of his time, I do not engage in a cultural study of popular dance beyond the hypotheses I shall put forward later in this introduction. Similarly, in reading Ruskin's reaction to the raucous music hall in chapter 1, I do not assume that he is an authority on the popular cultural practice of the nineteenth century. I read him as an attempt to square an established, even rigidified, aesthetic ideology with the newly emerging popular cultural forms that challenge it. Finally, then, my concern is with the construction and legitimation of aesthetic ideologies rather than with an analysis of specific body cultures.

If we take Schiller as the historical and theoretical launching point of this book—as the visionary of a classical and classicist model of social harmony that emerges even as the romantic tradition comes along to challenge it—it is important to note ambiguities within his own formulation of the English dance. We can use his presentation to distinguish

between two ideologies of the aesthetic's ability to effect closure and impose order on otherwise contingent social movements. In Schiller's presentation there are two formulations of the dance that are crucial to my argument in this book. First is the presumed experience of the participants, who reconcile freedom and necessity, the desire for bodily movement and the need to observe a choreography. This I term "performative" or "integrative" totality. Here, totality is the production of the bodily movements of those participating and does not demand a reflective awareness of the totality produced. As I dance, I do not know totality; I perform and embody it. Indeed, to "know" the totality would be to abstract myself from the dance and break the very flow and order I experience. At the same time, however, Schiller writes of being "a spectator in the gallery" and reproduces the vision as an aesthetic artifact or object, a "fitting image for the ideal" and a "perfectly appropriate symbol." At this level we have the second formulation, what I call the "mimetic" model of totality, in which a representation is sectioned off and made to stand for something else. The dancers function here as the symbol of a utopian social order. The observer knows the totality and knows the distinction between the idea of totality and its experience in the dance. Ideology operates at both of these levels—performative and mimetic—in distinct ways.

These two models of social order—performative and mimetic—will frame my readings in this book. A mimetic aesthetic ideology would be one in which the artistic representation of a better life serves to blind the audience to the social realities in which they live. In this model, art clearly serves as an antidote in Marcuse's sense of an "affirmative culture."[24] Aesthetic satisfaction in the mere "symbol" of a social utopia distracts us from the political praxis necessary to bring that utopian condition about in reality. Art serves as a sop for unrealized political action. This would, indeed, be ideology as false consciousness or false representation. (After all, what would be the real political context of an English dance at this point in history?) What I am calling the performative or integrative aesthetic ideology, meanwhile, is one in which art does not simply misrepresent, in a palliative manner, an existing social order. Instead, the aesthetic now becomes the realm in which new social orders are produced (rather than represented) and in which the integration of all social members is possible. Whereas the mimetic ideology approximates a traditional model of ideology as false con-

sciousness, the performative would be something more like a political unconscious, except that the performance of ideological work by the body moves us out of the very paradigm of consciousness in which the distinctions true/false, conscious/unconscious, and so forth hold sway. The equivocation in Schiller's letter between social dance (as experience) and dance as aesthetic spectacle is clearly crucial, for it already seems to mark a certain degradation of the ideological, a falling away from the power of full integration. At the very moment he posits the possibility of a fully integrative social order, Schiller himself looks on and aestheticizes from the gallery. Thus the integrative experience is, in fact, nostalgically imagined rather than actually experienced.

Schiller's letter already confronts us with a distinction between the dance as a social divertissement (at the performative or integrative level) and dance as an aesthetic spectacle (at the mimetic level). In other words, Schiller's presentation is already a transitional moment of sorts in the understanding of social choreography. Yes, there is the assumption that dance can teach us how we might transcend ourselves within the social sphere, but Schiller himself is already only an observer of that process. It remains unclear whether, historically, the possibility of transcendence has already retreated into the aesthetic realm in the more limited sense at this point; that is, into a realm that exists elsewhere—down there—as spectacle and reflection rather than as actual experience. This distinction between a totality that is performed and a totality that is mimetically represented is crucial with respect to the politics of social choreography. Marcuse's notion of "affirmative" art is helpful with regard to one form of aesthetic ideology (the mimetic), in which a false "fitting image for the ideal" is conjured up to paper over the cracks of social disintegration. Such an ideology, however, depends on the autonomy of the work of art—on its existence outside (and, implicitly, above) the everyday. The performative ideology, however, which excludes the position of the viewer and relies on one's engagement *in* the dance, presents important new possibilities of aestheticization. What I am arguing—in effect—is that only an understanding of ideology as something performed is adequate to the forms of the aestheticization of politics that we encounter in the late bourgeois era. It is only when the possibility of an "ideal" performance in the everyday realm is projected, as a "choreography," that we confront the phenomenon of an "aestheticization of political life." Every social

order has sought to represent itself aesthetically—one need only think of the origins of ballet in the baroque court—but in all such representations power was constructed along the axis of inclusion and exclusion. Only certain figures were accorded representative power, as others looked on. Schiller inaugurates a certain fantasy of full integration—even as, paradoxically, he himself looks on from across the English channel.

Effectively, the mimetic conception of totality is self-negating in that the exclusion of the work of art—think of the distance from the gallery down to the dance floor—already delimits and contains the totality. The confusion of subject and object, necessity and freedom, and the like is undone by the observing subject's relation to the dance as object. In other words, aesthetic attempts to effect totality as artifact always disrupt that totality. By contrast, performative experiences of totality would be those that seek to privilege the aesthetic moment itself as either integral to, or constitutive of, the totality. The totality is experienced as spontaneous, free, and self-grounding: no clearer definition than this of ideology is possible, of course. But Schiller himself is not dancing: he presents as an aesthetic artifact and object of the gaze a moment of self-contained totality. The performative totality—as experience—is already mediated by the mimetic, even as it denies that moment of the outside observer. This is its form of ideological foreclosure. The desire to harness the aesthetic impulse as an integrative social and political force is certainly not alien to the Schillerian tradition I have outlined here. In fascist spectacle, for example, the masses do not simply denote the collective, they are themselves an assemblage of that collective. Schiller's presentation of the English dance is transitional because it holds out the possibility of finding aesthetic forms of social order, while delimiting and containing that order in aesthetic form. Thus, it remains undecidable whether the boundary of art and reality has been blurred or reasserted.

In crude terms, one might say that I am using Schiller's example in order to parse out the otherwise intertwined moments of production and representation operative in ideology. I would argue that the decay of a fully integrative ideology—the aesthetic as experience of the dance—is what allowed for the emergence of highly aesthetic dance forms by the end of the nineteenth century. In ballet, for example, technique could be perfected at the cost of inclusiveness. No one ex-

pected the virtuosi of ballet to serve as models for aesthetic and politi-
cal integration: they were spectacle. In the words of Hans Brandenburg,
an influential early-twentieth-century German dance critic representa-
tive of the second historical moment to be focused on here, "ballet
blossomed in a period of European history when a one-sided bourgeois
intellectualism had reached its apogee, while at the same time prepar-
ing the way for a materialistic reaction. All feeling for the body had died
out and so, in a quite touching way, the stage became a place to cele-
brate an ideal of what had been lost in reality. The bourgeois' tired
organism sought to fascinate itself and whip up its atrophied instincts
through an extreme physical exertion of which it was otherwise no
longer capable."[25]

In this admittedly sloppy presentation—typical, by the way, of the
romantic anticapitalism ubiquitous in the writings of modern dance
enthusiasts examined at various points throughout this book—the
bourgeois figure enjoys the intellectual and spiritual elements of ballet
only as spectacle. Subconsciously, the bourgeois identifies—in his own
alienated body experience—with a distorted body whose very self-
alienation has reached the level of an aesthetic achievement. What
Brandenburg offered in the place of ballet, meanwhile, is "a true and
healthy *Körperkultur*" (9), whose own ideological underpinnings we
later need to examine. In this presentation, art has taken on a compen-
satory value—ideal rather than real—but Brandenburg's demand is not
for a more "realistic" *representation* of the body. What is required is an
experience of the body that will counteract both an ideological and a
physiological atrophy. This invocation of experience provides a corre-
late argument to my claim about the decay of integrative aesthetic
ideology. In fact, this mode of integrative ideology did not disappear;
rather, it migrated both to popular dance forms that were simplified to
encourage full participation (the dance craze of 1910–11 and on) and to
the realm of a "body culture" that emphasized "authentic" physical
experience over social mediation.

In the context of my reexamination in this volume of modernist
aesthetic histories, dance is crucial for the manner in which it problema-
tizes, in ways that prefigure the historical avant garde, the notion of the
"work of art." Discourses around dance in the nineteenth and early
twentieth century, I will argue, always express conjoined crises of the
(im)possibility of bodily experience (because experience presupposes a

consciousness that sunders the immediacy of body) and the fate of the aesthetic artifact in a form that is dynamic and evanescent. In a nutshell, dance asks two questions: Can I still experience something? Can I produce an artifact? In other words, are we to think of the "work" of art as noun or verb, as artifact or activity? If the work of art is thought in the everyday terms of "artifact" we risk losing sight—from the Schillerian perspective—of the integrative function of the aesthetic. That which has been enclosed and reified in an artifact is itself the finished product of a process rather than a dynamically cohering social force. To stress the productive or integrative nature of aesthetic work as a process or activity, however, is potentially to demote the work itself as artifact and to question our ability to stand back from, and reflect on, the totalizing (and totalitarian?) activity of dancing. Dance is a process of work that produces no work or artifact as residue. To a great extent, of course, this is what endears it to certain symbolists as a model for a solipsistic aesthetic. More specifically and polemically stated, a critical emphasis on dance as an aesthetic form of play reiterates and reinforces a certain tradition already found in Schiller. What is lost is any notion of work.

In chapter 1 I will examine a strain of nineteenth-century "aesthetic socialism" that derived the aesthetic terminology for theorizing dance from the traditional distinction of the plastic and the musical arts. In terms of this distinction, prevailing readings of modernism have tended to read the nineteenth century through the prism of the musical—with all forms aspiring to the condition of music. By focusing in chapter 1 on questions of work—specifically the work performed by the work of art—I seek to problematize this emphasis on the playful nature of dance. The category of social choreography allows us to study the work of art in two senses. First, how does choreography enact rather than simply reflect social order? What social work does it perform? Second, what is the significance of the reemergence of dance in the early part of the twentieth century for subsequent avant-garde attacks on the "work" of art as artifact? I shall trace in chapter 1 the way in which a discourse on dance and a discourse on work became intertwined in the course of the nineteenth century; my aim here is simply to note how, with the celebration of dance within modernist aesthetics, the category of work gets written out. This erasure I take as symptomatic of a certain ideological reading of choreography that seeks to obscure the social and material origins of its own aesthetic endeavor.[26]

On the one hand, a reemergent dance necessarily redefined the very conception of the work of art. It is not—in the sense elaborated by Hannah Arendt in *The Human Condition*—a "work" at all: it produces no object.[27] In other words, we might say that dance reemerges as a central and paradigmatic aesthetic form at the very point where bourgeois aesthetic discourse begins to question both the nature of its own social relevance (its "work") and of its own commodity status (its "works"). The reemergence of dance at the turn of the century—and the subsequent dance craze of 1910–11—prefigured some of the more radical avant-garde challenges to the institution of art. Whereas artists such as Marcel Duchamp would challenge the fetishization of the aesthetic artifact by offering up something apparently "subaesthetic," however, the prevailing discourse around dance obscured the crisis of the "work" or artifact by insisting on the "transaesthetic" and synthetic value of the choreographic. For a moment, the crisis within bourgeois aesthetics—a crisis centered around the nature of aesthetic "work" and the "works" it produced—could be presented as the sublation of bourgeois aesthetics. "Work" would be precisely that which the "play" of the aesthetic must hide. It is precisely such a reading that Kermode sees being developed in his study *Romantic Image*. I seek, instead, to restore the radical moment of the challenge—"Is dance a work?"—before it was resubsumed by a codified modernist discourse.

The very fact that dance does not produce a "work" or artifact to mark the fact that work had taken place particularly suited it to an aesthetic ideology of modernism that sought to obscure the materiality of work in its own productions. There is a fantasy of pure energy at play here that parallels a capitalist fantasy of pure profit, pure production. Dance became a preeminent aesthetic form during the modernist period not only because it exemplified those conditions of modernity famously identified by Baudelaire—the material and contingent—but because it equally effectively sublated them.[28] The figure of the dancer—rather than a notion of socially embedded choreography—resolved a fundamental cultural contradiction of capitalism. It exemplified social modernity, as a reliance on pure energy and progress, and aesthetic modernism, as autonomous play, in ways that other forms apparently could not.[29]

In a fully rationalized world, labor would be performed as a form of spontaneous bodily dance that generates rather than expends energy. It

is interesting to note how what I present here as an abstract paradigm shift—from play to labor—in the ideological function of choreography was, in fact, accompanied by mundane changes in the history of social and/or theatrical dance. Thus, for example, Belinda Quirey, a historian of forms of popular dance has even noted of the waltz—the nineteenth century's definitive contribution to social dance—that it "is basically a work rhythm. It was the first work rhythm that we ever accepted above the level of folk dance . . . Nor is Waltz specific to one single working action. There are dozens of working actions that can be done to it, but particularly anything that requires a good wallop on the first beat, and then a recovery period."[30]

A tendency that I note at the level of critical discourse—the movement from play to work as the defining paradigm—seems to announce itself first in new popular dance forms, and it is interesting to note this belaboring subtext to a social dance that was scandalous primarily for its erotic rather than its utilitarian overtones. Quirey calls the waltz the most important single change in dance as a form of social intercourse, claiming that it marks the definitive death of courtly dance as the hegemonic form and model of social choreography. It is, therefore, interesting to note how quickly after Schiller's celebration of a sociable English dance—still more closely tied to popular forms of country dance than was its continental counterparts—the assimilation of popular forms into fashionable dance began to introduce the moment of work, rather than play, into the performances of bourgeois self-aestheticization.

In the early nineteenth century, romanticism's demands for a more "genuine" and expressive culture led, on the one hand, to the emergence of social dance forms that were altogether new and, on the other, to the final flowering of ballet in nineteenth-century France—the period of Fanny Elssler and Maria Taglioni and the writings of Gautier. Although the ethereality of romanticism's dance aesthetic, both in the ballroom and on stage, might seem diametrically opposed to such vivacious new social dances as the waltz, it can be credibly argued that a new emphasis on expression also made possible, in a certain sense, enthusiastic critical perceptions of the waltz as the expression of a transindividual, primal life force. The waltz seemed to represent the very essence of dance itself, the most intoxicating and energizing force of human movement. Similarly, the second period of critical writing

that I have been citing in this chapter—the period immediately preceding World War I, reflected primarily in the work of prodigious German dance critics—coincided both with the dance craze of 1910–11, and, of course, with the debut of the Ballets Russes. To contemporary observers, the dance craze also seemed to presage the more visceral "craziness" of the war to follow. As a German critic of dance and body culture in general noted at the time: "The great dance epidemic that was merely suppressed by the war and broke out again all the more violently at war's end has something of that melancholy audaciousness that imbues all moribund epochs."[31]

My working assumption with regard to social dance, therefore—which I treat only peripherally in this work—is that it serves as a cultural trading post where aesthetic norms (in the more limited sense) are tried out for the social formations they might produce, and at which new types of social interaction are forged into new artistic forms. By way of example, Hans Brandenburg addressed directly the Schillerian inheritance in ways that might be useful for bridging the gap from Schiller to the twentieth century. Brandenburg offers an interesting analysis of the destructive inner dialectic of Schiller's aesthetic and social vision. Writing of the development of popular dance in the nineteenth century, he observes how

> The round dance signaled the end of the art of dance, insofar as it might be said to have existed. At least as long as it had been performed only by a gifted few, even social dance had remained a spectacle. After the rococo, when a cohesive style had, as in ancient times or in the Renaissance, completely unified an era for the very last time, the epoch of literature, science, and technology set in; a bourgeois epoch in which all bodily imagination was banished by an increased emphasis on the intellect. Dance no longer sought to stand above the world and give it expression through the spectacle of movement; it became a form of general social entertainment.[32]

This observation is important and bears some examination. Clearly there are the same two competing visions of totality here: one mimetic and external, reflecting on what it excludes, and the other performative and integrative, weaving a totality but producing no aesthetic object in which the totality itself can be represented or beheld. Even as a form of social choreography, Brandenburg argues, Renaissance and rococo

dance understood that they were intended to be seen—that they were a spectacle for all but the "gifted few" who performed them. The social choreography was exemplary, so to speak.

Brandenburg further argues that a degeneration in dance technique has gone hand in hand with dance's popularization. In other words, he traces a trajectory that inverts Schiller. Whereas Schiller expresses a certain allegorical nostalgia for the experience of a perfectly choreographed society, by the early twentieth century Brandenburg is arguing the reverse: that such choreographed societies were always spectacles, and that the real problem is that the moment of reflection—the speculation made possible by the spectacle—has been lost, to be replaced by an "intellect" that neither stands apart nor participates. Whereas Schiller traces the rise of an autonomous aesthetic and the aesthetic theorist's consequent distancing from any mundane or "performative" experience of unity, Brandenburg argues instead that all we have now is participation—"general social entertainment"—rather than aesthetic achievement. In political terms—terms that will recur throughout this book—I take this distinction as typical of the division drawn by Theodor Adorno between authoritarian and totalitarian fantasies.[33] Whereas ballet arose from a fantasy of absolute control (articulated as visibility, the opening up and splaying of the dancer's body for surveillance), Brandenburg now writes of a dance that envisages a social order in which such control is superfluous because each individual has an immediate, fundamental, grounding relation to the whole. The totality is participatory or, in my terms, performative: a "general social entertainment." Prefiguring Adorno's famous reflections on the culture industry, Brandenburg's writing (around the time of the dance craze) begins to articulate a theory of entertainment as a totalitarian culture industry. In this window from Schiller to Brandenburg we encounter the historical moment in which aesthetic experience was sundered from, yet nostalgic for, subjective and intrasubjective self-coincidence: the high point of the aesthetics of autonomy. In Brandenburg we find a critique of the aesthetic prefigurations of social totalitarianism. Whether or not we accept the conclusion, what interests me here is that it was a reflection on dance that enabled—or even necessitated—this reflection.

To me, the most compelling way of judging the political valence of a certain choreography, while taking account of its own aesthetic specificity, is, indeed, by way of an analogy with a social configuration. For

example, the traditional balletic form of self-presentation, in which the body is splayed open to be visible on a flat plane, clearly reflects the system of feudal representation in the absolutist courts, where the gaze was to be monopolized by the kingly subject/object of power. Likewise, the fantasies of immanent physical redemption in much modern dance—or the notion that bodies communicate immediately to one another by way of kinaesthesia—clearly suggests an analogy to a bio-politics that sees community as something physical and biological rather than political. A pervasive early-twentieth-century celebration of rhythm readily lent itself to irrational, vitalistic (and reactionary) notions of social unity, insofar as it posited an immediate passage from natural-biological rhythms to the social-aesthetic. To call this system of political analogy "metaphorical," however, assumes the primacy of the social and political structure that is replicated in the aesthetic form. Is it not possible that political fantasies have, quite literally, been rehearsed in the aesthetic arena before taking concrete political form in the everyday sense? Without trivializing the political by arguing that a dance is just as "fascist" as, say, Nazi laws on racial hygiene, I do think it is possible to extrapolate an underpinning fantasy structure that would link the two phenomena. To speak of the "homologies" of these elements of fantasy, however, is to speak in the language of fantasy itself, which serves to reify and quarantine as autonomous components the related and differentiated levels of the power structure it serves.[34] And precisely because the underpinning structure is a fantasy, it relies not only on political calculations but also on certain aesthetic norms for its narrative coherence. Fantasies only work as political and ideological forces if they have an aesthetic coherence and appeal. This aesthetic component is primary rather than secondary. Thus, when I use the term "totalitarian" with regard to an aesthetic event, I refer neither to the politics of the artist, nor to any favor lavished on such art by a regime. Nor, however, do I refer solely to the operation of a fantasy of wholeness, completion, and closure (we find this in ballet also, obviously). Totality itself need not be totalitarian. I refer instead to an aesthetic that derives its force from imagining that closure as something immanent, emanating from within: that is, from within the body of the dancer, or from within the very logic of the dance itself. As such, this totalitarian aesthetic performance does not derive from a prior totalitarian politics but rather shares with that politics a certain fantasy

structure—a belief in immanent, rather than socially (or even aesthetically) mediated, totality.

This difference is crucial. Schiller marks the transition from an imagined experiential social integration to a realization that this can only be a mere aesthetic representation in the bourgeois age. In short, he marks a transition from totality as a political project to totality as an aesthetic project. Not the least of his ideological moves is to locate this "perfectly appropriate symbol" in England, thus marking his own distance from it while implying that the more liberal political structures of England may, indeed, allow for a realization of this aesthetic ideal in the public realm. Brandenburg writes a century later, in a time of the resurgence of both popular dance in a new dance craze that brought many new steps from America and Latin America and of ballet with the Ballets Russes. His observations, I would argue, trace a shift toward a new totalitarian aesthetic—one from which there is no escape and in which there is no restraint because the dance is all there is. In a nutshell, Schiller uses dance to mark the nostalgia of bourgeois aesthetics for an ideal closure and self-coincidence, whereas Brandenburg's nostalgia is for bourgeois aesthetic values and competencies that might resist and set limits to an all-embracing "diversion," a totalitarian craze for dance.

In his study *The Structural Transformation of the Public Sphere*, Jürgen Habermas places this intraaesthetic development in a broader context by quoting Alewyn to the effect that "the bourgeois is distinguished from the courtly mentality by the fact that in the bourgeois home even the ballroom is still homey, whereas in the palace even the living quarters are still festive" (10). We are dealing here with the social and aesthetic transformations that are part and parcel of a shift from a feudal public sphere of visibility and representation to a bourgeois public sphere of both intimacy and coercive integration that shuns the very position of observer that Schiller adopted. In the bourgeois period, according to Brandenburg's presentation, there is no longer an audience able to constitute the dance as an aesthetic object. But at the same time there is no longer an immediate physical experience of the dance—it has been ruptured by the intellect. An analysis of social dance at this time of transition brings greater complexity and historical context to this theoretical argument. Quirey's assertion that "in the Romantic Revolution something very sad happened to western man. He

began to lose his choreographic identity" (74) suggests that the shift in the operation of the public sphere around the beginning of the nineteenth century also needs to be thought of in specifically gendered terms. The "representative" public function of the male disappears, she argues. This had to do with the new fashion for a more ethereal dancing on toes—and, indeed, a more general shift in posture and gait at the time—which was felt to be unmanly but indicative of the "grace" of dance. As Quirey notes: "The technique, high on the toes and with very soft arm movements, favoured the women's dancing from the start. Add to this the lamentable characters a man had to play, and the result is predictable. Ballet, and dancing in general, became thought of as effeminate" (76).

On the one hand, then, we have the theoretical historian Habermas arguing for a broad shift away from a "representative" to a more deliberative bourgeois public sphere, and on the other the disappearance from the ballroom of masculine self-representation. What results, in effect, is a form of division of labor. Women can continue to "represent" only because the representative public sphere that demands such acts of self-representation has been surpassed—and enclosed in an aesthetic realm—in the bourgeois era. In his *Tanzbuch* of 1924 the critic Hans W. Fischer—whom I cited earlier and to whom I shall return in the final chapter of this book—is characteristic of contemporary critical appraisals when he argues "wherever dance functioned as a direct expression of life, man always played a full, and sometimes even a leading, role: as suitor, priest, or warrior. He therefore maintains his role even in social dance, which remains, after all, essentially a form of courtship. Only as dance shifted function and became spectacle did a change take place in this regard."[35] Once social power and its physical embodiment—the king's famous two bodies—have been separated out, the representative public sphere cannot function. So-called representation becomes little more than ornament or display—women's work. The men, and their power, have disappeared into the cabinet offices. The only form in which masculine power remains is in its eroticization in the waltz. In other words, the display of erotic attraction in the waltz projects the so-called representative public sphere onto the realm of bourgeois intimacy.

What Quirey presents from a dance historical perspective as the sidelining of men can at the same time be taken as a denigration of the

ideal of social choreography in general and its delegation to a subaesthetic, popular, "feminine" realm. From the perspective of the Schillerian ideal of social choreography, what this effectively means is that the ideal of harmonious interaction has been retained in the form of an aestheticized social practice, but only at the cost of the trivialization of his concept of "play." The specific dance form of the waltz itself, meanwhile, injects into this realm of emasculated play a note of hard labor. It is as if the ideological work of the women was to sustain the fantasy of Schiller's ideal—even as the male society deserts it. And yet, to the contrary, we need to remember that the real scandal of the waltz lay in its eroticism: in the fact that men and women paired off exclusively and in immediate physical proximity in public space. This apparent contradiction—men abandon dance to the women, yet are themselves to be found dancing more lustily than ever—is no contradiction at all. The waltz was scandalous precisely because it no longer rehearsed new possibilities of social order—in the manner of social choreography—but served merely to demonstrate the schism between public and private and the dual or split function of men in each. In the words, once again, of Hans Brandenburg: with the waltz, "democracy, the bourgeoisie, emotion carried off the victory . . . The waltz was able to make available on an unprecedented scale the sheer joy of dancing, unleashing a veritable ecstasy of dance, an international mass psychosis, simply because its rhythm contains an impulse toward movement the likes of which had never before been experienced. It contained the rhythmic formula for all the pleasures of the dance."[36] Brandenburg sees the waltz not as one dance among others but as the unleashing of the very essence of the choreographic. Social choreography no longer functions as an interaction in which harmonious order might be envisaged and rehearsed, but as a communing with a putatively primal force or rhythm. Although I will not focus on popular dance in this book, I think we can clearly see— not only in the waltz, but also in the critical reflections it prompted— the emergence of a philosophical and sociological vitalism that would grow in ideological appeal during the historical period covered by this study.

In tracing the shift from Schiller's enthusiasm for dance at the end of the eighteenth century to Ellis's rueful assessment of it at the beginning of the twentieth, we need, finally, to distinguish not only between performance and spectacle but also between popular and high culture.

Ellis bemoaned the decline of an art form whereas Schiller's hopes were for an emerging form of explicitly *social* choreography. Brandenburg, I think, allows us to mediate the shift. The process that Brandenburg hints at—the aesthetic impoverishment of dance as a cultural achievement at precisely the point where it is expected to choreograph a new social order—is something for which we find ample historical evidence in the twentieth century. The dance craze of 1910–11 (its contemporaneity with the success of the Ballets Russes is, of course, striking) might now seem to us to have consisted of an eccentric variety of contrived and difficult dances, but—as a historian of popular dance observes—as soon as the craze spread, a simplification of steps became necessary: "The steps in fact were of no importance and could be learnt by anyone, young or old, able to walk in time with the music . . . Up to 1910, no matter what the dance, the main attraction lay in the actual steps, and in some cases, the exhilarating movement. After 1910, the main attraction was unquestionably the rhythm; and from now on rhythm was to inject all our dance forms with an entirely new force."[37]

While the spectacle of the Ballets Russes must certainly have contributed to an interest in social dance during the craze of 1910–11 (and, indeed, functioned in other ways as a stimulant to "cultural" consumption, with Nijinsky effectively becoming a mannequin for new trends in women's fashion),[38] the technical skills of the ballet in fact compensated for an aesthetic impoverishment of ballroom dance. As complicated and faddish new dances gave way to something simpler and more readily popularizable—the two-step and fox-trot, for example—the ballet remained not simply as a singular aesthetic achievement (acknowledged even by those who rejected its very presuppositions) but as a spectacle of the aesthetic; as perhaps the final staging of a society's drive to self-aestheticization. This polarization of the aesthetic continuum—prodigious Russian leaps on the one hand, collective shuffling of feet on the other—marks a historical juncture at which it became necessary to reassess established notions of both personal and aesthetic autonomy. We see here a social *techne* fetishized as technique on the one hand, and operating as a barely aesthetic social technology on the other.[39]

Thus, when the popular performers and teachers of ballroom dance, Irene and Vernon Castle, stated "When I say *walk*, that is all it is . . . It is simply one step—hence its name," they seem to be warning against any

aesthetic excess.[40] From the dance craze observed by Schiller to the dance craze of 1910–11, there has been a paring down of aesthetic expectation at the same time that there has been an expansion—a craze—in the extent to which a social choreography can be aestheticized. The "dumbing down" of social dance at precisely the point when dance itself becomes ubiquitous, as in the dance craze, will oblige me in this study to expand any consideration of dance to a more basic— pedantic—consideration of walking as the brute material of choreography. In two chapters devoted to the problem of walking and stumbling, I will seek to show how an entire tradition of writing about walking, gait, and posture sought both to romanticize the good old days when leisurely promenades were possible and to theorize its own motive force as something altogether more syncopated; vibrant but consistently threatened with collapse. Contrary to a tradition of modern dance theory that seeks to make our most "natural" movements the basis of an aesthetic, it will be necessary to examine how thoroughly "cultural" even so simple a motion as walking can be. As I show in chapter 2, dance might be seen as the culmination of an Enlightenment pedagogical project that extended from the minimal and functional (the simple act of walking, for example) through the expressive (a concern with the codification of gesture) to the aesthetic realm itself as a theater for the transfiguration of bodies.

By insisting on reading dance along this aesthetic continuum of bodily articulation, I resist a reading that takes for granted the metaphysical aspirations so often identified with dance as a form in which time and space, body and soul, seamlessly interpenetrate. While acknowledging the importance and prevalence of the vitalist discourse on rhythm, I will stress throughout this book, in polemical fashion, those moments in both dance and social comportment that threatened a break in rhythm: graceless actions that bring us back to earth. Here I will consider a history of gesture and look at instances of stumbling— feelings of bodily unease that suggest the noxious effect of modernity's rhythms. By no means does this work aspire to offer a history of dance; rather, it examines the solutions that social choreography—as the performance of social and aesthetic order, as the articulation, indeed, of the orderly relation of the aesthetic to the social—offered to certain pressing questions within cultural modernity.

1

The Body of Marsyas

AESTHETIC SOCIALISM AND THE

PHYSIOLOGY OF THE SUBLIME

Dance historians have generally regarded the nineteenth century as a low point in the development of dance as a serious aesthetic form in Western Europe. It is assumed that the balletic tradition, originally developed in Italy and then transported to the French court, effectively disappeared into Russian exile where it was nurtured under the anachronistic absolutism of courtly and state protection. Meanwhile, in Western Europe—after the period of high romanticism when the ballerinas Taglioni and Elssler were feted by the literary and artistic world—dance was reduced to the status of divertissement, or popularized and vulgarized in the music hall. However one might tinker with this broad historical account, it nevertheless seems undeniable that the postromantic period did, indeed, see a decline in dance's prestige and in the quality of aesthetic reflection accorded it—that is, until Mallarmé took up the critical tradition kept alive in the mid-century by Gautier and made dance a central trope for the poetic endeavor.[1] In this chapter I will begin by outlining what I take to be the stakes of a broad shift from tropes of play to tropes of harmonious social labor in figurations of

dance, before arguing that this shift mirrors a broader social rational-
ization for which dance provided a perfect aesthetic and ideological
vehicle. The figures I cover here are essentially literary intellectuals,
and thus this chapter will offer little of immediate import to the histo-
rian of dance. In order to recontextualize the institutional and aesthetic
decay of dance in Western Europe, I demonstrate that the idea of dance
nevertheless carried a particular charge for social and aesthetic theo-
rists of the period.

Instead of questioning the accepted dance historical narrative of
nineteenth-century decline on empirical grounds, I wish to recast the
question in the broader terms of social choreography. What structures
of social experience were being theorized or projected in an almost
subterranean discourse on choreography, even as dance itself seemed to
languish as a high cultural form? I would argue that there was a migra-
tion of cultural interest in dance away from the "high" cultural forms
toward the newly emerging forms of public amusement and mass en-
tertainment, on the one hand, and toward an emerging discourse of
anthropology on the other. The idea of choreography retained its im-
portance, I will argue, by virtue of a fundamental shift in its signifi-
cance. In brief, my thesis here is that the nineteenth century saw a shift
in writings on dance from a Schillerian concern with "play" as the
(pre)condition of human freedom to reflections on "work" or "labor"
as (respectively) the realization or the alienation of embodied human
potential. By the end of the century, the ideal of choreographed labor
had become an important component both in social modernization
and in the aestheticization of social and political thought. I argue that
by the late nineteenth century, reflections on dance centered around
the question of work in two important ways.

First, dance was invoked as a way of thinking about the kinds of
work, both material production and ideological reproduction, neces-
sary to the production of a cohesive social order. Meanwhile, in the
social sciences of the time, increasingly complex Western societies be-
gan to confront "primitive" and supposedly "integrated" social or-
ders through the prism of anthropology. Whereas moral judgments of
"primitive" societies led to condemnations of uncivilized savagery, a
focus on dance allowed for viewing such societies in terms of their
ritual enactment of a social cohesion that was singularly missing from
the rationalized, and increasingly mediatized, West. As industrial so-

ciety fractured across class lines and the growing political hegemony of the nation-state made any internal fissure seem dangerous to the welfare of the commonwealth, it seemed that the production of social cohesion had become increasingly hard work. Dance would serve to figure a kind of work—again, both material and ideological—that might actually be pleasurable. In a second sense, however—as an aesthetic phenomenon—dance also served to foreground the problematic nature of the idea of work when applied to the arts. What work does dance produce? Is dance useless—or, more charitably, "disinterested"—because it produces no object, or is the absence of an excess or residue that might be characterized as the "object" of the dance rather the realization of an aesthetic ideal of self-immanence, as the symbolists hoped? In short, is dance more, or less, legitimate as a form of art because it produces no object? I wish to argue that these questions presaged debates within the twentieth-century avant-garde concerning the problematic nature of the (fetishized) art object. I wish to argue also, however, that these two parallel debates in fact intersected in interesting ways in a tradition of what I call "aesthetic socialism." The figures making up this tradition—as presented in this chapter, primarily the literary sages of nineteenth-century Britain—envisaged a social choreography that cannot simply be conflated with the forms of aestheticized politics produced in Europe in the first half of the twentieth century.

Although by the end of the nineteenth century dance had been eclipsed both as a respectable aesthetic form and as a figure for democratic social order, it nevertheless reemerged in various compromised, "eurhythmic"—and, indeed, eugenic—forms. By the end of the nineteenth century, strikingly contemporaneous with the emergence of anthropology as a defined and respected discourse, there emerged a new, conservative strain of thinking about social choreography across Europe. Inspired by a Schillerian vision, this stream of thought nevertheless took quite antiliberal forms. Thus, for example, Herbert Spencer in an article from 1895 would cite dance in support of a hierarchical and vertical social order quite different from the horizontal interlacings of Schiller's "English dance." Referring to "those savages who have no permanent chiefs or rudimentary kings," Spencer notes that such societies generally lack any professionalized or theatrical conception of performance—"among them these incipient professional actions are

scarcely to be traced."[2] Spencer's linkage of dance to the process of social distinction and differentiation, or to what we might, in technical terms, refer to as rationalization, perhaps indicates an answer to the demise of "democratic" social dance as a cohesive social trope. The social order implicit in Schillerian dance was no longer relevant to a century in which modernization would turn on the emergence of technology and the rational operation of a technological rather than simplistically "democratic" order. Spencer is concerned with the absence, in savage societies, of any theatrical dance. The social differentiation necessary to establishing a class of dancers—necessary, one might say, to the institutionalization of the aesthetic—is lacking, thereby serving as a signal of a society's backwardness. Thus, we might argue that from Spencer's perspective the reappearance of dance in the early twentieth century as a highly specialized and professionalized phenomenon—in the form of the Ballets Russes—reflects a process of discursive rationalization that both isolates the aesthetic and deploys social and performative distinctions to reconfigure social order.

Although my focus in this chapter is on a tradition of British thought running from Carlyle through Ruskin and Morris to Wilde, the logic of the argument turns on a theoretical distinction between the categories of work and of labor that can most usefully be constructed retroactively. Although I focus here on questions of cultural politics in Britain, I will begin by briefly sketching out the social import of dance in anthropological and sociological writings in Europe in order to highlight a broader choreographic shift from play to work. A wide variety of late-nineteenth-century labor theorists turned to the example of dance in their writings to explicate their notions of a natural labor that might harness and regenerate labor power rather than simply use it up. In brief, they sought to harness the energy and enthusiasm that went into the "playful" performance of dance—particularly in those primitive cultures that were becoming the objects of anthropological investigation in the age of imperialism—to the performance of more legitimate social and economic labor. In the energies both consumed and produced in the enthusiasm of dance they saw a sublime "beyond"—a regeneration of entropic social forces through a vitalistic labor power that passes through and uses the individual. Dance—which for Schiller troped a utopian yet historical possibility, a "sublation of time in time"—now figured instead the anthropological condition of labor.

In *The Human Motor: Energy, Fatigue, and the Origins of Modernity* Anson Rabinbach, whose historical concerns run parallel to the literary analyses I offer here, has pointed out that questions of production and productivity were central to the work of scientists and social scientists on the continent at the end of the nineteenth century. According to Rabinbach, from the middle of the nineteenth century through, argu- ably, the end of the twentieth, "the metaphor of the human motor translated revolutionary scientific discoveries about physical nature into a new vision of social modernity."[3] "The laboring body," he argues, "was thus interpreted as the site of conversion, or exchange, between nature and society—the medium through which the forces of nature are transformed into the forces that propel society" (2–3). By tracing a troubling move from the Helmholtzian optimism of the 1850s—which posited the ultimate conservation of all energies—through to Clausius's discovery of the laws of entropy, Rabinbach aims to demonstrate how entropy, figured as fatigue, shaped social revolutionary thinking in the latter nineteenth century by taking the form of a materialist idealism or, as he calls it, a "transcendental materialism" (4). During this same period—the 1850s—we see the emergence in Marx's writings of an ab- stract category of "labor power" as opposed to simple manufacture. Tracing these shifts as constitutive of modernity, Rabinbach contrasts them with an eighteenth-century Enlightenment form of materialism:

> The old mechanical materialism of the eighteenth century, as Engels never tired of pointing out, was based on the principle that there had to be something beyond matter to explain its movement . . . With the doctrine of energy, finally, there was nothing beyond matter to explain its motion, no homunculus beneath the table. There was only matter in motion, with energy claiming true universality as the reservoir of per- petual motion of the universe, the source of its labor power. The old dualism of spirit and matter was overcome by a transcendental mate- rialism with its own monadic conception of reality—the unity of matter and energy—as energumen. (289–90)

I wish to argue that this search for the energumen was also central to discourses of social choreography in the nineteenth century and would culminate in a discourse of what I will call the "physiological sublime." Rather than tracing the transcendentalism of symbolist and postsym- bolist writings on dance to purely aesthetic precedents, I believe that—

with reference to Rabinbach's notion of "transcendental material-ism"—we can see this transcendental imperative in the context of a broader late-nineteenth-century search for the origins of social ener-gies. What I propose, then, is an analysis of the resolution of matter and spirit not in an aestheticized spirituality, which is the most common frame of reference for thinking about the relation of dance to literature, but in a materiality redefined through aestheticism. Aesthetic discourse provides a frame for thinking about social phenomena, no less than those phenomena shape our thinking about the aesthetic.

It would seem undeniable that the growth of an anthropological interest in dance at the end of the nineteenth century was related to concerns about the limits of human labor and its status as a component of human nature. In this respect, as in so many others, dance acquired a rather aporetic position because it seemed to indicate the existence of an urge or instinct toward activity among primitive peoples when the working hypothesis of most anthropological labor theorists was the natural idleness or inertia in man. In *The Human Motor* Rabinbach summarizes this puzzle nicely in his treatment of an essay by the social theorist M. G. Ferrero, who collaborated with his father-in-law, Cesare Lombroso, on groundbreaking works of criminology. "How," Rabin-bach asks, basing himself on Ferrero's observations, "could the 'inertia' so frequently observed among those savage peoples be 'natural' given their readiness to self-exertion and energy in dance?" (174). We shall encounter this philosophical and anthropological confrontation with the problem of "inertia" later in this chapter, where it serves as the crucial counterterm to Ruskin's very definition of art: *ars*—as Ruskin frames it—is the very opposite of cultural and bodily *inertia*. Before we even reconstruct Ruskin's aesthetic, however, Rabinbach's analysis serves to remind us that aesthetic questions as to the possibility of a natural culture (such as Schiller posits through dance) were directly implicated in a broader project of political economy that sought to locate the origins of labor power. I wish to argue that this influence of political economy on aesthetic theory was, however, a two-way street. The very terms and taxonomies of political economy, as we shall see, were in part structured by categories derived from the discourse of idealist aesthetic theory.

For the anthropologists of this time, dance was in some ways analo-gous to the incest taboo in that it constituted a cultural and yet univer-

sally occurring phenomenon. With regard to the puzzle of dance as a naturally occurring cultural form, Rabinbach argues that Ferrero and others "found the answer not in the utility nor purposefulness of work, but in the natural rhythms of the body" (174). Anthropological research into the choreography of "primitives" fed into concerns about labor insofar as it sought to demonstrate, in vitalistic fashion, the existence of a human instinct toward activity, exemplified by dance. In Ferrero's argument, for example, dance potentially served to refute a basic assumption that "the human spirit tends by nature to inertia."[4] In other words, the natural-cultural phenomenon of dance promised to reverse a growing cultural pessimism at the fin de siècle that linked physical and social entropy. Dance was an activity that produced a greater social energy than it consumed: it was potentially self-regenerative, it seemed.

Even the hugely influential German labor theorist Karl Bücher—who otherwise took issue with Ferrero in the study *Arbeit und Rhythmus*, which went into many editions—concedes that "nevertheless, one thing is certainly valuable in the work of this Italian scholar . . . the premising of his study on an activity that is not a form of work, but to which man in the state of nature dedicates himself with great gusto and diligence: dance."[5] This instinct, however, was to be thought physiologically rather than psychologically; and, indeed, one of the concerns raised by the idea of dance as a spontaneous activity was the bypassing of free human will that this suggested. As Bücher notes with regard to Ferrero: "Of all the elements that Ferrero deems important in native dances, there is only one that meets my criteria: its automatic character" (21).[6] Dance was of interest because it promised—or threatened—a human laboring subject deprived of will. In other words, if thinkers and artists on the Left criticized alienated labor as unfree, anthropological research at the same time suggested that dance—which had been used to figure free, organic activity—was, in fact, unfree because it involved no activity of will.

This unfreedom, however, has been repositivized in this discourse on dance as a freedom that exceeds the limited self-determination of the individual subject. Such discourse was of a piece at this time with the philosophical redefinition of "will" that moved away from a rational voluntarism and toward a more irrational "life force" that man did not control but that coursed through man and all of nature. Politically it is highly ambiguous, because it is predicated neither on a liberal subject-

centered conception of freedom nor on a materialist object-oriented "wordly" calculation of objective possibility. Romantic, organicist notions of the dance notwithstanding, it is clear that an entirely different intellectual tradition at the end of the nineteenth century was articulating through dance a new "automatic" concept of human labor power. Thus, when Bücher disagrees with the established wisdom of his time that holds that "work refers only to those movements oriented toward a useful goal that lies beyond the movement itself; all movements whose purpose lies in the movement itself, however, are not work" (1),[7] he effectively grafts—via dance—the traditional Kantian *Unzweckmä-βigkeit* of the aesthetic onto labor. Labor now functions as a self-legitimating natural human function. It is through dance that the purposive, rational, object-oriented activity of work is aestheticized and debased as a vitalistic and self-enclosing labor.

The antivoluntaristic aspect of this vitalistic "dance labor" lies in its rapprochement of physiology and mechanism. Thus, for example, Charcot's collaborator, Féré, who was also interested in questions of criminality and social disorder, argues that "the pleasure taken in rhythm . . . derives from the bodily activities resulting from it; experience effectively demonstrates that a rhythm manifesting order in both time and space facilitates the repetition of willed actions by rendering them in some sense automatic."[8] Physical pleasure, in other words, derives from the experience of automatization. Or, put another way, pleasure in the physical as such is predicated on the mechanization of the physical and the denigration of the willing subject. This abdication of the will, however, should not be seen as a simple "fall" into the physical, for through the activity of rhythm the body acquires an altogether different value, reformulating consciousness: "All these agreeable stimuli coincide with an awareness of an enhanced capacity for action that is, in fact, very real" (21–22).[9] In other words, consciousness does form a part of rhythmic bodily pleasure, but it is consciousness of a beyond or excess, of a *capacité*. Consciousness, we might say—in aesthetic terms—is being reformulated in terms of the sublime, as the consciousness of something yet to be realized. To this extent, the sociologists and anthropologists I present briefly here were realizing in the realm of social theories of labor an essentially romantic concept of sublime consciousness. The apparent distinction between romantic and technocratic models of postliberal "freedom" is, indeed, only ap-

parent. What we see emerging here in and through anthropological writings on dance are the ideological underpinnings of a romantic anti-capitalism characteristic of the writings of many modern dance pioneers both in Europe and in the United States.

For Ferrero, primitive dance opens up the possibility of an immanent will manifested contemporaneously with the actions it provokes: "In productive labor, the stimulus to action is willed, whereas in primitive *sports* it is practically automatic" (333).[10] In terms of Rabinbach's model of the *perpetuum mobile*, even "will" is now construed as an instance external to the energies unleashed in labor and dance: while it can set such motions in motion it challenges their autonomy and retards them. Most striking, then, are the implications Ferrero draws for basing a theory of work on an observation of rhythm. He describes the operation of will in labor as follows: "Almost every movement must, therefore, be preceded by an intellectual act that directs the action of the will providing the impetus for that movement. It is true that in modern industry the simplicity and repetitiveness of the actions performed by each worker means that a certain degree of automatism is introduced into skilled labor" (333).[11] Paradoxically, "civilization"—through the practice of division of labor and task specialization—returns at the virtual point to the condition of dance. Automatism is both origin and telos of activity and is typified by primitive dance and advanced capitalist labor. It is here that the dance trope comes into its own. The transition from primitive sport to civilized labor is achieved by virtue of rhythm, as Ferrero explains: "The angry man, who pummels his fists or stamps his feet furiously, augments his anger by these very actions; and this increased rage in turn renders his gestures more extreme and violent. There is a mutual action and reaction . . . The same is true of the dancer . . . once the first movements of the dance have been completed, they serve to animate the movements that follow" (333–34).[12] The dancer comes to represent the possibility of a self-sustaining energy, exciting itself through a reading and reiteration of its own rhythm. The first steps of the dance spur a recognition of rhythm and an awareness in the dancer of a capacity for sustaining activity beyond the apparent limits of his body. Dance produces the energy that reproduces it in turn.

This experience of a physical potentiality linked to "enthusiasm" as a form of anticipatory historical sense is, finally, what I call the "phys-

iological sublime": the body encoding in movement a consciousness of its own unexplored capacity. The pleasure derived from the rhythms of dance is, after all, ascribable to consciousness; in Féré's words, "the increased potential produced by rhythmic repetition of movements explains, in large part, the pleasure of dancing" (50).[13] Seeking to reconnect the central concerns of this anthropological and sociological discourse with the cultural politics of the period, one cannot help but be struck by the congruence of Féré's observations with certain curious, idiosyncratic distinctions insisted on by Ruskin, such as when, in *Praeterita*, he contrasts "right" dancing, which is silent in the placement of the foot, to "the modern artificial ideal" of stamping or tapping with the foot.[14] In this latter noisy dance we see the body generate its own "enthusiasm," generating an awareness of rhythm that will sustain it. If Féré and Ruskin write in different registers within different national traditions and draw different conclusions, their writings nevertheless seem to organize themselves around a shared set of categories. In what follows I seek to reconstruct in a rigorous, semiotically oriented way the ideological positions opened up by reflections on dance in the nineteenth century "aesthetic socialist" tradition.

While dance served ideologically as the exemplar for harmonious social interaction in the Schillerian tradition imported into Britain by Carlyle, by the end of the century the choreographic social utopia would become little more than an aestheticization of labor. Aesthetic debate about dance in the nineteenth century is simultaneously a reflection on the aporias of democratic social order and the limits and preconditions of capitalist economy. For its subsequent twentieth-century champions, the kinaesthetic potential of dance—its contagious communication of motion from one body to another—promised a form of immanent democracy in which communication passed throughout the broader body politic without recourse to language. But by this very token, such visions of the dance of democracy reverted to a vitalistic celebration of energy entirely consonant with an ideology of undifferentiated labor. In other words, the explosion of nonballetic modern dance rejects an authoritarian social and aesthetic configuration only by confusing all objectification—be it in language or in aesthetic artifact—with alienation and reification. Functioning for Schiller as a trope of natural order in which the rules of the dance correspond to the physical will of the dancers, by the end of the century dance articulates

instead a recognition of the potentially totalitarian outcome of any facile conciliation of necessity and will.

My original idea for this chapter was to trace Schiller's ideal of English social dance through a tradition of what I call aesthetic socialism in Britain itself. Thus, beginning with Carlyle—Schiller's great champion and translator in Britain—I had imagined tracing the figure of dance through the work of Ruskin and assessing its bifurcation in the work of Wilde and Morris, two figures deeply, though differently, influenced by Ruskinian thought. I was immediately struck, however, by the almost complete absence of reflections on dance in the work of Morris. Where else were we likely to find happy, bucolic morris-dancing workers if not in Morris himself, who has so frequently been presented as an anachronistic, artisanal semirustic figure in the age of mass industrialization? This first setback frames the study here. What antipathy exists between handicraft and footwork? What is there in Morris's commitment to the concrete aesthetic artifact that resists an aesthetic performance otherwise so apparently suited to his ideals of human joy in labor?

Certainly, one does find examples of utopian dance in the nineteenth-century aesthetic socialist tradition, most notably in the organization of social entertainment of the Owenite working communities,[15] but in such instances the socializing powers of dance derives, almost without exception, from its troping of labor. Looking forward to the late nineteenth and early twentieth centuries, I will argue that it is precisely this shift from the paradigm of play to the paradigm of work that made possible dance's extraordinary aesthetic renaissance in the writings of Mallarmé and in the performances of the Ballets Russes. Dance challenged traditional notions of the work of art by failing to produce an enduring artifact. It also fed into a broader social concern with the social choreographing of time and space. As dance came to figure the idealized harmony of bodies at work, the world of Taylorite time and motion studies no longer seemed so remote from the aesthetic terminology of plastic and musical arts. Even as the ballet developed into the most prodigious and ostentatious form of aesthetic spectacle in the early part of the twentieth century, a Europe-wide anthropological discourse around dance and labor paradoxically linked the aesthetic and the social organizations of time and motion. Rudolf Laban's late writings on energy are, perhaps, the most notable hybrid production of these linked discourses of aesthetic and social rationalization.[16]

Bearing in mind the congruence of the organizing principle of Féré's analysis with that passage from Ruskin's *Praeterita*, it is, indeed, remarkable to note how closely a set of aesthetic criteria derived from classical precedent and encoded in the traditional distinction between "musical" and "plastic" arts fit the new social and economic conditions of the nineteenth century. In a nutshell, a long-established tradition of aesthetic theory held that "plastic" arts were those that worked in space, whereas "musical" arts operated in the medium of time. Effectively, terminologies derived from the debate in aesthetics—and articulated around the scandalous form of dance—provide a framework for thinking about the development of labor and capitalism throughout the nineteenth and into the twentieth century: this is characteristic of aesthetic socialism. On the few occasions where dance is addressed directly in this tradition of thought it figures either as a utopian model of social order and nonalienated production or as a troubling premonition of the shift from artisanal to "energetic" models of labor; in other words, as the manifestation of an abstract, alienating, yet anthropologically grounded *Arbeitskraft*. Because dance confounds most of these criteria—it is a "plastic" art that nevertheless works in and through time—it is hardly surprising that it allowed figures such as Ruskin, for whom social and aesthetic reflection are never far apart, to think through political questions in an aesthetic framework. Dance, so clearly a challenge to the simple dichotomy of plastic and musical arts, lends itself to the synthetic study of "time and motion," and for this reason by the end of the nineteenth century it is encountered more frequently in discourses on work than in discourses on Schillerian play. The question, then, is whether dance is to be thought of as a liberation of productive forces from an investment in the products that stockpile and commodify labor power for purposes of exchange or as the *perpetuum mobile* regenerating productive forces. Is it alien to, or creative of, an ideal of labor? And need these two possibilities—the utopian and the technocratic, let us call them—necessarily exclude each other?

By the end of this chapter I will come to speak of questions of physiology, and I should preface my consideration now with some elaboration of what I take to be the materialism of my methodology. Clearly, to treat of questions of labor and capital through the prism of aesthetic production rather than analyzing aesthetic production itself merely as one subspecies of production would seem to run counter to a material-

ist analysis as we commonly understand it. My claim, however, is that it was precisely the nature of materiality that was being contested in the discourse traced here, and that simply to assume the primacy of "matter" to those discourses is to think materiality in an undialectical way. In brief, I will argue that the discursive formulation of materiality in the nineteenth century was heavily influenced by aesthetic terminologies inherited from the eighteenth century and that the aesthetic cannot, therefore, be thought of merely as a secondary discourse acting on or staging an already preestablished, preaesthetic materiality. More than this, I will argue that precisely those discourses that sought to abstract a concept of materiality from its specific aesthetic instantiations finally effected the most fundamental "aestheticization" of matter. Specifically, I am thinking of the discourses of vitalism—often identified in the twentieth century with Bergson, but developed as a scientific hypothesis throughout the nineteenth century—but also of the category of labor as it figures in certain strains of Marxist analysis.

In his study *Man and Work: Literature and Culture in Industrial Society* David Meakin argues for two broad traditions of thought with regard to aesthetics and work: the artisanal/artificial and the playful/organic. In the twentieth century Huizinga would recast the same dichotomy in terms of the plastic and musical arts, noting "the seeming absence of the play-quality in one [plastic] as compared with its pronounced presence in the other [musical]."[17] I wish to argue, however, that the privileging of "work" by the first tradition clearly does not necessarily privilege what Meakin calls an "'artificial' world of things." On the contrary, it seeks to legitimate this world of things on the basis of its origination in a "natural" human propensity—a natural rhythm. Within the tradition of what I loosely term aesthetic socialism, an interest in the varying definitional possibilities surrounding the apparently simple notion of work led to fundamental schisms. What does it mean for Havelock Ellis—a habitué, in other words, of "aestheticist" as well as "socialist" circles—to write a late work titled *The Dance of Life*, in which he asks himself "whether . . . a completed art ceases to be art" (65)? What antipathy exists between the idea of aesthetic completion and artistic value? How are we to interpret this displacement of the object of aesthetic production? Does it derive from a purely aesthetic tradition—a radicalization of Kantian "disinterest" to the point where the aesthetic pleasure no longer places any value on the actual existence

of the object from which it putatively derives pleasure? Or does it reflect, instead, a broader social concern with the phenomenon of labor in general? We need to ask ourselves, also, what it means for Morris—usually so indifferent to the musical in his overwhelming preference for the plastic arts—to be writing work chants. How does his model of nonalienated labor relate to the self-objectification and distancing involved in any artisanal act of making or *poesis*? In this respect his work is pivotal historically as well as to my argument here in this chapter. It is poised between a critique of alienation at one stage of capitalism and a recognition of the even greater dangers presented by the dwindling possibilities for (alienating) self-objectification (and, therefore, consciousness) once individual work has been reduced to abstract labor power.

Building on an analysis of the writings of John Ruskin now, I shall begin to trace the development of a discourse on popular culture and social choreography. My approach to the question of popular culture—and dance's fall from aesthetic favor in the nineteenth century, its descent into the realm of the music hall—is necessarily philosophical rather than historical in the strictest sense. For popular culture posed to critics such as Ruskin not simply a social and moral challenge but also an aesthetic and philosophical one. In contrast to the cohering cultural value of edifying works of high art, the realm of popular culture is an attempt to think about the opposite of the aesthetic work of the Muses: an acritical nonreflective *amusia*. Amusement, in Ruskin, stands for the loss of critical potential in art. Rather than thinking of amusement as the domain of an aesthetic experience that exists parallel to but beneath the domain of high culture, therefore, we need to think of it as a cultural condition in its own right, as the name for a certain cultural experience. Culture and amusement are, for Ruskin, parallel cultural epistemologies rather than terms to be defined hierarchically in relation to each other. Thus, rather than bemoaning the decline of dance in the nineteenth century, we need to ask ourselves what possibilities of social choreography were being explored in this netherworld of nonreflective "amusement," as Ruskin frames it. Ruskin himself vehemently opposed the depredations of this new mass culture, but he recognized clearly the contours of its value system.

The trivialization and vulgarization of dance in the nineteenth century should be observed not simply from an evaluative point of view as

a decline in standards but rather modally as a shift in function. In this way, the state of amusement—*amusia*, the loss of a critical space of leisurely reflection—is not *countered* by the rediscovery of dance by "serious" artists in the late nineteenth century but rather *pursued* by those same writers. When considering Mallarmé's famous celebration of the innovative modern dance of the American Loïe Fuller—where he takes her complete disappearance into the lights and veils that characterized her dance as a model for his own aesthetic—we need to recall that she was, after all, a music hall turn. We need to think about the relationship of these two senses of "amusement"—as both a postcritical cultural condition (either feared or celebrated) and as a specific emerging field of cultural practice. By looking at cultural writings that seemed to have already located a place for "amusement" within a fully articulated aesthetic, I wish to show how new forms of popular culture did not emerge entirely independent of prevailing high cultural paradigms.

The need to confront the aesthetic realities of a new culture of "amusement" scrambled the traditional binary of "musical" and "plastic" arts derived from eighteenth-century aesthetic theory and from classical precedent. With the appearance of mass cultural phenomena on the horizon of the high cultural critics, the "musical" now posited its own negation from within itself rather than simply opposing itself to an already existing, external negation ("the plastic"). Suddenly, the simple opposition of terms—"musical" and "plastic"—is semiotically complicated by the inclusion of a new negative term: that is, "amusement" as the internal rather than external negation of the musical. We read in letter 83 of Ruskin's *Fors Clavigera*, for example, that "the modern 'amusement' has practically established itself as equivalent to the Greek 'amusia'" (29: 262). In making this claim, Ruskin refers to the necessity of distinguishing between two forms of negation: x to the power of 0 and x to the power of $^-$. Negation can be thought of either as the absence of the positive terms or as the positive rejection of that term; as the absence of culture, to take our present example, or as the presence of the anticultural. Ruskin's distinction allows us to reformulate the simple binary of the "musical" and "plastic" arts semiotically in an exemplary Greimasian manner.[18] By chiasmatically mapping the two opposing terms of traditional aesthetic theory—"musical" and "plastic" arts— and their respective internal negations, we arrive at the following formulation:

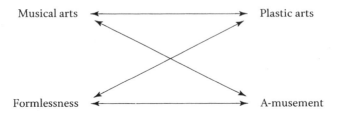

The structuring opposition of musical and plastic arts is complicated by both the logical possibility and the historical emergence of an internal negation of each of the terms. These four logical positions allow us to begin mapping various responses to dance as a cultural form in nineteenth-century aesthetic socialist thought. I propose that we use this frame as a way, now, of thinking about the cultural scene in the nineteenth century with respect to social choreography as it rehearsed the problem of the social energumen. What we need to find are the terms that reconcile the oppositions at each side of the semiotic rectangle. As we turn now to Ruskin, we shall see how an emerging social choreography becomes a crucial component to any such conceptual reconciliation.

"There being scarcely a word in Greek social philosophy which has not reference to musical law; and scarcely a word in Greek musical science which has not understood reference to social law," (29: 261) Ruskin's pronouncements on music, rhythm, and dance need not be read metaphorically in order to extract their social and political import. It is interesting to note that except for the early "Essay on Painting and Music" of 1838, Ruskin's critical interest in music dates from around 1860—that is, from the period of the completion of the *Modern Painters* project—which is also the period of his turn away from aesthetic concerns in the limited sense toward a consideration of broader social questions. From the perspective of music criticism, one would be tempted to concur with the author of the essay "John Ruskin and Music," who argues that "Ruskin remained essentially deaf to the vitality of purely musical expression, unwilling to admit any independent significance of musical form, and insistent that there is no intellectual content whatsoever in music apart from its association with verbal text."[19] I wish to argue, however, that the simultaneous development

of a critical interest in music and in social issues permits us to read Ruskin's amateurish musicology as directly sociological critique.

Ruskin's reassessment of aesthetic forms is based not on the respective relations to time and space that underpinned the traditional division of musical and plastic arts; instead, Ruskin distinguishes between the arts in terms of their respective cognitive functions. What we need to ask is whether the scandal of dance within the traditional configuration—as an art form that is both plastic and musical—is replicated in this new cognitive structure. Does dance present any sort of epistemological scandal in Ruskin's new system? It is in attempting to answer this question that we happen on Ruskin's "Greimasian" distinctions. In the first of the lectures from *The Eagle's Nest*, which originally were delivered to students at Oxford University in 1872, Ruskin takes some pains to distinguish between the various fields of science, art, and literature, and to trace his taxonomies back to classical precedent. Fundamentally, he distinguishes the three faculties in the following terms:

SCIENCE. . . . The knowledge of things, whether Ideal or Substantial.
ART. . . . The modification of Substantial things by our Substantial power.
LITERATURE. . . . The modification of Ideal things by our Ideal power.
(22:125)

Building on this distinction, Ruskin will argue that science deals with knowledge(s), corresponding to the Greek pursuit of *episteme*. To this extent it is contemplative and indifferent to the nature of its object (ideal or substantial): it dispels the condition of *agnoia*. Art, meanwhile, busies itself with *techne*: that is, it is a technical study aimed at dispelling the condition of artless *atechnia*. Literature, in turn, is concerned with *nous*—with the development of wit. Ruskin differentiates from within the category of cultural "work" according to the nature of the worked material (art is substantial, literature insubstantial), and while he insists that his own expertise lies in the realm of art, his insistence that "the object of University teaching is to form your conceptions;—not to acquaint you with arts, nor sciences" (22: 135) means that his vision of the university's mandate is, in his own terms, "literary."[20] His approach is Platonic insofar as it retains a notion of *poesis* and artifice, but now the self-subsistent alterity of the object as artifact

has been abandoned. The "product" of education is a form rather than a thing. In shaping conceptions, the university serves to form the ability to form: it produces subjects not objects; it creates, in Ruskin's all-too-easily trivialized terms, "a gentleman and a scholar" (20:18).

Techne, nous, and episteme can be used wisely or foolishly, Ruskin argues, producing what he acknowledges to be the apparently paradoxical possibility of a "foolish wisdom": "Σοφια, (wisdom) I say, is the virtue, μορια (folly) is the vice of all the three faculties of art, science, and literature. There is for each of them a negative and a positive side, as well as a zero" (22:130). It is at this point in the lecture that the example of dance serves to illustrate Ruskin's point in a highly suggestive manner. Elaborating on his distinction between two forms of negation in each of the faculties—the mere absence (or zero power) of Σοφια, on the one hand, and the positive presence of μορια on the other—Ruskin offers examples from two different fields: dance and sport. The difference of the two examples is telling and, though anecdotal, goes some way to explaining the devaluing of dance in the Victorian writers whom I treat here. Both examples are, strictly speaking, "technical" insofar as they pertain to higher or lower art forms. Furthermore, if we recall that Carlyle's translation customarily rendered Schiller's *Spiel* ("play") as "sport," the relevance of Ruskin's intervention to the questions being considered here should be immediately apparent.

An example of sporting Σοφια would be the cooperation of a rowing crew, Ruskin argues. The social importance of such technical "wisdom" is clear from his description of proficient rowing, which consists not only in the physical capacity for an action but also "implies the practice of those actions under a resolved discipline of the body, involving regulation of the passions. It signifies submission to authority, and amicable concurrence with the humours, of other persons"; this is its "moral rightness" (22:132). The rhythm of the rowing eight (and this concept of rhythm will be the conduit whereby dance enters discussions of poetics and poesis in the broader sense for the aesthetic socialist tradition) suggests an immanent bodily social order that bypasses the mediations of language. My body flows naturally according to its own impulses and flows in harmony with others—in harmony, that is, with something greater that flows through all of us. It is, in essence, a replay-

ing of the Schillerian trope. What is more interesting, however, is Ruskin's inability to imagine the negation of this technical *sophia*: a lack of sophia in rowing is figured merely as incompetence, as atechnia. "The folly of rowing," Ruskin writes, moving on to consider his example in its negative terms, "consisted mainly in not being able to row" (20: 133). Considered as techne, the negation of cooperative rowing would be an inability to row, a lack of technique or atechnia. In the consideration of rowing, rowing⁰ and rowing⁻ are effectively conflated: the negation of rowing and the technical inability to row are one and the same. In this example, folly and immorality are merely the correlates of inability and ineptitude.

This is not true of the example drawn from dance, however. Here, on the contrary, the "zero" [dancing⁰] is collapsed into the negativity [dancing⁻]. Dance, for Ruskin, will serve to figure the troubling possibility of a proficiency in evil, a prodigious folly, a foolish wisdom. He wastes little time on the sophia of dance, and moves on to describe an evening at the "Gaiety Theatre" in which "the supposed scene of the dance was Hell . . . and its performance consisted in the expression of every kind of evil passion, in frantic excess" (22: 133). This performance, far from being an example of atechnia, forces Ruskin to concede that "the skill they possessed could not have been acquired but by great patience and resolute self-denial" (22: 134). Whereas he conceives of the *moria* of rowing only as a zero or absence of skill, he conceives of the zero of dance only as a moria: "this folly of dancing does not consist in not being able to dance, but in dancing well with evil purpose; and the better the dancing, the worse the result" (22: 133). Dance, it would seem—and this point needs to be stressed—marks the possibility of a proficiency in evil, the point at which the zero becomes the negation of sophia. Dance unleashes the negative potential of a certain "technology" in Ruskin's writing. In the dance of the music hall, Ruskin imagines the dangerous collaboration of aesthetic competence and moral depravity.

It is well known that Ruskin was, in fact, a lover of dance, and by no means are all of his pronouncements on dance so negative. However, this positive negativity, this fear of a proficiency in evil, always lurks below the surface. The merely technical distinction of "musical" and "plastic" arts is generally displaced in his writing by a cultural dis-

tinction between "musical" arts and the degraded condition of "a-musement." While dance is by no means ontologically compromised, it is nevertheless in the realm of dance and music that Ruskin most frequently offers a historical analysis of the conditions of (im)possibility of an authentic culture under high capitalism. At several points in his work Ruskin conceives of evil dancers of great technique—as, for example, in letter 9 of *Time and Tide* where he cites the example of the can-can:

> It is many years since I have seen such perfect dancing, as far as finish and accuracy of art and fullness of animal power and fire are concerned. Nothing could be better done, in its own evil way; the object of the dance throughout being to express, in every gesture, the wildest fury of insolence and vicious passions possible to human creatures. So that you see, though, for the present, we find ourselves utterly incapable of a rapture of gladness or thanksgiving, the dance which is presented as characteristic of modern civilization is still rapturous enough—but it is with rapture of blasphemy. (17: 358)

In the letter of *Time and Tide* that follows letter 9, Ruskin will compare this "Chain of the Devil, and CanCan of Hell" with "the expression of true and holy gladness [that] was in old time statedly offered up by men for a part of worship to God their Father" (17: 359). Absurd though the leap may seem, Ruskin moves from the consideration of the can-can in letter 9 to a consideration in letter 10 of "The Meaning, and Actual Operation of Satanic or Demoniacal influence." In other words, the reflections on the techniques of evil, exemplified by dancing, feed directly into a consideration of a radical or positive evil; an evil, that is, that does not consist merely in a "zero," an inability to row, but in a moria or folly that manifests itself as competence. If we are surprised by Ruskin's vehemence, he assures us: "Do not think I am speaking metaphorically or rhetorically, or with any other than literal and earnest meaning of words" (17: 362). It is as if the attack on the false competence of dance needed to be underpinned by an implicit attack on the operation of metaphor and a strategic entrenchment in the "literal and earnest meaning of words."

Ruskin's two examples—the rowing crew and the can-can—obviously raise questions of the gendering of his cultural critique. Whereas mas-

culinity occupies the "axis of incompetence," so to speak (the rowers do not row perniciously but rather merely fail to row effectively), femininity is aligned with the "axis of immorality"—that is, symmetrically opposed to their male rowing counterparts, they dance proficiently even when they dance with evil intent. It is the exactitude of the frenzy of the can-can that so horrifies Ruskin—not a simple reversion to savage, untrammeled passions, but the harnessing of those passions to a new principle of order. In short, he sees in the French dancers—and the national codings of his examples are always as interesting as the question of gender—the first chorus line. Striking in Ruskin's presentation of the can-can of hell is the explicit way in which it references the emergence of a culture of mass reproduction. To this extent it is a direct precursor of debates in Weimar Germany (to be treated in the final chapter) regarding the Tiller Girls as definitive cultural icons of modernity. The linkage of the can-can to the emerging culture of mass reproduction at the time becomes clear in another of Ruskin's tirades. While the greatest works of Tintoretto, he writes, "hang in moist rags from the roof they had adorned, the shops of the Rue Rivoli at Paris were, in obedience to a steadily-increasing public Demand, beginning to show a steadily-increasing Supply of elaborately finished and coloured lithographs, representing the modern dances of delight, among which the cancan has since taken a distinguished place" (17: 133).

Clearly, then, Ruskin critiques the can-can not as the eruption of some precivilized, anarchic force but as the harnessing of such forces to the most modern modes of (re)production. The problem is not the irrational or immoral per se but rather its industrialization, as exemplified by the saucy French lithographs of the Rue Rivoli. Ruskin goes on—in a mode one might call ironic, if it were not Ruskin—to argue that because "the labour employed on the stone of one of these lithographs is very much more than Tintoret was in the habit of giving to a picture of average size," the labor theory of value fully validates a preference for dirty lithographs over Tintoretto. In letter 9 of *Time and Tide*, which explicitly contrasts "The Use of Music and Dancing under the Jewish Theocracy, compared with their Use by the Modern French" (again, not so subtly locating the evil of mass reproduction on the continent), Ruskin is clearly suggesting that mass consumption has now taken on the mantle of a modern religion. The dancing girls are

not, then, anomalous but rather entirely in synch with new mass cultural formations.

The mass commodification represented by the Parisian lithographs should not be thought of simply in terms of Ruskin's preference of high over low or auratic over popular art forms. The question is, instead, one of the status of the artifact as repository of labor, as a moment of rest in which productive energies have been gathered. By reducing the object to commodity—and here Ruskin presages Morris in a rather more sophisticated manner—mass reproduction resubjects a moment of rest (the object as the static reification of energy) to the iron laws of economic motion. To take a simple example, we can cite Ruskin's use of dance as a means to distinguish between "wages" in the economic and aesthetic realms. In letter 9 of *Time and Tide* he draws a fundamental distinction between biblical dance as the dance of thanksgiving and the degenerate status of dance under the conditions of wage labor and the culture industry. Taking Miriam's dance of thanksgiving on the Israelites's deliverance from Egypt as a holy and legitimate "expression of passionate triumph and thankfulness" (17: 352), Ruskin links it to "the rejoicing in the repentance from, and remission of, sins, expressed by means of music and dancing, namely, in the rapturous dancing of David before the returning ark" (17: 354). He then contrasts this—along with other biblical examples of thanksgiving and praise—to the drunken harvest festival of contemporary Swiss peasants in order to note how "your modern religion . . . has reduced the song and dance of ancient virginal thanksgiving to the howlings and staggerings of men betraying, in intoxication, a nature sunk more than half-way towards the beasts" (17: 357). In trying to extract some measure of good from the drunken objects of his scorn, however, Ruskin observes of the drunken dances of working people that even here we ought to be "thankful that some remnant of delight *is* still taken in dance-music. It is the last protest of the human spirit, in the poor fallen creatures, against the reign of the absolute Devil, Pandaemonium with Mammon on the throne instead of Lucifer" (28: 404). Theatrical dance, in the form of the can-can, marks the commercialization of Dionysian protest. Intoxication is no longer the "wages" of labor but the very labor in which the emerging culture industry must engage. Ruskin's religious terminology simply replaces Lucifer with Mammon.

Thus far Ruskin may seem to be offering a simple critique of cultural decay, but in fact he will argue "we are not, throughout Europe, wholly thus. There are such things, yet, as rapturous song and dance among us" (17: 357). But where is such rapturous dance to be found? It is "not indicative, by any means, of joy over repentant sinners" (17: 357); indeed, like the festivities in Switzerland it marks an "utter failure of joy; the paralysis and helplessness of a vice in which there is neither pleasure nor art" (17: 357)—the can-can. Paradoxically, Ruskin sees in the worst debasement of joy, in the can-can, a modern analogy for biblical thanksgiving. This paradoxical and disturbing configuration disrupts Ruskin's ethical and aesthetic categories; for the fundamental distinction of religious thanksgiving and joyless profit is from the very outset compromised. Although Ruskin cannot admit it, under the conditions of the culture industry dance is revealed for the economic exchange it was even in its biblical form of thanksgiving. In a perverse sense—one produced only by reading Ruskin against the grain—the can-can reveals a fundamental truth about Miriam. In effect, aesthetic socialist critiques of capitalism cannot dissociate themselves from notions of profit and production: aesthetic pleasure will itself be figured as an alternative to, but structurally modeled on, profit. As Ruskin observes in letter 5 of *Time and Tide*, " 'wages' in the full sense don't mean 'pay' merely, but the reward, whatever it may be, of pleasure as well as profit" (17: 334). The spontaneous "joy" of a Schillerian dance was always already a payoff, and with the emergence of anthropological studies of dance at the end of the century precisely this nexus of exchange would be examined. In the cultural realm, moreover, we will encounter by the end of the century a figure of biblical dance whose very different "expression of passionate triumph and thankfulness" brings together the very possibilities of dance that Ruskin wants to separate: Salome.

Even as it locates the conditions for the degeneration of dance historically, Ruskin's writing seems to operate under the fear that dance might, in fact, body forth the possibility of an ontological or radical evil. Beginning to fill in the gaps of our Greimasian schema, we might posit the following possibilities for supplying the complex term (which mediates the "musical" and the "plastic") and the neutral term (which mediates formlessness and amusement):

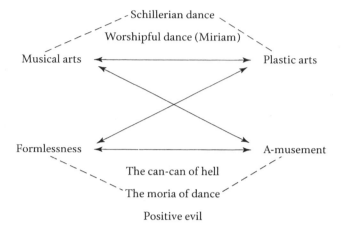

Schillerian dance posits social order as the historical sublation of the spatio-temporal terms that divide "musical" and "plastic" arts: "the play-drive . . . would be directed towards annulling time *within time*." The a-musement of the can-can makes of formlessness the very form of an aesthetic. This formlessness, in the form of dance, should not be thought of in purely privative or negative terms. It is evil as a positive possibility. Whereas music is consistently evoked in Ruskin's writing as a metaphor for social, order—or, rather, as its pedagogical inculcation— a social *choreography* tends to emerge at precisely those moments where the possibility of a disorder is considered. In effect, the can-can obliges Ruskin to a consideration of the culture industry in terms of that same "dialectic of Enlightenment" that would so famously preoccupy Adorno in the following century.

I have been contending here that the traditional opposition of the plastic and the musical arts acquires a new historical and social content in the nineteenth century as the musical comes to be opposed not only to the plastic but to the condition of amusement that denotes a form of "idleness." Amusement—as a social principle clearly related, yet implacably opposed, to play—conjures the specter of a society lacking in any aesthetic sense of the temporal and the historical. Anxieties about amusement reflect anxieties about social entropy. Amusement—in the sense of killing time or marking time—would be a condition of deliverance to the temporal, the abdication of national or rational historical subjectivity. For this very reason, it becomes a specific and central

concern of Ruskin in the essay "On the Relation of National Ethics to National Arts" (19: 163–94). Clearly, if musing about the Muses in the nineteenth century challenges traditional conceptions of what "work" is, it provides no less of a challenge to the concept of leisure. For some, in the nineteenth century the vitality and movement of dance holds out the teleological promise of a historical and social "beyond," while the utopian moment itself is to be thought of as a coming to rest, an end of history. For others, meanwhile, the utopian *is* the movement itself, the irrepressible human spirit or transcendental vital and historical force that must sweep away all that stands still. This crucial distinction is replicated in a parallel distinction between those for whom the static, objective quality of the aesthetic artifact represents the moment of rest (the moment in which I confront and contemplate my own subjective activity in an object at rest) and those for whom the existence of an object as the product of labor is extraneous to the joy of the activity of labor itself. Accordingly, "rest" can be thought of either as a utopian condition or as a failure of the historical energumen, as a condition of mere idleness. Judgments of dance will be indicative of social and political positions on questions of labor and "idleness" (or—as it will be reformulated only toward the end of the nineteenth century—unemployment).

Questions of play inherited from Schiller—and via Schiller from the aesthetic debates of the eighteenth century—were given a specifically social slant in this British debate and linked to social issues of labor, employment, unemployment, and wages. The aesthetic socialists essentially derived from traditional philosophical and aesthetic notions of "idleness" an imperfect taxonomy for understanding the functioning of high capitalism in an age of overproduction. In a period of industrial competition and growth, the classical Greek ideal of *shkole*, or leisure, as the condition of the "gentleman and scholar" coexisted precariously with a more Latinate (degenerate) concept of *otium*, or idleness and unemployment. To speak more clearly, the man of leisure coexists with the unemployed and the concept of what we might call "in action" becomes highly problematic. In an age in which otium, or idleness, becomes not only the privilege of aristocratic freedom but also the curse of the lumpenproletariat, the classical privilege accorded the term certainly cannot go unchallenged.

Reframing the problem in terms of stasis and motion, however—that is, in aesthetic terms—allows the nineteenth-century cultural critic an

antidote to empirical fears of social and cultural malaise. In this context Ruskin's translation of the opposing terms techne and atechnia by the Latin terms *ars* and *inertia* is particularly important. Motion, in Ruskin's translation, is crucial to his conception of art, if not literature. Ruskin's is not, ultimately, a cultural ideal of rest and repose; the task of art (as it comes to the help of literature) is to set bodies in motion. The function of ars is to counter the historical and physiological condition of inertia. The flexibility of the body and the movement of history are linked through Ruskin's concept of art. Nevertheless, due to the conflation of ars and techne in Ruskin's work, his aesthetic offers little resistance to merely "technological" or "technocratic" conceptions of social order. For this reason, at crucial points atechnia—that is, inertia—can acquire a value of resistance to technocratic order. The ambiguity of dance—an art form one might otherwise have thought of as entirely commensurate with Ruskin's "dynamic" conception of ars—is that it lays bare the disturbingly technological possibilities inherent in any such conception.

Ruskin's insistence on the opposition of ars and inertia was not, indeed, something that would be passed on without question to the aesthetic socialist tradition. As one critic notes, for example, "Morris was opposed to the 'hurried and anxious' pleasures which seemed to be a side-product of the degradation of work in his own society. Hence his call for 'an epoch of rest,' to borrow from the subtitle of his novel."[21] For Morris, it is the condition of hurried consumption that is to be avoided, and his privileging of the category of "rest" has repercussions for his concept of social order. Moreover, the privileging of rest derives from—or, perhaps, explains—the importance he places on work. In reconstructing an aesthetic socialist tradition, the key distinction to bear in mind is between the joy taken in labor—a moralizing position taken by Carlyle, Schiller's great champion in Britain—and the joy taken in the *object* of labor—as exemplified by Morris's artisanal ideals. This distinction goes to the very heart of the opposition between labor and work.

Without rehearsing in full the terms of Hannah Arendt's study *The Human Condition* on the basis of the fundamental categories of "work," "labor," and "activity," some schematic elaboration of the work-labor distinction might be helpful before moving on to Morris. Stated crudely, for Arendt "labor is the activity which corresponds to the biological

process of the human body, whose spontaneous growth, metabolism, and eventual decay are bound to the vital necessities produced and fed into the life process by labor. The human condition of labor is life itself."[22] In other words, although labor seems to represent man's submission to the necessity of toil, it also expresses and articulates biological human needs. Labor does not produce an excess: it consumes as it produces and is, to this extent, "energistic." It is its own natural economy. Furthermore, labor lacks that minimum of self-alienation necessary to ground consciousness in the instrumental awareness of a distinction of subject and object.[23] Because labor produces no object, it does not allow for the subject's confrontation with, and reflection on, his own activity in objective form. It is not yet objectified, as work will be: it produces no object in which man might confront his activity in an external form that would allow him to consciously posit himself as a subject. Labor is "unalienated" because the performance of labor does not yet demand a self-conscious human subject: but, by the same token, it is animalistic because the absence of an object denies man the possibility of becoming a subject in contradistinction to that object. To this extent, it effectively falls below the threshold of consciousness in a cycle of mere energy. Because the subject is not split it is not yet truly a subject, in labor, for it cannot know itself beyond its physical needs.

In "work," the objectifying split—or "alienation" in the technical rather than political or economic sense—of the subject comes about. I can now know myself and my actions through the objects I produce—that is, through objects "alien" to me yet nevertheless embodying my labor. Arendt polemically resists the degradation of the notion of work, in which the existence of the artifact grounds a system of values and posits man in a material world, to a notion of labor, in which value is of the nature of an energy and the alienating/objectifying moment of consciousness embodied by the object has been removed. Such a degradation, she argues, paves the way for an essentially atavistic and valueless Lebensphilosophie in which a "glorification of the sheer dynamism of the life process excluded that minimum of initiative present in those activities which, like laboring and begetting, are urged upon man by necessity" (117).

Arendt clearly outlines the importance of "the work of our hands, as distinguished from the labor of our bodies—*homo faber* who makes and literally 'works upon' as distinguished from the *animal laborans* which

labors and 'mixes with' . . . " (136). The instrumentality of manufacture retains the subject-object relation in a way that a physical activity that "mixes with" would not. As Arendt puts it, "the ideals of *homo faber*, the fabricator of the world, which are permanence, stability, and durability, have been sacrificed to abundance, the ideal of the *animal laborans* . . . and we have changed work into laboring" (126). What I would suggest with respect to dance is that while, as play, it figures as an alternative to the ideology of work, in terms of the dyad of work and labor it constantly threatens a return to the condition of undifferentiated and nondifferentiating labor. Holding up dance as an unalienated playful alternative to the object-oriented, fetishistic activity of alienated "work" under capitalism risks celebrating instead a biologized notion of activity, "labor," that is even more uncritically subjugated to the dictates of capitalism. By putting the entire body in motion, dance figures a movement beyond the manufactural and opens up the possibility of a totalizing—if not, indeed, totalitarian—model of social order. Whereas manufacture relies on the hand—the literal organ of any act of (self-)positing—the dance serves merely to put the body in motion, allowing for no necessary objective break from which a consciousness of worldly subjectivity could emerge. (This, indeed, has been the reason for its celebration in the writings of the symbolists and aestheticists, whose work sought to overcome the alienated conditions of capitalist production.) What dance as aesthetic form, and as object of aesthetic reflection, unmasks is the seamless labor of bodily integration that will be necessary if the liberal vision of Schiller is to be realized. While the project of social choreography I outline here sought to intimate the possibility of a utopian move beyond alienated work, it in fact fell below the threshold of objectification necessary to ground a social praxis. Dance, thus, potentially figures a condition of capitalist totalitarianism: Ruskin's critique of "amusement" is, in this sense, uncannily prescient of a condition perhaps best analyzed in the twentieth century in Horkheimer and Adorno's *Dialectic of Enlightenment*.

In the 1884 essay "Art and Labour," Morris defines his terms in a way that helps us understand the omission of music and dance from his particular brand of aesthetic socialism. Labor he defines as "the labour that produces things, the labour of the classes called the working classes . . . of the marker of things."[24] For Morris, labor is inextricably linked to the "making of things" and to self-objectification in those

things (i.e., in Arendt's terms it is work). His insistence on work in Arendt's sense (as "manufacture" invested in objects) opposes the vitalism of an increasingly hegemonic concept of labor thought of as abstract potentiality (or *Arbeitskraft*). Work is important not only because it privileges the moment of production—this it would share with "labor"—but because it includes the possibility of contemplation and rest. To this extent, Morris's concept of work is Aristotelian, finding its origin and telos in rest. In this same essay Morris defines art as "beauty produced by the labour of man both mental and bodily, the expression of the interest man takes in the life of man upon the earth with all its surroundings, in other words the human pleasure of life" (94). While he refers to "labour without which art could not exist" (95), it is clear that Morris's ideal of art also approximates Arendt's category of "action" as an agonistic process (in this case, between man and object, rather than between men in the medium of language). Beauty, for Morris, consists both in the product of labor and in the activity of labor itself—but it is only the existence of the object that allows for a retroactive enjoyment of the labor that went into its production. In Arendt's terms, Morris persistently stresses work over labor, and while his polemic seems to depend on a utopian conception of the possibilities of nonalienated labor (a form of Hegelian Marxism, we may say, in retrospect) this conception is always oriented toward the production of the object.

For all the stress laid on unalienated labor, Morris is, ultimately, more interested in the modes of social exchange made possible through the medium of the object. This would naturally imply the relegation of music and dance to the secondary position of arts that produce no object and therefore ground no objective social order. The uselessness that might make them attractive to other strains of aestheticism implacably opposed to utilitarianism and commodification renders them uninteresting to Morris's paradoxically utilitarian aesthetic. His insistence, in the essay "The Lesser Arts," that "nothing can be a work of art which is not useful; that is to say, which does not minister to the body when well under command of the mind, or which does not amuse, soothe, or elevate the mind in a healthy state" (34), makes it clear that for Morris the determining distinction is between use and exchange, and that for all his opposition to utilitarian mass production, the category of "use" grounds his aesthetic. Notably, this utilitarianism also

makes the concept of "amusement" acceptable to him: the ability to amuse is a legitimate aesthetic function. This marks a shift from the Ruskinian position and a positive reevaluation of the possibility at least, if not necessarily of the reality, of cultural amusement. Consequently, we might flesh out our earlier Greimasian configuration as follows:

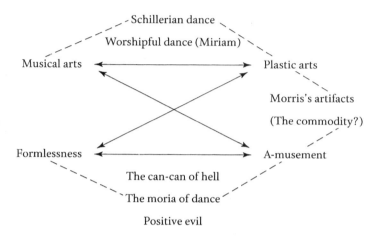

Whereas a straightforward critique of the culture industry might identify "plastic amusement" with the production of culture commodities, Morris bravely seeks to insert an alternative term into that strategic position. Uncoupling amusement from lack of reflection, Morris acknowledges its importance (and the importance of the amusical) in a way that Ruskin—invested in a notion of art that by its very definition depends on movement to counter inertia—could not. Rest, for Morris, consists not of a possible critical reflection but of a form of enjoyment that cannot be reduced to consumption—an enjoyment in which the object perdures and is not used up.

There is something of a quandary here: on the one hand, Morris wishes to stress the object rather than the process of production, but he does not wish to take the process of production wholly out of the realm of the aesthetic. "That thing which I understand by real art," he writes elsewhere, "is the expression by man of his pleasure in labour." The pleasure in labor is intrinsic to the aesthetic value of the object produced. Labor is, then, "expressive" and as such a concern of any aesthetic socialism, but Morris's logic is tortuous and retroactive; "I do not

believe," he writes of the worker, "he can be happy in his labour without expressing that happiness" (530). This is the sense in which pleasure is retroconstructed. The work is the expression of a joy that does not precede it. The product is not simply a product of joy: it retroactively produces (through expression) the joy that produced it. The existence of the joy is secondary to its expression ("I do not believe he can be happy in his labour without expressing that happiness"). The work (of art) creates the thing—happiness—that it expresses. The representation creates its own object, so that the expression of joy is displaced by the joy of expression. The logic of catachresis that I examined in the introduction again pertains here—the rhetorical expression in fact creates its own object.

This structuring logic of what Morris will term "hope" in work is not, ultimately, that of futurity but of anteriority; it is the hope of a nostalgic contemplation. Pleasure is a retroconstruction. The object that will subsequently legitimate an individual's work by allowing for his contemplation of that work in objective (indeed, alien) form, figures during the process of work as "hope." In "Useful Work versus Useless Toil" Morris defines his concept of hope as follows: "It is threefold, I think—hope of rest, hope of product, hope of pleasure in the work itself; and hope of these also in some abundance and of good quality; rest enough and good enough to be worth having; product worth having by one who is neither a fool nor an ascetic; pleasure enough for all of us to be conscious of it while we are at work; not a mere habit, the loss of which we shall feel as a fidgety man feels the loss of the string he fidgets with" (176). Paradoxically, the ideal of the subject actualizing itself in work can be located only in two moments: in the "hope" that in fact ruptures the very concept of the "actual" in labor by introducing a temporal futurity; and in the object that must by definition confront the worker in its alterity. The working subject will experience itself only through hope or through the object—that is, through the moments that sunder its self-enclosed subjectivity by subjecting it to either a spatial or a temporal logic of deferral. At the same time as Morris posits the possibility of nonalienated labor he seems to fear its implications, its potential surrender of the critical moment that Ruskin saw as essential to the subject. Morris's "hope of rest" might be said to derive directly from the classical tradition where the moment of rest is fundamental to the function of music as an accompaniment to the leisure, or shkole, of

the gentleman. In the aesthetic socialist tradition, the generic aesthetic questions of space and time and their deployment in various forms of art are projected outside the limits of the work of art itself to form the basis of a reflection on hope and enthusiasm as affective modes that question the work of art's separation from social and historical efficacy. This "ethical turn" in aesthetic socialism is not simply an attempt to insert works of art into preestablished moral norms but rather an attempt to derive those norms from the very terminology of the aesthetic itself. Thus, for instance, the temporality that informs the "musical" arts is rethought in terms of a relation to historicity—utopian "hope"—rather than as a structure cut off from history.

With specific regard to the questions of work and leisure treated here we can also note how Ruskin builds on Greek precedent to consider how music not only practices and induces leisure, but can also have its "enthusiastic" modes.[25] Aristotle, for example, writes of "the power which the songs of Olympus exercise: for beyond question they inspire enthusiasm, and enthusiasm is an emotion of the character of the soul."[26] This "enthusiasm" is important, for it is anticipatory in a way that music, by Aristotle's definition, should not normally be. Unlike Morris's hope—which, as "hope of rest" is, finally, grounded in atemporal repose—enthusiasm potentially scrambles the temporal flow, introducing a form of syncopation into the performance of our daily tasks. In Aristotle's model, the privileging of rest derives from the fact that it "gives pleasure and happiness and enjoyment of life, which are experienced, not by the busy men, but by those who have leisure. For he who is occupied has in view some end which he has not attained" (1338). What Aristotle does here with the category of "enthusiasm" is to introduce a double temporal scheme, to posit a split and deferral at the very heart of the musical. The logic seemingly replicates that which we have just encountered in Morris: the untrammeled subject will be posited either as the state to which "hope" or "enthusiasm" aspires; or, retroactively, as the putative subject of the pleasure that labor, or music, inspired. The teleological moment of repose, however, is missing—this is an anticipation that has no particular object. Enthusiasm denotes both an irrational exuberance and an orientation toward some imagined—sublime—goal rather than toward some given material and historical end. The philosophical question of "enthusiasm" as a mode of cognition is related, I would suggest, to the question of the sublime.

Enthusiasm is a feeling that cannot express itself, or as Lyotard will write in his consideration of Kant:

> Enthusiasm is a modality of the feeling of the sublime. The imagination tries to supply a direct, sensible presentation for an idea of reason . . . It does not succeed and it thereby feels its impotence, but at the same time it discovers its destination, which is to bring itself into harmony with the Ideas of reason through an appropriate presentation. The result of this obstructed relation is that instead of experiencing a feeling for the object, we experience, on the occasion of that object, a feeling "for the Idea of humanity in our subject" . . . The sublime is best determined by the indeterminate, by the *Formlosigkeit.*[27]

Ruskin's awareness of an inability of expression posits, in Lyotard's terms, the possibility of "an appropriate presentation." If enthusiasm is a "mode of feeling," I wish to argue that the aesthetic socialists I treat here work on the body as a medium of feeling and use it as a figure for what Lyotard characterizes as historically unrepresentable. The question then will be: How is the sublime both experienced and figured as "enthusiasm"? What physical sensation does it produce as the frisson of history that vibrates through bodies?

Ruskin is quite explicitly suspicious of "enthusiastic" modes of music, which he links with lawlessness, liberality, and licentiousness; as, for example, in the following passage from *Fors Clavigera* on the pedagogical value of music: "Make them [music and dancing] licentious; let Mr John Stuart Mill have the dis-ordering of them, so that 'no one shall be guided, or governed, or directed in the way they should go'—and they sink to lower and lower depth—till the dance becomes Death's—and the music—a shriek of death by strychnine. But let Miriam and David, and the Virgins of Israel, have the ordering of them, and the music becomes at last the Eternal choir, and the Dance, the Karol-dance of Christmas evermore" (28: 405–6). Ruskin's imagery may be lurid, but the danger of liberal dissolution in such musical excitement could hardly be clearer.[28] Music is to follow the logical meter of language. In the very early "Essay on the Relative Dignity of the Studies of Painting and Music and the Advantages to be Derived from Their Pursuit," however, he does make an exception for military music, which "excites the passions strongly, wonderfully" in order to "produce a strong excitement and bracing up of the whole body (1: 274). That the excitement produced by military

music—its "vibrations," as Ruskin puts it—effects a "bracing up of the whole body" suggests some anxiety about the limits and borders of a body that might require such a "bracing." In the case of this early essay, though, excitement creates the intensely physical effect of a defined and delimited—embodied—subject. It effects a "bracing" rather than an irrational "enthusiastic" dissolution.

What I want now to suggest is that both in the "enthusiastic" musical modes and in the anthropological and sociological writings with which I opened this chapter, the possibility of a physiological sublime is being explored as a mode of self-perpetuating social choreography. This social vision is linked to the rise of vitalistic Lebensphilosophie, whose forms it rehearses in the aesthetic realm. Although the sublime would normally be that which man imagines beyond specific historical embodiment, I am arguing that the body itself increasingly comes to figure that historically unfigurable possibility. By invoking a notion of "the physiological sublime" I wish to suggest the removal of all limit and definition from the subject to the degree where man is subsumed not by his ideal humanity but by the vital, muscular energies and "vibrations" that pass through him. How is this possibility experienced and/or contained in the writers on music and dance examined heretofore?

Notably, it is in the earliest writings that Ruskin retains his susceptibility to "enthusiasm." Notable also is the way that it is invoked only at the point he feels all utopian enthusiasm abandoning him—as, for example, in a letter of 1847 when he confesses that "enthusiasm is, in me, fast passing away," but nevertheless compares himself to those "men who really have genuine feeling, but do not know how to express it, and, with regard to myself, I admit the charge of enthusiasm at once, but my intended position—I know not if tenable or not—is that there is a certain kind and degree of enthusiasm which alone is cognizant of *all* truth and which, though it may sometimes mistake its own creations for reality, yet will *miss* no reality, while the unenthusiastic regard actually misses, and comes short of, the truth" (36: 80). In this instance Ruskin refers specifically to "the mode of *sight* of enthusiasm" (emphasis mine), but the citation from the essay on music from the same period suggests that the "excitement" that music can invoke partakes of a similar logic. Clearly, the question of enthusiasm and excitement is linked to a sublime inability to express that is nevertheless belied by a

"genuine feeling." Rather than stressing the limits of discourse Ruskin instead seems to use music to celebrate the physical sensation and presentiment of the sublime. We need also to note a double temporal frame: for while enthusiasm anticipates it seems to reveal its secret only in its passage, as it leaves the writer exhausted.

Kant's similar insistence that the experience of the sublime is "a vibration" throws us back to Ruskin's "bracing" music. Whereas Lyotard insisted on the possibility of "an appropriate presentation" of historical possibility only as the virtual and deferred point of imagination's striving, the images of bracing up in Ruskin posit a "presentation"—an embodiment—of sublime enthusiasm in the here and now. Indeed—and this is crucial to my argument in this book—Ruskin is concerned less with the presentation of an ideological sublime than with its experience, embodiment, and production. Ideology operates here as performative. The experience of the sublime that explodes the limits of the contingent historical subject, awakening in him a sense of his own humanity—an experience that supposedly beggars any figuration—is itself figured by Ruskin as the "bracing up" of a body. What is being posited in "enthusiastic music" is a specifically physiological experience of the sublime. This is the possibility of a social and bodily energumen that is something we also encountered in the "energetics" of the late-nineteenth-century social theorists considered earlier. What remains for us now is to consider the aesthetic possibilities offered by such a mode of figuration and the ways in which it might round out our Greimasian presentation of the nineteenth-century cultural debate surrounding dance.

Let us begin by confronting the remaining lacuna in our Greimasian construction—the mediation of the musical and the formless. The music of the enthusiastic mode seems of little use here because its effect is the production and binding of a body in the experience of a "bracing up." Nevertheless, it is my contention that in the work of Ruskin and on through Wilde we can trace a metaphorical resolution of this dichotomy of music and formlessness. If, as we have seen, Ruskin's reflections on music—and, by extension, on dance—are to be understood in the context of the taxonomy of "musical" and "plastic" arts, we need also to note the operation of distinctions within his discussion of music. The most striking of these is a distinction figured through the mythical

competition of Marsyas and Apollo, which is best glossed in the letter from a professional classicist Ruskin quotes in letter 83 of *Fors Clavigera*, where the opposition is defined as follows: "The competition was, then, in the first place, between the music of summer [i.e., Apollo] and the music of winter [i.e., Marsyas], and in the second place, between the music of animate nature and that of water and wind. This explanation would also apply to the competition of the Muses and the Sirens, since the latter represented the music of the seashore, while the Muses were associated with Apollo" (29: 271).

Ruskin will reconfigure this opposition of Apollo and Marsyas as a historical development, but we should note the opposition of Apollonian "animate" music and the disembodied and ostensibly inhuman music of "water and wind" represented by Marsyas. Marsyas seems to figure the disembodiment of music, and his own fate—the flaying he undergoes at the hands of Apollo on losing the competition—would support such a reading. Just as Marsyas disembodies music as the effect of "water and wind" so too shall he be disembodied by flaying at the hand of Apollo. Ruskin's gloss on this mythological figure translates it into a historical consideration of

> the three orders of the Deities of music throughout the ages of Man,—the Muses, Apollo, and Dionysus,—each with their definite adversaries. The Muses, whose office is the teaching of sacred pleasures to childhood, have for adversaries the Sirens, who teach sinful pleasure; Apollo, who teaches intellectual, or historic, therefore worded music, to men of middle age, has for adversary Marsyas, who teaches the wordless music of the reeds and rivers; and, finally, Dionysus, who teaches the cheerful music which is to be the wine of old age, has for adversary the commercial pirate, who would sell the god for gain, and drink no wine but gold. (29: 272).

Clearly, then, any blanket invocation of "the musical" as a simple term opposing the "plastic" arts risks simplifying Ruskin's conception of music, which is, in fact, developmental. That the Muses should be accorded an essentially pedagogical role in Ruskin's reconstruction of myth is altogether consonant with his pronouncements elsewhere. In his mythopoetic presentation, the Muses are opposed by the Sirens, Apollo by Marsyas, and Dionysus by commercial pirates, one set of

opposing terms following the other in historical sequence. Presented in this way, the "positive" escalation from the Muses through Apollo to Dionysus, is paralleled by the negative escalation from the Sirens through Marsyas to the commercialism of a piratical "a-musement."[29]

Ruskin's negative assessment of the Sirens is explicable from the perspective of his high Victorian moralism (and the gendering of cultural decay is all too familiar from examples cited earlier in this chapter); the opposition to commercialism, meanwhile, is entirely consonant with his refusal of the bourgeoning culture industry. Less obvious, however, is the negative value placed on Marsyas. Ruskin comments further on this in a passage from *Queen of the Air*: "Thenceforward all the limiting or restraining modes of music belong to the Muses; but the passionate music is wind music, as in the Doric flute. Then, when this inspired music becomes degraded in its passion, it sinks into the pipe of Pan and the double pipe of Marsyas, and is then rejected by Athena" (19: 342–43). Marsyas represents the degradation of inspiration: the music of the winds is the music of inspiration in literal and banalized form—a pennywhistle. Far from "bracing up," such enthusiastic modes oppose any "limiting or restraining." Disembodiment, rather than figuring transubstantiation and a spiritual movement beyond the constraints and contingency of the body, represents instead the absence of limit or restraint. Ruskin goes on to explicate the contest of Apollo and Marsyas in the following, highly significant, terms:

> Then, the strife of Apollo and Marsyas represents the enduring contest between music in which the words and thought lead, and the lyre measures or melodizes them, (which Pindar means when he calls his hymns "kings over the lyre,") and music in which the words are lost and the wind impulse leads—generally, therefore, between intellectual, and brutal, or meaningless music. Therefore, when Apollo prevails, he flays Marsyas, taking the limit and external bond of his shapes from him, which is death, without touching the mere muscular strength; yet shameful and dreadful in dissolution. (19: 343)

The distinction, then, is between language that produces its own music (Apollo) and music that produces its own language (Marsyas)—between rhythm as by-product and rhythm as origin.[30] Although consistently a champion of more natural aesthetic forms, Ruskin must clearly

be distanced, here, from any form of nascent vitalism that would take the rhythms of nature as the substratum for social and political discourse—that is, for an ideologically "naturalized" social choreography.

What I wish to stress here, however, is the nature and appropriateness of Apollo's response to Marsyas's hubris.[31] Ruskin effectively suggests that Apollo's punishment mimics and completes Marsyas's own project of dissolution: Marsyas's formless wind music does not respect the forms and limits of things, and as a consequence Apollo removes all form and definition from Marsyas himself by removing his skin. The membrane defining and delimiting Marsyas's body is removed and as a result he becomes pure energy, at one with the world into which he sends his music. Embodiment, then, is crucial to Ruskin's conception of music precisely insofar as it delimits and regulates the realm of music. Marsyas represents the possibility of an enthusiasm that is quite the contrary of "bracing."

I am suggesting, however, that the "bracing" vibrations of military music and the flaying of Marsyas are not, in fact, opposed; for what each does is figure the body purely as body rather than as the representation of a subject. Marsyas would be a body without identity—a lawless, limitless body—and as such a figure for living death: a living corpse, in fact. Marsyas's appeal to Apollo—"Quid me mihi detrahis?" (Why do you peel me from myself?)—figures a destruction through revelation: the embodied subject is himself subjected to the disembodying aesthetic he represents, subjected to the energies that flow through him and destroy him. Marsyas would not figure Ruskin's philistine condition of inertia but, on the contrary, the energy of ars taken to its self-negating conclusion—life itself, the palpitating organs and straining sinews of the flayed Marsyas, laid bare. This is a death by "liberation," the liberation of the body from its limiting skin, of the social subject from all constraint. As Ruskin writes in letter 57 of Fors Clavigera: "Liberty, whether in the body, soul, or political estate of men, is only another word for Death, and the final issue of Death, putrefaction: the body, spirit and political estate being alike healthy only by their bonds and laws" (28: 402).

One might say that Marsyas represents what Ruskin would call "liberal" music, and that Apollo represents the illiberal. In this instance, however, we might need to distinguish between two competing images of (dis)embodiment. Whereas the figure of Marsyas represents a social

energumen reduced to its own very motive force, disembodied, the kind of "liberties" taken in the can-can lead instead to a form of putrefaction, a collapse of the body into its own "mephitic vapors" (28: 403). This contrast between two equally critical attitudes toward liberal modernity helps us differentiate between modes of cultural critique. Whereas the critique of putrefaction figures the fear of cultural and bodily dissolution and disintegration, Marsyas is, by contrast, a much more ambiguous figure—the very energy of disintegration itself that needs to be understood not simply as a (bodily and cultural) collapse but as the drive toward new and frightening mass cultural formations.

If I have been invoking an aesthetic socialist tradition for which a consideration of Wilde would be necessary, I have offered no detailed presentation of where he might fit in that tradition. I might conclude this chapter, then, by reflecting on the fate of this Marsyas trope in his writing. In Wilde's "The Decay of Lying" Marsyas is once again opposed to Apollo. "Surely," the interlocutor Cyril exhorts his aesthetic friend, Vivian, who refuses to treat art in its social context, "you would acknowledge the temper of its age, the spirit of its time, the moral and social conditions that surround it and under whose influence it is produced." To this Vivian produces the oft-quoted and invariably truncated response:

> Certainly not! Art never expresses anything but itself. This is the principle of my new aesthetics; and it is this, more than that vital connection between form and substance, on which Mr. Pater dwells, that makes basic the type of all the arts. Of course, nations and individuals, with that healthy natural vanity which is the secret of existence, are always under the impression that it is of them that the Muses are talking, always trying to find in the calm dignity of imaginative art some mirror of their own turbid passions, always forgetting that the singer of life is not Apollo but Marsyas.[32]

Why is this passage surprising? We need to note first the gracious distancing from Pater, for whom music held a paradigmatic value among the arts. The passage is interesting in our context, however, for its identification of Marsyas with mimetic realism. For we have been in danger of confusing Platonic form and mimetic figure. My reading of Ruskin has been pushing Marsyas—with his formlessness—in the direction of the sublime, but here he comes back to earth with a realistic

thud.[33] The question I wish to confront in conclusion is whether it is possible to reconcile these two roles of Marsyas—the mimetic and the sublime—in a notion of sublime figuration, thus producing the following constellation:

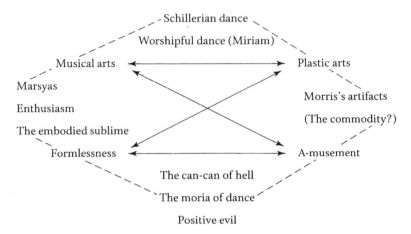

Wilde would complete the presentation and reconfigure our understanding of modernism by forcing us to rethink the role of figuration through the ambiguous figure of Marsyas—"disfigured" by his very reduction to a purely figurative (and energistic) impulse. What I have been suggesting, in effect, is that we need to demystify the sublime in our readings of the nineteenth century both as an aesthetic possibility, Wilde's representationalism, and as a social project, the attempt to harness economically the "social energumen."

Wilde's invocation of Marsyas—and the tradition of figurations of that figure in the writings of the Victorian sages—attunes us to the way in which questions of rhythm and energy that would come to dominate philosophical thought in the form of vitalism and Lebensphilosophie had already been worked through in aesthetic form as crucial problems of social choreography. In its subsequent reemergence as an aesthetic form, dance would come to reconfigure, through the materiality of the body, a debate about rhythms; rhythms of work, of life, of poetry. One senses the beginnings of new taxonomies in Wilde's writings, as for example in "The Decay of Lying," where he distinguishes (by simile) rhythm from music. "As one knows the poet by his fine music," Wilde writes, "so one can recognize the liar by his rich rhythmic utterance,

and in neither case will the casual inspiration of the moment suffice. Here, as elsewhere, practice must precede perfection" (972). At one and the same time Wilde seems to subscribe to a Paterian tradition that idealizes poetry as music and yet also to propose—by championing the rhythm of the lie rather than the music of poetry—an aesthetic practice not grounded on poesis. Notably, he rejects any notion of music or rhythm as instantaneous or spontaneous—it is always practiced and rehearsed. Could it be that dance, rather than figuring—as in the tradition of Yeats reconstructed by Kermode—the possibility of transubstantiation and transcendence, figures instead the biological materiality of rhythm distilled from the abstractions of musical form? Might dance be for Wilde the rhythmic form of the lie rather than, necessarily—as Kermode would have us believe—a performative, musical, revelation of truth?[34]

In conclusion, then, what I am proposing is that the aesthetic socialist tradition running from Carlyle through Ruskin—and along different streams to Wilde and Morris—was persistently but only darkly aware of the problems inherent in the ideal of social choreography derived from Schillerian idealism. By the end of the century, Schiller's playful social totality will have been replaced by the totality of labor. Whereas, in the Kantian formulation, the sublime lies in the subject's recognition of a suprasensual subject operative within him, in Schiller that recognition of a beyond has been socialized: beyond the individual is the choreography of society in which he dances. In the physiological sublime the body does not figure the philosophical condition of the subject; it figures, instead, the end of the figure, the resubsuming of the body by the "enthusiasms" it generates. In the turns and reels of Schiller's "English dance" the ideal subject has revealed itself as labor power. The disembodied body of Marsyas is the medium for thinking about a social energumen that passes through physical bodies but cannot be reduced to them. At the same time as the subject is dissolved by its participation in that greater social energy, the experience of that dissolution can be figured as a raw muscularity from which the defining membrane of the skin has been removed. The sublime as the unfigurable finds a paradoxically appropriate figuration, and the body, rather than consciousness itself, becomes the seat of experience. Ideology has already passed beyond questions of mere representation to questions of performance, experience, and embodiment.

2

Stumbling and Legibility

GESTURE AND THE DIALECTIC OF TACT

. . . the most general of the senses. We could well see or hear with just one small part of the body, but in order not to be automata that can be destroyed or dismantled without even noticing it, we require the sense of touch in all parts of the body.

[. . . la sensation la plus générale. Nous pouvions bien ne voir ou n'entendre, que par une petite portion de notre corps, mais il nous falloit du sentiment dans toutes les parties pour n'être pas des automates, qu'on auroit démontés et détruits, sans que nous eussions pû nous en apercevoir.]
—Chevalier de Jaucourt, "Le Tact," in *Encyclopédie*

Having suggested in previous chapters ways in which social choreography informed the project of nineteenth-century aesthetic socialism, I now wish to locate such social visions within a broader Enlightenment tradition of thinking about the relation of the physical body to the body politic. That is, here I will begin to examine the choreographic in its second dimension—as not only a disposition of bodies in social space but as a way of educating the individual body in its experience of itself and in its movement toward language as an expression of that experi-

ence. In terms of the "aesthetic continuum" outlined in the introduction, I will examine the threshold at which the aesthetic in the most fundamental sense (as sensory experience) passes over into "the aesthetic" in the more limited sense—as a socially endorsed framing of the sensual. Thus I will address physical movements that would not ordinarily fall under the rubric of choreography in the more limited aesthetic sense in order to examine the way in which bodily experience prefigures and prepares for the Enlightenment subject's passage into language. While my consideration of the body will constantly parallel an Enlightenment and post-Enlightenment reflection on writing and legibility, it is my contention that the possibility of "reading the body" has always been posited only in retrospect—as a utopian originary moment in which meaning was supposedly immanent, embodied, and uncomplicated by its social situation. I will argue that over the course of the nineteenth century repeated attempts were made to subject the body to a specific regime of legibility in continuance of an Enlightenment hermeneutic tradition.

By and large, these attempts—which built on the pseudoscience of eighteenth-century physiognomy—succeeded in suppressing a more radical strain of thought that recognized both the contingent nature of the body's movements and the importance of aesthetic criteria in establishing a social choreography. I do not, then, offer here a chapter that "reads the nineteenth-century body," but rather one that seeks both to locate the very possibility of bodily reading historically and to reexamine moments of critical stumbling in that hermeneutic. I will argue for a "dialectic of tact," in which social choreography is presented as a necessary accommodation to the state of a society fallen from grace (or self-immanence). This fantasized state of grace—the originary moment of true and immanent democracy—was figured as a situation in which the direct physical communication of members of a community with each other was still possible.

The pivotal figure in this chapter is the nineteenth-century French theorist of theatrical deportment and declamatory gesture, François Delsarte, who built on a tradition of speculation about the body's relation to language in order to develop a systematic study of physical deportment and public speaking that was immensely influential for the body consciousness of the educated middle class in Europe and America.[1] As a figure who fuses the taxonomic zeal of the encyclopedist with

the spiritualism of the nineteenth-century parlor, Delsarte serves as a bridge to the early theorists of modern dance in the United States. His observations on the significance of gestures—which originated, according to his own account, in his early training as an (unsuccessful) actor—were hugely influential at a time when a newly emergent bourgeois class was eager to represent through its body, as well as its possessions, its newly acquired status. If that status could be represented physically, it was assumed—in the "natural" language of the body—that the social status of this ascendant class could itself be represented as something natural and inevitable. This is, then, a chapter on bourgeois gesture. By making such a general claim I do not seek to oppose the bourgeois gesture to, say, the proletarian—although the criminological and cultural work by figures such as Cesare Lombroso and Max Nordau at the end of the nineteenth century was organized around just such divisions.[2] I am arguing instead that the very concept of "gesture" is itself bourgeois in the sense that it seeks to universalize and naturalize, through a choreographic embodiment, the cultural language of a specific class.

To this extent, Delsarte is pivotal precisely because he raises a question implicit in all of the other figures I treat in this chapter: When does a physical action function as a "gesture"? By tracing this question briefly through a variety of thinkers—from Rousseau to Bergson, then on to the Italian philosopher Giorgio Agamben, in our own day—I wish to suggest that bourgeois culture has always been troubled by the (im)possibility of embodying itself. Seeking to codify itself in a series of appropriate and acceptable gestures and manners, bourgeois culture always risked reducing itself to mere code, undercutting the naturalizing legitimacy it sought in the bodily language of gesture. At its most simple, I trace bourgeois social choreography back to learning comportment and how to walk—to the promenade that clearly shows off the body and makes of the very condition of man ("walking on his own two feet") an aesthetic gesture, a mode of representation. Walking is that human action where performance and text meet, where the question poses itself: Is this a gesture?

Before fleshing out this argument on walking, it is necessary to point out what is at stake politically in such reflections. In an essay examining the fundamental importance to Enlightenment political theorists, of the metaphor of walking, Bernd Jürgen Warneken cites as paradigmatic

Kant's essay "What Is Enlightenment?" with its exhortation to all liber-
ated humanity to "take a single step without the go-cart to which they
are harnessed."[3] As Warneken notes, this Kantian peripatetic pedagogy
also accepts falling as one of the processes whereby mankind will learn
to walk. Thus Kant's investment in a certain "epistemology of walk-
ing," so to speak, does not preclude the occasional inelegant stumble.
Examples of walking as the central trope of an emerging Enlighten-
ment politics abound. Thomas Hobbes famously defines freedom in
specifically physical terms as freedom of movement; and in a passage
that certainly complicates the class politics of Schiller's celebration of
dance, Johann Pestalozzi critiques the dances of the upper classes as
effete, and recommends instead a good, brisk, bourgeois stroll.[4] In the
late eighteenth century, for the first time, walking could be celebrated
either as an escape from a corrupt society and a return to nature, or as a
democratic and revolutionary communion with the hoi polloi.[5] After
quoting an enthusiastic German walker of the early nineteenth
century—"I consider walking to be the most noble and independent
thing about a man and believe that things would work better if people
walked more"[6]—Warneken concludes: "Particularly from the 1780s on,
a new bourgeois culture of walking is discussed and rehearsed in Ger-
many. It could be claimed with some justification that the bourgeoisie's
attempt to develop its own lifestyle and its own body culture did not
simply include walking and posture among other things, but that this
new culture of walking acquired a significant and independent role
both in inculcating a modern bourgeois habitus and in demonstrating
bourgeois self-consciousness" (179).[7] Clearly, the questions of walking
and gesture—or walking *as* gesture, as a "demonstration of bourgeois
self-consciousness"—are questions of cultural hegemony, and it is as
such that I wish to approach them now.

We might begin this examination of walking as bourgeois gesture at
the moment of its putative demise. In an essay on gesture from *Infancy
and History: The Destruction of Experience* the Italian philosopher Gior-
gio Agamben has argued that "by the end of the nineteenth century, the
gestures of the Western bourgeoisie were irretrievably lost."[8] This loss
of gesture, however, might be seen instead as a loss of syntactical or
legible gesture, for in fact what seems to have happened—at least in
Agamben's account—is instead an explosion of gesture beyond the
bounds of legibility. In charting the destruction of gestural experience

from the clinical writings of Gilles de la Tourette at the end of the nineteenth century, Agamben notes how the wild gestures noted by Tourette (and captured in the films of Marey and Lumière) seemed to have gone underground "until the winter's day in 1971, when Oliver Sacks, walking through the streets of New York, saw what he believed were three cases of Tourettism within the space of three minutes" (137). This historical and bodily return of the repressed leads Agamben to conjecture "that beyond a certain point everyone had lost control of their gestures, walking and gesticulating frenetically" (137). The fate of the gesture is interesting here: precisely to the extent that nonverbal languages have been subjected to a prevalent logocentrism, this very subjection has apparently unleashed a proliferation of unreadable bodily ejaculations. The repression of the body's (linguistic) movements has led to ever broader ranges of (uncontrolled) movement. It is as if we were faced with a paradigmatic Foucaldian play of repression and proliferation, in which the usual displacements that enable a sublimation have no "place" left. The body—the final resting place of the repressed, in so many cases—cannot itself be displaced. It is as if, in other words, displacement had reached a dead end and we had nothing left for protection and camouflage but the techniques of condensation—the terse, condensed gestures of Tourettism.

Of course, if we accept the hypothesis that Agamben proposes, any analysis of parapraxis—and the regime of reading on which it depends—becomes highly problematic. If the body's gestures have become spastic, we can no longer simply read back from them—even parapractically—to a putative subject. Thus the very project of situating such bodies culturally and historically—the project of cultural studies—becomes problematic because such bodies will not sit still long enough to be situated: they do not signify according to established norms of legibility. It is only from the perspective of an already alienated body that the somatic can be made to figure anything like a "natural language." In effect, Agamben's argument works only if we posit an implicit distinction between gesture and gesticulation; the former a willed linguistic articulation, the latter a subjection of the body to spontaneous or involuntary movements. "The gestures of the bourgeoisie" would then denote a bodily regime by virtue of which a certain class asserted its hegemony. The loss of bodily control observed by Tourette would then serve as the marker of the demise of bourgeois cultural hegemony. In

other words, Agamben understands "bourgeois gesture" as a form of embodied communication. Its crisis is a crisis of writing and intentionality (a loss of control of gesture) and of legibility (the gestures no longer "mean" anything). Bourgeois cultural hegemony, then, is understood as a certain regimen of reading and writing, and "gesture" would be the action wherein that regimen attempts to take on an apparently transhistorical and natural form: it is my body, not my class, that speaks. We find a similar logic in Adorno, where a nostalgia for the bourgeois promenade of the nineteenth century retrospectively simplifies what it meant to walk in that century.[9] I wish to demonstrate, however, that reflections on gesture always resulted from moments of stumbling. The self-assured bourgeois promenade was always a potentially precarious affair aestheticized most elegantly in an ironic essay by Balzac, "Théorie de la démarche."

The slight consideration Agamben's essay gives to choreography in either the limited or the expanded sense is as telling as his observation of Balzac's "Théorie de la démarche"—that it is, "when all was said and done, disappointing" (135). Agamben does not entirely neglect dance, however: it serves for him to describe the condition of Tourette's syndrome, in which "the patient is incapable of either beginning or fully enacting the most simple gestures; if he or she manages to initiate a movement, it is interrupted and sent awry by uncontrollable jerkings and shudderings whereby the muscles seem to dance (chorea) quite independent of any motor purpose" (136). Dancing, then, figures a movement beyond the communicative gesture—the sublime "vibrations" of Ruskin are now experienced only as a shuddering. Dance fails as gesture through an inability either to begin or to complete the gesture, and it figures a linguistic play that neglects the work of semiotic closure. Moreover, *chorea* necessitates a rethinking of "purpose" with respect to bodily movement. Dance figures either an aesthetic of interruption or, stated more positively, an openness to discourses that cut across primary lines of communication, confounding hegemonic meanings. And yet, dance—as movement "independent of any motor purpose"—might be taken as paradigmatic of a Kantian aesthetic of "purposiveness without purpose." This suggests a fascinating possibility that choreography as an aesthetic practice responds to the "loss of gesture" or "destruction of experience" in the bourgeois era; that it emerges both as an uncontrollable chorea, or symptom of the loss

of gestural control, and as an attempt to regain control through aestheticization.

This reading of dance, however, would finally limit itself too closely to Agamben's constricted parameters for understanding the nineteenth century. For example, his foregrounding of Tourette is tendentious: in the mathesis of nineteenth-century gesture an incalculably more influential figure was Delsarte, whose theory of oratory and gesture permeated many fields of cultural and social life. Perhaps the most striking cultural expression of a nineteenth-century obsession with "gesture," Delsarte's oratorical system—never satisfactorily transmitted in his own fragmentary writings—became de rigueur for would-be public speakers and, most notably, for genteel young ladies seeking to supplement their lessons in deportment. Isadora Duncan, for example, tells of her early exposure to salon Delsartism at her home in California. Delsarte's systematization of social self-presentation was obviously conducive to a society in which greater class mobility was now possible. The classification of gesture allowed for the naturalizing, through embodiment, of a newly acquired social standing (and the pun here is intentional). Not surprisingly, then, Delsarte's system would be most widely disseminated in the United States thanks to the proselytizing work of his followers Steele Mackay and Genevieve Stebbins, but it was also here that it was most thoroughly vulgarized as a tool of social climbing. By looking at the dissemination of the hugely popular work of Delsarte toward the end of the nineteenth century—and in a milieu that immediately and profoundly affected the choreography of the twentieth century via figures such as Stebbins and Duncan—I wish to show how a concern with gesture became a unifying cultural phenomenon. Any apparent loss of cultural hegemony on the part of the bourgeoisie was, in fact, no more than an inevitable failure to install that hegemony as a natural condition through gestural language and an all-embracing social choreography.

Tracing back to eighteenth-century treatises on the origins of language the various roles ascribed to dance and gesture as transitional forms of language would allow us to understand how for Enlightenment thinkers choreography, like grammar, served to organize "naturally" occurring communicative impulses. Were we to follow such a line of study—and in this chapter I do not, in fact, propose to cover origin of language debates from the eighteenth century—we would immediately confront the question of gesture and gesticulation both as a philosophi-

cal figure and as a historically determined articulation of the body.[10] While I propose to focus on precisely that essay by Balzac that Agamben passed over—and while I certainly do not wish to offer yet another reading of Rousseau's famous *Essay on the Origin of Languages*—it is helpful to consider a short passage from Rousseau in order to contextualize my arguments within a broader Enlightenment project. Specifically, I am interested in the question of gesticulation and its relation to mimesis. "Since learning to gesticulate," Rousseau opines, "we have forgotten the art of pantomime, for the same reason that with all our beautiful systems of grammar we no longer understand the symbols of the Egyptians. What the ancients said in the liveliest way, they did not express in words but by means of signs. They did not say it, they showed it."[11] It would be tempting to see in this passage a simple privileging of showing over saying, but the valuation of speech elsewhere in the essay and the implicit and subtle privileging of music over painting at the essay's end must make us wary. Rather than elaborating a semiotic from Rousseau, I would simply point out that gesture, as gesticulation, is already a problematic phenomenon. It is not a product of but rather a replacement for a lost mimetic capacity. Rousseau obviously uses "symbol" to indicate that language that predates articulation: "In the most vigorous language everything is said symbolically, before one actually speaks" (7). The symbolic writing of Egypt somehow figures as a language that predates speech, whereas gesticulation—the linguistic articulation of the body—marks the relativism of grammar.

It would seem that the possibility of meaningful body language is always something that we project onto the past. If it is Tourette, according to Agamben, who finally charts the demise of the bourgeois gesture, Rousseau is already forced to search in antiquity for gestures that retain some of the power he otherwise associates with the hieroglyph. His examples of symbolic gesture range from the violent ("Thrasybulus lopping off poppies") through the sensual ("Alexander applying the seal to the mouth of his favorite") to the quotidian ("Diogenes promenading in front of Zeno") (7), and culminate in the terrible "harangue" delivered to Darius by the King of Scythia.[12] According to Rousseau's own taxonomy, however, the example of Diogenes differs from all the others. The King of Scythia is already using language, whereas both Alexander and Thrasybulus engage in acts of amatory or violent touching. "Generally," Rousseau writes, "the means by which we can act on the sense of

others are restricted to two: that is, movement and voice. The action of movement is immediate through touching, or mediate through gesture. The first can function only within arm's length, while the other extends as far as the visual ray" (6). If this taxonomy is accepted, then strictly speaking only Diogenes engages in gesture, which is understood as movement mediated and distanced by symbolic signification. Gesture, then, would be the mode of passage from direct to indirect communication. It involves putting the body on display, and thus the most fundamental gesture is the simple act of self-presentation: the promenade. Diogenes actually becomes a symbol through the simple act of walking.[13] The promenade as a significant social gesture is, then, already a nostalgic figure in Rousseau, already a historical anachronism even before the nineteenth-century heyday of the flaneur. It marks the possibility of the body signifying in a symbolic or mimetic fashion without engaging in gesticulation.

Rousseau exemplifies in this essay what we might call a "dialectic of tact" in which rhetorical tactfulness enables a semblance of seamless social integration, but only in the face of a loss of actual tactile interaction. Gesture is already a mediated form of communication that comes into play with the demise of direct touching—politics "within arms length"—as a feasible practice. When communities can no longer embrace themselves quite literally, they resort to gesture. To study gesture, then, is to study instances of a failure to connect. Thus, the most basic of gestures would be the gesture that signifies the lack of connection, the gesture that displays its own failure in direct physical connection. It is just such a gesture that forms the basis of Balzac's "Théorie de la démarche" of 1833.[14] Balzac offers an anecdote at the outset of his study: in the street one day he observes a man exiting his carriage to hail a friend. Lurching forward to broach the acquaintance, the stranger loses his balance and stumbles as his friend moves out of reach of the salutary hand. It is this simple stumble on the part of a stranger that gives rise to Balzac's observations on the absurdly difficult task of walking. The stumble seems clumsy and tactless—and Balzac's essay will develop, in fact, into a treatise on elegance—and yet, marking the moment when the other moves out of reach, the stumble is the inaugural moment in which social tact becomes necessary. It is as if Balzac's instance of a failed salutation, a failed interpellation, marked precisely that moment where any natural, palpable social order is lost.

Stumbling, then, would be the gesture that inaugurates a language of gesture. Balzac's scenario troubles the simplicity of the famous Althusserian salutation or interpellation that we instinctively know to be addressed to us. Here, the friend remains oblivious to the stumbling commotion he leaves behind him. If walking is to be read as a gestural self-presentation, it is nevertheless preceded by a stumble over the threshold of social mediation. We might say that stumbling is less an instance of singular socialization than of a certain social order finding its footing. It marks not just the moment of nature's transition into culture—as in Rousseau, the somatic expressive gestures discovering their communicative value—but any moment at which one cultural order, perceived—or no longer perceived, in fact—as natural, makes place for another. Whereas the Althusserian paradigm focuses on the inevitable interpellation of the one hailed, Balzac is interested, instead, in the bumbling mechanisms of the one who hails.[15] "In society man is obliged to move continually from the center to all points of the circumference," Balzac notes. "He has a thousand passions, a thousand ideas, and his basis is so scarcely proportionate to the extent of his actions that at every moment he is in danger of being taken in a moment of weakness" (56–57).[16] Under such circumstances, how can he fail to stumble? Balzac's notion of a constant social movement "from the center to all points of the circumference" and the necessary *faiblesse* that results (i.e., man's inability to compose all his bodily indicators to signal the same hypocrisy) suggest that ours is a society produced by parapraxis.

"Théorie de la démarche," with its twelve central axioms and its pseudoscientific empirical rigor, reads as an extremely funny parody of taxonomic encyclopedism. Indeed, the essay begins with a defensive gesture of astonishment. Balzac asks: "Is it not extraordinary to note that ever since man has been walking, no one has thought to have asked how he walks, whether he walks, if he could walk better, what he is doing when he walks, or whether there might not be some better way to impose, change or analyze his walking: questions that bear on the very philosophical, psychological, and political systems that so preoccupy the whole world?" (17).[17] The absurdity of the presentation cannot mask a serious concern here—the same concern that informed the political theorists of the Enlightenment touched on earlier. Precisely those things that no one would think to ask—how we walk, for exam-

ple—are the things that form the basis of our world. To ask about walking (*démarche*) is necessarily to ask about how our society works (*marche*). Let us take the ironist at his word; for indeed it is strange that no one should have asked so simple a question—how walking can happen, or "*comment ça marche.*" Balzac's concerns are epistemological. Stumbling provides him with a model of scientific method—a model that allows him to critique and yet pursue the project of the Enlightenment *encyclopédiste*.

This text offers a curiously "postmodern" twist on scientific method as a form of stumbling that moves beyond any simple positivism. The central question of method, Balzac will claim, is itself a question of balance: "A madman is one who sees the abyss and falls in. The man of knowledge hears him fall, takes his fathom stick and measures the distance . . . There is no single movement, no single action that might not be seen as an abyss where even the wisest man might leave his reason and which might not provide the man of knowledge with the occasion to take his measuring rule and measure infinity itself. There is an infinity to be found in the slightest *gramen*" (26–27).[18] The *fou* simply falls—this is not what interests Balzac. Likewise, the measured empiricism and quantifications of the scientist do not interest him either. Instead, he explains, "here, I shall forever be between the fathom stick of the man of knowledge and the vertigo of the madman . . . placing myself at the very point where science touches on folly" (27).[19] He advances to the abyss, teeters and stumbles on its edge, then—by virtue of a *rétraction*—theorizes in measured terms. We might see in this stumbling a new and important critical methodology that takes the pathological and aberrant, the unbalanced, into the very act of critique, making parapraxis the very measure of praxis. By parodying the taxonomic vigor of the encyclopédistes, Balzac demonstrates how critical thought will constantly stumble rather than promenade across a terrain of leveled categories.

Notably, Balzac is interested not in an act of falling—an act of failing, let us say—but in stumbling; that is, in a failed fall, in an act of recuperation or rétraction. He is quite insistent on this point when citing, in mock academic style, from the existing authorities on the question of the démarche. Referring to the authority of Borelli's *De actu animalium*, Balzac chronicles his own disappointment on realizing that "Borelli tells us why a man, carried beyond his own center of gravity, falls; but

he does not tell us why that man often will not fall, if he knows how to make use of a secret force, discovering in his feet an unbelievable power of recovery [*rétraction*]" (40).[20] It is stumbling, not falling or walking, that is at the heart of Balzac's study of the *démarche*. He is concerned with how order and system are grounded on parapraxis rather than seeking, like Rousseau, some moment of immediate physical communication. Where Balzac does begin to expatiate on the refining of physical representation, his essay quite explicitly shifts gears into a consideration of elegance: that is, he envisages as a willed aesthetic construct that which Rousseau posits as an historical origin—a certain state of grace. This is what makes Balzac's study so important for those who seek to resist the aestheticization of politics: for while it recognizes the aesthetic endeavor as the basis of the social collective, it refuses to ground that political aesthetic in a moment of pure communication and communitarian self-immanence.

Stumbling needs to be thought of not as a loss of footing but rather as a finding of one's feet: it is the act in which the body rights itself by a rétraction and the mind becomes aware of the operation of measure and balance—"a secret force"—operating in and through the body. To reflect on what it means to walk is necessarily to reflect on what it is to profess a science. Is it, perhaps, to reflect on the necessity of a shift from Enlightenment science to the critique necessitated by the dialectic of Enlightenment? Although I hesitate to make what seems the inevitable deconstructive gesture, Balzac indeed finally obliges us to question the relation of walking to writing, and to ask what it might mean to stumble in literary terms. "You might ask why such emphasis on so prosaic a science" (20),[21] he reflects in a rhetorical aside that itself suggests the importance of the rhetorical. Walking is "prosaic" and Balzac is concerned with the question of writing prose. If this concern seems a little distant from our concern with social choreography, Balzac's own literary point of reference suggests the connection once again. Referring to the famous scene from *Le bourgeois gentilhomme* in which M. Jourdain takes lessons from his dancing master and his oratory instructor, Balzac reflects that "is man not here like M. Jourdain, who speaks prose without knowing it; walking without realizing what important questions his walking raises?" (19).[22] To reflect on walking is, for Balzac, to reflect—albeit in an ironic manner—on the question of science and method, on prose style, and on the condition of the bourgeois.

It is important to note—given the centrality in the modernist critical vocabulary of the figure of the Baudelairean flaneur—that the decadence of gesture and the problematization of the social promenade seem to have set in earlier than we might have assumed. A loss of balance is the corollary of what we might call "the exorbitant style" in Balzac's essay—a style that appears baroque and disjointed while nevertheless emanating from a central *idée fixe*. This exorbitance, meanwhile, is also at the very heart of Balzac's theory of movement: "I decided that man was capable of projecting out from himself, by all the acts deriving from his movements, a quantity of energy that was bound to produce some effect within his sphere of activity. What luminous insights in this simple formula!" (34).[23] He is concerned—in a manner that clearly presages Bergson, albeit ironically—with a vital energy that emanates from man in his actions and gestures. This concern turns on the question of a natural will unconsciously operative in man: "The fluid motor, that ungraspable will, the despair of all thinkers and physiologists" (41).[24] Stumbling opens up the realm of unconscious human action. Balzac's approach shifts, however, when he turns his mind to the practical implications of his observation of vital expenditure through movement and to the question of whether some profit might be drawn from this new discovery. He reflects: "Could it be that man has the power to direct the action of this constant phenomenon that he does not think about? Might he store up or stockpile this invisible fluid that he possesses without knowing it?"[25] In other words, do we exist in a world in which "vital expenditure" can be collected and amassed as a form of "vital capital"? Balzac, *avant la lettre*, is already assessing the value of philosophical vitalism to the economic and ideological well-being of the bourgeoisie. The danger that vitalism poses to the storing up of surplus value obliges him to seek out modes of stockpiling that value. We confront here similar concerns to the nineteenth-century theories of entropy and perpetual motion treated in chapter 1. Balzac seems to be offering the possibility of the kind of self-perpetuating expenditure that later theorists would link to the intoxicating effects of dance and rhythm: "There is a sublime prodigality in every exorbitant movement," he will observe in his final axiom (75).[26] The energies Balzac deals with in this essay—"prodigality" and "stockpiling"—are, finally, the twin energies that make the flow of capital possible.

How might we collect and amass gestural capital if, by their very

nature, gestures are prodigal and antipathetic to any economy? Balzac argues that "the soul loses in centripetal force what it gains in centrifugal" (56).[27] In this model human energies are essentially centrifugal, passing from man into the objects of his labor. The classic example of such exorbitant expenditure is, for Balzac, the act of writing itself, from which he draws his most ironic example of a possible resistance to energistic entropy. He writes admiringly of those "autograph hunters, and those who claim to be able to judge men's character by their handwriting," describing them as "superior people" (38).[28] The autograph hunter is a form of literary capitalist. He realizes that the autograph is not simply the indexical marker of the subject that produced it, but rather the fixation of the energies emanating from that subject. In collecting what we might call the "graphic power" of the great man, he acts like the capitalist who exploits the labor power of the worker. This, finally, is why focusing on the question of the truth or falsehood of gesture—and writing—is misplaced: gesture figures writing as a mode of performance. Gesture would be the happening of writing—writing beyond reference.

As we shall see, this emphasis on performance, while never fully lost, submerges in the taxonomic fervor of the nineteenth century. Subsequently, gestures will be traced to their origin—as the manifest to the latent: what will be forgotten is the "gesture work" through which the collective mediates and performs itself. We need to insist on stumbling precisely in order to rescue Balzac from a more facile notion of subjectivity that clearly appeals to him and that he draws from the eighteenth century. In extending his system of homologies Balzac refers to Lavater's physiognomic studies: "Before me, Lavater already said that since everything in man is homogeneous, his manner of walking must by necessity be as eloquent as his physiognomy: walking is the physiognomy of the body. But this was just a natural deduction from his primary proposition: *Everything about us corresponds to an internal cause*" (21).[29] This system of homology, reducible to "an internal cause," posits a centered notion of subjectivity at both the physical and the metaphysical levels. This physiognomic cataloging of the body is ideological precisely insofar as it posits a preexisting subject that can be inferred from both its actions and its physical embodiment. Although Balzac declares as his first axiom that "walking is the physiognomy of the body," the epistemology from which we are freeing him is precisely this

epistemology of the physiognomic, that will, in fact, reassert itself toward the end of the century. (The work of Lombroso and Nordau, for example, depended on just such an assumption of the homology of physiological and intellectual or moral traits.) My argument is that Balzac's stress on the stumble in performance draws attention to the *work* of social choreography, both collective and individual, but that this critical awareness will be buried again later in the century by an insistence on the legibility of the body, on the body as text. While the "scientific" claims of physiognomy were, of course, always rather precarious, the physiognomic epistemological construction can only continue to exist in an explicitly ideological form after Balzac effectively debunks it *malgré lui*. By shifting critical awareness from moments of legibility toward the notion of social choreography as a performance (in his consideration of poise and *élégance*), Balzac challenges our notions of "body as text" and indicates what I take to be a broader shift (exemplified in my reading of Isadora Duncan) away from essentially "literary" models of (national) culture, toward ideology as performative.

Near the end of the essay, as he begins to reflect on the deportment of passersby, Balzac introduces the distinction between *le mouvement faux* (a false movement), in which is revealed "the nature of the character," and *le mouvement gauche* resulting from habit (82). The former denotes a body, and its falsehood is referential (it reveals something "false" in the character), whereas the latter is performative and aesthetic, finally; its falsehood is an effect (produced on the observer) rather than a cause. As the essay moves from pseudoscientific reflection on the human motor to an altogether more frivolous assessment of the charms of feminine movement, it also moves away from questions of true and false, or le mouvement faux. The apparently sociological or merely fashionable turn toward le mouvement gauche constitutes, in fact, a rejection of the textual and referential as a means of "reading" the body. Balzac's treatise is not, in fact, about the legibility of the unconscious subject through his actions or parapraxes but rather the power of rétraction that causes us to right ourselves, to represent ourselves gesturally despite the fallibility of social interpellation. Balzac is already beyond a theory of interpretation that would depend upon *vrai* and *faux*. As the essay develops, it soon becomes clear that he is concerned instead with the *élégant* and the *gauche*. This movement of the treatise

from its own feigned center of gravity, or gravitas, is a critical stumble that opens up different epistemological questions.

That our earlier analogy of writing and a prototypical labor theory of value is not altogether misplaced is suggested by an example that Balzac offers to demonstrate the necessity of his shift from a physiognomic consideration of vrai and faux movements to a consideration of élégance. He describes a craftsman who lathes marble in a repetitive movement of exorbitant expenditure. Does the object, the production of objects, sap our power? What results in the workman is a gesture of habit—and habit is the origin of the mouvement gauche.[30] A critique of the inelegant is a critique not of misrepresentation—the habits inculcated by repeated labor are not "false," indeed they are adopted precisely because they are, in some sense, "correct" in their adaptation to the task—but of misproduction. The habits of repeated labor produce something "wrong" rather than derive from something wrong. We encounter here something akin to the aesthetic socialism of the English writers already considered. Balzac's critique of repetitive toil derives from an observation of an ugly or gauche action. Mechanized or repetitive labor is rejected for being gauche rather than faux. This methodological shift from a pseudoscientific treatise to a rather frivolous examination of elegance is extremely important. Like Morris, who saw the production of beautiful objects as tied to the physical production of beautiful subjects, Balzac derives an implicit critique of toil from the observation of a lack of élégance.

What is the significance of this criterion of aesthetic discernment? What do we gain from mustering an aesthetic critique of the gauche rather than a cognitive critique of the faux? Clearly the faux depends on a model of reference: a gesture is faux when it fails to reflect "the nature of the character." The gauche meanwhile is a purely aesthetic judgment—offending not because it is misrepresentative but rather because it is repetitive, belabored, and mechanical. It is wrong not because it fails to represent human subjects truly but because it fails to produce true human subjects. This is a crucial shift. Methodologically, Balzac points out what would become a persistent ethical problem throughout nineteenth-century reflections on gesture and comportment. If we are to read from the gesture its emotional referent, the project of cataloging becomes highly problematic because it reduces gestures to legible and

nominal signs that can simply be copied. If we categorize in encyclo-pedic fashion the mimetic language of gesture, do we not risk a dena-turing—a perfect dissembling translation of true affects into merely hypocritical gesture? (It is notable that Bergson, for example, uses over and over the example of Molière's prototypical hypocrite Tartuffe in his study *Laughter.*)

Balzac's vitalism might be read—at least in its linguistic implica-tions—as an attempt to counter such possibilities. Rejecting, by the end of the essay, the simple listings of an encyclopedia entry, he is con-cerned instead with a theory of writing organized around the active agency of the verb. In an analysis of action that will be taken up later by Delsarte, Balzac reads gesture as verb rather than noun—performance rather than designation: "From then on, movement, for me, included thought, the most difficult action of a human being; the verb, a transla-tion of thought; then walking and gesture, the more or less impas-sioned completion of the verb. . . . transformations of thought in the voice, which is the sense of *touch* by which the soul most spontaneously let flow miracles of eloquence and the heavenly enchantments of vocal music. Is the word not, in a sense, the heart and brain's manner of walking?" (34–35).[31] Of course, the idea that language can be thought of as "the heart and the brain's manner of walking" might easily be ac-commodated to a form of logocentrism, and Balzac himself facilitates such an accommodation when he argues, for example, that "granted that walking is the expression of bodily movements and Voice the expression of intellectual movements, it seemed impossible to me to make movement lie" (35).[32] The idea that walking is an embodiment of the metaphysical values of voice necessarily reframes our consideration of what it means to walk. However, we must not forget the importance of the stumble in Balzac's theory. If neither la démarche nor la voix can lie, both can, nevertheless, falter. Indeed, they both only become aware of themselves insofar as they stumble or stutter in performance.

Before moving on from Balzac, I should clarify what I take to be the critical significance of the stumble and, more broadly, the historical significance of Balzac's essay. It is important to note a dialectic opera-tive within the very episteme of physiognomy as Balzac understands it; a dialectic that allows us to see this essay as, in many senses, the thresh-old of a modern "social choreography" (it would subsequently become most important for Baudelaire). In moving on from Balzac let us say, for

the moment, that he serves in the present context to represent a certain nineteenth-century model of the promenade that has already been problematized by the very stumble that inaugurates his reflection. He at once confirms an urban, modernist nostalgia for the promenade, depicting a worldview in which elegance is more than just excess and display; in which "every jolting movement betrays a vice or a bad education" (59).[33] At the end of the essay, Balzac focuses on the question of representation in its political as well as its semiotic sense. Looking at the representational function of the monarch, he notes how "it has been proven in autopsies performed on royal personages that the habit of representing introduces vice into the princes' bodies: they are feminized" (86).[34] By dint of representing (and in this case no body is more representative than the king's) the body loses its equipoise and falls into vice, into the rupture of legibility and the jolting movement. Thus, we might say that the stumble or jolting movement is the last legible bodily sign insofar as it connotes vice, but the vice that it connotes is the fall from grace that sunders bodily performance from will, intentionality, or political subjectivity. To this extent, Balzac's stumble marks the threshold of legibility and illegibility. It is legible as the historical threshold of the illegible. Subsequent attempts to reinstate a purely mimetic notion of gesture will necessarily be anachronistic.

For Adorno in *Dialectic of Enlightenment* stumbling would subsequently become the paradigmatic mode of totalitarian induction; we all stumble at the threshold of subject formation and, in failing to become subjects, genuflect before the totalitarian collective. In Balzac I am stressing instead the self-critical rupture that stumbling makes possible; the awareness of the constructedness of social order. That Balzac launches into a celebration of elegance indicates that he by no means opposes constructed social orders to putatively natural ones. The criterion of political discernment is aesthetic, and Balzac envisages an aesthetic social order—a social choreography—that might be more physically and aesthetically pleasing than others. To this extent, he stands in the tradition of Schiller outlined in the introduction. What he resists, however, is the colonization of all critical potential by scientific positivism: the essay's movement beyond the faux indicates that the critique of ideology cannot, for Balzac, be restricted to a cognitive "reading" of false statements measured against empirical historical reality. Ideology is performative, and so is its critique—in this case, as élégance. Given the

privileged position accorded Balzac by Marx in his explication of art's ability to function as a critique of ideology even despite itself, I am suggesting that we need to reevaluate the importance of the performative, as opposed to the simply denotative, in our understanding of ideology and its critique. In Balzac there is a clear aestheticization of politics—he choreographs social orders that are elegant but in so doing he recognizes the fundamental function of social cohesion performed by the aesthetic. Thus, the historical significance I accord his work is retrospective rather than causal. It is for the critic that he marks a break—a break that historians need to historicize and evaluate for its broader significance.

In what follows I will look at the interplay of performative and taxonomic approaches to gesture in the wake of Balzac, and at the ways in which these approaches relate to each other. In essence, Balzac's move toward an aesthetic concern with deforming habit marks a methodological shift away from a reading of gesture and démarche as mimetic, semiotic, or reflective instants toward a concern with the epideictic or performative nature of gesture; a concern, that is, with what gestures enact rather than with what they represent. Moreover, I contend, the observation of physical "habits" also reflects a concern with the automatization and decadence of gesture that had already set in early in the nineteenth century. This concern with "habit" and its deleterious effects on human movement also forms the cornerstone of Bergson's theory of laughter, to which I now turn.

Notably, one of the central examples from Bergson's study is that of a pratfall observed in the street: "A man, running along the street, stumbles and falls; the passers-by burst out laughing. They would not laugh at him, I imagine, could they suppose that the whim had suddenly seized him to sit down on the ground. They laugh because his sitting down is involuntary. Consequently, it is not his sudden change of attitude that raises a laugh, but rather the involuntary element in this change,—his clumsiness, in fact."[35] The example is paradigmatic of Bergson's theory of laughter in so many ways that we would do well to stand among the passersby and refrain, for a moment, from laughing. What important elements of a theory of laughter are exemplified in this passage, and how do they contribute to our examination of a social choreography dependent on a stumbling? We encounter, first, laughter at the man's predicament exemplifying an "absence of feeling" (4) or that "momentary anesthesia of the heart" (5) that Bergson sees at the

heart of the comic. Contrary to theories of contagious kinaesthesia central to so much modern dance theory in the twentieth century, then, we see a community being produced through a curious anesthetic effect. Second, laughter is elicited here by a lapse of will. What remains to be seen, however, is whether the somatic eruption of laughter itself merely repeats or compensates for the failure of will on the part of the man who falls. Is laughter an intellectual or a somatic reflex, or both? Third, this lapse of will is itself seen as gauche or clumsy in physical terms. In fact, however, the gauche is always linked to the faux in Bergson's presentation, because all stumbling traduces a certain organic human nature. Fourth, those who laugh do so at the "mechanical inelasticity" (10) of the man who cannot adapt to specific conditions and who therefore falls. Finally, the laughter of the passersby is itself, on the contrary, "a living thing" (2), an irrepressible explosion of the vitality of the body. To this extent we might see this scenario of stumbling—fall and recovery—as descriptive of Balzac's rétraction, only now the force of rebounding has been projected onto the collective: in the fall we see man's lapse into mechanical rigidity; in the laughter of the passersby the recuperation of vital collective energy. This is not an instance of one man falling but of a paradigmatic social stumble in which the collective is established as a recuperation from the fall. Laughter, we might say, is the mark of that Balzacian rétraction that keeps us from the pratfalls of the fool. But where, we might ask, is the community?

The "momentary anesthesia" of Bergsonian laughter obviously challenges the kind of social order dreamt of in modern dance, with its grounding principle of kinesthetic, sympathetic movement. Indeed, the principle of anesthesia seems to call into question the fundamental viability of the social; for, in Bergson's presentation, "comedy can only begin at the point where our neighbor's personality ceases to affect us. It begins, in fact, with what might be called a *growing callousness to social life*" (134). In essence, then, the comic plays a paradoxically socializing role while itself deriving from a certain antisocial (and somatic) impulse. Clearly, Bergson attempts here to parse out the gesture of the one who falls and the gesture of laughter itself as a response. He demands "unsociability in the performer and insensibility in the spectator" (145). This presentation can all too easily be deconstructed, however; for it overlooks not only a certain sensibility of the laugher to the

laughter of others, but also the social work performed by the one who falls and makes possible the community of laughers. The opposition of this model to a choreographic understanding of the social becomes manifest in the text of *Laughter* when Bergson notes how we need only "stop our ears in a room, where dancing is going on, for the dancers at once to appear ridiculous" (5). Here is neither the bodily communication of kinesthesia nor the all-encompassing order of the Schillerian dance: social order as understood through a community of laughter is a critical construct: "Its appeal is to intelligence, pure and simple" (5). "This intelligence," Bergson observes, "must always remain in touch with other intelligences" (5). The man who finds dancing ridiculous because he has shut his ears to the beat, or *Takt*, of those around him is not necessarily empowered to laugh: "You would hardly appreciate the comic if you felt yourself isolated from others" (5). This community, we should note, depends on a paradoxical state of being "in touch" with others—even in our isolation the fantasy of an immediate pregestural social order persists.

Laughter needs community, then, but it also grounds it. If this is true, and if "the comic does not exist outside of what is strictly *human*" (3), then we must conclude that Bergson's conception of the human is essentially social. "Several have defined man as 'an animal which laughs,'" observes Bergson, "they might equally well have defined him as an animal which is laughed at" (3–4). The man who falls in fact performs vital human labor just as do those who laugh at him. It would appear, then, that any isolation of the forces of rétraction and social recovery on the side of those who laugh is premature. Here we begin to encounter certain problems. For while Bergson justifies the preceding statement by insisting that "if any other animal, or some lifeless object, produces the same effect, it is always because of some resemblance to man" (4), he also insists that what we laugh at is a lapse of will and a reduction of man to a mechanical level beneath that of humanity (see the second and fourth points above). So, do we laugh at things and animals because they remind us of people, or do we laugh at people because they remind us of things and animals? Bergson's anthropological binaries begin to blur.

Consider the notion that the man who falls does so through a mechanical habit. Bergson will use the example of a man whose routine is upset by a practical joke, whose chair has been moved slightly and who falls over because his body memory is stuck in the old patterns.[36] First,

we should note with regard to the victim of the joke that his gaucheness is a sign of intellectual operation at the level of the body: the body does what it thinks is right. It thinks, but thinks wrongly. The body merely thinks that it thinks, one might say—whereas in fact we are merely encountering that Balzacian *habitude* that is at the root of all gauche actions. Bodily gaucheness is a form of intellectual laziness or ideology. But is it the falseness of *what* the body (wrongly) thinks or the gaucheness implicit in the fact *that* it thinks that forms the basis of the comic? Bergson argues that "a comic character is generally comic in proportion to his ignorance of himself. The comic person is unconscious" (16). By contrast, the laughter of the passersby is both a recuperative vital force and "intelligence pure and simple." For all the irrationalism of Bergson's vitalism, *Laughter* in fact attempts to isolate a purely rational instance in social interaction. It is not only he who falls who becomes complicated: those who laugh are equally complex. Clearly the attempt to parse out conscious and unconscious across the two terms of the joke—those who laugh and those who are laughed at—is very reassuring. Nevertheless this attempt consistently fails: For to what extent is the laughter itself voluntary? Its very vitality springs from its ability to bypass the regimen of individual will. In many ways laughter is itself as mechanical as the man who falls.

Man becomes risible through his functioning as a machine, through mechanistic repetitions that invoke the brainless operation of a machine. But likewise, "laughter appears to stand in need of an echo" (5); it inaugurates a mimesis rather than being an unrepeatable and unique eruption of the body. Laughter too is caught in a logic of repetition and mimesis—no less than the butt of the joke: "It is not an articulate, clear, well-defined sound; it is something which would fain be prolonged by reverberating from one to another, something beginning with a crash" (6). There is something mechanistic and reiterative in the very enunciation of a laughter that Bergson would like to present as a sort of somatic commonsense: ha ha ha. Laughter is a form of sonic stumble. It is stuck in a repetition that is not yet articulation, but is—for Bergson at least—nevertheless human. At the conclusion of the book he will finally acknowledge this mechanistic element of laughter—supposedly itself the recuperation *of* the mechanistic. "Laughter," he writes, "is simply the result of a mechanism set up in us by nature or, what is almost the same thing, by our long acquaintance with social life. It goes off spontane-

ously and returns tit for tat" (198). This linkage of the machinic and the spontaneous indicates a new phase of vitalism passing over into "techno-logy."

Laughter, then, reveals the mechanisms at the very heart of the human, debunking the organicist tendencies of Bergson's vitalism. Moreover, the group formation necessary to laughter vitiates another of his crucial distinctions. Laughter is infectious in an almost literal sense—it is communicated from body to body: "How," Bergson asks, "should it come about that this particular logical relation, as soon as it is perceived, contracts, expands and shakes our limbs, whilst all other relations leave the body unaffected?" (7). When we laugh we do not, in fact, raise ourselves to the level of pure contemplative intellect but rather yield to a physical reflex passed on by the bodies of others. If we recall (from Rousseau) that gesture is inaugurated at the precise point when bodies can no longer directly communicate with each other by touch, this logic of contagion acquires an ideological significance: it articulates a quasi-pathological fantasy of immanent bodily community.

To maintain this image of laughter as a contagion, we might better describe it as an inoculation—the entry of the organic into an intellectual and social structure that was itself in danger of becoming mechanistic by its own rigor. To this extent, then, Bergson might be seen as radicalizing the tradition of Balzacian skepticism toward the taxonomic zeal of science. Whereas Balzac pokes fun at the taxonomic, cataloging zeal of the Enlightenment—which could happily embrace the organic world—Bergson's view is more Manichaean here. The rigor of taxonomy has been overtaken by the rigidity of the machine. What is at stake, of course, is the question of social order: organic or mechanistic? Where Bergson has traditionally been ranged alongside the organicists, we need to be sensitive to the mechanistic tropes that undercut his scheme of laughter at mere machines. Where his model of rationality itself seems to become mechanistic and closed, however, it too stumbles and becomes susceptible to the organic and bodily contagion of laughter.

This idea of laughter as inoculation is exemplified in *Laughter* by the rituals of the circus. The simplicity of Bergson's presentation of a theatricalized pratfall is only apparently simple. In aestheticizing the stumbling man on the street into the schtick of a circus clown, Bergson writes: "The first time, the clowns came and went, collided, fell and

jumped up again in a uniformly accelerated rhythm, visibly intent upon affecting a *crescendo*. And it was more and more to the jumping up again, the *rebound*, that the attention of the public was attracted" (58–59). It is no longer the very act of falling down that is comic in its implicit inflexibility and intractability; now it is the act of (social) rebounding (or Balzacian rétraction) that has become the source of laughter. The mechanistic and automatic impulse that always lies at the heart of the comic here presents itself not in the pratfall itself, but in a mechanistic and ritualistic self-righting that is at the root of the comic. The "rebound" of the clown mimes the rebound of vital energies that is itself enacted by social laughter: in laughter, a social intelligence also "bounces back." In effect, the audience laughs at the embodiment and enactment of its own strategy of laughter; it sees in the clown's rebound the image of its own rebounding through laughter. And it laughs. Because bourgeois society cannot admit that something is wrong—that people keep falling—it has to keep them mechanically bouncing back as if full of life.

Given that Bergson has taken laughter as a distinguishing feature of mankind, he quite rightly questions the suitability of the examples he has just given (the man who slips and the man who forgot that his chair had been moved) for "in both cases the result has been brought about by external circumstance. The comic is therefore accidental: it remains so to speak, in superficial contact with the person" (10). He does not draw the radical conclusion of Adorno, for whom stumbling is paradigmatically funny because it reveals that man himself is accidental: that there is, in fact, no human essence. Instead, Bergson retains the traditional distinction of essence and accident to ask of this superficial comic element: "How is it to penetrate within?" (10). He suggests imagining "a certain inborn lack of elasticity of both senses and intelligence" (11). He pictures this lack as a lag in tempo—a kind of syncopation—and asks us to "imagine a mind always thinking of what it has just done and never of what it is doing, like a song which lags behind its accompaniment" (11). He then acknowledges that "in one sense it might be said that all *character* is comic, provided we mean by character the *ready-made* element in our personality, that mechanical element which resembles a piece of clockwork wound up once and for all and capable of working automatically. It is, if you will, that which causes us to imitate ourselves" (150). That which resists is the comic—"all charac-

ter is comic." In a reversal of the Enlightenment trope of the subject standing on his own two feet—learning to walk—all centeredness, all character, is now suspected of rigidity and eccentricity. All character is now strictly mimetic (if only of itself). As we shall see when we move on to consider the popularization of Delsarte, what is demanded in place of this mechanical body is a new flexibility or elasticity—a fungibility that acts as the physical and mental identity structure corresponding to the conditions of exchangeable labor power.

What we seem to be confronting, then, is Agamben's scenario of a body unable to master its own movements. From the perspective of social modernization, however, this failure of the body is not to be understood as something unfortunate but rather as a necessary surrender of autonomy. The derisive laughter that stumbling evokes should not be understood as an irrepressible explosion of the vital, as Bergson would have us believe, but as a mechanistic, mimetic, and quasi-ritualistic iteration: ha ha ha. "The attitudes, gestures and movements of the human body are laughable in exact proportion as that body reminds us of a mere machine" (31). In broader terms, this brings us to the conclusion that the very notion of the gesture has itself become problematic and risible insofar as significant gesture might be presumed to maintain some pretense to autonomy. What Bergson corrects in a laughter that might more properly be called derision is a lack of the "flexibility" deriving from the *élan vital*. Flexibility, however, does not betoken "character" but rather its lack. It is not a spiritual state or an amalgam of skills but a merely physical condition. Thus, habitude—of which any character might consist—is encountered merely as a restraint on flexibility. The Balzacian formulations have been retained, but to quite different ends: whereas for Balzac habitude connoted a deforming physical action that hampered the development of a character displayed by physical elegance, for Bergson habitude in fact betokens character—yet for this reason it is equally to be renounced.

If we think of the movement from Balzac's promenade—already problematic and dependent on an aestheticization that seemed to recognize its precariousness—through Tourette's analysis we confront a fact that seems to sit uneasily with the implicit Bergsonian analysis of community. For Bergson, remember, "*tension* and *elasticity* are two forces, mutually complementary, which life brings into play . . . Society will therefore be suspicious of all *inelasticity* of character, of mind, and

even of body, because it is the possible sign of a slumbering activity as well as of an activity with separatist tendencies, that inclines to swerve from the common centre round which society gravitates: in short, because it is the sign of an eccentricity" (19). In such a configuration, Tourettism seems a particularly overdetermined historical syndrome. It figures that play of tension and elasticity that has become the very spring of Bergsonian social order. The tics of Tourettism are but one side of the coin, however. The demand for "elasticity" as a physical as well as spiritual condition provides us with an interesting backdrop for reading the growth of gymnastics and physical culture at the end of the century. Whereas the *Körperkultur* tradition of naturism and gymnastic dance would see in rhythmical movement the free play of a centered and self-centering subject—élégant in Balzac's terms—a Bergsonian reading allows us to understand how the privileging of rhythm and elasticity in fact reflected an antihumanist agenda. Rather than reading flexibility and elasticity as the virtues and competences of a centered subject, we might also read them as foreclosing that minimal fixation or habitude constitutive of character. In such a reading, the demand for flexibility would approximate Arendt's condition of labor rather than the agonistic intersubjectivity of action or the objectivity of work.

What I wish to indicate in this movement from Rousseau through Balzac to Bergson is a degeneration in the course of the nineteenth century from the social ideal of action to the minimal gesture and, finally, to the loss of gesture and a new ideology of mere "flexibility." This degeneration traces the collapse of an ideal of immanent community, the subsequent emergence of a strictly codified bourgeois subject capable of constructing and manifesting itself "aesthetically" through gesture, and the eventual somatization of that individual body to a condition of mere potentiality. To reiterate the terms employed in chapter 1, what we observe is the emergence of Marsyas as a prototypical postsubjective model of embodiment. As Bergson notes, even in the gesture—that seeming last retreat of the autonomous body as it seeks to articulate itself within and against a collective: "[society] is confronted with something that makes it uneasy, but only as a symptom—scarcely a threat, at the very most, a gesture. A gesture, therefore, will be its reply. Laughter must be something of this kind, a sort of *social gesture*" (20). Gestures threaten the hegemony of any universal schema of social legibility, for they mark either the last idiosyncratic retreat of the em-

battled subject or, as gesticulation, the demise of that subject (Agamben's Tourettism) and the loss of any referent to which the gesture might refer. And yet, in Bergson's presentation, society itself responds through a gesture reduced to the level of ritual: laughter. In moving now from Bergson to Delsarte—whose immensely popular exercises reinstated the taxonomic project mocked by Balzac—I wish to indicate a process whereby a regimen of bourgeois subjectivity was reconstructed through the rendering legible of gesture.

What I will suggest is that both Bergson's and Delsarte's reworkings of stumbling typify a return to a "physiognomic" way of understanding the body's actions. Now, however, the displacement of reading from the face and skull (as in Lavater) onto the entire body betokens a move into the parapractical, into the reading of bodies by their slips. Action has been reduced to the parapractical. As Bergson notes in an absolutely key passage:

> *Instead of concentrating our attention on actions, comedy directs it rather to gestures.* By *gestures* we here mean the attitudes, the movements and even the language by which a mental state expresses itself outwardly without any aim or profit, from no other cause than a kind of inner itching. Gesture, thus defined, is profoundly different from action. Action is intentional or, at any rate, conscious; gesture slips out unawares, it is automatic. In action, the entire person is engaged; in gesture, an isolated part of the person is expressed, unknown to, or at least apart from, the whole of the personality. (144)

In other words, the gesture necessarily problematizes the political and social ideal of action deriving from Arendt. The slippage from action to gesture is a movement from intention to automation—the sign of a new "techno-cracy." A gesture that was legible—physiognomically, in the eighteenth-century tradition—bespoke the persistence of a subject. If stumbling is to be understood as the debacle of the gesture—the fall out of action into gesture as a mode of bodily experience—we face two possibilities. Either the gesture is to be read counterintentionally, as parapraxis; or we need to examine the possibility of a loss of gesture—a complicated spastic body—in which the hegemony of the social is figured by a return to the somatic. Moreover, if we are to see in the nineteenth century's obsession with gesture and its composition an anxiety regarding the possibility of reading and constructing subjects

from their signs, we need also to ask what it means for this parapractical, antiintentional notion of gesture to be resubsumed under a system of legibility and interpretation in the Freudian system. What is the difference between Bergson's observation that "inadvertently to say or do what we have no intention of saying or doing, as a result of inelasticity or momentum, is, as we are aware, one of the main sources of the comic" (112), and Freud's reevaluation according to which we do at the unconscious level "intend" and signify by such lapses? Could it be that the very system of analysis that seemed to undermine the rational bourgeois subject (psychoanalysis) in fact restituted a system of legibility (a distant relative of Lavater's physiognomy) that refers back to a subject, even after thinkers such as Balzac more radically undercut any such restitution? And if so, is Freud not more closely linked than one might think to such contemporaries as Lombroso and Nordau, who extended such systems of legibility to bodies that seemed, through their stumblings, to have become increasingly illegible?

In tracing the persistence of an epistemology of legibility with regard to the body in the late nineteenth century, few figures can be as important as Delsarte. A failed actor who dedicated his life to cataloging the rhetorical gestures of the body, Delsarte wavered between the taxonomic zeal of an encyclopedic rationalist and the irrational metaphysics of Swedenborg. Although he never collected his thoughts in a definitive work, his system was picked up eagerly by devotees in both Europe and America and made the basis of a series of practical and pragmatic exercises that effectively reduced him to the status of the Dale Carnegie of the nineteenth century. Delsarte's "system" fuses the vitalist and the taxonomic aspects of the nineteenth century's concern with gesture. Many of his supporters and popularizers—particularly in America, where his practical exercises were stressed—accepted that the spiritual pretensions of the system were little more than mystical mumbo jumbo, identifying affinities and homologies across completely unrelated phenomena, from the smallest gesture to the movements of the cosmos. At another level, however—and particularly in its more popular forms—Delsartism served as a dictionary for the reading and writing of bodily signs. Not unlike vulgar attempts to codify Freud in terms of phallic symbols and dreambooks, Delsarte's system too was often reduced to a primer for reading—and, more importantly, writing—the body. Delsartism offered an etiquette in every sense of the

word, both a labeling and an ethos for a class seeking to naturalize its cultural hegemony through its very physical comportment.

That these two extremes—the mystical-arcane and the literal-mundane—should be produced by one system, however, should not surprise us. By the end of the nineteenth century the ideology of legibility had itself become a crucial metaphysical underpinning of social interaction. Through reading signs, it was assumed, some origin—some subject, intentional or otherwise—could be reconstructed. What Delsarte retains from the physiognomic tradition I have rather simplistically identified here with Lavater and the eighteenth century is a method of reading moral and spiritual qualities from the body—this despite the historical break with physiognomy marked by Balzac's "Théorie de la démarche," which ironically replaced pseudoscientific rigor with aesthetic élégance. Balzac presented the subject as a cultural construct, an elegant and gestural entity recuperated from an original, and literal, social stumble or faux pas. What Delsarte offers instead is the possible reconciliation of a radically constructivist notion of identity (for the first time, a model of reading the body would also serve as a primer for writing it; that is, for simulating affect rather than interpreting it) and a centered metaphysics (in which the missing core of the humanist subject is supplemented by references to a cosmic order).[37]

On one level, then, it is possible to reduce Delsarte to a "how to" of oratory and self-presentation, and this possibility clearly goes a long way in explaining his popular posthumous success. In an American study from 1889, *An Hour with Delsarte: A Study of Expression*, Anna Morgan warns: "Has it ever occurred to us that we are constantly creating impressions by our unconscious expressions, and in consequence are possibly being judged sickly, weak, conceited, vain, or vulgar? People form their estimates of our character, not necessarily through our language, for perhaps they have never heard us speak, nor through the expression of our faces alone, but through the bearing of our entire bodies. . . . This is not to be wondered at when we consider that the body is but the outward symbol of the development of the real or inner self."[38] Worth noting here is the retention of what I have been calling the physiognomic model of reading the body; Morgan's recourse to the notion "that the body is but the outward symbol of the development of the real or inner self." Notably, however, it is no longer the face, the traditional bodily repository of the subject, that is to be read but rather

the entire body. Even if Morgan quotes Addison's adage that "a man's speech is much more easily disguised than his countenance" (52), it is not just faces that will be read. The model of reading, moreover, is parapractical; the will controls neither the signals being sent nor the codes within which those signals will be read. The function of art, therefore—and of the Delsarte exercises—is to reinsert some notion of intentionality into the reading of the body and to avoid misreadings.

The central paradox of Delsartism, of course, lies in its codification of a putatively natural language and the resultant exposure of that language to artifice: once we reduce "nature" to a series of legible signs, we can counterfeit more effectively. A system that is supposed to unlock the deepest secrets of (human) nature through a homology of spiritual and physical attributes now in fact serves an upwardly mobile social class as a handbook on how to fake it. Thus there is a deliciously Wildean—yet unintended—cynicism to Anna Morgan's observation that "all gesture, to be natural, must be unconscious, or seem to be so" (62). If everyone knows such and such a gesture connotes such and such a sentiment, it becomes possible to feign and dissemble sentiments through bodily manipulation. Morgan's troubling warning is thus highly ambiguous. If people do, indeed, judge me as "weak, conceited, vain, and vulgar"—and the implication, of course, is that I am really none of these things but just appear to be through bad posture—how is it possible that these readings are, in fact, misreadings? We are faced with two models of reading: the parapractical and what we might call "the corrective." Either people judge us "weak, conceited, vain, and vulgar" because the body cannot lie (although we might seek to hide such qualities even from ourselves); or they judge us so because the body is sending the wrong signs.

If we allow the possibility—implicit in Delsartism—that the body is sending the wrong signals, the whole physiognomic system of homology is broken down and the ideology of natural language is revealed as fantasy. In this sense, then, Delsartism needs to be seen as a resistance to the model of parapraxis: there is no hidden self revealed against one's will, but merely a failure of the will to communicate properly in bodily terms. The opacity of the signifier—the body—distorts social communication. A study of Delsarte serves as a prophylactic or corrective. Thus, Delsarte performs a double ideological function in the narrative I present here: at one and the same time he recognizes the fail-

ings of the "physiognomic" epistemology while seeking to reinstate it across the entirety of the body. An insistence on the possibility of reading—even if it is only a complaint about ubiquitous misreadings of our body by society—seems even more important than the accuracy of the readings. Thus, a subject reemerges in a kind of Barthesian "author effect" as the putative origin of the bodily text.

In fact, though, Delsarte himself—unlike his commonsensical American devotees—was less than confident that bodily meaning could be traced back to any individual, intentional, authorial subject. As opposed to the didacticism of American Delsartism, the mysticism of Delsarte's own pronouncements offers a second solution to the central paradox: if the body is unable to lie, why is it saying such unpleasant (and, implicitly, untrue) things about me? Rather than reading gesture as the semiotic of an intentional subject, Delsarte derives meaning not from an intentional subject but from a higher being. To push an analogy, where Tourette sees physiological loss of control Delsarte sees a form of spiritual possession. Apparent parapraxis signifies a higher intentionality working through the body. "What is human reason, that faculty at once of so little avail and yet so precious?" he asks. "The answer," he concludes, "must spring from the study of the phenomena of instinct. . . . If these phenomena are directed by a physiological or a spiritual necessity, a necessity on which instinct is based, I am forced to admit, here, a reason that is not my reason; a superior, infallible reason in the disposition of things; a reason that laughs at my reason, which, in spite of itself, must subsist under pain of falling into absurdity."[39] In other words, misinterpretations arise by virtue of the individual's failure to master a kind of transcendental semiotic that occupies a space both higher than its own empirical subjectivity and more fundamental than its distorted experience of its own body. What I am proposing is that Delsartism marks a failed attempt to make sense of the body by forcing gesture to signify; by grafting onto the body (physiognomic) models of reading. This quest for meaning, however, bypasses the category of the intentional subject to imply a direct link between body and spirit that transcends the intellect. Where Delsarte differs from an analysis of parapraxis, however, is in his refusal to read *against* the category of the subject and in his displacement of intention into an external objective realm. Building on precisely the parapraxes that seem

to beset all gesture, Delsarte posits a more all-embracing metaphysical reasoning in which any absence of meaning can be recuperated.

What trace do we find of such a reason? It is a divine yet derisive Bergsonian "reason that laughs at my reason." Laughter serves, as it did in Bergson, to figure intellect. Whereas intellect was folded into biological reflex in Bergson, however, in Delsarte it has become transcendental. Nevertheless, it is not difficult to locate in Delsarte's system social imperatives entirely consonant with Bergson's humiliating social model. As if anachronistically versed in Bergson, early popularizers of Delsarte in the United States made the question of elasticity—as a spiritual as well as a physical virtue—the basis of their concerns. Elasticity, we may conjecture, is precisely that power of rétraction that can be proven at the moment of stumbling, as well as a capacity for the abstraction of psychic and physical labor. In *An Hour with Delsarte*, Morgan observes how, "thanks to the genius of Delsarte, we are in possession of means whereby we may obtain muscular strength, but not at the expense of flexibility, which is the basis of grace. He has given us a perfect method by which we may not only obtain freedom and elasticity of action, but one which adds force and meaning to our every moment. It frees the body from all restrictions, and renders it as it should be,—subservient to its master, the will" (8). Morgan superimposes aesthetic and productivist discourses in her concern for pairing muscular strength with flexibility. It is flexibility and "grace"—a fusion of aesthetic and religious qualities—that Delsarte offers as a supplement to the brute strength of the body.[40] Contrasted with the metaphysical vagaries of Delsarte's own sparse writings, Morgan's presentation is most notable, however, for its commonsensical American reintroduction of the will as the origin of expressive gesture. By reinserting notions of intentionality and personal agency missing from Delsarte himself, Morgan effectively makes of the body a means for the production of a subject. Her linkage of "force and meaning," meanwhile, tacitly recognizes meaning itself as the cultural force productive of those subjects.

In Morgan's digest of Delsarte, the body becomes a proving ground for both class and race distinctions to the same degree that the physical becomes the primary trope for the intellectual. Thus, she argues that "muscular flexibility is found in its greatest perfection among intellec-

tual people; and as the intellectual fibre becomes coarse in quality, so the muscles lose their delicacy, and as the muscles gain in mere physical force, they lose in temperamental or flexible strength" (46). The introduction of the category of flexibility is coterminous with an aestheticization of the social order. This privileging of flexibility over muscle reflects both industrial society's need for more fungible workers and fears about the dwindling muscularity of a postpioneer population. Not surprisingly, this aestheticization of the social order is underpinned by a healthy dose of racism: "As we said of the limbs in the chapter on the vital division of the body, that they attain the greatest perfection of physical strength among the inferior races of men, so in the highly sensitive organisms of the more advanced races, as the quality of the material becomes finer and the quantity is lessened, there is a gradual development toward the perfection of flexible strength" (46). Note the implicit fear that the inferior races are more vital: mental refinement seems necessarily linked to a "lessening" of quantitative vitality and to an increased "flexibility." Beauty and proportion are still white, for the idea that force and vitality are in themselves beautiful has not yet fully taken hold of aesthetic thought. What, then, are we to make of Morgan's assertion that "as man becomes civilized and refined there is a greater freedom in the movements of the arms and legs, showing a blending of the mental and emotional natures in man" (38)? Has the very ideal of social choreography become a (white) refinement of the dwindling vital force in this American context?

Time and again, the aesthetic and the sociological aspects of flexibility are intertwined in Morgan's presentation, the aesthetic discourse serving to legitimate the social demand for flexibility. Chapter 3 of her study—"Plea for Flexibility"—argues that "we must free the body from the stiffness of individuality by yielding it up to the claims of universality. We must break down error before we can build up truth. This object is attained in physical training by surrendering the body to the discipline of an aesthetical gymnastic drilling" (15–16). Freedom has come to mean the surrender of individuality to "aesthetical gymnastic drilling." As in Bergson, individuality is experienced only as a disabling "stiffness." Meanwhile, the criterion of "error" and "truth" has been conflated with that of bodily grace in a manner entirely opposed to Balzac's paradigmatic distinction between the faux and the gauche. Whereas Balzac's turn to the aesthetic served to destabilize

scientific certainties, positive truth claims now reenter the aesthetic realm. Science and art collaborate in shoring up the subject.

The question finally boils down to issues of literacy and legibility: the notion of being read and who gets to read whom. On the one hand Morgan posits a natural language of gesture, claiming that "gesture is the language of nature, and it is comprehensible to people of every tongue; whereas their different forms of speech must be laboriously learned before they can be employed or understood" (58). At the same time, however, she envisages the production of art in terms of genius and a necessary servility to the will of the great man. It is not fanciful, I think, to see the appeal of Delsartism—with all its contradictions—to the specific situation of late-nineteenth-century America. In the land of the melting pot the idea of a universal bodily language is clearly attractive, while at the same time posing a threat to the privilege of the literate classes. We all speak different languages but maybe there is one universal language of the body that would be democratic.[41] In the writings of figures such as Lombroso and Nordau—who sought to harness the physiognomic structure of homology derived from Lavater to the pseudosciences of eugenics and social Darwinism—it was primarily a question of reading the criminal classes. In America there arises now the frightening utopia of a universal legibility. The universal code is everywhere and nowhere—for there is, finally, no subject as referent outside the regime of legibility itself.

In Morgan this has become the possibility of panopticism: what if one were always being read; if every gesture could be read without our knowledge or volition? As a system, Delsartism may have originated in observations and interpretations of gesture—in "reading"—but as a practice it was obsessed, instead, with being read or, more precisely, being misread. "The pupil's attention," Morgan writes, "should be directed to the study of himself as the first step to a knowledge of others, and an assistance to him in observing nature and studying art" (10), for "the most gifted among us must learn to know himself" (111). Social existence becomes a form of proofreading, correcting the bodily errors that might obscure our legibility. Morgan's bodies have to be readers and writers at the same time, for fear that the signs be unclear or open to misinterpretation: "The study of the attitudes of the head and those of all parts of the body, especially the various expressions of the eye, nose and mouth, should be carefully practiced before a mirror. Most people

consult their mirrors for the single purpose of seeing their attractiveness; we should study them for the purpose of seeing ourselves as others see us" (97–98). This imposition of the task of self-reading means that in a literate democracy self-alienation is inevitable insofar as individuals are obliged to become the first readers of their own bodily texts in order to police the possibilities of their interpretations. Moreover, this regime of reading—for fear of being misread—is explicitly opposed to an alternative aesthetic concern with "attractiveness." Balzac's ironically scientific treatise on elegance has now shed all irony and, as Delsarte himself proclaims, "aesthetics, henceforward disengaged from all conjecture, will truly be constituted under the severe forms of a positive science" (57). The distinct epistemologies of the faux and the gauche will now merge: performance and textuality become one.

While it is not my aim to enter into the metaphysics of Delsartism, arcane as it is, it is nevertheless important to note the way in which the central value in his system is ascribed to "Being," which is described by Anna Morgan as a synthesis of "the soul and body." Being needs to be understood as an indivisible vital unit rather than as a simple reconciliation of the traditional metaphysical binaries of body and soul. It is through a consideration of semiosis that Morgan effects this shift. Describing the study of Delsarte as the study of "expression," she goes on to conclude that expression is "the Sign of the Being." By way of example, and as an introduction to Delsarte's triune system of vital, emotive, and mental forces, Morgan offers the following as examples of signs: the response to a question (mental sign); the cry of pain at being pricked with a pin (vital sign); and the cry of grief at learning bad news (emotive sign). To demonstrate the importance of the unity of body and soul in the definition of the sign, she points out that a dead body, when pricked, will not cry out because it lacks Being. Being, then, is a category that anticipates Bergsonian vitalism.

It is notable that all of Morgan's examples of sign appear, at first glance, to be indexical in the Peircean sense—each of them caused by the thing of which they are the sign. But in fact the signified of the answer is not the question; nor is the signified of the cry the pinprick. Morgan is quite precise when she argues that expression is "the Sign of the Being," for what her examples signify is the fact that the body is a signifying medium. It is only the body as a conductor of spiritual or physical stimuli that makes such signs possible. "Being" is the ability to

produce signs—no more, no less. In describing her pedagogical method Morgan reconstructs a conversation with a pupil:

> "Now, then, we have said that expression is a sign of the being. I will ask you, Mr. B., to exemplify or apply that definition in your own person by some action." Mr. B. reflects an instant, during an impressive silence, and then admits that he is unable to do so, at the same time shifting in his seat and crossing his legs with embarrassment in his manner.
>
> "Why did you shift so in your seat and cross your legs when you replied?"
>
> "Well," he continues, more confused than ever, "I scarcely know; I supposed it's because I was a little nervous."
>
> "Exactly, because you were a little nervous; you are not in the habit, I see, of analyzing these signs of your being; you answered my question unconsciously." (35)

Whereas a reading of this exchange as a parapraxis would assume that there was something the student wished to hide—either from himself or from his teacher—for Morgan the body simply wishes to keep open dialog even when the intellect is incapable of providing the required response. The student "scarcely knows" but comes to know through a reading of his own body.

Morgan's work represented a first wave of Delsartism in America, deriving from the work of Steele Mackay who not only came to dominate the reception and propagation of Delsarte's work on that continent but who was, in fact, the first truly to systematize the master's work. To locate the Delsartian inheritance in a distinctly American social choreography, however, would require examining the writings and teaching of Genevieve Stebbins. In reading her work the *Delsarte System of Expression* one is immediately struck by the simplifications that have taken place, even when compared to Morgan's presentation of Delsarte. Now, the value of Delsartism has been isolated: "There are two sides only to Delsarte's System, in spite of the fact that he built everything upon threes. These are the physical and the metaphysical. One is practical and valuable; the other is of doubtful use to any but the lover of metaphysical abstractions."[42] The concept of Being that, despite its nebulousness, made Morgan's work so interesting has been displaced by precisely the metaphysical binarisms that Delsartism otherwise sought to undo. Moreover, if we recall the epistemological un-

certainty deriving from Balzac's balancing act between the scientist and the madman, in the work of Stebbins—the most influential popularizer of Delsarte and the most directly engaged in reflections on dance that helped shape the work of early modern dance pioneers—this ambiguity has been definitively resolved: "This is an age of formulation. What Comte has done for exact science, Buckle and Mill for history, Spencer for culture, and Ruskin for painting, Delsarte has tried to do for action, for expression. It is as though the world, growing weary of productive activity, sought to pause and rearrange before plunging into further depths" (75). In the history of the propagation of Delsartism, we see here a culture "weary of productive activity," shunning the performative to set down a textual ledger of bodily gesture.

Particularly sensitive to the charge that Delsartism is imprecise and mystificatory, Stebbins resorts to a positivism that discards the Swedenborgian hermeticism of most of Delsarte's own pronouncements. By establishing strict discursive parameters—science, history, culture, and the like—she effects a shift away from Delsarte's own anatomistic conception of science and sees the very principle of discursive rationalization itself as the principle of positivism. In other words, sociology becomes the paradigm of science insofar as it is capable of plotting the relations between other sciences. Stebbins reduces Delsarte to a physiognomic system of homology. Whereas Morgan's semiotic was essentially indexical in its presentation of signs caused by the things they represented, Stebbins is resolutely iconic in her insistence on transhistorical and transcendental homologies. For example, she "credit[s] the French master with being the first in modern times to formulate a fixed principle or law that stands indisputable and unmovable in its triune manifestation in the art of human expression. This fixed principle is the great Law of Correspondance, a law almost as old as man . . . 'God created man in his own image'" (390). Precisely because it seeks to retain a notion of necessary causality while rejecting anything but what Althusser would subsequently call "expressive causality," Stebbins's Delsartism has to posit a purely internal cause: the divine, or nature.[43] "All outward forms being but manifestations of an internal cause, between which there was a co-necessity," she writes, there must be "a perfect correspondence uniting cause and effect" (391). The stumble that in Balzac made apparent that power of rétraction on which all elegance is based—and which in Bergson became the principle of

flexibility—has now been replaced by a rigidified insistence on the "fixed" and the "unmovable." What we have is a dialectical play between flexibility at the level of the social subject betokening a transcendent "fixed principle" at the level of the transcendental subject; a coalescence, that is, of metaphysics and social fungibility.

Recalling Agamben's description of Tourettism as "a movement . . . interrupted and sent awry by uncontrollable jerkings and shudderings whereby the muscles seem to dance (chorea) quite independent of any motor purpose" (136), we begin, I think, to appreciate the historical significance of Delsartism. In effect, what we encounter at the end of the nineteenth century are coexistent stages in the decomposition of reading strategies. Dance, as chorea, figures a semiosis "independent of any motor purpose"—in other words, a recognition of the "nonmotivated" nature of the sign. At the same time, however, a symptomatic reading of Tourettism posits a causality that reestablishes both a somatic and a semiotic "motivation." Thus, any diagnosis of Tourettism effectively undercuts the philosophical and linguistic presuppositions of the condition itself. Stebbins, meanwhile, can be seen as moving in the opposite direction. Starting from a belief in expression as semiotically motivated—either as index ("cause and effect") or as icon ("correspondence")—her work of popularization and standardization nevertheless pushes the body in the direction of the nonmotivated sign, the conventional symbol. It is, perhaps, Morgan—in a no-man's-land between the two—who retains the most interesting possibilities.

Notably, in attempting to generate his semiotics by means of a physiological rather than sociological motor, Delsarte finally makes his breakthrough in the Paris morgue. "Dead bodies only attracted me," he writes, with a rather necrophiliac turn of phrase, "when they were—if not dissected—at least flayed" (401). In this presentation we reencounter, in all its paradoxicality, that Marsyan impulse outlined in our consideration of Ruskin, Morris, and Wilde. For Marsyas—now a flayed body on the mortuary slab—represents a liberation of vital human forces that are themselves destructive of any delimitable human subjectivity. If dissection is the most obvious image of an attack on the bodily integrity of the subject, then flaying—the laying bare of the body's vital and muscular motor—is no less destructive. One is reminded of the definition of touch from the *Encyclopédie* that serves as epigraph to this chapter. Touch is the sense that establishes us as something other than

"automatons that have been dismantled and destroyed."[44] The skin—
that which has been stripped from the flayed body—is the very organ of
the tactile. At the point where vital forces are revered as mere principles
rather than as embodied historical realities, respect for both bodies and
subjects ceases.

For Delsarte, the possibility of reading bodies semiotically—and
thereby of fathoming the vital nexus of "motivation"—paradoxically
exists only in the moment of death. "I sought in some portion of the
body, common to all," he explains, "a form or sign invariably found in
all. . . . The hand furnished me that sign and responded fully to my
question. I noticed, in fact, that in all these corpses the thumb exhibited
a singular attitude. . . . Such persistence in the same fact could not allow
of a shadow of doubt; *I possessed the sign-language of death, the semiot-
ics of the dead*" (404; italics mine). Delsarte's project of semiotics is
grounded, finally, in the corpse. Conspicuously, the rétraction that sig-
nified life in Balzac has here become a death spasm, an "adduction or
attraction inward" (404) of the thumb that he encounters in all corpses
and that unlocks for him the complementary gestures of vitality. We
have finally arrived at that moment in modernity where the most ener-
getic and vital of movements resemble the final spasm or paroxysm of
death. At the heart of Delsartian vitalism is a deathly semiotic. This
extends to Delsarte himself as an observer at the morgue. Like the
spectator of a Bergsonian pratfall, he avows that "the emotion which
such a sight would have caused me under any other circumstances was
absolutely null at this moment; close attention dulled all feeling in me"
(405). The meeting of the aesthetic investigator and the corpse of Mar-
syas dramatizes a lack of sensation, an absence of "tact"—with only the
retracted thumb as the signifier of a final deathly movement. At the end
of the nineteenth century—before, that is, the point when vitalism
had been popularized as a dominant philosophical and ideological cur-
rent within modernity—Delsartism represented one effort to recontain
bodily and semiotic instability—"stumbling"—in a system that was it-
self nevertheless informed by vitalist presuppositions. As a social phe-
nomenon Delsartism seeks both to celebrate and contain the semiotic
profligacy of the body; to find immanent bodily meaning that can serve
as the basis of a social textbook. Taking it as a primer for a new social
"flexibility," we need to note for the sake of political critique that its
end and origin is the corpse.

3

"America Makes Me Sick!"

NATIONALISM, RACE, GENDER, AND HYSTERIA

All of representation is based on a making-present—of the nonpresent and so on. . . . Thus the assumption—Perpetual Peace is already here—God is among us—America is here or nowhere—the Golden Age is upon us—we are magicians—we are moral and so on.—Novalis, *Fichte Studies*

In this chapter I focus on Isadora Duncan in order to consider the cultural significance of dance as a form of political and national embodiment at the beginning of the twentieth century. My consideration of Duncan here will be prefaced by a reconstruction of some of the critical commonplaces that derived from and, in turn, helped shape the discourse and ideology of modern dance. By drawing on the writings of modern dance's early proselytizers in the United States, I argue for the emergence of a new aesthetic order in the early twentieth century, one in which choreography acquired an important—indeed, predominant—role as the privileged form of what we might call a "postliterate" culture. I seek, then, not simply to shift along the aesthetic continuum from a consideration of social choreography to a consideration of dance in the more aesthetic sense, but rather to highlight a moment when the aesthetic realm acquired a particular importance in the resolution of

essentially nonaesthetic problems of political self-representation in modern democracy. To talk of postliterate cultures is by no means to suggest that ideals of cultural literacy as the measure of national identity had been lost. By this time, the establishment of public schooling in leading industrial nations had clearly enshrined literacy as a preeminent cultural and civic virtue. Significantly, Isadora Duncan herself quite explicitly acknowledged philosophers and writers as her primary dancing masters. What I suggest here instead is an ideological adjustment whereby the ideals of prelapsarian language and community that had always informed Enlightenment thought (for example, Rousseau's genealogy of gesture discussed in the preceding chapter) sought and found in dance some adequate artistic expression. I call the era postliterate only to the extent that dance was thought to offer the possibility of a more "immediate" cultural expression unadulterated by the grammatical and formal demands of linguistically mediated "textual" cultures.

More specifically, here I am interested in how this realization of a certain linguistic fantasy served at the same time to complete two other logical structures. First, aesthetic theory's traditional division of plastic and musical arts would be overcome in dance. In the realm of cultural politics, meanwhile, a nation—America—would finally find its adequate aesthetic expression in dance. By overlaying these three ideological structures—language, aesthetics, and politics—I aim not to provide concrete historical context but rather to suggest a third way for thinking about historical determination with respect to cultural phenomena. Effectively, I am suggesting a structure of overdetermination in which shifts in the aesthetic order are fully explicable neither with respect to external historical determinants nor in terms of their own, wholly self-determining logic. Only those forms and genres that at the same time offer solutions to other, deeper, ideological problems will emerge from the variety of cultural possibilities as the characteristic aesthetic expression of a given era. In other words, I will argue that the immanent logic of aesthetic development generates solutions to its own problems that might then be picked up as models for the resolution of ideological conflicts outside the aesthetic realm. That these "aesthetic" solutions in turn reflect the conditions of the society that produces them goes without saying. The process is not monodirectional, however, and the aesthetic realm—as in the case of dance at the beginning of the twentieth

century—is capable of producing forms of social resolution unprecedented in the other political and ideological realms.

I will begin my consideration of the postliterate cultural formation with a quote from John Martin, the hugely influential dance critic of early American modernism. In his seminal study *America Dancing: The Background and Personalities of the Modern Dance* Martin observes: "In the present period of civilization an excessive evaluation is placed upon literacy . . . Nothing has meaning until it is translated into words; there is no substance in an emotional reaction, no validity in a muscular response; there is only language" (87–88).[1] Martin's mistrust in literacy is in fact a mistrust in the translations and mediations necessary to move from the body to text. In the place of such translation Martin develops a notion of immediate bodily communication, or kinaesthesia, that would become a crucial cornerstone of modern dance theory. Kinaesthetically, bodies talk to bodies by moving them in a form of sympathetic magic. Kinaesthesia serves as that language that does not require translation—a language without positive, static terms; a language in which the Saussurian "negative relations" that create meaning have been positively rendered material and organic. By cloaking the problem of translation as an attack on literacy, Martin contrasts his new aesthetic ideal to those of the nineteenth century, for which music was the privileged form of postliteracy—or, rather, the model toward which language, in the form of poetry, was supposed to tend. Martin contrasts dance, America's new contribution to the history of aesthetic forms, to music, the privileged, nonmimetic genre of late-nineteenth-century postromanticism and aestheticism. Reversing the commonplace that poetry was to aspire to the self-enclosing condition of music, he argues that music itself still partakes of a fundamentally verbal/ poetic episteme: "Music, with its method of notation and its elaborate fabrications of systems and codes . . . is reducible to paper and ink, those noble instruments of literacy . . . The dance, poor wretch, handed down from generation to generation by imitation, if at all, illiterate, unrecordable, depends for its existence upon the vulgar exertions of the body, that vile prison in which the sin of Adam has encased man's spirit" (*AD* 94).

Martin exemplifies in extreme form an antipathy toward a culture of literacy that is embedded in mimesis. Paradoxically, however, it is a mimetically choreographed moment ("handed down from generation

to generation by imitation") that lifts dance out of the representational, mimetic episteme encoded in writing. Furthermore, the fantasy of what I have been calling prelapsarian language is figured as the very opposite—as the condition of dance in "that vile prison in which the sin of Adam has encased man's spirit." Martin is attempting to resurrect a prelapsarian language in a postlapsarian body. In geopolitical terms, meanwhile, this means that he wishes to establish an authentic post-literate, nontranslated culture in America, the land of assimilation and cultural translation.

It might be tempting to see in Martin no more than a classic case of that logocentrism to which a couple of decades of theory have rendered us so alert: thus we encounter a familiar opposition to the letter, to writing and notation—and a privileging of performance or even an embodied "natural language." In this vein, for example, Martin writes that "it is safe to say that when any art form has got itself to the point where it can be translated into words, it is dead as an art form. (By 'words,' of course, one means in this place to imply the medium of intellectual factualism, and not in any sense the stuff, though it happens to have the literary designation of words, by which poetry projects its meaning)."[2] Although he is quick to explain that he intends no attack on poetry per se, such an attack seems implicit in his project. At the very least it is clear that for Martin dance is an attack on the very episteme of interpretive "literacy" that had thus far delineated national cultures. This marks a crucial shift from prevailing nineteenth-century assumptions about national culture that privileged a literary heritage and a shared language as the precondition of nationhood and that took academic shape in philology and anthropology. Martin's championing of the body against literacy is a championing of one conception of national culture over and against another.

How, then, did American culture as bodied forth in dance understand itself as heir to a cultural history whose privileged forms it tended to discard? In other words—reversing the terms in which the question is traditionally posed in considerations of modernism—how did dance understand itself in relation to poetry?[3] This question of literacy and embodiment is crucial, as we shall see, to understanding Isadora Duncan and the other pioneers of modern dance. In her 1927 essay "Dancing in Relation to Religion and Love"—an essay that allows us to think the relation of religion to rhetoric, or of the religious to the aesthetic—

Duncan presages that antipathy to the discursive that we have already noted in Martin. "People," she writes, "have an entirely false conception of the importance of words in comparison with other modes of expression, just as potent as words."[4] What does it mean to envisage a country dancing as Duncan—in the grip of a Whitmanian enthusiasm—does? To what extent and in what way can dance "embody" nation? And what is the significance of the shift from predominantly literary and philological figurations of cultural nationhood in the nineteenth century to a Whitmanian singing and, finally, to the performances of figures such as Duncan?

Of course, the division of literate and postliterate is highly schematic: those European nations that most clearly exemplify high literate cultures often privileged a romanticized "performative" bardic culture and oral tradition in constructing their literary genealogies. Their logocentrism was always suspicious of the textual. But this is the point. The shift from Europe to America and from literate to postliterate responds to anxieties about the possibility of any immanent self-defining cultural unity. Martin's linkage of the verbal to translation foregrounds problems already inherent within the episteme of literacy (i.e., the problems faced by any logocentrism). To hypothesize any such shift—from literature to dance—in the aestheticization of nationhood is to take cognizance also of a shift from representation to performance. The nation is no longer something already existing that needs only to be represented in language and literature: it is something that needs to be actively and performatively called forth in the dance. The nation has, for what I loosely term a "literate" culture, the status of a referent. With the shift to what I tentatively call the postliterate it acquires the status of something to be invoked and produced through performance. Thus, whereas literary representations of nationhood might at least notionally be held up as "true" or "false" representations—and judged accordingly—the danger of the new performative paradigm was that it might not simply mis-*represent*, but mis-*beget* the nation. The privileging of dance as a national cultural form brought with it the danger of a miscreant—or, more specifically, a miscegenated—culture. If America cannot close itself around a referent, it must perform its act of self-definition. Interestingly, Whitman's singing and Duncan's dancing are both forms that leave no artifact as trace—that do not even produce a referent. Thus, the nation becomes a work in progress and nationality

is oriented not toward the uncovering of a hidden past referent but toward the future. Nationhood becomes messianic.

In the words of Goethe's *Wilhelm Meister*, quoted by Novalis in this chapter's epigraph, the very status of American nationhood differs from that of other nations: "America is here or nowhere"—it is a perpetually present state, an ideology of perpetual presence. Thus, I will argue here that a certain narrative of aesthetic discovery was modeled on a narrative of the discovery of America, and I will present what I take to be some of the more important aesthetico-political consequences of such parallels. In looking at the specific social choreographies constituted through American modern dance, I wish to take literally this notion of a "shift" (from representation to performance) and to examine the narrative of aesthetic discovery whereby the perpetual "here" that is America is located. Obviously the possibility of a nonmimetic self-performative identity—implicit in the shift from literate to performative cultures—was particularly attractive to a nation grounded in the ideology of self-creation, a perpetually young nation sentimentally oriented toward the future rather than toward the representation of its past. Notwithstanding the importance of Germany in twentieth-century dance history, I will argue that the hegemony of a certain formalism in modern dance reflects America's desire to figure itself through dance not as one nation with its own characteristic aesthetic demands, but as the locus of both a historical and an aesthetic realization of nation and art in their very essence. In "America" a certain understanding of dance's very preconditions is completed as an aesthetic trope for a concomitant end of history.

The "here or nowhere" of Goethe's utopian vision exemplifies a certain ideology of presence that has become fixed and representable in a specific historical and geopolitical location: America. To identify the utopian with America is to suggest a specific geopolitical location for the realization and liquidation of ideology. I will be arguing that the "end of ideology"—linked, necessarily, to the surpassing of language that both Martin and Duncan see as the task of dance—is the American form of ideology par excellence. Both Martin and Duncan will renarrate the historical and aesthetic "discovery" of America and link it to what Martin calls "the heresy of an American art" (*AD* 21). The term itself—"heresy"—is, of course, significant; Martin, like many others, links this notion of heresy to a protestant American tradition, invoking

images of puritan exiles committed to the rigors of their art no less than their ancestors were to the rigors of their religion. As the conflation of aesthetic and moral puritanism progressed (suffering for one's art), it would even become possible to think of Isadora Duncan—whose relationship to any moral puritanism was highly complex and ambiguous, to say the least—as a puritan figure.[5] In the debate in question, puritanism figured both a sublime, romantic desire for pure form (puritan and protestant, indeed, in its iconoclastic opposition to mimesis) and the possibility of rational, classical order. Puritanism needs to be thought in aesthetic terms in both a formal and a substantive way. As the pursuit of pure form it eschews the body for abstraction—or, rather, understands the body itself as an abstract and grammatical articulation. As an ideology of substantive physical and moral purity, however, it calls for the display and purification of the body. This, I will argue, poses a dilemma in any understanding of American modernism—a set of forces pulling in opposing directions, toward abstraction on the one hand and toward the figuration of a (purified or aestheticized) body on the other—between, that is, the representation and figuration of purity and the iconoclastic purification "from" all representation.

This tension is one that informed the political, religious, and aesthetic discourse for the entire course of Duncan's career. According to Ann Daly: "Duncan projected an arc between late nineteenth-century romanticism and the secular collectivism of the 1930s: she shifted between these two realms and facilitated the transition, though she never completed the leap."[6] The paradox confronting those who sought a characteristically "American" cultural constellation lay in a certain ideological commitment to the oppositional notion of "heresy." To be American is to be a heretic, but the very structure of heresy is to take issue with any such identity. The paradox of American "heresy" is that it proves itself American even as it proclaims itself a heretic against all that is American—this is, indeed, the structuring paradox both of this chapter and of Isadora Duncan's own ambiguity toward her nationality. As Daly again points out: "Despite—or because of—her self-imposed exile (she left for Europe in 1899, at the age of twenty-two) Duncan was fundamentally informed by the idea, if not the reality, of her homeland" (10). Such a contrarian but sentimental relation to one's homeland is not, indeed, that unusual, but Duncan's "progressivist" ideology makes the final turn into reactionary and racist thinking pre-

cisely at the point when the division between "the idea" and "the reality" is erased; that is, at the point where her discourse is informed by a certain "idea of the reality" of America. This stage in Duncan's thought is clearly marked by the emergence of tropes of "reality"—geography and race, specifically—in her later writings.

I will begin here by establishing what early dance pioneers in America understood to be the project of a heretical American choreography. According to Martin, "the basic practice of real internationalism, whether in art or any other medium, involves the recognition of individual divergences, a respect for their values, and a willingness to pool these values in a common purpose" (*AD* 26). This model does not really hold for American dance as it would for German opera or Greek tragedy, however. For whereas these other "national" art forms become general by being absolutely specific in national-cultural terms (even German opera, although musical, depends on a regime of national language), American dance becomes specific and American by being general—by literally incorporating the possibility of translation as something passed from body to body rather than through language. It is the raw material of this American art form, the body, that will render it universal. Pure matter becomes the placeholder for, and then the actualization of, pure spirit. Herein lies the grave political danger that underpins the discourse of modern dance in its early years both in America and in Germany: the conflation of eugenics and pure reason. Where other nations attain some level of universality by virtue of giving lasting aesthetic expression to their national specificity (opera, or tragedy), America, we are told, discovers its specificity only through a fathoming of the universal (in dance). In other words, the formal self-completion of dance parallels the historical self-awareness of "America."

America is not only the medium for the realization of humanity: humanity is the medium for the realization of America. That America's self-actualization will mark not a coming to speech but a movement beyond language is vital, for what makes American dance general is its movement beyond any need for translation, its very physical immanence. Martin generally insists that "the whole idea of national art is, of course, abysmal nonsense" (*AD* 32). For him, art neither reflects nor represents a national essence in its purely formal principles: forms are geopolitically neutral, predicated as they are—in the case of dance—on the articulation of a body figured as preliterate. The discovery of a

prelinguistic language, however, is something that Martin will link to a specifically American experimentation in dance. In his presentation, American modern dance pioneers demonstrate their national sensibilities in the very movement beyond nationalism, in their realization of a formalism emptied out of ideological content. Martin sees America as the proving ground for an art that will not simply reflect but shape a nation. The myth of American self-actualization through art and the myth of the arts' own systematic self-reconciliation (i.e., the overcoming of the schism between musical and plastic arts in dance) are linked in such a way as to suggest a historical and aesthetic idea of manifest destiny. History can in fact be located—in America—in the moment of its completion: just as time folds into space in dance, history will fold into America. As we shall see, Martin is led to posit a universalism of the body that runs counter to a secondary critique of aesthetic and political colonialism in his work.

It is precisely the attempt not to sink into chauvinism that leads Martin instead into sublative and totalizing conceptions of America as, quite literally, a utopian "end of history." How can we have an American art and yet resist narrow nationalism? Not unreasonably, Martin observes how "it is even permissible in the most orthodox circles to speak of Greek tragedy, Italian primitives, German opera, Russian ballet. They are no less international or universal, apparently, for being associated with specific peoples. But let some temerarious soul venture to mention American dance" (*AD* 29). The problem, however, comes when we consider the specific aesthetic form—dance—that will constitute this American heresy. Unlike all the other forms he cites, Martin ascribes to dance a specific quality: natural language. He uses the term metakinesis to describe what would subsequently come to be known in dance theory as kinaesthesia—the natural sympathy of one body for the movements of another. According to this notion, "when we see a human body moving, we see movement which is potentially producible by any human body and therefore by our own; through kinesthetic sympathy we actually reproduce it vicariously in our present muscular experience" (*AD* 117).

The very terms in which Martin insists on the cultural specificity of aesthetic forms assigns a particular importance to dance and, consequently, to America: "Because man, wherever he lives, gives the first expression to all his emotional experiences in terms of the movement

of a body which, in spite of great variety, is fundamentally the same everywhere, it is possible for men of different cultures to respond in a measure to each other's arts; but because the objects which inspire these emotional experiences depend so largely on local conditions, it is impossible for men of different cultures to respond to each other's art in equal measure" (*AD* 27–28). The ideological slippage in Martin's argument—the slippage that allows him to figure kinaesthesia as, in effect, a natural and prelinguistic language—is the erasure of the mimetic. Although metakinesis is an experience in which "we actually reproduce" (i.e., a mimetic and secondary reproduction), it is still a "present muscular experience." In other words, it is a performative reenactment rather than a denotative re-production. Nevertheless, Martin presents metakinesis in the form of a hermeneutic, calling it a sixth sense in which "what we see we interpret in terms of our own muscular experience" (*AD* 113). Metakinesis turns the body into a producer of interpretations. Thus it never escapes the regime of literacy and representation, despite the critic's claims to the contrary.

In defining a specific form for his American heresy, Martin's argument runs roughly as follows: cultural phenomena are always limited and determined to the extent that they are articulated in a national idiom (Greek sculpture, Italian opera, etc.). This does not necessarily curtail their ability to function beyond national and historical limits and to address all of humanity: on the contrary, it demonstrates the embeddedness of man himself in history. The general is not the opposite of the specific but rather its sublation: the general must acknowledge its relation to specificity. We can be spoken to only by those whose historical inability to address us in our own language resonates with our perception of our own historical limits. Dance, however, is different. In the passage cited above, Martin distinguishes between the dance medium (the body, "fundamentally the same everywhere") and the "matter" of dance ("emotional experiences depend[ent] so largely on local conditions"). In the case of Greek sculpture, the body has been reduced to matter rather than medium: almost paradoxically, the living thing (the body) becomes the object of a representation and an object (stone) becomes the living medium of communication. The transhistorical, transcultural element is missing from the body itself as medium—it is the stone that perdures and "speaks" across time. Thus, the general validity of Greek culture derives from a specificity sym-

bolized by the passage through a stone that resists any transubstantia-
tion. The same will not be true of dance as a specifically American form.
Martin envisages the body as medium rather than material when it
comes to American dance, while recognizing that "any theory of dance
that attempts to make use of the body as an instrument of pure design
is doomed to failure for the body is of all possible instruments the least
removable from the associations of experience" (*AD* 92). In other
words, despite its orientation toward production and performance
rather than reference, purely abstract dance is never possible because
the medium itself—the human body—functions as a trace of the fore-
closed figure of the specific. Distinguishing American dance from Ger-
man ideals of absolute dance, Martin notes of the former that "it has
never confined itself, even in its most experimental period, to absolute-
ness. Indeed, it could not do so from its very nature, for the movement
of the human body is inevitably associated with experience and cannot
be made into an abstraction of line and form under any circumstances"
(*AD* 66).

Any absolute that cannot account for the specificity of bodies is not
absolute at all but rather "confined." The putative German commit-
ment to the absolute renders their aesthetic nationalism merely ab-
stract, as opposed to an American identity that is historically realized
and is itself, indeed, a "realization" of history. For Martin, dance is the
closest thing to a natural language of the body, and it passes universally
from body to body through "association" rather than translation. Con-
sequently, to posit dance as *the* American art is to posit America as the
locus of humanity's self-actualization. What is "specifically" American,
in other words, is America's passage—through the specific medium of
the dancing body—beyond historical specificity. Martin's materialist
idealism is inflected by an idealist materialism: the body becomes the
locus of humanity beyond national cultural limitations. What this
means, of course, is that America—for which dance is a natural and
adequate aesthetic expression—takes as its specificity the general itself:
humanity. While modern dance will be American, its very physicality
will make it international.[7] Again, the political implications are trou-
bling; the moral purification of mankind can potentially be reduced to
a eugenic project.

What is it about dance that will make it peculiarly suited to the
expression of "America"? To answer this question, of course, is to

confront "America" as something other than an empty signifier and to acknowledge a cultural or historical specificity that aligns it with dance rather than with some other form. The crucial ideological element in establishing this link is puritanism—which, in the debates around modern dance, slowly transmutes from a religious to an aesthetic creed. Martin's early invocation of "the sin of Adam" makes it clear that puritanism is an unconscious as well as a conscious trope in his argument. A puritan consciousness of that sin implies, for Martin, a commitment to the limitations of the body. Dance expresses a condition of worldliness opposed to metaphysical otherworldliness and acknowledges man's fallen nature. Again, Martin is torn between a desire to transcend this fallenness in American dance and a recognition that it is precisely this embodiment that lends dance its "immortal" value. If America comes to a sense of self by way of a confrontation with the universality of the body, it likewise comes to a recognition of the spiritual through an experience of the lapsarian body. These two puritanisms, the aesthetic and the moral, constantly transect Martin's conception of American dance; and not only Martin's. For all the universalism of his rhetoric, he resists any passage beyond the physical; indeed, the movement into dance is a movement *into* the physical as the site of universal, nontranslated language.

What does it consist of, this "heresy of an American art"? For the colonized American to posit an indigenous art form is to be a "heretic," Martin contends—but to be a heretic defines the very essence of what it means to be an American: the very heresy of claiming dance as an American form itself confirms the assertion. The rhetorical logic of this heresy decrees that because what I say is a heresy—namely, that dance is an American form—what I say is spoken as a true (and truly heretical) "American." The act of heresy guarantees rather than negates the truth of the American heretic. Martin's argument is that "the outstanding American trait, anti-authoritarianism"—heresy—is also exemplified by the dance of Isadora, which was "anti-authoritarian in that it rejected all set formulations of movement codes, functional in that it dealt with problems of human emotion instead of with the plight of distraught butterflies, democratic in that it took the dance away from a little cult of initiates and urged everyone to practice it" (*AD* 41). At this stage of the debate, heretical "anti-authoritarianism" is taken as demanding the rejection of "all set formulations of movement codes" as well as the

expression of human emotion rather than the representation of an external referent ("distraught butterflies").[8] Bodily "spontaneousness" has not yet been replaced—as it would be later—by an "objective" experimentation with bodies in gravity, by fall and recovery. America's contribution to dance stresses a "functional" element that demands not a minute attention to the mechanisms of movement but rather a simple change of thematic. It is still mimetic—indeed, all the more so because its themes are now substantive; "human emotion," for example, rather than the trivial conceits of ballet that served as mere pretexts for movement. "America" is not yet a formal imperative.

With regard to the historical force of American aesthetic and political heresy, Martin will argue that "the momentous overthrows of authoritarianism which are resisted by armed force" are presaged by "skirmishes of smaller dimension which prepare the ground for greater contests" (*AD* 58). He takes as an example the "ragtime uproar of 1910 and thereabouts," as if seeing in the new frenetic choreography the harbinger of a coming revolution. Dance, in other words, no longer represents a historical achievement, but nor is it yet caught in the ahistorical synchronicity of formal self-reference: its referential function is anticipatory. Dance presages and projects the future. Unlike other characteristic national art forms, American dance will serve not to reflect an already established cultural consciousness, nor to lead a people to recognize itself, but, in fact, to produce and bring about the national consciousness.

The act of presaging, however, is not only temporal but also geographical: America will represent the future to Europe through dance. Most explicit in such claims was Martin, with his tendency to consider Duncan alongside the popular dance crazes that swept the world just before World War I. In this conflation—which would have horrified Duncan, of course—he accurately reflected European responses to American dance imports, which did, indeed, tend to blur the boundaries between high and low culture—carried away, as they so often were, by the vigor of the new forms. Keeping in mind Schiller's presentation of the English dance as a model of harmonious social order, it is clear that by the turn of the twentieth century the prevalent ideal of social choreography had changed. Martin notes how the colonial boot is now on the other foot: "Europe is even now generally shocked at theAmerican idea of ballroom dancing; it is so unstandardized, so haphazard . . . Actually its real claim

to distinction is its spontaneousness . . . The beautifully behaved dancer of, say, the English ballroom has really no idea what a genuinely creative sport dancing can be when it is done in the best American style" (*AD* 60). The contrast with Schiller could scarcely be more striking; Schillerian *Spiel* has now been rationalized as sport. More important, though, the points Martin makes with regard to Duncan—her antiauthoritarianism, her functionalism, her democratic impulses—prove, in his presentation, to be essentially true of dance per se. In realizing a specifically American form of dance, Duncan implicitly brings to its realization dance *tout court*. Because dance is a performative rather than representational and denotative form, Martin will argue, "there is no alphabet of movement, no set of symbols passed on by convention of authorities" (*AD* 74). Again, there is the attack on the textual, literate culture: systems of writing and notation are linked explicitly to authority whereas performance is implicitly aligned with an immanent national truth. This paradigmatically logocentric gesture claims for America, through dance, a direct access to truth denied those cultures whose self-expression is still grounded in text—German philology for example. The very ephemerality of dance seems to resist both linguistic codification ("alphabet" and "symbols") and "convention of authorities." If, in Martin's presentation, Duncan's dance is unruly, it thereby approaches dance's pure form, which must always be unruled and unruly—resistant to the "authority" of written notation. In adapting dance to America, Martin implies, Duncan in fact reveals something fundamental about it—its antiauthoritarian resistance to denotation and codification (or writing).

Martin's consideration of the "heresy of an American art" is further couched in terms of a sophisticated critique of cultural imperialism and colonization. The rhetorical logic may be reconstructed as follows: "The whole idea of national art is, of course, abysmal nonsense" (*AD* 32), and even if it were not, America, as a colony, has been deprived of the right to lay claim to self-identity through art. The claims of America—any claims made in the name of America—are necessarily the claims of a heretic. To embrace one's identity as an American, therefore, one must first pass through a rejection of identity itself as a culturally coherent totality. Dance—as a preparatory and performative rather than denotative art form—is itself heretical: it invokes and yet defers identity as something tentative in need of being produced rather than

as something self-evident in need only of finding adequate representational form. There is a natural affinity between the messianic mode of identity of a postcolonial America and the performativity of dance. "Just how," Martin asks, "does one apportion international art in this system of esthetic imperialism?" (AD 34). As interesting as the formulations Martin reaches are the possibilities he rejects, for his is no naive championing of oppressed colonized nations and repressed aesthetic possibilities. He sees neither in the dance of the native American Indians nor in the cultural resurgence of Harlem a model for "American art"—for these, he argues, are already cultural possibilities marked by the force of their oppression: "Thus, however great the art of the Indian, which we have virtually never seen, and the art of the American Negro, which has not yet been created, we have no claim to them whatever beyond that of the plantation owner to his minstrels' performances. They are the arts of the subject peoples of America" (AD 37).

I will have cause in this chapter to return to both of these images—the jazz dancer of Harlem and the ecstatic Indian dancer—for, in fact, they offered very different aesthetic possibilities to early practitioners of American modern dance. The Indian, in short, serves to figure an atavistic desire for a savage purity (and identity), whereas the jazz dancer merely acts out the depredations of the culture industry in the absence of all cultural self-identity. Martin even notes how "the European connoisseur's discovery of indian and negro art should put us roundly to shame, but it comes too late to save the situation" (AD 34) as if to point out a strange complicity of cultures—the jaded European culture of the connoisseur and the rejuvenation the European hopes for from "primitive" cultures. What Martin posits as "heresy" is an origin that is rupture—a native American art form that has at its very origin the break with Europe, a break that would render impossible its facile reappropriation by the connoisseur. (Although one of the central ironies of modern dance's emergence in the United States is that American modern dancers did, indeed, seek success in Europe before they could establish themselves at home.)

Martin's invocation of "subject peoples" is characteristic here, for in his review of the early years of American modern dance he articulates the emergence of a national aesthetic form in a fascinating manner in terms of postcolonial identity formation. "The devoted colonial," Martin will observe of his parochial opponents, believes "that art has been

discovered in its various departments by certain individuals in the past, much as Captain Cook discovered Hawaii" (*AD* 22). The colonial's error consists in likening art to geographic landmasses, yet again and again Martin, and others such as Duncan and Martha Graham, will do precisely this when seeking to characterize the expansiveness of American dance forms. But there is a difference: "America," Martin writes in a Goethean rebuttal of such colonialists, "is here" (*AD* 22). We have here two narratives of (cultural) colonialism; two different perspectives. The difference, of course, lies in the play of the "there" (Hawaii was "there" and Cook discovered it) and the "here" that is America. The "there" of a discovery—Hawaii was already there, waiting to be "discovered"—is opposed to the temporal and spatial "here"—an immanent America that is *not* "already there" and that can only be experienced rather than posited (or "placed"). The one colonialist narrative (the narrative of Captain Cook) approximates what I have been addressing through the term "literate": something is there waiting to be discovered/referenced. America, however, is "here"—it exists in a presence that can only be performed and that is, moreover, spatial more than temporal.

In seeking to establish a truly "American" dance form Martin is necessarily unable, of course, to take into full account the indigenous culture that was already "there"—for to do so would be to fall back into the Captain Cook narrative of discovery and an entirely different episteme of cultural representation. His own cultural colonialism is a result of his investment in the aesthetic immanence of America. This, of course, is the central paradox behind his postcolonial formulation of an American dance aesthetic. On the one hand, Martin resists Eurocentric notions of the aesthetic, which he links to an ideological universalism, and claims that such formulations assume that aesthetic forms, like land masses, are always already "there" waiting to be discovered. However, by placing himself in the spatio-temporal present—"America is here"—he posits an aesthetic immanence that effaces history. The universalist spatial "here," we might say, effaces the historical perspective. In other words, Captain Cook at least acknowledges that there is, or was, a "there" there: Martin cannot. For him, the American ideology will be, preeminently, an ideology of matter, of the body. The body itself replaces the universalist and colonizing subject as an ideological center. Its transubstantiation through dance, meanwhile, ignores the

existence of all external materiality—of those bodies that might, however inconveniently, already be "there."

It is important that we understand this American embodiment as a shift in the very definition of ideology. To acknowledge allegiance to an intellectual idea of nation is to acknowledge, implicitly, an allegiance to the idea of the idea: to experience nation as something posited and ideally constructed. To claim to embody the nation, however, is to assert a national immanence: America is "here"—in my body. This distinction between body and idea raises questions of literal and figurative language that I address below with regard to Isadora Duncan. The somatic body is not a rhetorical figure for the national body politic but rather is the medium through which the idea of nation passes into the literal. Ideology, I would argue, needs to be understood in precisely this way: not simply as a set of tropes and figures but as the moment where those tropes and figures displace or enter into the literal. At its extreme, hysteria is the condition of ideology.

Isadora Duncan's relation to the two forms of American puritanism— aesthetic and religious—reflects an ambiguity as to her own status as a descendant of the colonists. On the one hand, as an Irish woman of self-proclaimed frontier stock she opposes "the Puritan spirit of America" but she acknowledges that "I was still a product of American puritanism . . . the land of America had fashioned me as it does most of its youth—a Puritan, a mystic, a striver after the heroic expression rather than any sensual expression whatever, and I believe most American artists are of the same mould."[9] In a eulogy to Duncan, Max Eastman would refer to the result of this ambiguity within her in a peculiarly fitting formulation as a "wrongtiousness" that negates yet replicates the righteousness of Puritanism. In his commemorative essay in *The Art of the Dance* Eastman takes note of "an exaggerated reaction against America's 'righteousness.' *Wrongtiousness* is what you would have to call it if you wished to appraise it with a sense of its origin" (47). This felicitous coinage of "wrongtiousness" is extremely helpful in assessing Duncan's relation both to the puritan tradition and to the generation of dancers that followed on from her. It is not a simple, determinate negation but rather a dialectical negation. What it resists, finally, is an orthodoxy—be that an orthodoxy of consent or an orthodoxy of dissent. As Shaemas O'Sheel notes in *The Art of the Dance*: "America fighting the battle against Americanism—that was Isadora." In this sense,

"Isadora was very American. The big way in which she conceived things, and undertook them, and the way she succeeded with them, was American. Even her faults were American—her passion for 'pulling off stunts'— 'gestures' is the way she would say it—was American" (39). Formally, for all of Isadora's neoclassical posturing, her greatest skill lies in "pulling off stunts" or "gestures"; there is something of the music hall "turn"—a certain resolution of high and low—in Isadora's high cultural schtick.

Although it is not my aim in this chapter to render an impression of Isadora Duncan dancing—thereby "doing her into dance," to borrow Ann Daly's own borrowing from Isadora—it is nevertheless important to gain some notion of the stages of her career and the kind of body she presented at each stage. Daly's study is indeed one of the very best for conveying some sense of Duncan's changing stage presence. After Duncan's 1899 departure for Europe, Daly divides the dancer's career into roughly three stages. The first involved the lyrical manipulation of space in the three-dimensional enlivening of classical precedent. As Daly notes of Duncan at this time: "Her dancing, which was based on physical release, seemed to materialize her spectators' inner longings and impulses. This fluid self freely circulating—an image of "becoming"—appealed to a wide variety of spectators, who saw in her the embodiment of their own desire for social, political and artistic change. She was, for them, a symbol of spontaneity and freedom" (15). At this stage Duncan was offering something aesthetically new, but offering it quite specifically as a cultural import that effectively reasserted the "colonial" status of her homeland. This began to change in a second stage, characterized by the more allegorical dances of the war years. Under the influence of Nietzsche, as well as the towering theatrical figures of Eleanore Duse and Ellen Terry, Duncan "took to heart the example of the Greek chorus, and she endeavored to fuse the arts of music, drama, and dance" (15). Emblematic of this period were Duncan's interventionist dances—particularly the Marseillaise, for which she draped herself in the French flag. Although such interventionism alienated many in her base of radical supporters in America at this time, these dances made explicit—albeit in crude form—the project of national embodiment with which I frame Duncan's work in this chapter.

In the final stage of Duncan's career—roughly speaking, after 1922–23

and the sojourns in Soviet Russia—Daly sees "a monumental Isadora who barely moved, striving for the ultimate: to harness the force of dynamic movement in utter stillness. Her solos, sculptural and increasingly independent of their musical accompaniment, became more a matter of tragic acting—the expression of epic gesture—than dancing" (15). Although Duncan seemed to have penetrated to the heart of the Greek and classical models that had always inspired her, that very breakthrough went hand in hand with a new nativist discourse in her polemical writings against "nigger culture" and a playing up of her true-blue frontierswoman Americanism in her autobiography. In this Duncan differed from exoticist and orientalizing dancers such as Ruth St Denis, in that she no longer sought foreign examples *for* their foreignness but, rather, as the key to a more fundamentally "American" identity.

Ted Shawn, whom I discuss below, would subsequently attempt to characterize dance movements according to their gender specificity. Much that he would associate with "male" dancing was, in fact, derived from Duncan. As Daly points out, Duncan's dance was not vocabulary intensive—it was based on quotidian gesture and movement rendered pathetic through emphasis and repetitions but never reduced to a series of poses. (Particularly in the later years, however, when Duncan excised all extraneous movement from her work, many claimed that it was, indeed, a mere series of poses). These quotidian and gestural traits are values Shawn would claim for masculine dance. Even in photographs of Duncan from the earlier "prettier" dances we encounter an attempt to render massive the plane of the face and chest. For all of her skipping—imitated, much to her disgust, by her many acolytes—Duncan always located the seat of movement in the solar plexus (not the feet or legs), opening up her chest and pulling it upward out of a solidly grounded pelvis. Daly's descriptions of these basic and enduring elements of Duncan's aesthetic all serve to assert the autonomy of the embodied subject, following Duncan's own rhythms rather than a beat arbitrarily imposed by musical accompaniment. Duncan famously had a preternatural rhythmic sense that could dance against the beat while capturing the profounder flow of the music. She was, even in this regard, "wrongtious."

Max Eastman's invocation of Isadora's wrongtiousness allows us to think of the American national mission in dance—its "heresy"—as

something distinct from the national cultures of Europe. It is a cultural vision that seeks not an ideological closure but rather an embodiment; it is nation as body rather than nation as idea. We should note, however, that Duncan was not simply wrongtious—she was often just plain wrong. For example, she explicitly rejected "the ragtime, the trivial foolish jingles" (*IS* 38) as in any way representative of a true American culture. The racism underlying her rejection proves to be the rule rather than the exception in the writings of modern dance pioneers in America. As Susan Manning has noted, for all of its claims to a universal, transnational language of the body, "modern dance became an arena for the forging of national identity, while 20th-century ballet became an arena for international competition."[10] For Duncan, however, racism is but one element in a broader cultural snobbery that was part and parcel of her attempt to justify her own cultural endeavor in terms derived from nineteenth-century European high culture, even as she consistently presented herself as an American rebel. Her simultaneous invocation of an ethnic ancestry and her rejection of other ethnic cultures raise the question, however, of precisely which bodies will be allowed to embody the nation. Duncan, for one, would have been aghast at the conflation of high and low culture taking place in Martin's invocation of "American" forms of social dance as harbingers of a new social order. "America makes me sick," she will proclaim, "positively nauseates me. This is not a mere figure of speech. America produces in me a definite malady" (*IS* 129).

Of particular interest to me in this characteristically emphatic pronouncement is the linkage of America not only with a certain physical sensation of nausea but with the rule of the literal. Taking specific issue with the forms of American social dance, Duncan further complains, in an essay titled "I See America Dancing," that "it seems to me monstrous for anyone to believe that the Jazz rhythm expresses America. Jazz rhythm expresses the South African savage. America's music will be something different. It has yet to be written . . . Long-legged strong boys and girls will dance to this music—not the tottering ape-like convulsions of the Charleston, but a striking upward tremendous mounting" (*AOD* 48–49). It is telling that in denying to jazz and popular ballroom dance the status of an American art form Duncan should refer to the "convulsions" of the Charleston, as if this dance form somehow aestheticized her own abject relation to America. On the one hand she

insists that America makes her sick (convulses her), while on the other she refuses to draw from this the logical aesthetic conclusion; namely, that the dance forms appropriate to twentieth-century America may, indeed, be convulsive rather than inspirational. I see in this a perfect example of "wrongtiousness," or "America fighting the battle against Americanism." Try as she might to escape American literalism, Duncan is trapped in it: her rejection is physical and embodied; her hysteria is a literal expulsion of American literalness.

We can trace the rhetorical logic of racist and racialist images in American writings on choreography back to Duncan's nausea and with it the likely experience of "vomiting"—a hysterical attempt to locate and expel the foreign within the national body.[11] Duncan's convulsive reaction both rejects and enacts the status of the "literal" that is identified with America—her body dances a form of abject, convulsive Charleston even as she avers that such dances make her sick. In terms of the shift I have been tracing from literate to postliterate or performative notions of nation, it appears that when Duncan despairs of America she pushes it in the direction of the literal—the letter. But even as she does so it retains a literal grip on her body, convulsing her just as it convulses the dancers of the Charleston. Even as she rejects America, her body somehow remains American. Duncan offers clear examples of her "new ideology" in her 1927 essay "Dancing in Relation to Religion and Love"; an essay that allows us to think about the relation of religion to rhetoric, or of religious to aesthetic puritanism in her work. In this essay, we see coming together a variety of concerns that are traced throughout this chapter. Clustered around the trope of puritanism are issues of sexual liberation and ascetic aestheticism; concerns with the founding of nation and racial purity; dance formalism, and so forth. Here, these concerns all turn around the question of language.

It is important to read beneath the surface of Duncan's explicit ideological pronouncements—her racism and her eugenicism, for example—not in order to excuse them but rather to trace their implication in a broader attempt to move beyond an existing regime of language. Ramsay Burt has rightly noted in his study *Alien Bodies: Representations of Modernity, "Race," and Nation in Early Modern Dance*, how "in the inter-war years, difference was often expressed through bodily metaphors, 'pure race' being understood in terms of 'pure blood,' while anxiety over national boundaries (cultural, geographical) was equated with

concern over bodily boundaries, pollution and degeneration. Dance, whose primary means of communication is of course the body, therefore became a locus of anxieties over loss of national and racial identity as a consequence of the impact of modernity."[12] Consider, for example, Duncan's pedagogical zeal in the following passage: "It is of the utmost importance to a nation to train its children to the understanding and execution of movements of great heroic and spiritual beauty; to raise their many bans on the realization of sex, which is a fine thing in itself, and to put these same prohibitions on the frivolous caricatures and symbols of sex which are found in such dances as the fox trot and Black Bottom" (*AOD* 126). Beyond the attack on popular culture and the appeal to a new sexual ideal, Duncan's perverse puritanism—her wrongtiousness—reveals itself as a championing of what we might call the "real" (rather than the "literal," which again implies literacy and textuality) over the figurative. What she seeks is the self-realization of the nation through a "*realization* of sex"; her vehement opposition to popular culture, meanwhile, is an opposition to "*caricatures* and *symbols* of sex" (emphases mine). The opposition could scarcely be more explicit: a championing of an embodied—"realized"—sexuality over and against the symbolic. This antirhetorical rhetoric, I would argue, marks a crucial shift in the understanding of the function of the body in ideology: the body no long tropes the nation but rather realizes it and offers a fantasy of access to the real that bypasses the symbolic.

Of course, the question of embodiment raises questions of gender as well as race. Aesthetically, we might postulate that at this time the female body offered possibilities of ideological "realization" closed to the male, whose traditional ideological function remained mediated through discourse. As Duncan herself notes in her essay of 1905 "The Dancer and Nature": "One might well be led to believe that women are incapable of knowing beauty as an Idea, but I think this only seems so . . . Through the eyes beauty most readily finds a way to the soul, but there is another way for women—perhaps an easier way and that is through the knowledge of their own bodies . . . Not by the thought or contemplation of beauty only, but by the living of it, will woman learn" (*AOD* 66–67). Whereas Susan Manning in *Ecstasy and the Demon: Feminism and Nationalism in the Dance of Mary Wigman* has stressed the emergence of female spectatorship as a crucial moment in the kinesthetic continuum, it seems clear that for Duncan the function of woman

lies in embodying rather than visualizing and figuring the idea.[13] Op-
position to what I have been calling "literacy" and the opposition to
contemplation are of a piece. The new ideological body—the body that
seems to insist on its own reality and resist a figuratively ideological co-
optation—is female. We need to recognize in this formulation the open-
ing up of new ("antiideological") ideological and representational pos-
sibilities from within the gender stereotypes and rhetorical common-
places of the fin de siècle. The notion that men know and women
embody is to be found again and again in late-nineteenth-century and
early-twentieth-century sociological, sexological, and aesthetic writ-
ings, but now the opposition acquires new ideological significance.
Now, for the first time in America the nation is "here" rather than
"there," experienced immanently rather than posited ideologically. As
an embodiment of this new conception of nation, the female body
acquires new significance. Pointing the way into a new century, yet still
imbued with the romantic connotations of an old one, the body of
woman serves as a vehicle—a non-figurative vehicle, we should stress,
because this is not simply a question of a shift in tropes—for this new
experience of nation.

What I am suggesting here is that the new conception of embodied
nationhood and the shift from the ideal male to the corporeal female
opened up new aesthetic representations of nation. Martin's theoriz-
ing of metakinesis, for example, smacks of Freud's early, Charcot-
influenced description of medieval hysteria that "appeared in epi-
demics as a result of psychical contagion."[14] And it is perhaps not a
coincidence that Duncan's discovery of the solar plexus as the origin of
movement matches Freud's isolation of the hysterogenic zones "in an
area of the abdominal wall corresponding to the ovaries, in the crown
of the head and the region under the breast" (1:43). I am not suggesting
anything so banal as that Duncan was a hysteric—only that her rejec-
tion of national and sexual "caricatures and symbols" enacts and ex-
emplifies a shift toward new (and politically troubling) experiences of
nationality whose terms we can also find analyzed in early discourses
on hysteria. Nor, of course, am I positing an epidemic of hysteria as
historically determinant of the turn of the century. Instead, I wish to
examine the semiotic and somatic conditions of a certain aesthetic
ideology, a certain social choreography.

A model for understanding the shift from what I am terming, for

simplicity's sake, literate to postliterate aesthetic ideology can be de-
rived from later Freudian analyses of the shift from obsessional neu-
rosis to hysteria. In a neurotic compulsion, in the "Project for a Scien-
tific Psychology" Freud explains that

> the *formation of symbols* also takes place normally. A soldier will sacri-
> fice himself for a many-coloured scrap of stuff on a pole, because it has
> become the symbol of his fatherland, and no one thinks that neurotic.
> But a hysterical *symbol* behaves differently. The knight who fights for
> his lady's gloves *knows*, in the first place, that the glove owes its impor-
> tance to the lady; and, secondly, he is in no way prevented by his
> adoration of the glove from thinking of the lady and serving her in
> other respects. The *hysteric*, who weeps at *A*, is quite unaware that he is
> doing so on account the association *A-B*, and *B* itself plays no part at all
> in his psychical life. The symbol has in this case taken the place of the
> *thing* entirely. (2: 349)

In other words, in hysterical symbol formation, "*A* is compulsive, *B* is
repressed" (2: 350). It is telling that Freud draws his first example from
the realm of patriotism, for I am suggesting that the shift that permits
America to see itself dancing is a shift from a neurotic ideology of
nationhood to what we can provisionally call a hysterical one. We need
to distinguish between two modes of nationalism—one of which I iden-
tify with the literary-discursive formation of nineteenth-century phi-
lology, and the second of which eschews the discursive to seek imma-
nent aesthetic form in the dancing body. The shift from the former to
the latter is one that seems, furthermore, to be intimately tied to "the
heresy of an American art," to a peculiarly "American" understanding
of national self-representation. The resistance to translation most ex-
plicit in Martin's formulation of American modern dance—"when any
art form has got itself to the point where it can be translated into
words, it is dead as an art form"—is the characteristic form of this new
ideology.

We can co-opt this passage from Freud to elucidate a specific mo-
ment in Duncan's career: the charge of vulgarity aimed at her when, in
a moment of interventionist fervor at the beginning of World War I,
she wrapped herself in the French flag and danced—or posed—to the
strains of the Marseillaise. In the semiotic terms outlined by Freud,
the symbolic force of this performance is neurotic not hysterical—a re-

lapse into symbolic modes of national self-representation (identified by Freud with the male soldier and the flag). Isadora's "neurotic" perfor- mance in this, the second stage of her career (as outlined by Daly) implies that what I have been positing as a shift in nationalism—both temporal (from nineteenth to twentieth century) and geographical (from Europe to America)—is not abrupt and absolute. Duncan's per- formance was felt by many contemporaries to be uncharacteristically vulgar, but we need to understand the relation of the aesthetic charge of vulgarity to the symbolic nature of patriotism. The new nationalism— the nationalism performed in dance—is one that spurns explicit artic- ulation and the traditionally mimetic signifiers of denotative language. It is performative, implicit in the body itself—invested in movement. And yet according to Freud hysterical symbol formation is, on the contrary, rigid and "excessively intense" (2: 350): "Instead of *B*, *A* al- ways becomes conscious—that is, cathected. Thus it is *symbol-formation* of this stable kind which is the function that goes beyond normal defence" (2: 352). On the one hand, then, we have an ideology of dy- namically produced symbols—the body as a symbol of the nation that requires no flags or conventional markers and standards—and on the other a rigidity of symbolic formation that seems to filter into Duncan's very performances, eliciting from critics charges of vulgar "posing." To offer a critique of this new nationalism, then, we need to examine the relationship between its fluid, organic ideal of immanent community and the rigidity of the semiotic regime on which it relies.

In the tenth of his series of "Introductory Lectures on Psychoanaly- sis," Freud develops a semiotic of four types of symbolization: namely, relation of part to a whole; allusion; "plastic portrayal" (i.e., rendering visible and thereby disguising); and the symbolic. He then argues that "since symbols are stable translations, they realize to some extent the idea of the ancient as well as of the popular interpretation of dreams . . . They allow us in certain circumstances to interpret a dream without questioning the dreamer, who indeed would have nothing to tell us about the symbol" (15: 151). Thus we should beware of simply under- standing the symbolic as something organic that resists simple trans- lation—in strict opposition to a mechanistic or "literate" allegory. It is the very stability and translatability of symbolism that is particularly open to the collective task of nationalism. It is hardly surprising, then, that Duncan would be accused again and again of merely stringing

together in her dances a series of *poses plastiques* derived from classical precedent—for this freezing (or friezing) of movement exemplifies the rigid nature of hysterical symbol formation disavowed in protomodernists' insistence on kinesis or movement. At the same time as the ideology of embodied nationhood seeks to make organicist claims that mask its ideological provenance, it cannot simply open itself up to representational instability. The semiotic fluidity of dance would not provide the "stable translations" necessary for social and national cohesion, and so dance needs to organize itself around fixed poses and attitudinizing.

That we cannot assert a simple epistemological rupture in the semiotics of nationalism—a "historical trauma"—might be inferred from the complexity of Freud's etiology of hysteria.[15] He certainly suggests that the cause of hysteria is often clearly linked to a trauma, but that "in other cases the connection is not so simple. It consists only in what might be called a 'symbolic' relation between the precipitating cause and the pathological phenomena—a relationship such as healthy people form in dreams" (2: 5). There is, of course, a paradox here: the breakdown of symbol formation is the result of a merely symbolic system of causation: one fails to symbolize thanks to an overly symbolic or dreamlike reading of a cause. Thus, "in taking a verbal expression literally and in feeling the 'stab in the heart' or the 'slap in the face' after some slighting remark as a real event, the hysteric is not taking liberties with words, but is simply reviving once more the sensations to which the verbal expression owes its justification . . . Indeed, it is perhaps wrong to say that hysteria creates these sensations by symbolization. It may be that it does not take linguistic usage for its model at all, but that both hysteria and linguistic usage alike draw their material from a common source" (2: 181). Hysteria, then, is an example of "taking literally" that is both caused by and results in rigid symbolic structures. In other words, the body has become an engine for the rediscovery of the literal at the heart of the symbolic order of language. It is not a question of "taking liberties" with language; not a self-grounding "democratic" break with closed symbolic ideologies (indeed, the symbolic is itself more "democratic" in Freud's presentation because it is grounded in consensus and convention).

In explicating his model of hysterical causation—a "symbolic" break with symbolization—Freud uses the example of vomiting following on

a feeling of moral disgust. It is, we might surmise, the same process that Duncan invokes when she proclaims "America makes me sick—positively nauseates me. This is not a mere figure of speech. America produces in me a definite malady." Duncan's insistence on the literal condition of nausea is important: for her, vomiting is the moment of recognition of the nonfigural at the heart of language. This experience of language parallels the newly "embodied" experience of nationhood: America would, indeed, make her vomit. The very attempt to purge herself of America—as a national and a linguistic paradigm—is enacted in the realm of the literal that America represents for her. We might recall that paradox of American puritanism turned against itself in Duncan's wrongtiousness—the attempt to rid oneself of American moral puritanism through a more literal bodily purgation. Vomiting is the misrecognition of the obligation to embody, a hysterical expulsion of the hysterical episteme—a performative contradiction.

The question raised by this overlaying of Freud is essentially semiotic. How do bodies signify, and how do different bodies signify differently? Does this newly foregrounded bodily function of national representation shift us out of the possibility of "metaphor" in general and into a hysteric realm of nationalism? In other words, perhaps the "connections between the individual body and the collective body" (*ED* 28) that Susan Manning rather loosely identifies as the basis of choreography's ideology cannot be imagined simply along the lines of a symbolic representation. Indeed, the terminology of national self-identity already pervades Freud's understanding of hysteria when he argues that we need to treat traumas like "a foreign body" (2: 4) that enters our system and continues to work. Duncan's literal "sickness" at America allows us to think of vomiting as an expulsion of foreign bodies that both expels and enacts the hypersymbolic function that has taken control of us. The problem is that these traumas alienate us from our own bodies by making them the ground of a symbolization we no longer control. It makes our own body foreign. This is why we need to pursue the abject relations suggested in Duncan's literal nausea. If our hypothesis is true and hysteria becomes the condition of new national ideologies we need to face some troubling consequences. The dilemma of this new American "embodied" nationhood lies in a both implicitly and explicitly racial "urge to purge" that only serves to alienate us from our own American body. In what remains of this chapter I will concen-

trate on two related questions: racist eugenicism and gender panic as discourses on the fitness of bodies to their work of representation.

For Susan Manning, "what is difficult to accept with regard to Duncan is how intertwined were her feminism and nationalism. Both were tainted, her feminism with eugenics, her nationalism with the possibility of female spectatorship" (*ED* 285). Clearly, aesthetic and eugenic questions were closely linked for Duncan, who argues that "it is not only a question of true art, it is a question of race, of the development of the female sex to beauty and health, of the return to the original strength and to natural movements of woman's body. It is a question of the development of perfect mothers and the birth of healthy and beautiful children. The dancing school of the future is to develop and to show the ideal form of woman. It will be, as it were, a museum of the living beauty of the period" (*AOD* 61). This ideology of "perfect mothers" and "beautiful children" is overdetermined, driven by both a racism and a commitment to high culture that coalesce in an opposition to "nigger-culture." Duncan's racism demarcates the field of debate for early modern dance theorists in the United States precisely because the idea of performing the nation, rather than simply denoting it in mimetic fashion, entrusts to aesthetic creation an ideological function parallel to physical procreation. If my performance brings the nation into being, and if the nation in this new episteme is embodied, then my dance becomes a eugenic exercise.

While the rejection of "nigger-culture" is all too common in the writings of early modern dance theorists, it is interesting to note how this racism plays out against a romanticization of the figure of the Native American. The figure of the Native American serves, especially in the later modern dance, as a polemical counterpoint to the depredations of a popular culture coded as negroid. The racism of this construction goes without saying, but it is interesting to note the recurrence of the aesthetic underlying it. We will recall Martin's more nuanced rejection of both Native American and African American cultural forms as "the arts of the subject peoples of America" (*AOD* 37). Ted Shawn—cofounder, with his wife, Ruth St Denis, of perhaps the single most influential dance school in America, Denishawn, and later founder of America's first all-male dance troupe—in turn refers to black jazz culture as "scum."[16] His charge is repeated in less virulent form by Martha Graham, who turns instead to the Native American for an

alternative cultural and eugenic model, arguing: "We are an essentially dramatic country. We build in mass and are built in mass, spiritually and physically. We have two primitive sources, dangerous and hard to handle in the arts, but of intense psychic significance—the Indian and the Negro. That these influence us is certain—the Negro with his rhythms of disintegration, the Indian by his intense integration, his sense of ritualistic tribal drama.[17] Graham's opposition of Negro "disintegration" to Native American "intense integration" is telling; for the problematic of "integration" clearly allows of a political as well as an aesthetic reading. The Native American therefore serves two functions: he holds out the possibility of an "aboriginal" dance—that is, the reconstruction of an American origin—and the possibility of a resistance to popular culture that would not necessitate a retreat into the highbrow and equally "convulsive" forms of ballet.

In fact, Graham's essay flirts with political analogies only to confound them. Ambiguously, she writes: "Subject as we are to immigration physically, and sympathetic to it as we are spiritually, these waves of influence almost engulfed us. With what results in the art of the dance? That as an integral art form it did not exist and that the foreign forms were reduced to decadence in this country by the transplanting" (249). Immigration is something to which we are "subject" and yet the importation of people and ideas leads to degeneration. The influence of eugenic thinking on Graham's aesthetic seems clear: implicit in the parallel of foreign forms and foreign races (as "immigration" or "transplanting") is an assertion that a racial decadence befalls the immigrant. "As a result" of this empathy with the immigrant, Graham will write, "we have had a dance of 'appearance' rather than a dance of 'being'— instead of an art which was the fruit of a people's soul, we had entertainment" (250). Here, entertainment is posited not simply as a cultural value coexistent with, and inferior to, high culture: it is being opposed to a concept of ontological dance. America expresses itself through entertainment because, we are asked to believe, it has no ontological sense of self.[18]

Building on and moving beyond Duncan, Graham will proclaim: "We shun the imperialism of the ballet, the sentimentality engulfing the followers of the great Isadora Duncan, the weakling exoticism of a transplanted orientalism" (252). Just as Duncan and others claimed that the importation of European forms was inimical to the democratic

American spirit, Graham seems to be suggesting that any form of transplanting leads to decadence and degeneration in both art and life. Consequently, as a transplanted culture, Negro jazz will be rootless—as, of course, is the orientalism of Graham's teacher and rival, Ruth St Denis. Martin's rhetorical resistance to "translation" is here refigured as a political resistance to the disintegrating sorts of cultural transmission effected through immigration. In Martin's interpretation of Graham, we can perhaps best assess the relationship of geography to nation, national institutions, and the concept of *Volk*: "In what she has called the psyche of the country she bases her art, and her relation to it is almost a mythic one. She is a tenth generation American, but it is to the continent itself she belongs rather than to its people alone or to its national organizations. With its vastness and its variety, the rhythms of the American continent must necessarily be rhythms of integration rather than of expansion: the need is not for spreading out but for drawing together" (*AD* 203–4). The shift toward the body in apportioning the work of national representation has now progressed even further and the task has been displaced onto the very geography of the nation.[19] Whereas the attempt to ground national ideological cohesion in the body was an attempt to escape the very charge of ideology, the American experience of migration in fact renders even the body itself unstable. The putative ideological and aesthetic purity of the American body is compromised by cultural miscegenation. Only an intensely introspective and "integrative" Native American culture seems to resist this mingling, but finally it will be the land itself that allows for a postsubjective "nonideological" figuring of national ideology.

The fundamental question is that of the "aboriginal." All the figures considered here—Martin, Duncan, Graham, and Shawn—center on this question: Can there be an aboriginal American dance? If so, does it consist of Native American traditions or of a dance that reflects America as a historical force; an industrialized dance? If no such characteristic dance form exists, are we to eschew reflections on origin or are we to look outside America for anthropological remnants of an aboriginal dance (as early "exoticist" dancers did)? The anthropological displacement of originality onto the "other" marks a national alienation from the very concept of origin. The attempt to posit a cultural or genealogical origin will be replaced by a search for (geopolitical and metaphysical) "ground." Thus, the concern for all of these figures is with de-

veloping a social choreography that not only regulates the functioning of the community but also demonstrates that functioning to the rest of the world as a national characteristic. The desire to play off the immigration and assimilation central to the American experience against the "integrative" aesthetic represented by the Native American leads to precisely that hysterically literal vomiting and compulsive expulsion of "foreign bodies" that we saw in Duncan. What is required is an image of embodied nationhood that will not be an image—a metaphysical ground that will shun its own metaphysical pretensions through a merging with the literal dirt—the dirty literalness—of the ground on which we dance.

If our hypothesis regarding the "hysterical" nature of the new nationalism is correct, we obviously also need to consider the status accorded within this ideology to the male body. While hysteria is traditionally coded as feminine, it is not a question in this new nationalism of a traditionally "masculine" symbolic chauvinism being replaced by a new "feminine" performativity. Women had long since been privileged as symbolic national figures in popular and political iconography. Nevertheless, the new episteme of nationalism did pose particular problems to the male dancer. What has now, in popular prejudice, become a reflex association of dance with effeminacy originally posed more fundamental political, as well as social, problems. This problem of embodiment—the need to embody both masculinity and Americanness—is one that provided the ideological motor for the choreographic and entrepreneurial work of Ted Shawn and his male dance troupe. An anecdote from Shawn's memoirs might help us understand the issue more clearly. He tells how at the beginning of his career a fraternity brother "admitted, though grudgingly, that dancing might be all right for aborigines and Russians, but he contended that it was hardly a suitable career for a red-blooded American male."[20]

What configuration of forces—sexual, national, and racial—lurk behind this formulation? The question of sexual difference and effeminacy has been reduced to essentially racial terms—to the question of "red blood." If dance is, indeed, to become the quintessential American art form, what does this say about the American male? Clearly, our reflections on the nature of origin and the possibilities for an aboriginal dance need to be read in the context of a certain gender crisis concerning the activities proper to "a red-blooded American male." Historians

have already demonstrated that there was a cultural crisis articulated around the turn of the century in and through male bodies. Male bodies did, however, continue to play important ideological functions within dance—vide Nijinsky—and perhaps the major development within ballet in the early part of this century was the emergence, indeed, of the male body. So the question we need to ask as a correlate of the question of race is: What does it mean for a man to dance in America? If the paradigm for national embodiment has, indeed, shifted—if the body of the woman now provides the (hysterical) model for an immanent and nonreflective experience of nation—what does it mean for men to persevere, nevertheless, in dancing? In other words, are the twin tasks of proving dance's masculinity and proving its patriotic credentials—tasks we might assume to be unproblematically linked, given the patriarchal overcodings of most nationalisms—irreconcilable? If the very paradigm for national embodiment has been ideologically "feminized," might the male dancer not run the risk, indeed, of falling into a form of unavoidable camp, a performativity that renders even masculinity itself a masquerade? Certainly, a retrospective consideration of those works by Shawn that have been preserved on film can only strengthen such doubts.

The comment of Shawn's fraternity brother needs to be read in the context of internal political battles about the racial, rather than simply national, coding of art forms. Julia Foulkes has argued that "Shawn transformed his offstage homosexual inclinations to an onstage American virility, shaping the American male dancer into a near-nude Greek ideal of an athlete-artist: a heroic image that Americans heartily embraced."[21] While this might certainly have been Shawn's own perspective on his achievements—and as reminiscences by members of his troupe seem to bear out—I think here we need to take a slightly more critical glance. It is tempting to take Shawn's dichotomous views of gender at face value when in a 1916 article he contrasts his own masculine dance to "the decadent, the freakish, the feverish" Nijinsky.[22] As Susan Foster has noted, "where Nijinsky danced forth just this vision of the connection between sexual deviance and artistic brilliance, Shawn sought to mask the possibility of homosexual preferences and to refute any association between sexuality and creativity. Shawn's dances choreographed a closeting of the kind of homosexual desire [Havelock] Ellis describes."[23]

We are not concerned here with questions of who was or was not a trailblazer for a queer presence on stage, but I think we need to distinguish between what we might tentatively call "masculinity" and "virility." While Foster is obviously right, her observations by no means lead us to accept Shawn's assessment of Nijinsky. Shawn may be right in that early article—"America demands masculinity more than art" (19)—but for all that Nijinsky's masculinity or even his sexuality were at question, his virility never was; at least, not on stage. The feral and virile power of Nijinsky lay, for his audiences, precisely in his passage through the potential effeminization inherent in spectacular performance. His sexuality was perceived as an excess rather than a lack (of masculinity). Admirers were, therefore, often disappointed at meeting the unassuming and slightly malformed young man offstage. Shawn, by comparison—precisely because he must combat the effeminization potentially inherent in the medium—exudes a quite hysterical masculinity that undercuts its own pretensions. The masculinity his dances project is mimetic, prudish, or even camp. Foster's description of Shawn's dances give us some indication of what film footage also confirms—the centrality of the pose (a term already compromised well before the Marquess of Queensberry accused Wilde of 'posing of a Somdomite' [sic]) to Shawn's vision of masculinity. Foster writes of the dancers' "stiff torso, arms held rigidly in place," of "clenched fists," of dancers who "locomoted and then posed," of "relentless, repetitive, symmetrical" movements (164).

The nexus of virility and masculinity, then, is rather more complex than might first appear. Masculinity, we might say, is a hypostatized and hysterical enclosure of the otherwise uncontainable energies of virility. By contrast, a review from the German *Berliner Tageblatt* makes the connection clear between race and masculinity. "Ted Shawn," it states, "is a native of America. Usually you couple this land with the dancing of nigger-obstreperousness and the harassing of the jazz bands where everything sways in an elemental rhythm. Shawn has appropriated out of these phenomena only the best of his native country: freshness, youth, even boyishness. In his case you search in vain for the sluggish, degenerate Russian weariness of civilization—that soft unmanly femininity that disgusts us."[24] That the Ballets Russes should be associated with effeminization may not be surprising, but it is interesting to note how central a role this association played in the rejection of

ballet by certain modern dance enthusiasts. What I wish to note here, however, is the double front on which war is being waged—against the racial threat of "nigger-obstreperousness" and against the degeneracy, and degendering, of Russian ballet.

In defending his dream of an all-male dance company in an interview titled "Should Men Be Graceful?" Shawn invokes the traditional distinction between the spatial and the temporal in order to defend dance as an expression of masculine vigor: "God made man's body as beautiful as woman's. The perfect female body is passive rather than virile. It is beautiful in repose and languor, while man's body is beautiful in action and in its display of strength. A male dancer can be thoroughly masculine and there is every reason that he should be. But we have regarded beauty as belonging solely to woman for so long, that we consider beauty in itself effeminate, whereas beauty has no sex."[25] This passage is important for the way in which it envisages a "new" form of (masculine) beauty that is dynamic rather than passive. The attempt to rethink beauty as something dynamic partakes of the aesthetic ideology that I have been tracing here. This ideology sees the aesthetic as formative rather than merely mimetic (although, in practice, Shawn's own dances were highly mimetic on the whole) as well as an *activity* rather than an escape from social reality in Marcuse's sense of affirmative culture.

In order to befit dance as a medium for masculine activity, definitions of beauty organized around the poles of time and space, active and passive, and musical and plastic have to be reformulated. This entails a redefinition of the "work" of art and a reconsideration of the notion of performance. So long as it was considered a feminine activity, performance could content itself with traditional definitions of beauty: even as the woman performed she remained, nevertheless, an object or artifact for the male gaze. Dance as feminine activity does not threaten the status of the aesthetic artifact because the female dancer became, in effect, an artifact herself. When men perform, two problems clearly arise: first, the potential scandal of a male object of the male gaze (the queering of dance) and, second, the status of the artifact in performance. In order to avoid the scandal of a homosexualized aesthetic consumption (men watching men, whose performance is secondary to their physical embodiment), a new definition of aesthetic production is necessary. In a contemporary essay on Shawn's 1930s project for a

male—and masculine—dance, one critic, Lucien Price, poses the problem as follows: "But how shall male dancers erase the stigma against males' dancing? By dancing like men and not like women. Then how does a man dance? Their programmes are built from those rhythms of bodily movement which are recognizably peculiar to the male: hunting, war, ritual magic (tribal); planting, harvest, threshing floor, wine press (labor); play, sport, ceremonial (folk); and based on these—as sonata and symphony, 'pure music,' derive in part from folk dance and folk song—the dance as pure art form."[26]

The critic's assessment returns us to a question posed earlier that now needs answering in specifically national and gendered terms—that is, the status of "work" in the writings of early American modern dance pioneers. Price is actually reiterating what was for many the most objectionable of Shawn's theses on dance: namely, its reliance on outmoded gender stereotypes that held that women's work configured the small enclosed spaces and gestures of sewing, cradling, and enclosing, whereas the work of men suggested the opening up of an expansive space and a broad gestural language. In *The American Ballet*, Shawn draws his distinction in the following way: "Men have always done the big things, the important things in life, being quite willing to let the embroideries and ornamentations be the work of women. And until big themes, religious themes, cosmic themes, become again considered as the natural and rightful field of the dance, men capable of doing big things will not see in the dance an opportunity for great art expression" (93). By means of these grossly simplified gender binaries, Shawn argues that because religion condemned dance, dance was not able to treat the important things in life and became courtly and trivial—that is, effeminate. Of note for my consideration of ornament in the final chapter of this volume is the presentation of ornamentation as women's work.

Shawn's vision of America dancing, meanwhile, acknowledges the heterosexual compact that grounds even the seemingly antiauthoritarian American social dance. This element in Shawn's thought is commented on by contemporaries in the following tone: "Masculine Dancing (says Mr. Shawn) is on the sweeping scale; the great gestures. . . . All great gestures, Mr. Shawn says; perhaps on the grandiose order—gestures that start from the ground up and sweep out to an ending that is not an ending, but suggests a sort of going on to infinity. Now the femi-

nine gestures are more restricted . . . Their gestures suggest those of needle-work, rocking the cradle."[27] Any problematizing of the work-character of the aesthetic is of particular importance to the male dancer, who legitimates his aesthetic endeavor as the work of national self-representation. The problematic of work in Shawn's choreography divides itself between the desire to present dance itself as work and the desire to demonstrate the possibilities for a mimetic representation of work through dance. Which of these two justifies dance as masculine "work"? The problem Shawn will face is whether dance itself will have to remain mimetic in order to represent its own grounding in work, or whether it must efface this mimetic moment in order to assert that it *is* work, that it is a primary mode of production rather than as a secondary mode of reproduction and representation. In other words: the double bind consists in the need in the dance to represent and reiterate dance's movement beyond representation: do I present dance as hard work, or do I represent hard work in dance? The dilemma derives from the need to mark mimetically the relation to work as a grounding (masculine) principle and the disruption from the origin that a mere mimetic marking necessarily effects. To merely represent work thematically is to exempt oneself from the traditional obligation to work—to engage in the feminine work of reproduction rather than the masculine work of production. (It is highly significant that in all of the early propaganda for Jacob's Pillow, the home of Shawn's all-male dance collective, Shawn consistently spoke of the work the men performed in clearing the space, building their home, and so on. The dance company itself had thus become a microcosm of the American frontier.)[28] Shawn's fetishization of labor in many of his works offers a sexually inflected version of that shift I demonstrated in chapter 1—from dance as play to dance as labor. For Shawn, the interplay of male bodies in labor provided an acceptable framework for the rhythmic and erotic interactions that were otherwise taboo. Similarly, in writing of the foundation of Jacob's Pillow Shawn would write obsessively of how the men worked together to clear their own space—a space of dwelling but also a space of the aesthetic and (though never so acknowledged) of the erotic.

What is at stake is the status of representation as "work"—that is, as production or reproduction. Shawn's innovation—from an avowedly masculinist and yet anachronistically organicist position—was to aestheticize industrialization itself as the "techno-logy" of a newly erot-

icized social organization.²⁹ In the light of my reflections in the introduction on the history of social dancing, it is important to note that Shawn opposes his own high art (however camp) to the hegemony of social dance in its dominant and debased form of couple dancing. "I believe there is a place in the history of dancing for the couple dance," he writes in *The American Ballet*, "but when social dancing has entirely degenerated into couple dancing, it is a very sad time for the art of the dance" (45). While the relationship of theatrical to social dance has been theorized in terms of the relation of high to low, elite to mass culture, Shawn's theatrical elitism should be seen as something more than a simple aesthetic position. It is also a social critique: for "if we consider the true meaning of the word 'social,'" Shawn argues, "these dances are most decidedly not social and are almost anti-social" (41). The heterosexual imperative, he argues, actually works against the formation of broader social collectives by subtracting individuals from the group and pairing them off on the dance floor. The social vision embedded in so-called social dancing is inappropriately heterosocial, he will argue: "The wooing and courtship theme in life has its place, and a very important place, but it should not absorb all of our life . . . I believe that in this factory age, when so many people are doing routine things—take as an example the workers in a Ford factory . . . [that] man needs something better as a dance, to release his pent-up creative instinct" (46). The critique seems startlingly "queer" *avant la lettre*. Shawn is examining the ways in which an emerging commodity culture exemplified by the new dance craze not only reinforces the hegemony of a new monopoly capitalism but also normalizes and aestheticizes the heterosexual contract.

If social dance encodes heterosexual relations as a normative social order, obviously the maintenance of a high-low cultural divide at the same time retains the possibility—within high culture—for nonheterosocial experimentation. By the same token, new forms of work also open up possibilities of homosocial interaction, in which—to follow Foster's description—there is "no trace of the degenerate, no hint of the feminine. Inverting the invert, the dancers never looked soft or flexible; they never curved. They never even touched except in those rare moments when the choreography stipulated that all bodies contribute to a common design" (168). Given the degeneration of social dance to the minimal social unit of the heterosexual couple dancing together,

Shawn's reassertion of the high cultural mode allows for precisely the homosocial modes of dance to be found in works such as his *Symphony of Labor*. In short, for all his posturing, Shawn allows us to glimpse the continued importance in the twentieth century of the high cultural domain as an arena for homosocial experimentation. It is precisely when Shawn embraces industrialization as a template for the rationalization and abstraction of human motion (i.e., as the modernist practice described above by Foster) that the possibilities for apparently deeroticized homosocial encounters proliferate in the (aesthetic) workplace. Shawn's bodies become physically intimate at precisely the moment they become abstracted through their assimilation to a technological order of production. Thus, Shawn's aestheticization of labor is, on the one hand, politically troubling in that it posits a perfected technologized social order; on the other hand, however, the aestheticization of labor also makes visible the moments of excess—and the persistence of gendered bodies—in every rationalized interaction.

Rather than sharing Martha Graham's belief that "integration" necessitates a return to preindustrial or mythological cultures, Shawn sees the progressive movement of American history itself as a process of rationalized—yet eroticized—integration. The industrialized mythology of his own age represents for Shawn not only a new social order demanding new mimetic responses but also a model of "integration" through labor that is as compelling aesthetically as it is socially. T. Jackson Lears has demonstrated in his study of American antimodernism, *No Place of Grace: Antimodernism and the Transformation of American Culture, 1880–1920*, how many of the issues considered here—crises of gender, fears about immigration, and so on—came together at a crucial historical juncture.[30] He notes how "as the nature of work changed and women, immigrants and black men 'invaded' men's spheres, masculinity was experienced as increasingly difficult to prove. Sexuality emerged as a central element of American manhood" (99–100). While we are accustomed, from a Foucauldian perspective, to focusing on the emergence of "sexuality" in the late nineteenth century as a juridical and medical concept, in America at this time other forces are at play. Studying dance as the work of social integration—as social choreography—allows us to explore the emergence of sexuality, instead, as an aesthetic exploration of specific sociological phenomena. Similarly, anxieties about social changes in America—specifically with regard to

the question of immigration and the emergence of new competition in the workforce—also led directly to calls for an "integrative" rather than "disintegrative" aesthetic. This aesthetic—identified with the Native American rather than with the "disintegrative" influences of Negro culture—would offer one channel of escape from social "disintegration."[31]

In conclusion, we might see in the emergence of new modes of aestheticizing nationhood through dance—modes themselves identified with America as a nation—a response to certain crises in both personal and national configurations of subjectivity. Given though she was to melodramatic nationalist performances and simplistic national caricatures, Duncan enacted a shift toward what we can only provisionally call a "hysterical" or performative nationalism.[32] The paradoxicality of her position is revealed precisely in the compulsion—the choreographic "convulsion," indeed, that she would reject in her modernist successors yet experience through her own body—to vomit at the thought of America. For the expulsion and rejection of America's hold on her body is itself enacted in precisely the medium that the newly embodied nation would sanction—at the level of the real. Likewise, for all of her indebtedness to literary and philosophical precursors, Duncan nevertheless made possible a way of thinking the aesthetic beyond the traditional notions of "literacy." With the canonization of modern dance as America's national art form, Martin would subsequently make explicit the ideal of a move beyond community bonded in a mediated fashion by discourse to community physically bonded by metakinesis. The attack on literacy and the move beyond traditional symbolic forms of national identification go hand in hand.

4

The Scandalous Male Icon

NIJINSKY AND THE QUEERING OF SYMBOLIST AESTHETICS

The Nineteenth Century's guilt, *World War One*, was danced by Nijinsky on January 19, 1919. —Frank Bidart, *The Sacrifice*

Of the various characteristic forms that helped define the contours of a modernist aesthetic, dance is, perhaps, unique in that its leading pioneering practitioners were women. From Loïe Fuller through Isadora Duncan, Martha Graham, Mary Wigman, and others, dance provided a medium in which other voices of modernity might make themselves heard. Correspondingly, the groundbreaking scholarship in the field also has been carried out by female scholars whose work was central to establishing the related disciplines of dance history and performance studies in the academy. To engage in dance history, therefore, is to place oneself at a faultline of gender and aesthetics as they have been deployed in the establishment of a modernist canon. More recently, work on the male dancer has questioned some of our assumptions about the gendering of dance by examining the cultural context of male performance in the early twentieth century.[1] Such studies demonstrate what we perhaps already know—that male dancers have consistently been

effeminized from within the ideology of modernist performance. They slip from a position of masculine power and control exercised through cognitive knowledge into a dangerous realm of the body, while at the same time surrendering the traditional male power of spectatorship to become objects of aesthetic pleasure for an audience that for the first time—at the beginning of the twentieth century—was made up of both men and women. The display of masculinity is dangerous not only to the observer—who runs the risk of surrendering to an inappropriate voyeuristic pleasure—but also to the very condition of the male as a rational (i.e., male and unmarked) subject. The male dancer is a scandal—but what exactly *is* an aesthetic scandal, once the claques and coteries have gone home and the cheers and hisses have died down? Is there a "logic" of scandal—something intrinsic to performance rather than a contingent circumstance of its given historical coordinates?

Certainly, there is a narrative of scandal; it is the master narrative of modernist performance, no less. The scandal of Nijinsky's performances, the consciously engineered brouhaha of the opening nights— *L'apres-midi d'un faune* when Nijinsky feigned masturbation on stage; and *Le sacre du printemps* when the music was all but drowned out by the cheers and hisses of the audience—have become iconic moments in the recounting of modernism's genealogy. These moments offer dates and places around which a history can be written, and they dramatize that "tradition of innovation" that serves as our master narrative of modernism's glorious onward march. Perhaps the best example of this is Modris Eksteins's important study, *Rites of Spring*, which builds around Nijinsky's startling and scandalous choreography a veritable mythology of modernism, foregrounding the moments of violence inherent both in its aesthetic and in the politics that responded to that aesthetic.[2] Eksteins makes of Nijinsky an iconic figure for the atavistic male violence celebrated by modernism, and he offers an extraordinarily homophobic reading of cultural modernity organized around the thematic of sacrifice. He rightly points out that this major work by Nijinsky concerns the sacrifice of a young maiden, and he draws on this observation to critique a homosocial culture he conflates with homosexual desire. As Eksteins observes:

> If Diaghilev was increasingly bent on confrontation and sensation, so were his collaborators. In retrospect the preparations for *Le sacre* have

an almost conspiratorial air . . . the initial title Stravinsky assigned to the score was revealing and hardly affirmative: The Victim. And in the libretto the last tableau involves, of course, the sacrifice of the chosen maiden. The ballet ends with the enactment of a death scene in the midst of life. The usual interpretation of the ballet is that it is a celebration of life through death, and that a maiden is chosen for sacrificial death in order to honor the very qualities of fertility and life that she exemplifies. And yet in the end, because of the importance attached to death in the ballet, to the violence associated with regeneration, to the role of "the victim," *Le sacre* could be regarded as a tragedy. (39)

To Eksteins, Nijinsky serves as an icon to imply that modernism's exclusion of, and violent antipathy toward, women is the work not of a misogynistic heterosexual logic but of a homosexual cabal that hijacked Western culture sometime shortly before World War I. He writes quite explicitly of a conspiracy, a plot, of avant-gardists: "a kind of homosexual Swiss Guard" (34), he calls them, citing Stravinsky, a heterosexual coconspirator who turns state witness. Similar assumptions have underpinned many dance historical approaches to Nijinsky, however illuminating they may be in other ways.[3]

One might counter this scenario of homosexual misogyny anthropologically by discussing the logic of sacrifice inherent in all systems of representation, in the substitutional play of signifier and signified; or by historical context: the logic of displacement and sacrifice, for example, is complicated by Marie Rambert's recollection that in rehearsal Nijinsky himself danced the role of the Chosen One for Maria Piltz and conveyed a self-destructive frenzy that the female dancer could not match.[4] Instead, I wish in this chapter to tackle two fundamental concepts left unexamined by readings of Nijinsky as an icon of modernism's logic of scandal. The very terms "icon" and "scandal" themselves have been subsumed by the narratives of cultural history they ground and have lost the specificity of their meaning with respect to the works they seek to explain. How might Nijinsky allow us to understand just what an "icon" is, just how a "scandal" works? Do his works and the critical responses they generated at the time reflect any awareness of the semiotic specificity of these terms? Instead of reading the scandalously iconic figure of Nijinsky for *what* that icon connotes, might we return to his works in the hope of rediscovering *how* the icon connotes?

At first sight, there might seem no more mimetic medium of signifi-
cation than the icon. Like photographs or portraits, iconic representa-
tions relate to their referents by a system of mimetic similarity that
seemingly denies all autonomy to the signifier. To this extent, nothing
would seem less suited to modernism's orientation toward abstraction
and linguistic play. From such a perspective, the iconic would seem
hopelessly compromised by its dependence on representation and fig-
uration. However far removed the icon might seem from the logic of
abstraction we normally identify with modernism, my argument is that
a reexamination of the nature of Nijinsky's "scandals"—as something
fundamental to the problem of performance itself, something more
fundamental than the banal head-to-head of competing cultural cliques
on a given night in Paris—allows us to reexamine the operation of an
"iconic" impulse within pre–World War I modernism. I will argue that
the "queer modernism" that Eksteins effectively holds responsible for
an entire culture of violence in the interwar period was itself the "vic-
tim" of a cultural sacrifice, whereby a transgressively embodied and
performative masculinity was consigned by a tradition of post–World
War II criticism to the realm of cultural kitsch and identified with a
mimeticism that is in no way adequate to its cultural significance.

The traditional gendering of cognitive power relations at the turn of
the twentieth century held that while men could know truth, women
could embody it. In this division of labor, it seemed, there was some-
thing for everybody. Men gained power over systems of knowledge at
the price of sacrificing the possibility of any experience of truth, while
to women was ascribed the possibility of unmediated experience, un-
clouded by consciousness, but unformed by rational reflection. To ar-
gue simply that the dancer is effeminized by overstepping this bound-
ary is to underestimate just what it was that Nijinsky felt he could
achieve through dance. "I am a philosopher who does not reason," he
would write in his diaries, "a philosopher who feels."[5] A Socrates, per-
haps, who learns to dance only in old age, when facing imminent death,
or a Nietzschean Zarathustra, whose philosophy is expounded in the
dance. "Feeling" is invoked here not as a feminine, embodied supple-
ment to knowledge but as an alternative medium for its production.
Nijinsky thereby offends one of the most basic assumptions of the
autonomous bourgeois aesthetic as it had been traced by Kant in the
eighteenth century—namely, the separation of aesthetic and cognitive

regimes. It was precisely through the choreographing of the male body, I will suggest, that a fusion became possible at the time. In this chapter, I wish to consider Nijinsky's modality of "feeling" as something both physical and cognitive, as an experience articulated through the male body. I shall demonstrate the ways in which his body is refunctioned as it performs this work and I will outline a semiotics of the male body as something for which an otherwise abstract and disembodied aesthetics of modernism sought to make a place. I will argue that the critical modernist commonplace whereby the Ballets Russes have been presented as "the dream of Mallarmé realized" is woefully inadequate to an understanding of the work of Nijinsky as dancer and choreographer. Instead, in this chapter I posit a radical break between the symbolist milieu of the fin de siècle in which dance first reemerged as a viable and serious art form (in Fuller, and then Duncan) and the choreographic work of Nijinsky.

In order to trace this development I will focus on two performances by Nijinsky, whose work—like Duncan's—was never filmed. I will trace an arc from Nijinsky's most radical work, his choreography for *Le sacre du printemps*, to his final public performance in 1919 at a private benefit in St. Moritz, at which it finally became clear that he had, indeed, become insane. I will approach the first event through an important essay by Jacques Rivière that places Nijinsky's work within a choreographic continuum from Loïe Fuller through the work of Fokine for the Ballets Russes (the dances that made Nijinsky famous). Rivière's essay—for all its faults and its still tentative movement toward a new postsymbolist vocabulary adequate to Nijinsky's work—acknowledges the radical break that Nijinsky enacts. I will address Nijinsky's final, traumatic performance through his own diaries, kept as he slipped rapidly into insanity. Using the terminology of the American nineteenth-century semiotician Charles Sanders Peirce, I will argue for the "iconic" status of Nijinsky's performance, a mediated and semiotic relation to the "truth" of dance quite different from Duncan's ideals of immanent embodiment. The "literalness" of Duncan's performance, as demonstrated in the preceding chapter, marked both her break with and her indebtedness to a condition she herself identified with "America." Contemporary critics grappling with Nijinsky, by contrast, were haunted by the need to understand his choreography in terms of a poetics or a rhetoric. It is to this queer rhetoric of the male body that I seek to give theoretical

articulation in this chapter. Within this space of rhetoric that recognizes the materiality of signifiers, both linguistic and bodily, Nijinsky's choreography, I wish to argue, was open to the plays and displacements of sexuality in ways that the ultimately "literal" and antirhetorical choreography of Duncan and Shawn could never be. Similarly, it opened up a space of figuration that cannot be collapsed into mere mimetic representationalism.

Jacques Rivière's essay of 1913 on *Le sacre du printemps* is a startling and impressive attempt to come to terms with the significance of Nijinsky's choreography.[6] Essentially, it seeks—as Nijinsky seeks—to work its way out of a symbolist aesthetic ideology, yet it inevitably falls back into the rhetoric of that ideology in seeking a new critical language for Nijinsky's aesthetic innovations. Rivière effectively demonstrates the limitations of a traditional aesthetic logic organized around the binary terms "symbolic" (i.e., an organic and self-transcending system of representation in which signifier and signified bear a putatively natural relation to each other) and "allegorical" (i.e., a merely mechanical and constructed relation of signifier and signified). Here I will submit that Rivière's work suggests the need to introduce a third term—"iconic"—as an aesthetic possibility that cuts across such long-established dualisms. In positing a radical break between the new works choreographed by Nijinsky and the Ballets Russes repertoire established by Fokine, Rivière marks out two stages of innovation against artifice (herein lies, in fact, one of the limitations of his analysis—namely, his tendency to view aesthetic "progress" as a movement away from artifice into a preaesthetic, prelinguistic, and, ultimately, prehuman condition with "no trace of aesthetic effect. The work is presented whole and in its natural state" [164]). First, in the works of Fokine, Rivière finds a reaction to the artifice of a Loïe Fuller, darling of the symbolists. Fuller's artifice consisted of "the play of lights, floating draperies, veils that envelop the body and disguise its shape, the blurring of all contours; the dancer's chief aim is to lose herself in her surroundings" (164). In opposition to such vagueness, Rivière argues, Fokine offers line and contour; he "brought clarity back to the dance" (164). In one stroke, then, Rivière makes impossible any simplistic attempt to read the Ballets Russes as the dream of Mallarmé realized. Fokine's rejection of symbolist transubstantiation—the conflation of dancer and dance—culminates in a reemergence of the body. "Henceforth, our only im-

pressions were to come from the body's own movements and from the clearly visible and distinctly outlined figure drawn by the dancer with his arms and legs" (164): the body reemerges from the veils, indeed, from the very dance that veiled it. Faced with such works, Rivière avers, "I made a discovery in art similar to that of geometry in the sciences" (164).

At this stage of the argument Rivière identifies this discovery with "a perfect scientific demonstration" (164). There is, however, something troubling about an aesthetic that can be reduced to the terms of science, and it is perhaps Rivière's own reductionism that leads him to perceive a similar reductionism in the work of Fokine. According to Rivière, although Fokine's aesthetic advance lay in the re-presentation of the body from beneath its veils, in his works the body nevertheless disappears once again beneath the very figures it traces. "What is there that still obscures the dancer even after he has divested himself of all accessories?" Rivière asks. "The very intensity of his motion, his passage, his flight across time, the arabesque described by his movement: he travels along a road which he destroys in the very act of his passing" (164). Motion itself—and I shall pursue this line of thought in the final chapter of this book—has acquired an obfuscatory function, consuming the dancer in the same way that Fuller's lights and veils consumed her. What Rivière implicitly uncovered here is the operation in the aesthetic realm of a vitalistic ideology that conceives of meaning only as "force" or movement. Despite the apparent liberation of the body in Fokine's work, the body has, instead, been subjected to energies and forces that pass through it and consume it, much as Fuller was consumed by the lights and "flames" of her dances.

In those ballets that made him famous—such as Fokine's *Le spectre de la rose*, which Nijinsky would profess to find *trop joli*—"Nijinsky's body literally disappears in its own dance" (165). Rivière professes to find beyond the artifice of a Loïe Fuller, already rejected by Fokine, a second level of artifice in Fokine himself—namely, "dynamic artificiality." This artifice, or "lack of inner truth" (165), in works such as *Le spectre* is the moment of self-sublation: "In the course of his first ten steps, the dancer outlines a figure that immediately thereafter threatens to leave him, to escape, to go off on its own . . . Unchained, they regenerate each other by repetition, by redoubling, by variation . . . Thus, in their hands, the body loses its own form and articulation" (164). What are

we to make of this subjugation of the body to the "figures" it traces, and of the "redoubling" that so threatens Rivière in Fokine's choreography? Why does this aesthetic of balance and reiteration threaten Rivière's project for a truly modern choreography? In Rivière's presentation of Fokine, the disappearance (or disarticulation) of the body and the outlining of a figure are coterminous. As bodies disappear, figures are generated. As if picking up on Rivière, recent critics have argued that "although Fokine may have been introducing types of representation that were new to dance, they could nevertheless be fitted into existing conservative gender ideologies."[7] Fokine's failure fully to surpass early modernist precursors seems also to have entailed a failure to rethink the operation of gender in dance (and his own dismissive references to Nijinsky's "lack of masculinity" lend credence to such a conflation of the ultimate conservatism of his aesthetic and gender ideology).[8]

In Rivière's presentation of Nijinsky's work, passions reveal themselves in such a way that "we are able to contemplate them before the arrival of language, before they are pressed upon by the multitudinous and subtly varied but loquacious crowd of words. There is no need for translation; this is not a sign from which the subject must be interpreted" (167) Dance operates as a language that precedes language. This vision will parallel a projected sociology of "man's movements at a time when he did not yet exist as an individual" (168). Quite contrary to Nijinsky's own insistence on "vibration" as a mode of communication—and countering the iconic refusal to "stand for" something—Rivière wishes to eradicate from Nijinsky's "choreo-graphy" all sense of "vacillation." What this leads to is the assertion of a grounding "etymological" function in Nijinsky's choreography—a return to linguistic and somatic origins. Thus, Fokine grounds his vision "choreographically" in opposition to rhetoric: "Nijinsky's language consists of perpetual detail; he lets nothing pass; he seeks out all the corners. There is no turn of phrase, no pirouette, no preterition" (166). Finally, the etymological return to the very origins of movement proves itself antipathetic to any pirouette or rhetorical turn of phrase. Although he rejects the figural production of subject positions in Fokine, Rivière nevertheless attacks not the ideology of the subject itself, but the need for translating that subject through movement and linguistic mediation. This privileging of etymology over syntax makes of Nijinsky a

policeman of the dance—letting nothing pass, seeking out all the corners. This policing, finally, will extend to the body itself. Thus, for example, the etymological impulse behind Nijinsky's work supposedly envisages a strict ordering of the body in which "motion has been reduced to obedience: it is constantly made to return to the body . . . This is motion that does not run off, that has been forbidden to chart its own little tune; motion that must come back to take orders every minute. In the body in repose, there are a thousand hidden directions, and entire system of lines that incline it toward the dance" (165). The rejection of movement as that which causes the body itself to disappear finally leads here to an aesthetic of stasis. While Rivière purports to see in the body at rest "a thousand hidden directions," he rejects the rhetorical turn of the pirouette, privileging a return to stasis figured linguistically as an etymology. The result, for Rivière's analysis, is a monumentalism in which movement is only ever virtual and never actual, an aesthetic, indeed, that tends toward the totalitarian.

Implicitly, Rivière modifies the conclusions drawn in the preceding chapter about the decline of the philological and discursive as determinants of national identity. In fact, an academic philological concern with language has not simply been replaced by a new ideal of "embodiment," as my study of Duncan might suggest. A traditionally philological concern with linguistic derivation has also provided a model for understanding a certain "etymological" metaphysics of the body opposed to the mere grammar of social coexistence. In other words, it is not a question of "nineteenth-century philology" versus "twentieth-century body culture"; rather, what we find in Rivière is a shift away from the kinds of structural semiotics being developed at the time in linguistics that moves back to an ideology of origin and etymology. He attempts to ground the body's "own form and articulation" in an exclusive linguistic notion of etymology: "The body no longer is a means of escape for the soul; on the contrary, it collects and gathers itself around it; it suppresses its outward thrust; and, by the very resistance that it offers the soul, becomes completely permeated by it, having betrayed it from without" (166). This is a quasi-totalitarian world of "complete permeation" with no escape. Rivière's aesthetic model—grafted onto Nijinsky—is one of control and restraint, guaranteed by the unitary origin of embodied language. This gesture toward an alternative model of cultural production is at best, of course, politically ambiguous: it was

Rivière, after all, who would subsequently launch the conservative post–World War I *rappel à l'ordre* in French cultural life.

What Rivière misses in his insightful but tendentious presentation is the very fact of performance of which Nijinsky himself (educated entirely within the institution of the theater) remained constantly aware. To accommodate the actuality of performance to Rivière's critical response to Nijinsky, I turn now to a second performance—Nijinsky's final, terrifying appearance at the Suvretta House in St. Moritz at the time of his final descent into madness. Rather than simply opposing a "poetics" or "rhetoric" of dance to the actuality of performance, however—thereby privileging performance itself as an immanent happening of the choreography's "truth"—I wish to invoke the semiotics of Charles Sanders Peirce as a way of reconciling performance and text, body and soma. In essence, we confront the same question that framed the preceding chapter: What happens to the body—in this case, the male body—when it is obliged to perform the work of representation? It is in the critical and performative elaboration of this "work" of representation—not in the circumstances of specific stormy performances—that we must locate the scandal of Nijinsky's career and the ultimate "queering" of symbolist aesthetics.

As preface to our consideration of Nijinsky's final tragic—and, yes, sacrificial dance—let us consider the relationship of dance to the scandalous by way of René Girard's important essay on the Salome figure. In this essay, Girard assumes an ideology of dance performance that effectively elides representational work in order to set up an opposition of dance and scandal, arguing that, "scandal is everything that prevents us from dancing. The grace of the dancer delivers us less from our bodily infirmities, which are insignificant, than from skandalon itself. The movements of dance seem to untangle for us the otherwise unyielding knots of our desires. To enjoy the dance is to identify with the dancer; it is to dance with her and no longer to feel our imprisonment in Mallarmé's 'ice' or to be mired in Sartre's 'visqueux.' "[9] Scandal, here, is ontologically opposed to dance. To enjoy dance is to engage in a work of identification, while scandal is associated with both "bodily infirmities" and "our desires" and must be countered by an act of dancerly "grace." Only if dance is figured as disembodied and nondesiring does this distinction hold, of course—and Nijinsky's choreography is scandalous precisely because it refuses that separation. Girard's understanding of

dance—as the antithesis of skandalon—is mired in gender assumptions ("to enjoy the dance . . . is to dance with her") that are all oriented toward the establishment of a kinaesthetic identity. Nijinsky's choreography, I will argue, sacrifices precisely this subject position.

Girard's notion of skandalon is drawn from biblical and ecclesiastical Greek, where it is generally translated as "offense" or "unseemly or unrighteous conduct." This meaning, however, is only a secondary derivation from a more fundamental meaning of skandalon, in which it indicates either the trigger of a trap on which bait is placed in order that the trap be sprung, or a "stumbling block." For Girard, according to one critic's gloss, "the skandalon designates a very common inability to walk away from mimetic rivalry."[10] Scandal is, thus, related to the mimetic desires that generate cultural violence (the links to Eksteins's presentation of the violence of interwar culture are obvious here) and results at the somatic level in the erection of a "stumbling block," in an "inability to walk." Dance, meanwhile, as the bodily translation of a religious grace, is the aesthetic negation of such offence. In what follows, we shall see how the stumble, or scandal, forms the very basis of a choreographic vision in Nijinsky. Scandal is an aesthetic rather than contingently cultural circumstance in Nijinsky's work. It is not, then, a question of tracing the specific "scandals" to which his works famously gave rise but rather of understanding the function of scandal itself in his choreography—a "dis-graceful" aesthetic, so to speak.[11] Girard's ethical concept of the mimetic will be transformed, as I hope to show, into an aesthetics of the icon.

What exactly is the role, then, in Nijinsky's choreography of the skandalon that is otherwise presumed to be so inimical to the very aesthetic principles of the dance? To answer this question, let us begin with the performance noted by Frank Bidart in the epigraph to this chapter. It is the evening of Nijinsky's last public performance: his "marriage with God" on 19 January 1919 at the Suvretta House in St. Moritz. Teetering on the brink of insanity, Nijinsky seeks to represent to the well-heeled audience of this Swiss spa town the horrors of war by dancing among them and around them—by completely confronting them with his dance. As the dancer notes in The Diary of Vaslav Nijinsky, the audience is clearly terrified; which is for the best, as "God wanted the public to be in a state of excitement" (139). Nijinsky's own fevered mental state both facilitates communication and is itself that which is

communicated: "The public understands me better when I am vibrat-ing" (139), he will claim. Contrary to Rivière's assertion that Nijinsky's choreography excised all "vacillation" from the dance, Nijinsky him-self characterizes his very mode of communication—alienating him from any fixed notion of self and, finally, from sanity itself—as a self-differentiating "vibration." Scandalously, as he begins his dance Ni-jinsky stumbles and bloodies his foot, but "the audience did not care because my dancing was beautiful" (139). The aesthetic lapse and the establishing of the very possibility of beauty seem inextricably linked through the moment of this stumble. In order that the dance communi-cate, two things are necessary: an aesthetic "lapse"—the stumble—and an injury to the dancer's body, an injury that foregrounds the body itself as a signifying medium. It is through this slip that a specifically iconic representation is opened up—the dancer's bloodied foot stands in for (or, indeed, does not stand at all, but rather "stumbles for") the maimed and bloodied soldiers of the war.

This is an aesthetic lapse that establishes meaning. Meanwhile, the entry of meaning into aesthetic performance results in a materializa-tion and maiming of the aesthetic vehicle—the dancer's body. A hor-rified member of the audience looks: "I showed her the blood on my foot—she does not like blood. I made her realize that blood is war and that I do not like war" (139–40). The dancer's body is sacrificed to the representation of a greater sacrifice—war. This representational logic of sacrifice is at the same time a logic of substitution. Nijinsky stands in for the bloodied, maimed, and murdered soldiers of World War I: the substitution is iconic. Violence is the condition not only of war but of representation itself—Nijinsky's self-sacrificial commitment to the ob-ligation of signification. Violence is performed on the body in order that it be subjugated to the task of representation. Similarly, a certain violence is practiced on the self-enclosed aesthetic itself: Nijinsky slips. Nevertheless, he asserts: "My dancing was beautiful." The slip that establishes the chain of sacrificial signification—his bloodied foot for their bloodied corpses—at the same time becomes a precondition of beauty. Unlike the self-erasure of the "work" of dance that Rivière saw in Nijinsky's performance of Fokine, Nijinsky's own choreography foregrounds both work and violence as the preconditions of the male body's act of aesthetic representation. "Beauty" itself—as the seamless, symbolic meeting of signifying body and signified spirit—is called into

question as an aesthetic category. The male body cannot claim to "embody" truth and beauty without displaying the violence that such concepts necessarily introduce into the social realm and the violence that this task of representation necessarily enacts on the dancer's body.

This one incident effectively captures the crucial questions I wish to treat in this chapter. First, the question of Nijinsky's communicative vibration—which one might in other ways easily reconcile with theories of kinaesthesia central to modern dance both then and now—raises the question of stability: the stability of representation and the stability of identity. Paradoxically, it is only when he stumbles that Nijinsky recognizably "stands for" something. His "vibration" both destabilizes and yet fixes and circumscribes the space of the subject. But vibration is also linked to the question of movement and signification. To make the link explicit: vibration would be the movement of paradox implicit in the very notion of a semiotically "motivated" sign. In the language of the study of signs, a "motivated" sign is one in which—contrary to structuralist notions of pure difference—there is some necessary relation between signifier and signified. The "motivated" sign, in semiotic terms, is in a sense fixed because the relation between signifier and signified is a necessary one. Yet a motivated sign might also be thought of a sign that moves—a fugitive sign exemplified by the movement of dance, a sign that resists any fixation. What I am suggesting here is that Nijinsky's choreography for the male body brings to the fore certain problems inherent in any notion of cultural and semiotic "motivation." While the element of necessity inherent in the motivated sign guarantees some fixity, the motivated sign is also a sign that has been set in motion, that cannot be fixed. The attempt to introduce order into signifying practices introduces at the same time movement and temporality, the possibility of slippage. The tension between these tendencies, I will argue, results in Nijinsky's "vibration"—a play of movement and stasis—and the eventual fall into representation; the bloodied foot for the bloodied soldiers. Nijinsky serves as icon—and serves, ultimately, as an icon of the icon (his sacrifice to representation is, after all, a representation of sacrifice). Thus he obliges us to consider a counterpraxis of modernism that challenges the hegemonic discourse that takes abstraction, textual play, and indeterminacy as organizing categories.

The next question to consider is the specific mode of motivation in Nijinsky's performance at the Suvretta House: blood for blood. In

terms of the semiotic system elaborated by Charles Sanders Peirce—which I treat more extensively below—this is an example of iconic representation. This category of the icon, I will suggest, is important in several ways. First, as we have seen, it suggests a certain mode of representation—motivation as something paradoxically fixed and shifting. Second, the very representationality of the icon suggests an aesthetic in which the moment of figuration and mimetic representation has been—contrary to prevailing accounts of modernism—not only retained, but made the very essence of the aesthetic system. Third, Nijinsky's self-sacrifice is also self-reflective in that it signifies sacrifice—the sacrificial slaughter of the soldiers. In other words, it is not simply a question of one bloody signifier necessarily linked to one bloodied signified: there is an iconic homology of modes of signification also. My sacrifice is an icon of their sacrifice; and I sacrifice my sacrifice to theirs in order to represent it: thus, the iconic here thematizes itself. Turning, now, to a dispassionate formal analysis of the icon as semiotic modality, let us not forget the violent material implications of iconic representation for the body of the dancer.

The semiotic notion of "motivation," the possibility of a necessary and logical link between signifier and signified, introduces causality into the signifying process. It suggests the possibility of prediction and necessity, and yet does so through the medium of movement (motivation) and temporality. In order to understand the icon in some sense historically—as indicative of a historical shift in signifying practices and as the basis of an aesthetic that would challenge prevalent notions of modernism—I offer here a rudimentary presentation of Charles Sanders Peirce's tripartite theory of the sign. Peirce characterizes three basic categories of sign as follows:

> A sign is either an icon, an index, or a symbol. An icon is a sign which would possess the character which renders it significant, even though its object had no existence; such as a lead-pencil streak as representing a geometrical line. An index is a sign which would, at once, lose the character which makes it a sign if its object were removed, but would not lose that character if there were no interpretant. Such, for instance, is a piece of mould with a bullet-hole in it as a sign of a shot; for without the shot there would have been no hole, whether anyone has the sense to attribute it to a shot or not. A symbol is a sign which would lose the character which renders it a sign if there were no interpretant. Such is

any utterance of speech which signifies what it does only by virtue of its being understood to have that signification.[12]

These rational forms—these forms, indeed, that for Peirce constitute rationality itself—also suggest divergent theories of aesthetic form. Particularly striking in light of the "catachretic logic" I have invoked throughout this study is the definition of the icon as "a sign which would possess the character which renders it significant, even though its object had no existence." This icon renders visible a purely logical possibility, the idea of its referent, but cannot be thought of mimetically because its very visualization risks obscuring the idea beneath the tracings of the pencil. The iconic and the mimetic modes cannot be collapsed into each other—and it is through this space of difference, I contend, that Nijinsky's choreography slips.

Sticking with Peirce's own presentation for the moment, however, let us make explicit certain aspects of the argument perhaps obscured for those unfamiliar with his terminology. The iconic sign refers to a thing or idea, but is not materially dependent for its own existence on the existence of the thing to which it refers. For all that it represents, the icon is nevertheless antimimetic in the traditional sense since it conjures up the thing it represents, giving, in the act of representation, a reality to something notional. It is not the *result*, in other words, of a traditional motor process of cause and effect. To this extent, the icon is "disinterested"—in the sense Kant sees as fundamental to the workings of genuine aesthetic response—in the existence of the object it represents. Furthermore, the icon conjures *itself* up, as a material trace, in the act of signification. The index is here less interesting: as the contrary of the icon it is a representation materially produced by the thing it represents. It is, in a fundamental sense, motivated: without the existence of its own signified it would not itself exist. Finally, the symbol is of interest precisely because it has enjoyed a privileged aesthetic status within modern, postromantic aesthetic theory—most specifically in studies of dance. While we should beware of conflating Peirce's terminology of the symbol with that which we might otherwise derive from a tradition of aesthetic theory, it is not incompatible with romantic notions of the symbolic as a sublime coincidence of signifier and signified.

Peirce's identification of the symbol with the "name" suggests an ideal of Adamic language familiar from eighteenth-century language

debates; an ideal that hints at the operation, beneath apparent arbitrariness, of some inner, unfathomed necessity. By contrasting the symbolic structure of "names" to the logic of the Peircean icon, I seek to challenge the ways in which we habitually understand the function of cultural "icons" such as Nijinsky. Our constructions of the cultural "icon"—as the term has entered cultural studies—is, in Peirce's terms, more strictly speaking symbolic. An "iconic" cultural history, or a history written through cultural icons, would be one that could be reduced to so many "names" arrayed synchronically, as if meaning could somehow escape the temporal force of historical causality. Moreover, the common assent necessary to the establishment of an "icon" in this strictly symbolic sense is also a culture-forming moment—for it is not the collective that founds the arbitrary signifier, but the arbitrary signifier that makes explicit the community of those who assent and recognize the "name." It is this common understanding of the icon—this confusion of icon and symbol, in fact—that I challenge here.

Beyond the tripartite taxonomy of signs, Peirce also examines the modality of the sign's operation—likewise divided into three moments. Although these related notions of what he calls firstness, secondness, and thirdness are characteristic of all signs and cannot be mapped directly onto the homologous division of icon, index, and symbol (or name), the three sign forms nevertheless seem to be distinguished by their relative reliance on these functions of firstness, secondness, and thirdness. One might think of icon (or likeness), index, and symbol (or name) as forms of the sign in which the characteristics of firstness, secondness, and thirdness have, respectively, become the dominant. In Peirce's presentation, secondness as a quality of the sign would be "some real connection with the thing it signifies" (141) and thirdness the limitation that "it is necessary for a sign to be a sign that it should be regarded as a sign" (142). The symbol foregrounds thirdness, for example, because it is a sign only for the community that recognizes it as such. The index clearly entertains "some real connection with the thing it signifies." The icon lends a "material quality" (for example, "a lead-pencil streak") to an idea ("a geometrical line") and thus enjoys a privileged relation to the category of firstness as glossed by Peirce. In other words, the icon insists on the materiality of the signifier—the materiality of the body—in ways that run entirely counter to a symbolist aesthetic of the body's putative disappearance into the dance (as in

Mallarmé's presentation of Fuller). Simply to insert Nijinsky into a narrative linking dance and its literary figurations—from Fuller, via Duncan—is to preempt precisely the semiotic and aesthetic shift that Nijinsky in fact represents. He does not simply represent something different from Fuller; he represents differently, iconically.

Peirce's presentation of "firstness," the function of the sign fore-grounded in the icon's "material quality," questions certain essential assumptions of symbolist aesthetics. He glosses "firstness" as follows: "In the first place, like any other thing it must have qualities which belong to it whether it be regarded as a sign or not. Thus a printed word is black, has a certain number of letters, and those letters have certain shapes. Such characters of a sign I call its material quality" (141). This foregrounding of the materiality of the signifier suggests an aesthetic alternative to the communitarian metaphysics of the symbol. Thus, for example, the "significant" moment picked out from Nijinsky's perfor-mance at the Suvretta House was the moment of injury in which the aesthetically self-containing performance was interrupted by a stumble signifying the bloodletting of the war. This slippage materialized the signifying medium of the dancer's body. Rather than taking this stum-ble as an isolated aesthetic faux pas, we need to locate the radical break marked by Nijinsky's choreography in a foregrounding of the mate-riality of the signifier at precisely the moment where the body itself is subjugated, or sacrificed, to representation.

Aesthetically, an insistence that the sign display its own qualities—firstness—translates in Nijinsky's thought and practice to a refusal of perfection, a refusal of the signifier to disappear into its own signifying function. Thus, the bloodied foot—reminding us of Nijinsky's perform-ing body and of the work or representation—becomes a precondition of the "beauty" of his performance at the Suvretta House precisely be-cause he seeks to represent the way in which bodies—as representatives of nations—are being forgotten. While Nijinsky's avoidance of perfec-tion foregrounds the materiality of the signifier—and thereby under-mines the complete subjection of the signifying moment to its refer-ent—we need to note that it is, paradoxically, a scandalous aesthetic failure that makes the signification possible in the first place. It is only because Nijinsky stumbles and bloodies his foot that the significant linkage to the war and bloodletting is established. Thus, imperfection is not simply a failure of the signifying process but one that makes signifi-

cance legible in the first place. We might see the semiotic and the aesthetic in a compensatory relation here—the significance of the work is established at the cost of an aesthetic flaw: the semiotic slippage is at the same time a dancer's slip. The scandal that Girard opposes definitionally to the grace of dance has become the very principle of Nijinsky's aesthetic rather than a question of merely contingent taste.

At the same time, however, we need to recall from Peirce's presentation that "the Icon does not stand unequivocally for this or that existing thing, as the Index does. Its object may be a pure fiction, as to its existence" (252). The fact that "the Icon does not stand unequivocally" is marked in Nijinsky's performance both by the quite literally equivocal physical "vibrations" and by his body's eventual collapse in the dance. However, and this is crucial with respect to this iconic aesthetic, the body that is foregrounded in its materiality by virtue of the dancer's injury is not some kind of prelinguistic, "natural" somatic body, as Rivière claimed. Nor is it a body such as Duncan's that can take pain as the measure of truth and falsehood. The pain of an injury is, for Nijinsky, the very precondition of a body's access to truth—the representation of the senseless bloodletting of World War I. In a nutshell, Duncan effectively argues for an aesthetic purity grounded in nature: if it feels unnatural, if it hurts—as ballet does—then it is wrong. Nijinsky, by contrast, grounds his aesthetic in the moment of inevitable rupture with nature: unless it hurts, so runs the logic, he cannot know true from false. Whereas the dancer understood from a symbolist position performed the disappearance of her own body into the rhythm of the dance itself, any iconic understanding of the dancer would necessarily "knock up against," to use Peirce's terms, the materiality of the bodily signifier.

In an aside that allows us to introduce the reality of performance into the otherwise systematic presentation of semiotics, Peirce observes that "an occurrence is something whose existence consists in our knocking up against it." The shock of performance, semiosis in action, is a physical one: the sensation of knocking up against the "material quality" of the sign, a bloodletting. Nijinsky's works are scandalous not merely because they offend a certain historical taste—as the scandalous and violent opening nights of *L'après-midi d'un faune* and *Le sacre du printemps* make clear—but also because they stage the moment of shock itself, where aesthetic meaning "knocks up against" and brutalizes the

body of the dancer. The fact that the icon "does not stand unequivocally" further suggests, I think, a privileged status for the dance as an aesthetic form that also "does not stand"; that displaces bodies through time and space. The "pure fiction" of the icon's referent, however, potentially obliterates the reality of the referent by making it a mere "logical possibility." In other words, the bloodied foot that allows us to make the link to the bloodied and maimed bodies of the soldiers might also prevent us from making the link by engaging our solicitude for the present, the moment of performance. The icon makes thinkable what might not be thinkable otherwise—to the point, even, where we might suspect that it conjures into existence what it supposedly only represents. In other words, the iconic dance covers over its referent as it traces it—like writing or, to use Peirce's own very apt analogy, a diagram, "a lead-pencil streak . . . representing a geometrical line." By making visible and overt the idea of a geometrical line, the pencil streak not only marks out but covers over the spatial possibility it renders visible. Made literal or material, the trace covers its traces. Whereas the index depends for its existence on the existence of its referent, as the bullet hole depends on the bullet, in the iconic the possibility arises that the referent might, in fact, depend for its very existence on its representation. When the icon conjures something up, we cannot truly know if what it conjures up is, in fact, there. Something is created, or at least made visible, but something is sacrificed and hidden also.

My aim in this chapter has not been to examine the various and specific cultural phenomena of which Nijinsky served, in his own time and since, as icon. Important work has been done on Nijinsky both as a fashion icon and as the icon of a homosexual sensibility that has otherwise been ruthlessly eradicated from the modernist aesthetic canon.[13] I have been suggesting, however, that his iconic aesthetic was necessarily linked to the performative parameters of the male body at the time and to an acknowledgment of violence, pain, and sacrifice over and against an aesthetic of taste that asserted the seamless interpenetration of body and spirit, signified and signifier, and so forth. To this extent, then, we cannot abstract this aesthetic paradigm shift from the question of gender and, indeed, sexuality (as a deployment of gender). Nijinsky's performance of masculinity asserts the culturally masculine recoding of performance through a foregrounding of pain, sacrifice, the materiality of the signifier. With regard to the genealogy of modernist aesthetics, I

argue here that Duncan's innovations—acknowledged as crucial, often grudgingly, by practically all participants in the Ballets Russes—could nevertheless be squared with a gender binarism dictating that men "know" truth while women "embody" it. Nijinsky both queers this tradition—his is a male embodiment, of course—and yet helps re-establish a male-oriented canon of modernism; one that foregrounds, through the operation of the icon, those moments of pain, suffering, discordance, work, and the like that have become commonplaces in our vocabulary of the self-reflexive modernist artwork. If the female performer held open the possibility of an embodied aesthetic truth, Nijinsky demonstrates the violence that must be done to the body in the name of such embodiments. What is "queer" about this aesthetic is its refusal of a simple dichotomy of the natural and the constructed body, a foregrounding of the "work" that underpins the mythic cultural idylls that form the backdrop to Nijinsky's choreography.

By taking as our model Peirce's example of the pencil mark that visibly designates a geometrical line—even as it, in a sense, traces over and obscures the notional line it represents—we arrive at a play of iconic signification finely balanced between the overt and the covert. The pencil mark makes overt an otherwise merely notional line, but in its overt depiction it covers over something essential as well. This iconic play of overt and covert is surely reminiscent of that epistemology of the closet elaborated by both D. A. Miller and Eve Sedgwick in their presentations of the fictions of homosexual identity, and invoked elsewhere by Michael Moon in his citation of Nijinsky as the cultural bearer of the "open secret" of homosexuality at the beginning of the century.[14] The play of overt and covert seems intrinsic to the icon, which reveals even as it covers over, and to Nijinsky also as an icon of iconic sacrifice. We need to address these questions of truth and deception raised by the icon, whose access to truth seems, precisely, to lie across the way of deception. If Nijinsky as a homosexual icon evokes merely the "logical possibility" of a homosexual identity—itself an important cultural function in this historical setting—does he not also foreground the very physicality and materiality of the signifying function? We read in many anecdotes of the slightly freakish physicality of Nijinsky offstage, as if observers were surprised that anything material could be left of him after he had performed the work of representation onstage. Others, indeed, comment that very little was left of him, that

he was personally totally unremarkable; and we might even take his madness as the effacement of personal identity in the face of the work of aesthetic representation.

In reinscribing in explicitly sexual terms the question of "sacrifice" implicit in all semiotic substitutions, Jean Cocteau observes in his diaries that Nijinsky "gave himself to Diaghilev as a means of carrying out his mission. A sort of *sacrifice à la russe*."[15] Nijinsky's own conception of his relationship to Diaghilev, which Cocteau is merely reiterating and commenting on here, places sexual identity itself as the sign of a *sacrifice à la russe*. Here we face the questions of causality, motivation (in the semiological sense) and temporality in the icon. Is the "homosexual" subject—"Nijinsky"—that which is produced by the icon? Or is it instead that which is forfeited according to the iconic logic of sacrifice? Michael Moon has written in this context about the "strain of being a visible and intensely mystified embodiment of the open secret of male homosexuality in Paris and London in the decade or two after the epochal downfall and death of Oscar Wilde" (29). I wish to suggest that the specific sexual content of the icon "Nijinsky" is structurally related to the very form of iconic representation that his choreography foregrounds, with its play of overt and covert. Nijinsky's "stress," as Moon phrases it, is his sacrifice, but it is perhaps not too tortuous to recall here those etymologies cited by Lincoln Kirstein in the opening pages of his history of dance, which include, among other things, the notion of stretching—of *stressing* or tensing—concepts that acquire a new cultural significance in the context of Nijinsky's career.[16] I am suggesting here that the specificity of Nijinsky's "stress" derives as much from the task of "bearing a sign" as it does from the content of the sign itself, and that this burden is, indeed, intrinsic to his notion of choreography. The violence done to Nijinsky as the icon of a radically modernist aesthetic constituted a stress, a tensing, a queering that depended less on the specific sexual identity of the performer—he seems to have been only opportunistically homosexual—than on the representational limits of the iconic male body, to which cultural "embodiment" was both dictated and foreclosed. Nijinsky's "queer" aesthetic consists not in the expression of a sexual identity but in the performing of an iconic male body.

5

From Woman to Girl

MASS CULTURE AND GENDER PANIC

In tracking cross-cultural phenomena through dance it is tempting to divide the "Americanization" of European culture into two broad, and roughly sequential, periods. The first consists of the response, both in literary circles and in the popular psyche, to the wave of women dance pioneers such as Isadora Duncan and Ruth St Denis. Certainly, the central European tradition of *Ausdruckstanz* would find its precedent and inspiration here. The second period is characterized by reactions to the newly efficient and "Taylorized" body of the American production line, which found popular aesthetic expression in the mechanized movements of dance troupes such as the Tiller Girls. In such a presentation, then, "America" represents two seemingly contradictory impulses: toward expressive freedom, on the one hand, with a rejection of the rigid and arbitrary balletic forms that Isadora Duncan had stigmatized as anachronistic and antidemocratic; and, on the other hand, toward rationalization, mechanization, and standardization. This temptation to schematize the influence of America into two phases—emancipatory and rationalized—is overdetermined; for such a model also implicitly parses out high and low culture into those first and second stages re-

spectively. In such a schema, the "high cultural" pioneers laid the groundwork for a subsequent enthusiasm for dance that would then be distorted and capitalized on by the broader cultural industry. Thus, at first glance it might seem that emancipation lies in the realm of high culture, and standardization in the products of an American culture industry that was becoming increasingly influential in Germany.

Moreover, it is clear that this periodization is necessarily tied to questions of gender and the varying new "typologies" of femininity being exported from the United States. The response to American social experiments in acceptable gender roles was particularly pronounced in Germany, where, for example, the absence of any serious ballet tradition allowed progressive thinkers to respond much more enthusiastically and unequivocally to Duncan than was the case in neighboring France, where ballet—however decrepit—had an institutional history. Likewise, the late emergence of Germany as an industrial nation meant that enthusiasm for the forms of American mass culture, such as the Tiller Girls, resonated with an indigenous national project of rapid and belated modernization in ways that would have been difficult elsewhere in Europe. As early as 1902, Arthur Moeller van den Bruck, the gadfly Nietzschean intellectual—and subsequent leading figure in Weimar Germany's so-called conservative revolution—would refer to the Germans as "Americans with a Greek heartbeat" and argue that "if any poet is to succeed in harnessing the international katharsis unleashed by the modern variety theater and in our multifaceted modern-day existence within the conflictual structure of tragedy or comedy, that poet will be a German."[1] Germany was the place where the empty rituals of mass culture might be reconnected with a cultic, mythic value, where a rational—and rationalizing—modernity might encounter its radical, irrational, mythic. The reference to Moeller's book of 1902 also reminds us that the so-called and oft-noted Americanization of Weimar culture—particularly during the period of *Neue Sachlichkeit*, from around 1925 on—did not produce itself ex nihilo. A discourse on variety theater and its cultural implications can be dated back to the beginning of the twentieth century in Germany, where it was often seen as the one symptom of fin de siècle decadence from which germs of a new modernity might nevertheless be cultivated.

In simple terms, in this chapter I examine how new models of mass cultural identity emerged in interwar Europe as a result of the importa-

tion of American theatrical dance forms. My emphasis here is on different registers of theater dance rather than on popular social dance trends, which I touched on briefly in the introduction. I further wish to demonstrate in this chapter how debates about gender and cultural hierarchies helped shape each other. My critical intention is not simply to trace a history of cross-cultural reception but to demonstrate how an inability to account for imported cultural phenomena within the existing cultural logic for the first time effectively necessitated the development of a critical conception of social choreography as a means of analysis. The predominance of performative, ritual, and choreographic modes of social cohesion in a given society does not necessarily lead to the emergence of a critical vocabulary for articulating or critiquing that society's choreography. Indeed, it seems that some distance—the distance of cross-cultural transmission and translation, perhaps—is necessary if such a critical discourse is to arise. To argue that specific societies are highly aestheticized (either in their self-conception or in their de facto practices) is not the same thing as arguing that such societies produced a sociological discourse of "social choreography" adequate to the elaborate forms of performance that imbue them. Quite the contrary; it is only when a certain choreography breaks down, in periods of transition, that the operation of choreographic norms and conventions becomes explicit and a critique of social choreography becomes retroactively possible.

In the preceding chapters, I demonstrated how questions of both gender and sexuality were crucial to the aesthetic and cultural processes of modernization. Critical attempts to establish an abstract modernist aesthetic emptied out of the contingencies of age, sex, race, and the like inevitably "knock up against" the realities of gendered bodies in both theatrical and quotidian performance: dancers stumble and vomit. As an aesthetic genre, dance had been almost unique in the central role it reserved for the figure of the woman—even though, as feminist scholars show, the crucial distinction of choreographer and performer served to dislodge women from the central aesthetic position by rendering them mere executors rather than creators of dance. As we saw in the case of Duncan, however, even where the "genius" of the dance was indisputably female, the ideological "significance" of her performance was still very much at stake. The emergence of the female body on the stage—and even its deployment on the dance floor, as

illustrated in the introduction—corresponded to shifts in the under-standing of ideology. Rather than ideology being a rational system of belief that put bodies in motion, the bodily presence itself, in the "hys-terical" mode outlined with respect to Duncan, became the guarantor of the immanence and truth of an ideological construct. In this chapter, I move from the realm of a self-policing "high art" to the realm of popu-lar culture in interwar Germany to show the progression of this shifting relation of ideology to body. In its most lapidary form, it is a shift away from the figure of the Woman to the figure of the Girl—that American hybrid that so fascinated German audiences and German intellectuals in the period of relative economic stability from 1924 to 1929.

In this concluding chapter, I will examine both theoretical and popu-lar critical responses to the importation of American culture into Wei-mar Germany in order to suggest that one of the crucial responses to the breakdown of a homogeneous national culture lay in a redeploy-ment of the gendered terms in which concepts of "mass" culture had heretofore been understood. In brief, I will trace a shift within a consis-tently feminized mass culture away from the figure of the alluring fin de siècle "Woman" to the new, rationalized and hygienic persona of the American "Girl." It has become commonplace to note the identifica-tion, both then and now, of an aesthetically and socially stigmatized mass culture with the feminine "other" of a rational, modernist, mas-culine high culture.[2] By taking the example of Weimar Germany, I will demonstrate that a simple gendering of existing binaries of (masculine) high and (feminine) low culture fails to take into account important differentiations existing at the time within the stereotypes of each gen-der and cultural stratum. In earlier chapters I examined some of those shifts as they affected the body's perceived ability to embody ideas (of nationhood, for example) and concentrated on the iconic function of the male figure. In this chapter I focus on popular cultural codings of femininity in the period immediately preceding and following World War I. Specifically, I will argue that in the shift from a figure of Woman to the figure of the American Girl, so ubiquitous in Weimar cultural criticism, we encounter not simply a shift in ideologies of gender but a radical shift in the understanding of mass cultural modernity itself. The Girl is not simply one part of a broader phenomenon of cultural "ratio-nalization": rather, she is the emblematic figure of that process and, in many ways, the figure that brings it about in the popular imagination.

The examination undertaken here occupies a mid-space between cultural-historical analysis and abstract aesthetic theory in order to elucidate the ways in which social choreographies are produced in the translation from one level or realm of culture to another. Taking my cue from Siegfried Kracauer's analyses of the Tiller Girls—the most famous of the drilled female chorus lines that visited Germany at this time—I will focus on the aesthetics and politics of the revue form, which was generally understood by German intellectuals as the primary example of the Americanization of European culture.[3] While dance pioneers in Germany and America alike were keen to dissociate themselves from the tradition of the music hall, the variety theater (variété), and the revue, it was precisely the revue format that seemed to exercise the greatest influence on a huge swathe of intellectuals in Germany from the late nineteenth century on. In their writings, the aesthetic implications of the revue would be worked out alongside, and often explicitly in opposition to, an earnest, metaphysically laden tradition of modern dance in Germany. It is important to read the revue as a cultural form that not only incorporated choreography as one element within a broad range of entertainments, but—with its loose organization of a series of acts or "turns"—also suggested new modes of aesthetic structure, new possibilities of a social choreography beyond the footlights. Traditional, cohesive principles of theatrical organization were thrown out in this new form of entertainment, which was predicated solely on the stringing together of diverting acts or turns. This new freedom, and this hegemony of the *amusia* that had so troubled Ruskin, in turn suggested new modes of atomized social organization. In taking the "low cultural" revue as a prism through which to focus on changing social choreographies in interwar Germany, therefore, I wish to challenge readings of the cultural process of modernization that have focused solely on the unquestionably important tradition of modern dance in Germany. Any account of modernism, modernity, or modernization that fails to take into account debates about popular culture at the time ignores the very arena in which the terms were being defined, and from which German artists and intellectuals—such as Brecht and Kracauer, to name just two—so often took their central concepts and practices.

The enthusiasm for a rationalized popular culture cut across traditional political boundaries of Left and Right. Walter Benjamin's celebration of mass reproducibility, for example, is but one theoretical

formulation, however equivocal, of a more general enthusiasm among both intellectuals and the consuming public in Germany for the liberating effect of industry in the cultural realm.[4] For these reasons, however, we cannot understand German enthusiasm for emerging American cultural forms at this time as a simple cultural capitulation. Clearly, the realignment of gender and cultural hierarchies that the reception of these forms implied had been prefigured in earlier debates within the mainstream of German culture. As the cultural critic and sociologist Fritz Giese states in his definitive study of so-called *Girlkultur*: "It was not a German mentality trained in the tradition of Turnvater Jahn that was receptive to this new dawn and to woman. Rather, it was a free America that first arrived at this new physical culture—first in ideal and theoretical terms, and then in a practical and applied form."[5] This new American phenomenon of physical culture supplemented a perceived lack in the Germans's historical sense. If American body culture represented something new it was, nevertheless, something for which Germans—with their nineteenth-century ambitions for national unification so closely linked to questions of physical regeneration and drilling—felt a particular affinity. Thus, Giese contrasts American industrial rationalization, which respects the rhythms of the body, with the military rationalization and subjugation of the body identified politically in Germany with the figure of Turnvater Jahn. Nevertheless, a traditional focus in German thought on the necessity of healthy bodies to the well-being of the state at least provided a frame of reference for his assessment of this new form of body culture.

In his magisterial study *Berlin Cabaret*, Peter Jelavich demonstrates certain crucial shifts in popular mass culture from the pre- to the post–World War I era in Germany.[6] In the prewar era, when Berlin was one of the fastest-growing cities in the world, the theme of modernization—so crucial to the revue—was one that allowed for a foregrounding of Berlin itself as a national exemplar of modernity. The characteristic elaborate reviews at the Metropol Theater that began in 1903 carried titles such as "Get the Latest!! The Very Latest!!" ("*Neuestes!! Allerneuestes!!*"—1903), "You Gotta See it!" ("*Das muss man seh'n!*"—1907), or "*Chauffeur—In's Metropol!*" (1912), which aimed to put on display the modernity of Berlin as well as the phenomenon of the revue itself as an exemplar of that modernity. This cultural self-confidence diminished considerably after the war, according to Jelavich; the prewar exuber-

ance of a growing nation was replaced by an attempt to cast modernity in specifically international and cosmopolitan terms. In its postwar forms, the Berlin revue aimed to prove its modernity by offering up acts of international quality that had earned a reputation elsewhere on the stages of the world. Modernity is now measured not simply in terms of relative national cultural production (a kind of cultural gross domestic product) but in terms of possibilities for consumption and the ability of urban cultural entrepreneurs to bring international cultural goods to the marketplace. Specifically, of course, it was America that came to stand for all things modern and that came to be showcased on the Weimar revue stage. Moreover, the revue itself changed as a mode of production. Under the aegis of figures such as Erik Charell (1894–1973), James Klein (1886–1940s), and Herrmann Haller (1871–1943), the *mondain* entertainments of the prewar period were replaced by the kinds of megaspectacle that prompted theorists such as Kracauer to develop ideas of the "mass ornament" to account for such new forms of entertainment. On a given night in the peak season of 1926–27, Berlin's competing revues collectively seated upward of eleven thousand people. As the title of Charell's 1924 revue indicates, this form of entertainment was intended *For Everyone!* (*"An Alle!"*). Perceived cultural sophistication consisted less in the judgment of an elite, social or cultural, but in the very operation of the market itself, in its ability to match what was on offer elsewhere and to disseminate the goods to a mass public. Cosmopolitan sophistication and mass dissemination went hand in hand.

In tracing these shifts Jelavich focuses on concerns about public decency and highlights various attempts to regulate public nudity—female nudity, that is, of course—in the face of a relaxation of laws of preliminary censorship after the war. To this extent, his study of the variety theater turns on questions of the legitimacy or illegitimacy of its content. I argue, however, that the "promiscuity" of these new forms of entertainment was not simply a question of what was put on show, but rather now seemed embedded in their very mode of production. Whereas the prewar Metropol revues were generally authored by a single person or a team of musical and lyrical collaborators, the new mass spectacles were cobbled together from any number of pieces in a random organization that seemed to reflect the arbitrariness of life in the modern urban milieu. Moreover, unruliness and cultural decay

seem measurable now as a principle of production rather than as a matter of what, precisely, is exposed on stage: the unmotivated leap from one turn to another is itself unseemly. The temporal organization of the form—not just the type of music it showcased—seemed radically syncopated. As one observer quoted by Jelavich noted: "Just as operetta is defined musically by the three-quarter time of the waltz, the revue is characterized by two-quarter time, and more precisely by syncopation. A revue without syncopation seems almost unthinkable to us today."[7]

"Syncopation" functions in the critical discourse of the time as a kind of code word for cultural disruption—think of Adorno's later, much-maligned essay "On Jazz."[8] It stood for a distortion of the very parameters of temporality necessary to the establishment and transmission of any consistent and meaningful cultural narrative. Syncopation occupied a singular position in the debates concerning rhythm that I outlined in the introduction. On the one hand, it clearly disrupts a measured and established social *Takt*—but it was precisely the reduction of primal rhythm to such rationalized Takt that the vitalists rejected. Thus, the culture of syncopation imported from America was particularly threatening, for it demonstrated how modernity could generate, from with itself, its own counterdiscourse, so to speak. Rigid and reified social conventions of tact could be opposed not only by a return to a vitalistic Körperkultur but also by passage through the very process of rationalization itself. Nevertheless, there is something paradoxical in the writings of the time in this notion of a syncopated mass culture, for syncopation seems to deny the common ground, a historical place, within which a mass might find itself.

Despite focusing on the question of decency, when it comes to a consideration of the chorus line Jelavich is obliged to note the almost fetishistic recurrence of a rhetoric of desexualization. If the revue was constructed according to the principles of what we might call a "formal promiscuity"—the potential movement of parts or acts from one place on the program to another, the equivalent of Benjamin's photographic notion of "reproducibility"—the Girl reintroduced an element of propriety. Studies such as Fritz Giese's *Girlkultur* took readers behind the scenes of the girls' routine—as, indeed, did many Hollywood films of the era—to emphasize the hard work and gymnastic training that left the sexy starlets little time for romantic dalliance. The Girl signified work not (sexual) play. If, as Jelavich convincingly argues, the imme-

diate postwar concern was with reestablishing some parameters for the acceptable public display of female nudity, the subsequent growth of the revue as a mass form of entertainment in the 1920s seemed to bring with it different concerns.[9] What, then, is the relationship of the growth in popularity of the new Girl—specifically, the chorus girl—to the displacement of overt sexuality as the central concern in discussions of popular entertainment? If the body of woman serves in popular cultural form as that which might be revealed—and that which, through revelation, might show us more than we can handle—the Girl no longer poses that threat. Her ideological function is entirely different from that of the woman, the concerns about her performance almost unrelated to the concern with sexuality and nudity that had swarmed around even figures such as Duncan.

The influential reviewer Herbert Ihering argued that "the American Girls are a sight worth seeing and a standard to follow. Beauty on stage, not through nakedness, but through motion."[10] Though still a spectacle the girls have become normative, a "standard" rather than a sexual *promesse de bonheur*. In Ihering's opposition of spectacular nakedness and a new kind of "motion" we begin to sense the larger philosophical questions that framed the intellectuals' reception of American popular culture at the time. His opposition depended on an underlying binary of "vital" and "static" culture that was a commonplace of the Lebensphilosophie of the time. The irrationalism and vitalism of Lebensphilosophie provided a crucial ideological underpinning to the choreography and writings of the practitioners of Ausdruckstanz of the period—an attempt to capture in dance primal forces threatened by the alienating and inevitable process of social rationalization. The dance historian Claudia Jeschke has encapsulated the common cultural cause of Lebensphilosophie and Ausdruckstanz as a "cultural space . . . nurtured by a variety of philosophical, even cosmological, ideas about nature, body, rhythm and women, which, as early as the second half of the nineteenth century, were meant to help overcome social alienation."[11] Within this "cultural space" Ihering's pronouncement is important, for Girlkultur does not here simply oppose the primal "rhythm" as a cultural value. Instead, it dances to the even more powerful rhythm of capitalist production, thereby undercutting simplistic oppositions of organic/rhythmic and mechanical/arrhythmic cultural values, vital and moribund social orders. It is this harnessing of ideals of primal

rhythm to the realities of mass production that rendered the phenomenon of cultural rationalization so attractive to the German intellectuals of this period. As if in fulfillment of Moeller van den Bruck's 1902 prediction, the girls have transformed rational, agnostic modernization into a mythic logic of its own; they have reconciled the organic and the mechanical, the rhythmic and the rational, in ways that made them a peculiarly potent symbol to a generation of intellectuals fluent in the critical vocabulary of Lebensphilosophie.

I wish to focus here on the interplay and opposition between the two modes of embodied culture suggested by Ihering—nakedness, on the one hand, and motion on the other—to argue that a shift from the former to the latter—both within Ausdruckstanz and, in very different and indeed antipathetic ways, within revue culture—marked a shift in the function of ideology. This shift—while obviously not a clean break because nudity was always a central component of even the most sophisticated mass revues—is not simply a shift in what is or is not acceptable with respect to the display of women's bodies: but rather is a shift in which the very significance of the woman's body changes. It is a shift from truth as a referent, as something to be displayed or laid bare, to truth as something dynamic, to be performed and brought into being. Truth and nakedness can no longer be unproblematically and rhetorically linked as they were for Duncan. If, as we shall see, it is Kracauer who has become synonymous with the examination of Girlkultur as a form of cultural "display," Fritz Giese is, in fact, closer to the mark with his observation of the girls that "they weren't just a spectacle, they were an achievement (*Leistung*)" (17).[12] While I would not wish to argue that the pre/post World War I divide is marked by the erasure of all display, it seems clear that for intellectuals of the time the original thrill of seeing something displayed is replaced by seeing something in motion, performed or, in fact, produced. Truth is no longer something extrinsic that needs to be displayed (as in a sexual revelation) but rather is something that has to be performatively produced: it is, indeed, the very fact of production, its inexorability, that is the truth. Performativity, here, needs to be understood not in terms of a playful questioning of the absoluteness of truth but as cultural work, the work of the production line that the girls brought to the revue. Truth no longer lies in the Schillerian realm of play—whereby an individual freely reconciles himself with the dictates of a choreographic necessity—but in

the impersonal dictates of a system of mass production that nevertheless taps into a primal force greater than the contingent historical subject herself.

We also need to note the implicit gendering of this shift from revelation/display to performance or Leistung. Film theorist Steve Neale has noted how, in filmic representation, femininity can be laid bare, or visualized as a secret to be revealed.[13] The female body always has a certain self-referentially fetishistic function: it stands for what is hidden; and what is hidden, more often than not, is the secret of female sexuality. The male body, meanwhile—and here he uses the classic example of the Western gunfight—can be shown in close-up only at the moment of a test, when some special performance or achievement is demanded of it; the fiction being that we are looking not at the body but at its actions. It would not be anachronistic to apply similar terms to the analysis of interwar popular culture, for such gender ideologies certainly date back at least as far as the nineteenth century. Thus, for example, Ernst Schur in his 1910 study *Der moderne Tanz* is typical in arguing that "it may well be that there is a masculine and a feminine form of dance. The feminine is plant-like, unfolding itself softly, blindly in search of itself. The masculine form is an animalistic desire to take possession. Where the first transpires spiritually, the latter seeks to conquer."[14] This characterization, which one finds repeated ad nauseam in the writings of *Ausdruckstanz* promoters and *Körperkultur* enthusiasts, is particularly helpful in distinguishing between various forms of interwar dance culture. *Ausdruckstanz* is entirely compatible with such an ideology. While generally not exactly "softly unfolding," its pretensions are toward the organic and the expressive. The Girl, however, is a cultural *Leistung*—she encroaches on the realm of masculine performance, in the sense of a task or work accomplished. In the same way that variety theater scrambles simple binaries of high and low culture, in its specific historical form as *Girlkultur*, it also scrambles cultural gendering. The girls do a man's work.

If both *Ausdruckstanz* and *Girlkultur* are marked culturally as feminine, it is clear that they stand in radical opposition to each other—or, rather, that *Girlkultur*, with its fetishization of rhythm as a totalizing and organizing social and choreographic force, offers a formidable ideological and aesthetic opponent to *Ausdruckstanz*, which had defined itself in opposition to a formalism and academicism that was presumed

to lack all sense of deeper rhythm. Typical of responses to the ubiquitous revue form as a model for new social orders is the 1928 study *Körperschönheit und Körperkultur: Sport, Tanz, Gymnastik*, by Hans W. Fischer, whose work I treated briefly in the introduction. Imbued with the terminology of *Lebensphilosophie*, but nevertheless open to the aesthetic potential of the Girls, Fischer notes that the rationalization that takes place in the revue is one that derives directly from the impulses that animated ballet: "The idea of animating a whole string of young girls in perfect synchronicity is a truly American mechanization of the principle of ballet: but a mechanized form can also be perfectly beautiful if its precision is immediately apparent. The Tiller Girls succeed in this."[15] By contrast to the revue's debt to ballet, the same critic argues that "there has thus far been no fertilization of the revue by aesthetic (modern) dance. It owes its looser form to its intimate relationship with modern social dance" (207).[16] The play of liberation and repression in this passage bears further examination. The revue challenges the primacy of the symbol as an aesthetic and social ideal, thereby contesting those literary historical narratives of "dance in modernism" that eschew the social coordinates of choreography. Rather than transcendence, sublation, order, and resolution in the symbol, we have a purely metonymic chain (of Girls)—a *Kette*—that depends on the most fundamental human drives. At the same time, however, we have a tension between the structural *Szenenkette* and Fischer's strikingly similar imagery of the Tiller Girls, the "string of young girls." While we have been liberated from the transcendentalism of the symbol, by no means do we have an immediate erotic or aesthetic gratification. The semantic resonance of the "chain" as a model for thinking about the new metonymic structure is all too clear: fulfillment (sexual and aesthetic) is deferred along the endless line of identical legs. (Kracauer, as we shall see, is quite explicit on this point.)

The question remains, however, whether the revue is to be understood as a relief (*Auflockerung*) from the high seriousness of *Kunsttanz* or as a mechanization and reification of the aesthetic impulses formerly represented by the ballet. Does the revue prefigure an avant-garde aesthetic of fragmentation, or does it instead lend a false finish and totality to each of its interchangeable fragments, obscuring the possibility of any overarching cultural synthesis? If the latter is the case, I would argue, this reification needs to be understood not simply as a banaliza-

tion of a high cultural form (the ballet) into a lower one (the chorus line) but, quite literally, as the reinstallation of the artifact at the center of aesthetic concern. For while the revue represents a nonorganic, non-narrative principle of aesthetic organization (any act can, in theory, follow or precede any other) in the expertise of each performer (or, finally, in the line of girls) we still encounter a reification: the reduction of the performative and indeterminate moment of *Kunst*, to the trick, the "schtick," the "turn," the *Kunststück*. The revue, in the advanced form of the Tiller Girls, enacts a social choreography derived from the ballet but rendered mechanical and precise. Despite this rationalization and rigidification of order, however, there is in the revue also a form of "loosening up"—*Auflockerung*—that can be traced back to the developments in social rather than artistic dance. In Fischer's presentation, *Gesellschaftstanz* and *Kunsttanz* stand on the side of a certain social and aesthetic *Auflockerung*, ballet on the side of strict order, while the revue—torn between these poles—nevertheless offers the possibility for a radicalization and mechanization of strict order. Clearly, with the globalization of the culture industry and the parallel emergence of a fully autonomous aesthetic sphere, the terms of Schiller's cultural and political analysis (elaborated in the introduction) have been complicated. Without wishing to homogenize the thought of intellectuals often in intense and polemical debate with each other, we might schematize the field of choreographic analysis for Weimar cultural critics as follows:

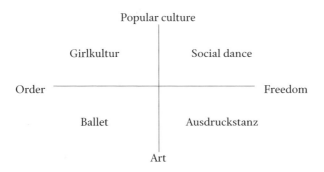

Countering the rationalization and commodification of performance, or "turn"—in the revue, we also find precedents for a looser, "metonymic"—rather than symbolic or organic—social choreography. First

there is the nonorganic arrangement of "turns" that can be shuffled and reorganized in any succession throughout the evening's entertainment, and in the performance itself we have the metonymy that is amply suggested by the line of Girls' kicking legs. In the study of *Körperschönheit* by Fischer cited above, we find the following assessment of the variety theater: "Variété demands the finished product; it rejects anything that is still in flux. For this reason, it can tolerate art only when it has become artifice [*artistisch*]. In this regard, it resembles the ballet, which also prizes a dazzling but entirely insignificant pirouette more highly than any expression of emotion that lacks the necessary effortless technical mastery" (207).[17] Fischer's lumping together of the variety theater and ballet—an association, we should note, that was not without some institutional justification because Diaghilev's dancers often appeared in nontraditional venues in the years when ballet had to reestablish its cultural credentials in the West—reflects his allegiance to *Ausdruckstanz* and to *Lebensphilosophie*'s privileging of a formative "becoming" over fixed states of "being." What the girl challenges, though, in her allegiance to the variety theater's demand for "the finished product," is an entire ideology of gender that held that women do not produce objects, or works—that they are themselves their own objects. To quote again Hans Fischer—this time from his *Tanzbuch* of 1924 (although his assessment might have been culled almost at random from among similar contemporary pronouncements on gender in relation to cultural production): "Man stamps his essence upon works that exist outside of him: he is a creator. Woman, by contrast, is above all a creature; her essence, her highest value remains closed within her."[18] In contravention of this cultural scheme, Girls are not creatures, they are creators, emblems of the very principle of capitalist mass production. But herein lies the snag. Just what do they create? As synchronized performers—whose rigor seemed to stand in opposition to an increasing and disturbing cultural syncopation—they are not individual objects of feminine display in the traditional sense. And yet there is no actual object or work to which we can point as the result of their cultural Leistung. They are a conundrum: they produce, yet they produce no thing. They are not "femininely" self-centered and self-centering because their entire performance relies on a synchronization with others. Just what, then, is a girl? Or, rather, what does she do?

It is in the essay "Girls and Crisis" by Siegfried Kracauer that we find

the beginnings of an answer to this question—an essay written quite some time after his famous essay on the mass ornament that has cemented our understanding of his response to the popular culture of his time. "Girls and Crisis" is a review of the Jackson Girls, whose performance Kracauer attends after the 1929 Wall Street crash and the resulting economic collapse. He seems to be seeing through his own earlier naive celebration of the Tiller Girls when he bewails: "One doesn't believe them any more, those rosy Jackson Girls!"[19] A simple historicization of Kracauer's observation might lead us to reconstruct the following logic to his argument: Prior to 1929, when the American economy was, indeed, the engine of world prosperity and the very epitome of modernization, the Girls really did stand for something. Then, we could believe in them. Now that the economy has stalled and the Girls just keep on dancing, we can no longer believe in them. It was always just an illusion after all. Ramsay Burt effectively makes this case when he writes that for Kracauer "in the light of the economic depression and the rise of fascism, the mass ornament appeared to him a delusion. What earlier had been informed by an avant-garde sensibility was now described with a witty cynicism."[20] In fact, I want to argue—with respect to those respective "truths" of nakedness and motion—that this is not the crucial point. Kracauer's very premise—"one doesn't believe them any more"—marks not a loss of ideological faith but a passage beyond the necessity of belief as a guarantor of ideological fidelity. This realization crystallizes a crucial move beyond the metaphysics of cultural conservatism that still marks Kracauer's writings up until the mid 1920s.

I wish to suggest that one can best elucidate the development of Kracauer's responses to mass culture—as well as the shift in the very functioning of ideology at this particular historical juncture—in terms of a refocusing of mass cultural critique away from the figure of Woman to the Girl, from the promise of a laying bare (a "nakedness") to the exhibition of female motion itself as a place where material production and ideological reproduction meet. The girl, we might say, becomes a motif in the sense of *motivum*. In this new configuration, ideology is no longer a system of belief that holds at its core a (sexual) truth that can be laid bare. It has become a *function*, a system of deferral that keeps *disbelief* in motion. The shift from woman to girl, I will argue, is a shift from ideology as a system of belief to ideology as a self-sustaining and

self-legitimating social function, a shift from the promise of revelation to the reality of mere motion or function.

The figure of Woman as emblem of mass culture (examined in detail by critics such as Andreas Huyssen and Tania Modleski) relied on the fantasy of a physicality and fleshliness that threatened to engulf the male consumer. Woman figured an organic unity that promised an enfolding cultural totality in the face of modernist, masculine rationalization, but her sexual allure potentially disempowered the male viewer, subjugating him to that mythic totality. She was, in archetypical terms, the siren whose story one could hear only at the cost of one's life. Thus, nineteenth-century responses to emergent mass culture often pick up the rhetoric of contemporary mass psychologists such as Le-Bon, according to whom the mass or mob was feminized and irrational.[21] "If the mass can be seduced and led like a woman," the argument would go, "its cultural forms might in turn seduce and engulf you like a woman." The ideology of the Girl has given up on this all-engulfing totality as its referent, and thus cannot present even the female performer herself in a cohesive bodily form, as Kracauer observes: "The Tiller Girls cannot be reassembled retrospectively into human beings; the mass gymnastics are never undertaken by total and complete bodies, whose contortions defy rational understanding. Arms, thighs and other parts are the smallest components of the composition" (*MO*).

The Girl offers neither the threat nor the promise of a reintegrated organic culture because she herself is inorganic. With respect to the female body and popular culture, then, I wish to argue that critics of an emerging mass culture were caught between the observation of the new phenomenon and the absence of new tools of analysis for its comprehension. Thus, the "mass" of mass culture would first be grasped in terms of a nineteenth-century tradition of social theory exemplified by figures such as LeBon—as something irrational and primeval, intrinsically feminine. The figure of the Woman negates all difference and mediation by offering a satisfaction—a revelation, a nakedness—that simultaneously threatens. The Girls—as another critic, quoted by Jelavich, notes—by contrast "are a so-called *plurale tantum*. That means that the concept appears linguistically only in the plural."[22] In other words, they perform the opposite function to Woman, parsing out into metonymic seriality the concept of the mass that the Woman still man-

aged to embody in a total or symbolic form. Whereas the Woman figured male anxiety at the potential loss of identity in a newly emerging mass culture, the Girls are themselves disembodied and disseminated. Their seriality entails a whole new notion of the mass and a whole new notion of truth in ideology. There is no longer a truth to be revealed as something primal and hidden, and the Girls are quite upfront in revealing that there is nothing to reveal. Truth is of the nature of function not revelation. Benjamin makes this clear in his foray into the genre of what we might call *Girlkritik:* "The revue caters to the bourgeois desire for diversity, more in terms of number than in the nature and arrangement of its presentations. It will soon exhaust its store of inspiration. Ever since it undressed the female body to the point of total nudity, its only available mode of variation was quantity, and soon there will be more Girls than spectators."[23] Ideology lies now in the realm of consumption, and mere nakedness—the ideological promise of ideology's unveiling—has lost its novelty value. We have entered a realm of cynicism.[24] In Benjamin's presentation, this new ideological configuration will be complete only when we have all become Girls, when we all perform and produce in the social and economic realm according the "standard" set by the Girls on stage.

While the kinds of metonymic social connectedness suggested in the revue intrigued two generations of intellectuals who confronted American popular culture in the early twentieth century, we find again and again that such challenges presented by American cultural exports are recontained within an existing regime of cultural literacy. One form of this recontainment accepts the traditional gendering of mass culture as feminine and resists the figure of the Girl in the name of Woman, as a central cultural fetish. The figure of the revue girl as vamp that Marlene Dietrich has so embedded in our cultural memory of the Weimar Republic is in fact a hangover from an earlier cultural constellation that was about to be eclipsed (*The Blue Angel*, after all, was the film of a Heinrich Mann novel satirizing the moral hypocrisy of pre–World War I Wilhelmine Germany). Typical of the ways in which those in the community of *Ausdruckstanz* trotted out traditional gender stereotypes in an attempt to reconcile the radically new phenomenon of *Girlkultur* with pre–World War I feminizations of mass culture is an article of 1926, in which the author argues that the revue offers particular aesthetic and social challenges "because its overriding principle is the

negation of all symbol, allegory, dilemma—even the most primitive narrative—all of which are sacrificed to an ordering of scenes determined by the drives alone." The passage goes on to argue, however, that precisely because the revue represents the chaotic and asymbolic "it places at its center the symbol of the non-symbolic, the allegory of chaos, the primal image of the non-logical, the beautiful, merely beautiful, sensuous animalistic woman."[25] Once the revue's resistance to a symbolic, harmonious social and narrative structure is itself reinterpreted symbolically—through the figure of Woman—as a "symbol of the non-symbolic," grounds for a more traditional ideology are reestablished. At the heart of this ideology, moreover, is the "beautiful, merely beautiful, sensuous animalistic woman." The feral woman—a femme fatale in whom the danger of structural aesthetic collapse is presented as a form of sexual release—emerges as a vitalistic force of nature only by virtue of a rhetorical doubling: the recuperation of the asymbolic as something that can and must be symbolized. Fascinatingly, binaries of gender are reimposed—through the established figure of the beautiful woman—precisely in order to reestablish a symbolic order that is under threat and in order to code that threat as feminine. Although the femme fatale (think of Wedekind's Lulu) represents cultural collapse, she at least represents it in some legible form. She is still readable, still this side of the cultural collapse she symbolizes. The girl, on the other hand, represents a cultural and gender shift that cannot simply be reinscribed in terms of traditional female threats to the rationality and cohesion of culture.

It is always facile to posit absolute cultural breaks in history, yet I do think it is possible to posit a fairly abrupt shift in both the popular and critical cultural discourse of this time away from the figure of the organic Woman to that of the rational Girl. The transitional period of that shift is broadly contemporaneous with a move within high culture toward the so-called new sobriety (Neue Sachlichkeit) that concerned itself with the concrete problems of modern urban existence rather than with the metaphysical and humanist preoccupations of Expressionism. We need to ask ourselves what maneuvers are possible between this ideological manipulation of the figure of Woman and the new cultural paradigm of the Girl that emerged in the 1920s as the lynchpin of the vital new *Girlkultur*. Does the Girl resist this sexual recuperation of primal disorder or simply rationalize it further? I want

to argue that the crucial break that needs to be acknowledged with respect to the reception of Girlkultur—as opposed to earlier forms of "Anglo-Saxon" popular culture such as the music hall—is the specific coding of the female body and the rejection of Woman in favor of Girl. I will argue that the Girl as figure breaks with an earlier model of the feminine as symbol of the asymbolic; that she breaks with a regime of legibility that could find a place more readily for earlier versions of the femme fatale.

What makes Weimar Germany a particularly fascinating study for any analyst of the transmission of early global mass culture is the porous boundary within the critical discourse of the time between day-to-day feuilleton journalism and the highly sophisticated elaborations of aesthetic theory in the work of figures such as Siegfried Kracauer and Ernst Bloch.[26] Journals of the time, such as *Querschnitt*, enjoyed a large readership and provided a forum in which poets could write about boxers and painters about acrobats—and boxers, indeed, about poets. Rather than simply parsing out high and low culture and developing a vocabulary suitable to each, critics of the time in Germany tended to draw broad-ranging sociological implications from their exposure to mass culture and to reflect back the lessons learned onto their analyses of so-called high culture. In brief, we can distinguish between those for whom dance figures a displacement and instability (both physical and metaphysical, as we have seen in the course of this book), and those for whom it figures as either stasis or silence; a more essential language, movement itself as a self-defining principle. Kracauer's theoretical breakthrough consists in finally overcoming a conservative cultural critique that divides metaphysical and profane choreographies to see that the operation of the profane is not simply a mimetic displacement of thwarted metaphysical desire.

The existential starting point for dance criticism at this time—and it is remarkable to think that the complex arguments of figures such as Kracauer and Bloch were available to large audiences thanks to the proliferation of reviews and the tradition of the feuilleton—was the belief that any analysis of choreography departs from the existential experience of "an empty space" (*MO* 129) or a *Hohlraum* (Bloch). For Kracauer this experience is the result of Enlightenment disenchantment and a form of "*exile* from the religious sphere" (*MO* 130). To this extent Kracauer's work would not be distinguishable from that of any

number of (predominantly conservative) cultural critics of his own time—or even of our own. As a forerunner of the Frankfurt School, Kracauer utilized choreography to analyze a new mass cultural phenomenon that seemed of itself to demand a reintegration of philosophical analysis into the contingent critique of modern social forms. The idea of a social choreography becomes useful precisely at the point—and I am arguing that Kracauer's critical legacy marks that point—where we no longer simply read back from cultural production to its socioeconomic base. To simplify, in social choreography we are obliged to see not so much a "working through" of social reality in aesthetic form but rather an "acting out" that blurs the distinction of aesthetic and nonaesthetic (when is a movement a dance?) and demands a new critical method and vocabulary for the analysis of ideology.

Kracauer was for a long time best known for his work on film—specifically for his study on Weimar cinema, *From Caligari to Hitler*, in which he sought to demonstrate an ongoing aesthetic obsession with auratic power in German film; an obsession that would find a resolution in the aestheticized politics of fascist spectacle. Recently, the translation of a collection of Kracauer's writings, *The Mass Ornament*, has revealed to an English-speaking readership the author's percipient analyses of mass culture, situating him as a forerunner of the Frankfurt school in many important ways. Notably, the most famous of Kracauer's essays are those that deal with both cinema and dance as forms of mass entertainment. His interest in the phenomenon of the Tiller Girls, though, to take just one example, was far from idiosyncratic: Weimar intellectuals were obsessed with the development of Girlkultur and with American cultural imports. The most remarkable work on this question is, perhaps, Fritz Giese's *Girlkultur*. Kracauer's reflections on a certain form of dance as mass entertainment have become well-known, entering into a field of debate on aesthetics and mass production long identified with Benjamin's essay "The World of Art in the Age of Mechanical Reproduction." This dissemination of Kracauer's work is rather selective, however, and does not take account of his ongoing fascination with social choreography. In short, what he has to say specifically about choreography has been lost in the consideration of what he has to say about spectacle.

Kracauer's basic argument with respect to social choreography is perhaps best rendered in the 1925 essay "Travel and Dance," which is

included among the translations of *The Mass Ornament*. Considering the post–World War I explosion of the travel industry and the simultaneous proliferation of, and revolution in, ballroom dance forms, Kracauer argues that both of these phenomena offer profane expression of a spiritual desire for that which lies beyond us. He reads travel and dance as the false or abusive translation into physical terms of metaphysical longings. Interested primarily in social data, Kracauer concentrates not on "theatrical" or "aesthetic" dance but on popular dance, arguing that "the society that is called 'bourgeois' indulges in the desire to travel and dance with an enthusiasm far greater than that shown in any previous epoch for these sorts of profane activities. It would be all too facile to attribute these spatio-temporal passions to the development of transportation or to grasp them in psychological terms as consequences of the postwar period. For no matter how correct such indications might be, they explain neither the particular form nor the specific meaning that both of these manifestations of life have taken on in the present" (*MO* 65). For a sociologist, Kracauer is surprisingly happy to reject sociologizing analyses of the "dance craze" or what he calls "spatio-temporal passions." He uncouples form and meaning from both psychology and social developments to argue that travel and dance respectively spatialize and temporize—that is, render profane— the futile lingering religious desire for metaphysical certainty, or *Haft und Grund*. The desire for metaphysical transcendence has been vulgarized into a profane desire for "another place" or "another time" because historical time and space are the only media in which we can perform and represent that longing for transcendence. Paradoxically, the desire for fixed meaning—and the awareness that we are not, in fact, fixed in the modern world—leads precisely to the fetishization of a movement toward some literal "beyond" or "elsewhere." We move to the music in order to displace ourselves, our conception of transcendence having become purely negative. The "spatio-temporal" passions" are not simply passions that can be located in time and space but rather are the passions that *create* time and space as deferrals. By seeking realization, such passions provoke a movement out of ontological time and space into historical and geographical coordinates.

In other words, Kracauer's analysis of dance presages my own category of social choreography by employing the choreographic not as something that can be located within an already established historical

and spatial sphere but rather as something that creates that sphere—in this case, as a placeholder for unrealizable metaphysical longings. Thus, rather than being reducible to its social determinants this choreography sets the terms of the social. Dance is work performed on (as well as in) time and space, Kracauer will argue. Modern dances "are no longer events that happen to unfold in space and time but instead brand the transformation of space and time itself as an event" (*MO* 67). This observation is crucial in understanding the significance of a reemerging dance aesthetic for a broader social choreography in the early years of this century. To reduce the analysis of such phenomena to their sociohistorical determinants—to "events that happen to unfold in space and time"—would be to miss the radical thrust of Kracauer's analysis of shifts in the experience of time and space. Choreography does not simply operate within time and space (and is, therefore, not reducible to historical determinants) but rather "transforms" both time and space and brings into existence a "world," a realm of the nontranscendent profane.

Kracauer explains the profane rationalization that takes place in travel and dance as a parsing out of the immanent and self-enclosing *Ineinander* of religious experience—the dialectical transcendence and negation of our personal spiritual experience—into a banal sequential *Nacheinander*—the mapping out in profane temporal and spatial sequence of those very experiences that were aimed at the transcendence of spatial and temporal specificity. However, one can trace over the course of Kracauer's writings on the question of social choreography a development away from such notions as he begins to examine more fully the implications of the choreographic. At this first stage, he begins from a position easily reconcilable with the cultural conservatism of many of his contemporaries. "The *real* person," he writes,

> who has not capitulated to being a tool of mechanized industry, resists being dissolved into space and time. He certainly exists in this space here, yet is not utterly dispersed in it or overwhelmed by it. Instead he extends himself across latitudinal and longitudinal parallels into a supra-spatial infinity that should not in any way be confused with the endlessness of astronomic space. Nor is he circumscribed by time experienced as expiration or as measured by the clock. Rather he is committed to eternity, which is different from an endless extension of time . . . Thrust into a spatio-temporal life to which he is not enslaved,

he orients himself toward the Beyond in which everything in the Here would find its meaning and conclusion. (*MO* 68)

Kracauer here defends a traditional idealist, transcendental subject— "the *real* person"—against its dissolution into the contingencies of time and space. Ignoring, at least in these earlier writings, the worldliness of Schiller's insistence on "annulling time *within time*," the early Kracauer sees in the sequentiality of dance only a relativism that traps man in the spatio-temporal, when he is—or should be—"committed to eternity." A reading of this essay from 1925 certainly yields a more conservative Kracauer than the better-known celebrant of mass culture who would author the essay "Mass Ornament" in 1927. To dance, at this stage in his writing, is to fall short of (or even refuse) metaphysics—traditional romantic codings of transcendental dance notwithstanding. The liberating potential of such a refusal has yet to be envisaged. To dance is to act out the impossibility of metaphysical self-realization in a reified and mechanized world. The Ineinander and the Nacheinander are implacably opposed.

In Kracauer's earlier writings, the mass threatens to become a collective in which difference becomes indifferent, and yet it already offers the possibility for new and progressive cultural formations.[27] It is not until the famous essay "The Mass Ornament," however, that Kracauer will begin to elaborate such a progressive critical possibility. Distinguishing between his own notion of the ornament and more conservative *völkisch* ideologemes, Kracauer observes that: "The bearer of the ornaments is the *mass* not the people [*Volk*], for whenever the people form figures, the latter do not hover in midair but arise out of a community. A current of organic life surges from these communal groups— which share a common destiny—to their ornaments, endowing these ornaments with a magic force and burdening them with meaning to such an extent that they cannot be reduced to a pure assemblage of lines" (*MO* 76). Here, Kracauer draws a distinction between two forms of ornament: the communal, organic, völkisch and magical ornament, which is burdened and always lands somewhere—on a ground; and the ornament of the masses, which "hovers" and is "a pure assemblage of lines." Clearly, the organic ornament stands in a tradition stretching back to William Morris. In such a presentation, the ornament is a positive and vital expression of the very excess that

makes a culture into a culture. The prevailing aesthetic ideology of modernism has taught us to read ornament as disguise—as an excess that masks a fundamental weakness in the artifact's formal structure.[28] In an alternative modernist narrative, meanwhile, William Morris's organic ornament was the very expression of a cultural excess—the excess that *is* culture—displaying itself by the very detail that obscures. While there is a note of nostalgia in Kracauer's presentation for grounded ornament (as there is in Benjamin for the auratic work of art), he acknowledges the historical necessity of the ornament that "hovers."[29]

The relationship of the mass ornament to its particular society is harder to pin down—precisely because it hovers. The organic ornament is "grounded" in its social context—this is what makes it "magical." To this extent, Kracauer seems to be linking magic to mythic structures, to the possibility of a grounding of reference as opposed to the indeterminate "hovering" of the mass ornament. While it is possible to read mimetically—and mythically—from the organic ornament to its referent and ground, the mass ornament has been emptied out of content to become, implicitly, a "pure assemblage of lines." This image of the line appeals because we will encounter it again and again in the writings of Kracauer and his contemporaries in the form of the high-stepping chorus line. Almost paradoxically, the chorus girls will come to stand symbolically for the end of grounded symbolic reference. Their line symbolizes the linearity of metonymy and deferral that seems to characterize the mass ornament. To this extent, as we shall see, they stand at the very threshold of legibility as cultural phenomenon. They do not represent the end of representation as the crucial term in a critique of ideology—they perform it. Similarly, the mass does not *represent* itself in its ornamentation—it *performs* itself.

"The Mass Ornament" of 1927 marks a critical breakthrough that moves beyond the more traditional critiques of alienation and rationalization toward a realization that capitalism "rationalizes not too much, but rather too *little*" (*MO* 81) and that the process of radically self-negating rationalization "leads directly through the center of the mass ornament, not away from it" (*MO* 86). Although the central figures of the "Mass Ornament" essay are the famous Tiller Girls, Kracauer insists that the ornamental be read at two levels: on the one hand as the spectacle provided by the girls themselves; on the other as the config-

urations, or "stars," that such performances produce from the audience, from "the masses, themselves arranged by the stands in tier upon ordered tier" (*MO* 76). This too is characteristic of social choreography as I have conceived it in this book: an altered relationship of the audience to its acknowledged representation. It figures the distinction between what I earlier called the integrative (or performative) and the mimetic forms of social totality.

On the one hand, the Girls perform an ideal of absolute integration and coordination reminiscent of the effortless grace of Schiller's English dancers. But Schiller, we will recall, could observe that self-enclosing unity only from the gallery, and only across the distance that separated absolutist Germany from nominally democratic England. In this radicalized and updated form, the Girls have now become absolute spectacle. Indeed, Kracauer's theory of the mass ornament holds that ultimately the ideological unity created by the spectacle is to be sought not in the technocratic coordination of the Girls but in the reactions of the fascinated audience. United in its exclusion from the cultural display, the audience is paradoxically included in the realm of the aesthetic as an autonomous aesthetic construct. The implicit weakness in Schiller's presentation—the disavowed recognition that the ideal of social choreography could only be an aesthetic construct predicated on forms of spectatorship and exclusion—has now become the very principle of the mass ornament.

The material on which ritualization and rationalization operate in Kracauer's analysis is primarily erotic. In the mass ornament, Kracauer maintains, the same principle of bodily display underpinning the ballet is maintained, but there is nothing left to display other than the mere "locus of the erotic." We might elucidate the newly performative ideological function of the Girls here by means of a contrast with Freud's treatment of sexual display and genital revelation in dreams. The descriptions Kracauer offers of feminine "display" are reminiscent of those moments in Freudian dream interpretation where the form and content of dream signification coincide. Freud talks of incomplete dream narratives where the analysand will break off his recounting and say "and then there is a gap." For Freud this narrative gap is not, in fact, a gap in narrative, but rather the displaced narration of another "gap," the narrative recuperation of the vaginal gaps, or "genital apertures," that the child has seen but cannot acknowledge having seen. In other

words, the form is really disavowed content. The formal narrative gap, for Freud, is really a "gap" at the level of content: something that cannot be acknowledged at the level of content or substance is displaced into the very structure of narrative but remains an empty space. We have here a logic of inverse fetishization, where an unacknowledged thing is displaced not only onto another thing but also onto the very logic of narrative. Invoking Marx's analysis of the fetish—whereby a thing stands in for a relation, a commodity for labor—here we have instead a relation standing in for a thing. In ideology, this secondary relation is the very act of "relation" that constitutes narration itself—the failure, in fact, to "relate" what has been observed.

Kracauer's Tiller Girls reverse this process, providing a model of the kinds of interpretation of ideology I am trying to get at here. There is no explicit gap in narrative. But the "gaps" that one sees as the Girls kick their legs (or that one never quite sees, of course) are the gaps in a coherent historical narrative. In this case, the content that one never really does see is, in fact, form—the breakdown of ideological narrativization. Whereas in Freud the narrative "gap" in fact itself continued to signify the unavowed display of female "gaps," in the Tiller Girls the promise of a display of female gaps seeks to hide, through display, the fact that narrative structures no longer hold. What is displayed is a vacuum of meaning—or the very mechanisms of meaning's erstwhile production. If the logic of Freud's dream gaps might be called inversely fetishistic (we get a break in narrative instead of the unacknowledgeable "thing," the traumatic feminine "gap") Kracauer's logic is fetishistic in a more traditional sense. He implicitly acknowledges that breaks in narratives of social cohesion might be more traumatic than the mere display of a "gap-object." Although the Girls cleverly do not offer an erotic display, they indicate in what they do not show the fact that a "locus" of the erotic exists. The "display" of the Tiller Girls, then—the simultaneous splaying of the legs, the revelation of the locus of the erotic—is a semiotic display. Sign collapses into soma as the putative "locus of the erotic." Rather than a traditional displacement from sexual object to object fetish, this gap as the "locus of the erotic" stands in for the erotic experience itself. In other words, in the girls' display the female "gap" becomes a simulacral fetish of itself.

There is a certain cynicism or irony to this ideological performance—as if the very brashness of the display were itself enough to excuse the

taboo on the thing displayed—the ideological "gap." What I present here as a process of cultural fetishization is linked to a recodification not simply of gender but of the entire technology of the sexual during this period. Certainly, as far back as the 1902 study on the variety theater by Moeller van den Bruck the reorganization of sexual relations and the reorganization of cultural hierarchies had been linked. Thus, in a passage strangely close to Kracauer's later observations about the transformation of the erotic under the aegis of Girlkultur, Moeller observes of that same can-can that so profoundly—and, perhaps, so rightly—disturbed John Ruskin: "The wilder dances of other races are nothing more than their folk dances reduced to the most expressly sexual form . . . In the Can Can the first stirrings of the mass take shape, the desire to transcend everyday reality for something higher" (159–60).[30] Already in 1902, Moeller sees emerging from within the sexual and choreographic realms a distinction of *Volk* and *Masse*. The mass is not at all a merely quantitative phenomenon, and it marks not the disruption of transcendence but, by its demand for standardization, a movement toward the transcendance of individualized sexual desire. Its very libido operates in a different way. The ascendance of Girlkultur, in which a principle of systemic efficiency replaces all phallic guarantees, should not be read as simply the replacement of one gendered cultural paradigm by another—a feminized mass culture displacing an obsessively masculine high culture. Girlkultur demonstrates the importance of narrative as a ritual act of social cohesion rather than as a mythic reference to communal values. Rationalization is the modality rather than the referent of the Girls' performance.

To demonstrate the kinds of shifts in critical thinking necessitated by the girl, I wish now to move to a later piece by Kracauer that demonstrates most clearly the reasons why a critical move to social choreography is, in my opinion, necessary as a move beyond more traditional models of "reading" ideology. Having argued that we cannot simply read from the Tiller Girls for an interpretation of their time, in a later essay Kracauer seems to do just that. In "Girls and Crisis," writing of the Alfred Jackson Girls in 1931 (i.e., during the Depression), he observes how "the effect achieved by these girls has to be termed ghostly." He adds: "They seem like a remnant from long-lost years rising now at an inopportune time, their dances montages emptied of a former meaning. What is it that they, like an image become flesh, embody?

The *functioning* of a flourishing economy . . . They were not merely American products, but a demonstration at the same time of the vastness of American production" (566). The Girls are no longer timely—they are spectral because they suggest the functioning of an economic miracle machine that has meanwhile ground to a halt by 1931. What, and how, do these girls represent? They are "emptied of meaning," a "montage"; they "embody," yet they are "ghostly." They are a "remnant," and yet their meaning—"the *functioning* of a flourishing economy"—is directly tied to their specific historical context. There is something wrong in the persistence of representation even as its historical referent—the booming economy—has become obsolete. However, as we shall see, it is precisely because the Girls did not signify in any referential way that the death of the putative referent—the economic miracle—does not impact their performance.

On seeing the Jackson Girls, Kracauer retroactively realizes that his original analysis of the mass ornament was insufficiently radical. While Kracauer always read Girlkultur as a performative ritual—as something shorn of any "legible" mimetic meaning and, therefore, necessitating a new mode of critique—his earlier writings nevertheless tied that shift in reading paradigms to a specific historical moment: the globalization of American production techniques and American culture. To this extent, his earlier essays attest to a unique and rather paradoxical historical moment: namely, the moment at which one can historically determine that it is no longer possible to determine historically the "significance" of a cultural artifact in a purely referential (let us say, base-superstructure) manner. If the fetishization of production in American cultural exports (the machinic chorus line, for example) marked a shift away from reference and mimesis, it was still possible, at that last moment, to provide a mythic narrative—history—that accounted for that shift. Nevertheless, the shift is real, and the fact that it can itself be "read" does not alter the fact that it has subsequently disabled any simple reading strategy for the critique of ideology. We are in the realm of ideology as performance. Thus, it is entirely fitting—and "proof," indeed, of Kracauer's thesis— that the Jackson Girls continue to "simulate" production even though the miracle of production has apparently ceased. They need no referent because the whole paradigm of production has shifted. No slowdown in production need affect the rituals of reproduction once the mythic link to a putative historical referent has been severed. At this stage of capital-

ism, the twin imperatives of commodity production and ideological reproduction have become uncoupled, and the ideological has itself become an autonomous mode of production—exemplified by the Girls. In fact, in this anachronistic display, the Girls demonstrate how the putative social referent of all aesthetic performance is itself a catachretic function, rather than an origin, of mimesis.

In the shift from woman to girl we have a move from symbolic to asymbolic cultures, from reference to performance. Kracauer observes of modern mass society that "it can no longer transform itself into powerful symbolic forms, as it could among primitive peoples and in the era of religious cults." In other words, the mass ornament no longer represents symbolically the collective that produces it, but rather produces a spurious collective that it is incapable of representing. "It is the *rational and empty form* of the cult, devoid of any explicit meaning, that appears in the mass ornament" (*MO* 84). The mass ornament is not, therefore, a "symbol" from which we can "read" back to a sociohistorical referent. It is productive rather than mimetic. Kracauer reminds us that the analysis of social choreography now needs to look beyond a simple sociological reading that links aesthetic expression to social structures. To simply "read" social or political commentary from the mass ornament is to assume a model of legibility that the mass ornament has left behind. The Tiller Girls become the model for Kracauer's notion of ornament not because of *what* but because of *how* they do (or do not) represent. The legs arrayed as "a pure assemblage of lines" are abstractions rather than representations. Any mimetic reading of the Tiller Girls—for example, a base-superstructure analysis of their representation of relations of production, or a sociological analysis of their enactment of rationalization—would miss the point. If, as Kracauer seems to indicate, they mark the loss of a mythic cultural and aesthetic significance, we cannot simply "interpret" them as if that loss were itself "significant" in any unproblematic way. For all that we might "read" Kracauer as an early cultural critic and analyst of the turn from verbal to visual culture, any such reading will be anachronistic, ignoring the very turn to the visual that we are proposing.

Kracauer's concept of the ornament obliges us to rethink, as I have attempted to do throughout this book, the sociological process of rationalization through the prism of the aesthetic. Although prevailing models of aesthetic modernism present rationality and rationalization

as demanding the obliteration of all ornament as artifice and excess (or in terms of the architect, Adolf Loos's famous essay, as a "crime"), Kracauer's analysis of Girlkultur demonstrates the metaphysical under-pinnings of any such minimalism. The desire to strip away from the art object all that is extraneous to it assumes a notion of cultural essence—displaced into the putative "integrity" of the materials—that can no longer pertain at a certain historical juncture. Girlkultur does not de-mand belief in its putative referent (the marvels of an inexhaustible capitalist economy): it merely fascinates. Whereas the figure of the femme fatale suggested the hidden existence of an irrational, sexual-ized, subterranean realm, however, Girlkultur demonstrates instead the inseparability of the rational and the irrational. The moment of "truth" in their performance—a revelatory mimetic relation to certain sociohistorical conditions—is itself extraneous. As ornament they re-veal by their very excess, by their final untimeliness or belatedness.

This, finally, would be the "spectral" nature of the Girl. What the Jackson Girls make possible for Kracauer is what Slavoj Žižek has like-wise proposed, namely "a reading of spectrality as that which fills out the unrepresentable abyss of antagonism, of the nonsymbolized real."[31] The social choreography of the girl reconfigures ideology. Ideology no longer operates through the symbolic figure of the *"beautiful, merely beautiful woman"* (no longer, that is, as a falsely symbolic resolution of the "empty space" that existentially motivated cultural criticism in this time) but rather in an entertainment, a performance of the very antago-nism that ideology would normally be thought to conceal. This is why—despite my demonstration of a shift in the theory and practice of the revue theater away from revelation toward truth as the very fact of motion itself—the category of display remains crucial in Kracauer. "Display" would be the mode of cultural performance in which it is revealed that nothing is to be revealed. As Žižek notes in his essay "Fantasy as a Political Category": "What we are arguing is not simply that ideology permeates also the alleged extra-ideological strata of ev-eryday life, but that this materialization of ideology in the external materiality renders visible inherent antagonisms that the explicit for-mulation of ideology cannot afford to acknowledge. It is as if an ideo-logical edifice, in order to function "normally," must obey a kind of "imp of perversity," and articulate its inherent antagonism in the exter-nality of its material existence."[32]

Žižek's location of ideology in reality itself, rather than in the discourses on it, is precisely what we have seen intimated at strategic moments throughout this book. Thought in terms of performativity rather than referentiality, the operation of ideology cannot be reduced to a regime of misrepresentation or false consciousness. This by no means suggests, however, that there is no outside of those narratives (that is, that "history" is all just "text"). Indeed, it is above all the recent overreliance on tropes of cultural "textuality" and "reading" that an analysis of social choreography must serve to counter. The model for a critique of ideology, therefore, would not be, on the one hand, that "ideology says things work this way when really they work that way." Nor, on the other hand, can we capitulate critically by insisting that ideology is a narrative that gives the impression that things "work" at all, when really they don't. This would be the critical response suggested by a simplistic—base-superstructure—reading of Kracauer's Jackson Girl essay. The operation of ideology we can derive from Kracauer's analysis of social choreography holds that things work in the way they do *because* we misunderstand them. Our "false" narrative is part of their "true" operation. Thus we are back at Balzac and the inadequacy of any positivist notion of vrai and faux with respect to ideology. Or at Bergson, whose description in *Laughter* of "purely material sincerity" as the condition of the ideologue's operation is quoted by Žižek in "Fantasy as a Political Category" (91) as a precursor of his own reformulation.

What I am proposing beyond Žižek's reformulation of ideology, however, is that this ideological function of "display" now exists within the compensatory relation of high and low culture. Whereas Kunsttanz still sought to exclude or resolve its own ideological contradictions (i.e., it understood ideology in traditional terms of obfuscation or false resolution), the girls turn ideology into performance and "display." To elucidate: think of the difference between the Freudian dream narrative that transferred onto the level of narrative itself the "gap" that could not be narrated, on the one hand, and the "display" offered by popular culture, on the other. In the former case we have what Fredric Jameson in *The Political Unconscious* has called "the ideology of form" and posited as the final hermeneutic horizon of interpretation.[33] A displacement, that is, of awkward or unrepresentable material into the very formal principle of the work. With a much less rigorous formal imperative—a mere Szenen-

kette—the popular cultural forms deriving from a vaudevillian tradition do not effect such a displacement. What I am calling their "compensatory" ideological function lies precisely in their performance of the ideological contradictions that must remain unacknowledged or unresolved in high cultural production. Inverting Jameson's formulation, the Girls do, indeed, perform the very "form of ideology."

We need to ask how far we have really come from the "CanCan of Hell" that so disgusted Ruskin to the Jackson Girls in 1930s Berlin. Ruskin was horrified at a certain "proficiency in evil" that the can-can girls represented—something "worked" that should not have. Similarly, Kracauer realizes that something works that should not—the performance still works in the absence of its mimetic referent. Ideology no longer exists in a series of (mis)representations of a putative referent (the post–World War I boom), but in the "purely material sincerity" of a performance. The Girls demonstrate how ideology has always functioned in capitalism. What they allow—and what retroactively justifies my category of social choreography as a method—is the "rereading" of symptomatic understandings of ideology. Kracauer lays bare the mechanism of social choreography, thereby revealing not so much a historical rupture (i.e., a new functioning of ideology) as an interpretive rupture. Now we can read how ideology has always functioned as performative—at least since the institutionalization of the break between high and low culture that I have elaborated in this book through a reading of Ruskin (but that could perhaps be traced elsewhere or earlier in the nineteenth century).

When Kracauer writes of "Girls and Crisis" he discovers that he writes not of a crisis *of* capitalism but of the crisis that *is* capitalism. Although I take Kracauer as that moment in the process of rationalization when the Žižekian reframing of ideology becomes thinkable, and as the moment where it passes into popular cultural entertainment, such a method was clearly presaged in Balzac. We need to recall Balzac's distinction—drawn at a moment where *Théorie de la démarche* shifts gear from mock encyclopedia to fashion plate—between a false movement (*mouvement faux*) in which is revealed "the nature of the character" and the *mouvement gauche* resulting from habit.[34] The former, we will recall, denoted a body and its falsehood as referential (it reveals something "false" in the character), whereas the latter was performative and aesthetic, finally; its falsehood is an effect (produced on

the observer) rather than a cause. An attentiveness to the aesthetic, I have argued throughout this book—an attention that is, to the gauche rather than the faux—necessarily reveals the ways in which ideology lies in practice (habitude) rather than just in representation. Historically then—at the level, that is, of the history of method—we need to read the latter part of the nineteenth century as a retreat from this insight; as an attempt to restore the regime of reference and to characterize ideology in terms of (mis)representation through an insistence on the primacy of "reading" (physiognomies, etc.).

What interests me about social choreography as a critical method is its acknowledgment that the work of aestheticizing the individual and the work of aestheticizing the collective are supposed to be one and the same. This, precisely, was the thrust of Schiller's seminal observation: "It is all so skillfully, and yet so artlessly, integrated into a form, that each seems only to be following his own inclination, yet without ever getting in the way of anybody else. It is the most perfectly appropriate symbol of the assertion of one's own freedom and regard for the freedom of others." My reason for privileging the aesthetic, as a tool for the critique of ideology, however, is precisely not because it performs the ideological and material work that Schiller reserves for it, but because, as we have seen throughout this book, the aesthetic sense of self—once developed as a function of choreography—serves always to mark the threshold over which we stumble in our entry into society.

For this reason the essay on the Jackson Girls is of particular importance, offering as it does an apparent disjunction between the functioning of the girl contraption and the collapse of the economy. If the girls help us understand the function of ideology, what they finally make apparent is that its function, tautologically, is to function come what may. The imperative of production theatricalized by the Jackson Girls returns us to the question of method and the status of social choreography as a tool for understanding cultural production. Although I have been arguing in this book for a historical movement toward performative rather than "literate" or referential models of cultural and national identity, Kracauer's observations serve at the same time to hold us back from too ready an embrace of "productive" models of cultural analysis. Thus, at first sight, the churning of legs in the chorus line long after the economy has ground to a halt clearly choreographs the expanded "relative autonomy" of the cultural sphere in late capitalism. But that auton-

omy, of course, renders problematic any reduction of the cultural phe-
nomenon to the historical moment ("late capitalism"). What Kracauer
realizes on seeing the Jackson Girls is essentially what Žižek argues
when he writes: "This is exactly how capitalism differs from other,
previous modes of production: in the latter, we can speak of periods of
'accordance' when the process of social production and reproduction
goes on as a quiet, circular movement, and of periods of convulsion
when the contradiction between forces and relations aggravates itself;
whereas in capitalism this contradiction, the discord forces/relation *is
contained in its very concept.*"[35]

This break in the operation of ideology (away from the cycle of
"accordance" and "convulsion" that determines a base-superstructure
relation) entails a break with an episteme of representation and a
movement toward a new configuration of ideological performativity. In
Žižek's terms from the same essay: "Ideology is not simply a 'false
consciousness,' an illusory representation of reality; it is, rather, this
reality itself which is already to be conceived 'ideological'—*'ideological'
is a social reality whose very existence implies the non-knowledge of its
participants as to its essence . . . 'Ideological' is not the 'false consciousness' of
a (social) being, but this being itself in so far as it is supported by 'false
consciousness'*" (305). This "non-knowledge," I am arguing, has been
deemed the function of low culture precisely insofar as its "cult of
distraction" eschews cognitive claims at a time when high cultural
forms such as Ausdruckstanz were beginning to claim a privileged em-
bodied "knowledge" of some ecstatic beyond. This is not to claim, of
course, that low culture is somehow "ideological" in a way that high
culture is not. As both Adorno and Žižek would argue, ideology is (in)
the rupture. However, the historical emergence of popular culture as a
commodity (no more or less than the high cultural commodity) with its
own institutional spaces necessarily changed the configuration and op-
eration of ideology in culture. Whereas the ideological function of high
culture might previously have been "affirmative" in Marcuse's sense of
the word—the false aesthetic resolution of unresolved social antago-
nism—this function changes when high culture operates in tandem
with low cultural forms. Precisely that reconciliation of body and spirit
that was traditionally associated with dance within modern poetics
must be reread from the perspective of a critique of ideology as false
transcendence. But this is not the point. By hypostatizing the choreo-

graphic experience as the locus of a knowledge beyond knowledge—a knowledge of the (metaphysical, or even mere anthropological) "beyond"—early modern dance necessitated a realm of nonknowledge—a realm of "display" to which the contradictions have been banished.

I have been tracing through this work a double history: a tentatively sketched history of specific, sequential, and often overlapping social choreographies on the one hand, and a history of method on the other. This second history of method demonstrates not only how the content of ideological structures changed, but how the very operation of the ideological shifted from an essentially "literate" to an embodied and performative experience. My claim has been that the performative nature of choreography necessitates a shift in our understanding of ideology. The two histories—a history of method and a history of social choreographies—rejoin each other at the moment where the specific "historical" choreographies produce and necessitate a new critical method. In other words, social choreography cannot be understood as a self-evident category of analysis for all societies. Rather, it becomes apparent and manifest only at a certain historical point as a way of retrospectively rethinking social structures. Ideology, then (pace Marx and Althusser) does indeed have a history that is not merely the history of its successive forms, but of its functions and functioning. My two narratives are reconciled in the answer to a question: At what point within the first narrative of specific social choreographies is the category of social choreography, as I have been using it, produced as a critical possibility? At what historical point, in other words, does this notion of choreography emerge as a model for "rereading" historical social structures? Kracauer, I argue, bears witness to precisely that historical moment, and he thereby allows us to read the nineteenth century also through the prism of social choreography.

This is the significance—if we may still use the word—of the Jackson Girls: although they are themselves a historical phenomenon they demonstrate to us, through Kracauer, the need for new modes of cultural analysis that move beyond models of interpretation based on the experience of "reading." As they grind on with their dance, the issue is no longer *what* the Girls represent but the imperative *that* they represent. Thus, we cannot simply take our thesis regarding the emergence of new "performative" cultural paradigms to mean, as the same assertion might in the context of traditional histories of modernism, that we

have moved somehow "beyond" representation and figuration. The "pure assemblage of lines" produced by the Jackson Girls needs to be thought not simply in aesthetic terms as a move beyond representationalism into abstraction. Indeed, the problem the Girls pose for Kracauer—and for us, methodologically—is precisely that they persist in representing even when the object of their reference no longer pertains. The "postliterate" episteme I have been proposing, therefore, needs to be thought not in terms of a simple move beyond representation but as a reinvestment in it—a refunctioning of representation as ritual rather than myth. When the machines of production grind to a halt, the cultural machines of ideological reproduction slip into overdrive in order to reaffirm the reproductive imperative. If in his essay "The Work of Art in the Age of Mechanical Reproduction" Benjamin famously plays off the aesthetic aura against technological reproducibility, the spectral presence of the Jackson Girls, by contrast, demonstrates the auratic value of reproducibility itself—the awful truth that reproduction must go on. Writing at a time of economic crisis, Kracauer was finally led to generate an analysis of social choreography as a response to this historical moment, in which the very relation of cultural artifacts to their putative historical determinants shifts. When ideology reveals itself to have a history after all, an analysis of social choreography would be the critical method that asks not what things stand for but how they stand at all.

Notes

1 This reference to "das neu erweckte Interesse für diese Kunst" is from a letter of 18 January to Christian Körner. See Friedrich Schiller, *Schillers Werke: Nationalausgabe*, vol. 28, ed. Edith Nahler and Horst Nahler (Weimar: Hermann Böhlaus Nachfolger, 1992), 168.

2 Quoted in Havelock Ellis, *The Dance of Life* (London: Constable and Co., 1923), 53–54. Subsequent references to Ellis are hereafter cited in the text.

3 Letter of 23 February 1793 to Körner in Schiller, *Schillers Werke*, vol. 27, 216–17. Translation in Schiller, *On the Aesthetic Education of Man*, ed. and trans. Elizabeth M. Wilkinson and L. A. Willoughby (Oxford: Clarendon Press, 1967), 300.

When eventually Körner—Schiller's tardy essay writer—did complete his essay he maintained many of the Schillerian motifs, noting how "the free play of living beings in their world is characterized by the victory of form over mass in movement. Force hovers effortlessly and unopposed in space. It is not chained to the ground by gravity, but cleaves to it through inclination. Every muscle retains its specific receptivity and elasticity and yet each submits to the gentle authority of a power that it seems to obey." [Das freie Spiel des lebenden Wesens in seiner Welt wird durch den Sieg der Form über die Masse in der Bewegung bezeichnet. Die Gewalt schwebt im Raume ohne Anstrengung und ohne Widerstand. Sie wird nicht durch Schwere an den Boden gefesselt, sie haftet an ihm aus Neigung. Jede Muskel behält ihre eigne Reizbarkeit und Elasticität, aber alle stehen unter der milden Herrschaft einer inneren Kraft, der sie freiwillig zu gehorchen scheinen.] (Christian Gottfried Körner, "Über die Bedeutung des Tanzes," in *Ästhetische Ansichten: Ausge-*

wählte Aufsätze, ed. Joseph P. Bauke [Marbach: Schiller Nationalmuseum, 1964], 50).

4 The most nuanced and sustained account in English of the dance motif as an organizing trope within modernism is still to be found in Frank Kermode, *Romantic Image* (London: Fontana, 1971 [1957]). See also Kermode, "Poet and Dancer before Diaghilev," *Partisan Review* 28, no. 1 (January–March 1961): 48–75. More recently, a similar thematic has been revisited in Terri A. Meister, *Movement and Modernism: Yeats, Eliot, Lawrence, Williams, and Early-Twentieth-Century Dance* (Fayetteville: University of Arkansas Press, 1997).

The most comprehensive synthetic presentation of the dance trope in modernism is to be found in Gregor Gumpert, *Die Rede vom Tanz: Körperästhetik in der Literatur der Jahrhundertwende* (Munich: Wilhelm Fink, 1994). Gumpert discusses Mallarmé, Hofmannsthal, Valéry, Rilke, and others.

Mallarmé's famous essay "Ballets" forms the basis for most critical readings of a symbolist treatment of dance: see Stéphane Mallarmé, "Ballets," in *Oeuvres*, ed. Yves-Alain Favre (Paris: Garnier, 1985). Less ubiquitously cited but equally important are his "Autre étude de danse: Les fonds dans le ballet (d'après une indication récente)" (*Oeuvres*, 233–37); and "Crise de vers," (*Oeuvres*, 269–79). Translations are to be found in Stéphane Mallarmé, *Selected Prose Poems, Essays, and Letters*, trans. and introduction by Bradford Cook (Baltimore: Johns Hopkins University Press, 1956) ("Ballets," 61–66; "Crisis in Poetry," 34–43).

The locus classicus for a consideration of dance tropes in Rilke are the 1923 *Sonnette an Orpheus*, in Rainer Maria Rilke, *Sämtliche Werke*, 7 vols., ed. Ernst Zinn (Frankfurt: Insel, 1955–1997).

For Valéry's considerations of dance, see Paul Valéry, *Oeuvres*, 2 vols., ed. Jean Hytier (Paris: Gallimard, 1957–1960). Specifically, dance is foregrounded in "Philosophie de la danse," "L'âme et la danse," "De la danse," and "Degas, danse, dessin." Translations can be found as "Philosophy of the Dance," in *Collected Works of Paul Valéry. Vol. 13: Aesthetics*, ed. Jackson Matthews, trans. Ralph Mannheim (New York: Pantheon, 1964), 197–202; "Dance and the Soul," in *Collected Works*, vol. 4., trans. William McCausland Stewart (New York: Pantheon, 1956), 27–62.

One of my assertions in this book, however, is that limiting the consideration of the interplay of dance and literature to a simple consideration of tropes of dance in literature necessarily produces a misrepresentation of dance's importance for the modernist aesthetic. Dance, in fact, served to *displace* predominantly literary or philological notions of cultural coherence at this time. Certainly, the key term that allowed for and demanded a historicizing of dance has, in modern criticism, been the category of gender. Judith Lynne Hanna's *Dance, Sex, and Gender* (Austin: University of Texas Press, 1988) represents one of the most thoroughgoing attempts in this direction. The most recent, and most successful, work to rethink broader modernism

from the perspective of dance history is Ramsay Burt, *Alien Bodies: Representations of Modernity, "Race," and Nation in Early Modern Dance* (London: Routledge, 1998). A further advance represented by this work lies in its refusal to limit considerations of broader modernism to a purely anglo-American context. As we shall see throughout this book, modernism as an international phenomenon looks very different in different national contexts. Whereas Burt's work brings to the consideration of dance a theoretical apparatus derived from other fields, I wish instead to demonstrate the ways in which a consideration of dance necessarily questions certain theoretical suppositions of that apparatus.

Susan Manning's *Ecstasy and the Demon: Feminism and Nationalism in the Dance of Mary Wigman* (Berkeley: University of California Press, 1993) is one of the best examples of the ways in which aesthetic considerations can interact with, but not necessarily be reduced to, historical determinants.

5 It is necessary at this early point to take note of what might seem an omission in the discussion of performativity in this book, namely the absence of a detailed discussion of the widely circulated usages of the term deriving from Judith Butler, *Gender Trouble: Feminism and the Subversion of Identity* (New York: Routledge, 1990). My primary reason for this omission is the misuse of the term in debates that claim to draw on Butler. Specifically, the notion of performativity that Butler proposes has been refashioned to support "postmodern" or ludic notions of identity formation that stress in an almost voluntarist fashion gender as construction. In subsequent cultural studies Butler's argument for social construction has either been repositivized (by the implicit reinsertion of a "performer" into the otherwise nongrounded episteme of performativity) or radicalized into some version of the primacy of discourse or "textuality." Given that in the next chapter I attempt to uncover a certain genealogy of the ludic or Schillerian "play," it clouds the issues to invoke Butler at this stage. Further, Butler works with a notion of gesture that needs further historical elaboration (such as I attempt in chapter 2) when she argues that "acts, gestures and desire produce the effect of an internal core or substance, but produce this *on the surface* of the body, through the play of signifying absences that suggest, but never reveal, the organizing principle of identity as a cause. Such acts, gestures, enactments, generally construed, are *performative* in the sense that the essence of identity that they otherwise purport to express are *fabrications* manufactured and sustained through corporeal signs and other discursive means (136)." The function of gesture shifts historically in a way that makes it impossible to posit the Foucaldian play of identities and acts in anything other than a historical context. In other words, it is not simply a question of a shift from performative to ontological and back to performative identities: the very binary is itself the historical phenomenon.

The sense in which performativity as utilized here *does* correspond to Butler's usage is in its insistence on performativity as "constituting the iden-

tity it is purporting to be. In this sense, gender is always a doing, though not a doing by a subject who might be said to preexist the deed" (25). As Butler rightly notes, this is a problem of ontology, but by concentrating in this book on moments of stumbling, of the gauche, or of bodily convulsion I want to examine the question less in terms of the crisis of the subject than in terms of the crisis of socialization.

6 It is not my aim here to reiterate the various positions within the ideology debate in materialist criticism. This work is admirably undertaken in what is still the most notable mapping of the various possibilities: Fredric Jameson, *The Political Unconscious: Narrative as a Socially Symbolic Act* (Ithaca: Cornell University Press, 1981).

7 Marx notes that "Balzac was thus compelled to go against his own class sympathies and political prejudices, that he saw the necessity of the downfall of his favourite nobles, and describes them as people deserving no better fate" (*Marx and Engels on Literature and Art: A Selection of Writings*, ed. Lee Baxandall and Stefan Morawski (New York: Telos, 1973), 92. Louis Althusser reorients Marx's formulation in his "Letter on Art in Reply to André Daspre," by insisting:

> I do not believe one can say, as you do, that he *"was forced by the logic of his art to abandon certain of his political conceptions in his work as a novelist."* On the contrary, we know that Balzac *never abandoned* his political positions. We know even more: his peculiar reactionary political positions played a decisive part in the production of the content of his work . . . The fact that the content of the work of Balzac and Tolstoy is "detached" from their political ideology and in some ways makes us "see" it from the *outside,* makes us "perceive" it by a distantiation inside that ideology, *presupposes that ideology itself.* It is certainly possible to say that it is an "effect" of *their art* as novelists that it produces this distance inside their ideology, which makes us "perceive" it, but it is not possible to say, as you do, that art *"has its own logic"* which *"made Balzac abandon his political conceptions."*

(Louis Althusser, "Letter on Art in Reply to André Daspre," in *Lenin and Philosophy and Other Essays* [New York: Monthly Review Press, 1971], 221–27, 222–23). In other words, we need to beware of arguing for a determining autonomy of what we might call "the aesthetic imperatives of his realism." My argument would be that the "aesthetic imperatives" are dictated not by an external logic of "art," but by the structure of a political fantasy and its need to close around a coherent narrative. It is precisely—as Althusser points out—because such narratives attempt not to "see" that they reveal an ideology's blind spots.

8 The most eloquent exponent of this position is, of course, Georg Lukacs; see his *Essays on Realism*, ed. Rodney Livingstone, trans. David Fernbach (Cambridge: M I T Press, 1981).

9 Many dance scholars have criticized this move also for its tendency to erase the semiotic specificity of dance. See, for example, Jill Dolan, "Geographies of Learning: Theater Studies, Performance, and the 'Performative,'" *Theatre Journal* 45, no. 4 (1993): 417–41.

10 Amy Koritz, "Re/Moving Boundaries: From Dance History to Cultural Studies," in *Moving Words: Rewriting Dance*, ed. Gay Morris (London: Routledge, 1996), 88–103, 91.

11 Fredric Jameson, "On Cultural Studies," *Social Text* 34 (1993): 17–51.

12 For methodological reflections on dance history, see Janet Adshead-Lansdale and June Layson, eds., *Dance History* (London: Routledge, 1983). The status of source materials and the implicit method of "reading" primary and secondary materials is, in particular, the focus of Layson's essay, "Dance History Source Materials" (18–31). A sustained critique of recent moves toward the "reading" of dance is to be found in a review of the work of Susan Leigh Foster by Marcia B. Siegel, "The Truth about Apples and Oranges," *Drama Review* 32, no. 4 (1988): 24–31.

13 Susan Leigh Foster, *Reading Dancing* (Berkeley: University of California Press, 1986), 237.

14 Peggy Phelan, *Unmarked: The Politics of Performance* (London: Routledge, 1993), 148.

15 "Wenn, wie es seit dem 16. Jahrhundert üblich ist, das literarische Motiv in seinem mittellateinischen Wortsinn als *motivum* aufgefaßt wird, das heißt als 'Beweggrund' des narrativen Vorgangs, in dem ein handlungstreibendes Element gesehen werden kann, so wäre es entweder tautologisch oder aber doppelbödig, von einem 'Bewegungs-Motiv' zu sprechen: 'Bewegt' doch ein Motiv schon *per definitionem* das literarische Geschehen . . . Die Frage nach der Figuralität des Tanzes soll dabei eine thematische mit einer rhetorisch-texttheoretischen Lektüre verbinden" (Roger W. Müller Farguell, *Tanz-Figuren: Zur metaphysischen Konstitution von Bewegung in Texten; Schiller, Kleist, Heine, Nietzsche* [Munich: Wilhelm Fink, 1995], 8). Where translations in this book are my own, the original text will be given in a note.

16 Mark Johnson, *The Body in the Mind: The Bodily Basis of Meaning, Imagination, and Reason* (Chicago: University of Chicago Press, 1987), xv.

17 Friedrich Schiller, *On the Aesthetic Education of Man*, trans. Reginald Snell (New York: Frederick Ungar, 1965), 96.

18 Josef Chytry, *The Aesthetic State: A Quest in Modern German Thought* (Berkeley: University of California Press, 1989), 83.

19 Paul de Man, *The Rhetoric of Romanticism* (New York: Columbia University Press, 263–90, 264.

20 The notion of mimesis invoked here should not be thought strictly in dance historical terms as pertaining to the reforms made by Jean Georges Noverre with respect to the *ballet d'action*. The account offered by Susan Manning of dance's participation in the logic of abstraction and moderniza-

tion (what she calls the "Greenbergian" account of dance history) would be more pertinent here:

> In this account, twentieth-century dance traces a progressive evolution, Breaking from the pictorialism integral to eighteenth- and nineteenth-century theater dance and then reenacting this break in successive approaches toward the ever-receding horizon of absolute dance. In the eighteenth and nineteenth centuries Western theater dance adhered to a mimetic ideal, aspiring to be "a living picture of the passions, manners, customs of all nations of the globe," in the words of Jean Georges Noverre (1760), the leading theoretician of the pictorial ballet. In the early twentieth century the mimetic model gave way to an ideal of self-reflexivity, dance 'devoted . . . to those characteristics which belong exclusively to dancing,' 'the configuration of motion in space,' in the words of André Levinson, a leading theoretician of dance modernism. (*Ecstasy and the Demon*, 19)

Whereas Manning rejects this formal solipsism as part and parcel of the ideology of a modernism that seeks to absolutize itself as a noncontingent and transhistorical condition, however, I argue that the mode of historical determination has itself moved beyond the "mimetic"—certainly by the early twentieth century. Thus, I take Manning's argument one step further, thereby tending to refute it, to contend that situating aesthetic artifacts within a historical context whose own aestheticized underpinnings have not been scrutinized, is itself ahistorical. Insisting on a certain autonomy of the aesthetic is entirely compatible with an emphasis on historical contextualization. Throughout this book I shall resist the "reading" of dance as "text," but concomitant with that polemic is an emphasis on the role of the aesthetic itself—as practice or performance—in determining "context."

Also crucial to the question of the mimetic in dance is Mark Franko, "Mimique," in *Bodies of the Text*, ed. Ellen W. Goellner and Jacqueline Shea Murphy (Rutgers: Rutgers University Press, 1995), 205–16.

21 See Jürgen Habermas, *The Structural Transformation of the Public Sphere: An Inquiry into a Category of Bourgeois Society*, trans. Thomas Burger with the assistance of Frederick Lawrence (Cambridge: MIT Press, 1991) (hereafter cited in the text). For a Frankfurt school consideration of dance and the regulation of the body under European absolutism, see Rudolf zur Lippe, *Naturbeherrschung am Menschen*, 2 vols. (Frankfurt: Suhrkamp 1974). For a more detailed consideration of the ideological status of dance in the baroque period, see Mark Franko, *Dance as Text: Ideologies of the Baroque Body* (Cambridge: Cambridge University Press, 1993).

22 On the concept of aesthetic ideology, see Jochen Schulte-Sasse, "General Introduction: Romanticism's Paradoxical Articulation of Desire," in *Theory as Practice: A Critical Anthology of Early German Romantic Writings*, ed.

Jochen Schulte-Sasse et al. (Minneapolis: University of Minnesota Press, 1996), 1–43.

23 Insofar as a notion of the bourgeois "institution of art" is utilized in this work, it is derived from Peter Bürger, *Theory of the Avant-Garde*, trans. Michael Shaw, foreword by Jochen Schulte-Sasse (Minneapolis: University of Minnesota Press, 1984).

24 See Herbert Marcuse, "The Affirmative Character of Culture," in *Negations: Essays in Critical Theory*, trans. J. Shapiro (Boston: Beacon, 1968), 88–133.

25 "Die Blüte des Balletts fiel in eine Periode, in der in Europa eine einseitige, verbürgerlichte Geistigkeit ihren Höhepunkt erreicht hatte und doch innerlich bereits die Reaktion des Materialismus vorbereitete. Das Körpergefühl war völlig erstorben und eben deshalb verehrte man in geradezu rührender Weise auf der Bühne ein Ideal dessen, was man nicht mehr besaß. Der träge gewordene Organismus des Bürgers wollte sich durch die äußerste Möglichkeit einer ihm selbst versagten Befähigung faszinieren und in seinen verkümmerten Instinkten aufpeitschen lassen" (Hans Brandenburg, *Der moderne Tanz* [Munich: Georg Müller, 1913], 90).

26 Carlyle's translation of "play" as "sport" was but the first step in a radical reevaluation of dance that would—by the end of the nineteenth century—lead to its identification with a problematic of work and labor. Schiller privileges play because he bases his aesthetic on a classical precedent that has no model for noble work; thus, the concept becomes problematic when adopted by the aesthetic socialists. Fourier's fantasy of *travail attrayant* (developed in *Le nouveau monde industriel et sociétaire* [Paris: Bossange Père, 1829]) first exemplifies a tendency taken up by Carlyle's claim in *Past and Present* that "all work, even cotton-spinning is noble; work is alone noble . . . man perfects himself by working" (quoted in Alasdair Clayre, *Work and Play: Ideas and Experience of Work and Leisure* [London: Weidenfeld and Nicolson, 1974], 64).

Schiller's reasoning would resonate throughout the nineteenth century in interesting ways as far as dance was concerned. Owen, for example, takes Schiller's notion of play as a model, instead, for labor. As one historian of *Social Radicalism and the Arts* has noted, unlike Morris, Owen "required the individual producer, making things with his own hands, to be replaced by collaborating groups of producers who, for good results, must work together in a humanly and humanely designed harmony with certain restrictions on machine production . . . It was characteristic of Owen as a utopian socialist to emphasize, together with the need for social harmony in an industrial age, the arts of music and of social dancing, because music, of course, connotes harmony, and the cotillion harmonious co-operation among its participants" (Donald Drew Egbert, *Social Radicalism and the Arts: Western Europe* [London: Duckworth, 1970], 385–86).

Dance's role is highly interesting in this configuration, shifting in ways that help explain what I see as its subsequent fall from grace. It now figures not the immanent social relations between men (or men and women) but rather those relations as mediated through labor and production. In other words, it loses its pretensions to aesthetic immanence and becomes the aesthetic medium for rethinking social order—social "grace"—in terms of relations of production. Music as the force of "social harmony" and the model of law goes back to Plato, of course, but now dance is invoked as the passage of this law into action. Consequently, dance's reconfiguration of potentially alienated labor might be taken as a symptom of the aestheticization of the condition of alienation itself. In Owen, the personal grace of the limbs has been displaced by the social dispositions that dance makes possible. Further work on this question in Owen and others is to be found in Chris Waters, *British Socialists and the Politics of Popular Culture: 1884–1914* (Manchester: Manchester University Press, 1990).

27 For the distinction between "work," "labor," and "activity," see Hannah Arendt, *The Human Condition* (Chicago: University of Chicago Press, 1958). This volume will be treated in greater detail in chapter 1, where I outline in a note the importance of Arendt's method for my project in this book.

28 If Schiller represents one key moment in the emergence of choreography as a paradigm for the conflation of cultural and social modernity, it is more usually Baudelaire—a more recognizably "modern" figure—who is cited as the source of that same tradition. As one astute critic notes, quoting Baudelaire's famous formulation:

> "La modernité, c'est le transitoire, le fugitif, le contingent." The quotation outlines both the criteria necessary for a definition of the modern, and the fundamental elements of the dance: the transitory and the fleeting are the essential properties of dance when played out as one form of the performing arts: and *after* the break with the balletic aesthetic paradigm, contingency too becomes a specific criterion of free dance: specifically, in the foregrounding of chance and improvisation, and in the presentation of the moving image as a "spontaneous" emotional expression. Thus, dance embodies a basic model for the modernist aesthetic and steps out from its supporting role in the hierarchy of the arts into the very center. It becomes a symbol of modernity and the key to all the arts, which attempt to reflect the new technical age as an epoch defined by movement

> ["La modernité, c'est le transitoire, le fugitif, le contingent." Damit sind nicht nur Kriterien für die Bestimmung des Modernen benannt, sondern diese Merkmale kennzeichnen zugleich die Kunst des Tanzes: das Transitorische, Flüchtige ist dem Tanz als exponierter Spielform der darstellenden Künste grundsätzlich zu eigen; und das Merkmal der Kontingenz wird

nach dem Bruch mit dem ästhetischen Paradigma des Balletts zu einem spezifischen Kriterium des freien Tanzes: nämlich in der hervorgehobenen Bedeutung des Zufalls, der Improvisation und der Präsentation des Bewegungsbildes als eines "spontanen" Empfindungsausdruckes. Der Tanz verkörpert mithin ein Grundmuster der Ästhetik der Moderne und tritt damit aus seiner Hintergrundposition in der Hierarchie der Künste plötzlich ins Zentrum: er wird zum Symbol der Moderne und zum Schlüsselmedium aller Künste, die das neue technische Zeitalter als eine durch Bewegung definierte Epoche zu reflektieren suchen.]

Gabriele Brandstetter, *Tanz-Lektüren: Körperbilder und Raumfiguren der Avantgarde* (Frankfurt: Fischer, 1995), 36. The Baudelaire quotation is from Baudelaire, *Oeuvres complètes*, ed. Y-G le Dantec (Paris: Gallimard, 1954), 892.

No clearer argument need be made for the paradigmatic status of dance within the genealogy of modernism. This is an altogether more worldly conception of the modern—one that engages historical time explicitly and obliges us to precisely the kind of consideration of the promenade and social graces that I wish to undertake here. At the same time, however, this tradition, too, has been watered down by a conflation of *le transitoire* and *le contingent*. An appropriation of choreography to this Baudelairean paradigm of the modern is also something I seek to resist in this book. Whereas the contingent implies accident and a commitment to historical and social determination, the category of the transitory has, I would contend, served to dehistoricize. The transitory has, so to speak, become musical, a moment that in its disappearance seems to mock a more mundane "historical" temporality by pointing to the possibility of a sublime beyond that is located in the aesthetic. Again, I seek here to counter that reading (to be traced below) by insisting, if need be, on the plastic and spatial as the repository of historical time. All too often we are faced with two alternative but equally romantic notions of modernity that might be mapped crudely in terms of the oppositions of body/space and movement/time. Each, however, is grounded in notions of a performative immanence that need to be challenged. Consequently, the body will stand here as that which resists the ideology of movement, while movement in turn must challenge the ideological "materiality" of the body. The hegemony of space and the hegemony of time both offer a potent ideological rhetoric: a critique of social choreography must stage their encounter in an altogether more dialectical manner.

29 In chapter 1, I already begin to examine how the Schillerian ideal of free "play" would be displaced by a growing tendency over the course of the nineteenth century for critical reflections on dance to liken it to socially useful *labor*.

30 Belinda Quirey, Steve Bradshaw, and Ronald Smedley, *May I Have the Pleasure? The Story of Popular Dancing*, ed. Libby Halliday (London: Dance Books, 1976), 70 (hereafter cited in the text).

31 "Die große Tanzepidemie, die durch den Krieg nur unterdrückt wurde, nach seiner Beendigung aber um so stürmischer ausbrach, hat etwas von der melancholischen Verwegenheit, die alle sterbenden Zeiten durchtränkt" (Hans W. Fischer, *Das Tanzbuch* [Munich: Albert Langen, 1924], 16).

32 "Der Rundtanz bedeutet den eigentlichen Verfall der Tanzkunst, wofern wir eine solche als bis daher vorhanden annehmen wollen. Jedenfalls war selbst in der Gesellschaft die Tanzbewegung noch so lange ein Schauspiel gewesen, wie sie von wenigen Begabten ausgeführt wurde. Nachdem aber im Rokoko zum letzten Male, wie in der Antike und der Renaissance, ein einheitlicher Stil eine ganze Zeit durchdrungen hatte, begann die Epoche der Literatur, der Wissenschaft und Technik und der Verbürgerlichung, und die zunehmende Vergeistigung schaffte die Phantasie des Körpers ab.

Der Tanz suchte jetzt nicht mehr, über die Allgemeinheit erhöht, den Sinn dieser Allgemeinheit in einem Bewegungsschauspiel auszudrücken, sondern wurde zu einem allgemeinen geselligen Vergnügen" (Hans Brandenburg, *Der moderne Tanz*, 23–24).

A similar degeneration is traced by Huizinga in his famous study *Homo Ludens*, where he argues that "the supersession of the round dance, choral, and figure dances by dancing *à deux*, whether this takes the form of gyrating as in the waltz or polka or the slitherings and slidings and even acrobatics of contemporary dancing, is probably to be regarded as a symptom of declining culture. There are reasons enough for such an assertion if we survey the history of the dance and the high standards of beauty and style it attained in former ages, and still attains where the dance has been revived as an artform—e.g. the ballet. For the rest, however, it is certain that the play-quality tends to be obscured in modern forms of dancing" (J. Huizinga, *Homo Ludens: A Study of the Play-Element in Culture* [Boston: Beacon, 1955], 189). As Huizinga also observes, rather pessimistically, "the nineteenth century seems to have little room for play . . . These tendencies were exacerbated by the industrial revolution and its conquests in the field of technology. Work and production became the ideal" (218).

33 The distinction between the merely authoritarian and the more insidiously totalitarian nature of modern existence forms the basis of the analysis in Max Horkheimer and Theodor W. Adorno, *The Dialectic of Enlightenment*, trans. John Cumming (New York: Continuum, 1987).

34 Fredric Jameson lays out this question of potential "homologies" of ideological material in his consideration of Althusser in *The Political Unconscious*. Critiquing the kinds of loose homology he identifies with Lucien Goldmann, Jameson at this point supports Althusser (whom he otherwise critiques): "The true target of Althusserian critique would seem to me . . . the structural notion of homology (or isomorphism, or structural parallelism)—a term widely in use in a variety of literary and cultural analyses . . . in which it is affirmed that at some level of abstraction the 'structure' of the three quite

different realities of social situation, philosophical or ideological position, and verbal and theatrical practice are 'the same'" (43–44). By contrast, Jameson argues, what Althusser offers is an analysis in which the monadic autonomy of each of the terms of the homology is fissured by the fact that the terms are themselves related within the social fabric in precise and concrete and institutional ways: "Althusserian structure, like all Marxisms, necessarily insists on the interrelatedness of all elements in a social formation; only it relates them by way of their structural difference and distance from one another, rather than by their ultimate identity, as he understands expressive causality to do. Difference is then here understood as a relational concept, rather than as the mere inert inventory of unrelated diversity" (41).

35 "Wo der Tanz sich als unmittelbare Lebensäußerung gab, hat immer der Mann an ihm den vollen, zuweilen sogar den führenden Anteil gehabt; als Werber, als Priester, als Krieger. Er behält seine Stellung darum auch im Gesellschaftstanz, der ja im Grunde immer eine Werbung geblieben ist. Erst, als der Tanz abrückte und zur Schau wurde, vollzog sich hier ein Wandel" (Fischer, *Das Tanzbuch*, 35).

36 "Das Demokratische, das Bürgertum, das Gemüt hatten gesiegt . . . Die unerhörte Popularisierung der Tanzfreude, ihre geradezu epidemische Verbreitung, den Tanzrausch als eine internationale Massenpsychose vermochte der Walzer nur durch den Zustand, daß sein Rhythmus einen Bewegungsimpuls von einer nie dagewesenen Zündkraft enthält, daß er die rhythmische Formel aller Tanzlust ist" (Brandenburg, *Der moderne Tanz*, 24).

37 Frances Rust, *Dance in Society: An Analysis of the Relationship between the Social Dance and Society in England from the Middle Ages to the Present Day* (London: Routledge and Kegan Paul, 1969), 84.

38 Nijinsky's status as both an icon of homosexual desire and an avatar of the marketplace is considered by Michael Moon in "Flaming Closets," *October* 51 (1989): 19–54. Moon also draws on work examining orientalism in fashion as influenced by Nijinsky. See also Peter Wollen, "Fashion/Orientalism/the Body," *New Formations* 1 (spring 1987): 5–33.

39 Writings both on the waltz and on the early-twentieth-century dance craze bring us back to an all-pervasive ideology of "rhythm" that became the leitmotif of a broader cultural modernism around 1910, permeating both aesthetic and social discourse. While it is not my objective in this work to offer a whirlwind intellectual history of early-twentieth-century Europe, we might by way of shorthand identify the newly hegemonic choreography with the popularization of vitalism and *Lebensphilosophie* in the early part of this century. From the perspective of a revitalized and newly vitalistic culture that stressed spontaneity, animal force, and the body as the conduit for the release of psychic energy into the phenomenal world, the historically legitimate ideological critique of ballet degenerated into a programmatic demand to "break out of a century whose ugliness could only be experienced as inimical to the

body, in order to . . . 'embody in the flesh a more beautiful image of man' "
[aufzubrechen aus einem als häßlich und körperfeindlich empfundenen Jahr-
hundert und ein . . . 'schöneres Menschenbild im Fleische vorzuzeigen']
(Gumpert, *Die Rede vom Tanz*, 7; the quotation is from the Marxist cultural
critic Ernst Bloch). If ballet were to be rejected for its falsity and anachronistic
aestheticization of the human body, then it was necessary to posit a non-
anachronistic, historically legitimate aesthetics of the body; a *Körperkultur* or
body culture.

This question of rhythm is extremely important for any analysis of the
tempo of modernity. As one important champion of modern dance observed
at the time: "The search for rhythms characterizes our age. Social life, art,
even science echo the call. It is in rhythm that we seek new models for
linguistic expression (the chorus), for the theater (in space and movement),
for social dancing (the hegemony of syncopation), for the streetscape (traffic
problems in the cities) and for industrial production (rhythmic approaches to
work)" [Das Suchen nach Rhythmus ist eine charakeristische Erscheinung
unserer Zeit. Das soziale Leben, die Kunst, selbst die Wissenschaft von heute
widerhallt von diesem Ruf. Man sucht den Rhythmus in neuen Formen des
sprachlichen Ausdrucks (Sprechchor), der Bühnenkunst (Raum, Bewegung),
des Gesellschaftstanzes (Herrschaft der Synkope), des Straßenbildes (Ver-
kehrsprobleme der Großstadt), der industriellen Produktion (Rhythmisier-
ung der Arbeitsvorgänge] (Ernst Ferand, "Rhythmus und Takt," in *Tanz in
dieser Zeit*, ed. Dr. Paul Stefan [Vienna: Universal Edition, 1926], 40–41, 40).

It is important to note how the all-encompassing trope of rhythm allows for
a social vision that unites such disparate elements as jazz dance, traffic prob-
lems, and theater reform. The perception of rhythm as a central issue of
modernity led not only to different conclusions about the world, but to a
different conception of how that world was integrated. This insistence on
rhythm introduced new aesthetic—one might say antiaesthetic—elements
into social choreography by insisting on the presocial provenance of aesthetic
forms. It excises any notion of aesthetic competence—the footwork equivalent
of "handicraft" in traditional object-oriented modes of aesthetic creation.

40 Irene and Vernon Castle, *Modern Dancing* (New York: Harper & Bros.,
1914): 43. Quoted by Rust, *Dance in Society*, 84.

CHAPTER 1 THE BODY OF MARSYAS

1 Feminist scholars working with this narrative have nevertheless pointed
out how the downgrading of dance as an art form marked a devaluation of
what was, effectively, one of the only aesthetic spheres in which women were
predominant. The distinction that developed between aesthetic conception
and performance, it has been argued, allowed for the emergence in the early

twentieth century of the (male) choreographer as a heroic figure at the expense of the (female) performer. See Amy Koritz, *Gendering Bodies/Performing Art: Dance and Literature in Early Twentieth-Century British Culture* (Ann Arbor: University of Michigan Press, 1995).

Gabriele Brandstetter has elaborated on this feminist critique to demonstrate the formal impact of emerging female dance celebrities at the turn of the twentieth century. Whereas anglo-American feminists have pointed out the way in which the emergence of the choreographer as a key figure—in the Ballets Russes for example—serves to downgrade the female dancer to mere executant, Brandstetter argues that a newly emerging notion of celebrity actually unleashes through these feminine figures the full potential of what I term social choreography as something that cannot be limited to the strictly aesthetic realm: "The distinction between a 'role' and the 'actor' interpreting it— characteristic for drama as well as for the ballet—became obsolete with the appearance of Loïe Fuller, Isadora Duncan, Ruth St Denis and their successors. The habitus of individuality that had become programmatic aesthetically and ideologically in expressive dance—along with a marked resistance in almost all cases to any documentation, sketches or even notation of their dances— renders the conventional concept of the 'work' of art obsolete" [Die Trennung zwischen 'Rolle' und interpretierendem 'Akteur,' die nicht nur für das Schauspiel, sondern auch für das Ballett charakteristisch ist, wird mit dem Auftreten von Loïe Fuller, Isadora Duncan, Ruth St Denis und ihren Nachfolgerinnen aufgehoben. Der zum ästhetischen und weltanschaulichen Programm erhobene Habitus des Individuellen im freien Tanz—gekuppelt mit einem nahezu bei allen Vertreterinnen ausgeprägten Widerstand gegen Dokumentation, Skizzen oder gar Notationen ihrer Tänze, läßt den konventionellen Werkbegriff in diesem Kontext obsolet erscheinen] (Gabriele Brandstetter, *Tanz-Lektüren: Korperbilder und Raumfiguren der Avantgarde* [Frankfurt: Fischer, 1995], 25.)

2 Herbert Spencer, "Professional Institutions: III. Dancer and Musician," *Contemporary Review* 68 (July 1895): 114–26, 115.

3 Anson Rabinbach, *The Human Motor: Energy, Fatigue, and the Origins of Modernity* (Berkeley: University of California Press, 1990), 1.

4 "L'esprit humain tend par sa nature à l'inertie" (M. G. Ferrero, "Les formes primitives du travail," *Revue scientifique* 5, no. 11; series 4 [14 March 1896]: 331–335, 331). Ferrero is perhaps best known as the coauthor with his father-in-law, Cesare Lombroso, of *The Female Offender* (New York: Appleton, 1895), although his later reputation was made as a historican of ancient Rome. In his early work Ferrero was concerned with the issue of energy and entropy as both physical and cultural phenomena.

5 "Eins aber ist gewiß von Wert in der Abeit des italienischen Gelehrten . . . das Ausgehen von einer Tätigkeit, die nicht Arbeit ist, die aber der Naturmensch anerkanntermaßen mit Lust und Ausdauer auszuüben pflegt:

dem Tanze" (Karl Bücher, *Arbeit und Rhythmus*, 3rd ed. [Leipzig: Taubner, 1902], 20).

6 "Von allen Momenten, welche Ferrero am Tanze der Wilden wichtig schienen, ist nur eines, welches der zuletzt von mir gestellten Anforderung entspricht: sein automatischer Charakter."

7 "Arbeit soll nur die auf die Erzielung eines außer ihr gelegenen nütz-lichen Erfolgs gerichtete Bewegug sein; alle Bewegungen, dagegen, deren Zweck in ihnen selbst liegt, sollen nicht Arbeit sein."

8 "L'agrément du rythme . . . provient des activités corporelles qui en résultent; l'expérience en effet montre que le rythme qui manifeste l'ordre à la fois dans le temps et dans l'espace favorise la répétition des actes volontaires en les automatisant en quelque sort" (Charles Féré, *Travail et Plaisir* [Paris: Felix Alcan, 1904], 21). Féré was a collaborator with both Charcot and Binet. With the latter he claimed to have discovered what they called "transfer" and perceptual and emotional polarization. He was later forced to retract these "discoveries." Féré was primarily concerned with the phenomena of hyp-nosis, hysteria, abnormal psychology, and the relation of physical degenera-tion to criminality.

9 "Toutes les excitations agréables coïncident avec la conscience d'une capacité plus grande d'activité, capacité plus grande qui existe en effet."

10 "Dans le travail productif, l'excitation à l'activité est volitive, tandis qu'elle est presque automatique dans le *sport* sauvage."

11 "Presque chaque mouvement doit donc être précédé par un acte intel-lectuel qui dirigera l'acte volitif sous l'impulsion duquel le mouvement sera accompli. Il est vrai que, dans l'industrie moderne, les opérations accomplies par chaque ouvrier étant très simples et toujours les mêmes, un certain dégré d'automatisme s'introduit dans l'habileté professionelle."

12 "L'homme enragé qui tape furieusement des poings ou des pieds excite encore plus, par ce seul fait, sa rage, et sa rage augmentée rend encore plus emportée et plus violente sa gesticulation. C'est une action et une réaction mutuelles . . . Il en arrive de même au danseur . . . les premiers mouvements de la danse accomplis, ceux-ci deviennent les excitateurs des mouvements successifs."

13 "L'augmentation de la potentialité produite par la répétition rythmique des mouvements rend compte au moins d'une partie du plaisir de la danse."

14 John Ruskin, *The Complete Works of John Ruskin*, 39 vols., ed. E. T. Cook and Alexander Wedderburn (London: George Allen, 1903–12), 35: 559–60. All susbequent references to all of Ruskin's works are from this edition and are noted in the text by individual title and edition page number.

15 For more on this, see Donald Drew Egbert, *Social Radicalism and the Arts: Western Europe* (London: Duckworth, 1970); and Chris Waters, *British Socialists and the Politics of Popular Culture: 1884–1914* (Manchester: Manches-ter University Press, 1990).

16 See, most notably, Rudolf Laban and F. C. Lawrence, *Effort: Economy in Body Movement* (London: Macdonald and Evans, 1947).

17 David Meakin, *Man and Work: Literature and Culture in Industrial Society* (London: Methuen, 1976), 190.

18 For an elaboration of this scheme of analysis, see A. J. Greimas and François Rastier, "The Interaction of Semiotic Constraints," *Yale French Studies* 41 (1968): 86–105. I should stress that I use Greimas in the same way that Jameson does in *The Political Unconscious* (Ithaca: Cornell University Press, 1981); that is, not as an undialectical structure of binaries adequate to ideological analysis but as reflecting in its very rigidity precisely the structures of closure necessary to a coherent fantasy structure. In Jameson's terms: "The semiotic rectangle becomes a vital instrument for exploring the semantic and ideological intricacies of the text—not so much because, as in Greimas' own work, it yields the objective possibilities, according to which landscape and the physical elements, say, must necessarily be perceived, as rather because it maps the limits of a specific ideological consciousness, and marks the conceptual points beyond which that consciousness cannot go, and between which it is condemned to oscillate" (47).

19 William J. Gatens, "John Ruskin and Music," in *The Lost Chord: Essays on Victorian Music*, ed. Nicholas Temperley (Bloomington: Indiana University Press, 1989), 68–88, 74. Gatens also paraphrases the received wisdom that Ruskin "has no ear for the higher effects of the arts, is not what we call musical," from W. G. Collingwood, *Life and Work of John Ruskin*, 2 vols., 2nd ed. (London: Methuen, 1893), 1:93.

20 Finally, his schema links science to knowledge, art to deeds, and literature to conceptions. We might schematize as follows:

Science	*Art*	*Literature*
Knowledge	Deeds	Conceptions
Episteme	Techne	Nous
Opposes agnoia	Opposes atechnia	Opposes agnoia

At this point, however, Ruskin has to acknowledge his departure from the classical system most fully schematized by Aristotle; for in Aristotle we encounter five, not three, terms: *phronesis* (sense or prudence) and *sophia* (wisdom), as well as *techne* (art), *nous* (wit), and *episteme* (science). "But how of the sense and the wisdom?" Ruskin asks. Perhaps "we ought to have two additional schools, one of *Philosophia* and one of *Philophronesia?*" (22: 130). No, he argues, for *sophia* is a modality of the operation of the first three faculties (I leave aside, for the moment, his treatment of *phronesis* as common sense). In other writings we will see how the practice of *sophia* is identified with poetry, as for example in the passage from *Modern Painters* where Ruskin seems so radically to question traditional *ut pictura poesis* terminology:

"Painting," he writes, "is properly speaking to be opposed to *speaking* or *writing*, but not to *poetry*. Both painting and speaking are methods of expression. Poetry is the employment of either for the noblest purposes" (5:31). This identification of *sophia* with *poesis* is, of course, highly significant in terms of Arendt's distinction of (poetic) work and labor.

21 Chris Waters, *British Socialists*, 56.

22 Hannah Arendt, *The Human Condition* (Chicago: University of Chicago Press, 1958), 7.

23 Adopting a taxonomy from the *Nicomachean Ethics* and the *Eudemian Ethics*, Arendt demonstrates how the Greeks' disdain for the necessities of life, and their insistence on freedom as freedom *from* the necessities of work and labor, led to a privileging of activity as the truly human political condition. While her study might be read as a plea for a return to such ideals of political activity and as rejecting the reduction of all activity to the status of calculable labor that it has acquired both in capitalism and Marxist critiques of capitalism, Arendt also demonstrates a dialectic within Greek thought that paves the way for the denigration of the very values on which that thought was based. By the time of Augustine, she argues, with his celebration of the *vita contemplativa*, "the term *vita activa* lost its specifically political meaning and denoted all kinds of active engagement in the things of this world" (Arendt, *The Human Condition*, 14).

Clearly, the Christian privileging of eternity (as a metaphysical concept) over Greek notions of "immortality" as an endurance in and against historical and worldly temporality means that such an "engagement in the things of this world" will acquire a negative value. Consequently, as Arendt notes, distinctions crucial to the Greek worldview are lost. However, "it does not follow that work and labor had risen in the hierarchy of human activities and were now equal in dignity with a life devoted to politics. It was, rather, the other way round: action was now also reckoned among the necessities of earthly life, so that contemplation (the *bios theoretikos*, translated into the *vita contemplativa*) was left as the only truly free way of life" (14).

The Achilles heel of the Greek system is the concept of *shkole*, which was taken up in Roman civilization as *otium*. This concept expands the concept of "freedom from" to include freedom from the time-consuming activities of political life. At a certain point, freedom to engage in politics is eclipsed by a freedom from politics—and Christianity's privileging of unworldly eternity over worldly Greek notions of immortality further facilitates this shift. Transporting Arendt's framework to the nineteenth century, I would like to suggest that some troubling of this framework does, in fact, take place—but not necessarily in the places one might expect. By suggesting that these questions of work and performance are intrinsically poetic questions, I wish to suggest a slightly different way of understanding the relation of poetics to history. In looking here at questions of work and idleness, I do not reduce them to

"historical" referents drawn from capitalism in an age of growing unemployment, but propose instead to read "history" through these aesthetic—poetic—issues.

In Arendt's narrative, Christian otherworldliness builds on a Greek disdain for the necessities of life, work and labor, in order to develop a blanket condemnation of worldliness that will subsequently consume even the Greek ideal of political activity. Arendt contends that the subsequent privileging of contemplation and *theoria* "has not been changed essentially by the modern break with tradition and the eventual reversal of its hierarchical order in Marx and Nietzsche" (17). If, as Arendt argues, the Augustinian shift toward a *vita contemplativa* implied a denigration of all activity as an engagement in worldliness, it nevertheless also provides new models and legitimations for action. "Only *homo faber*," Arendt writes, "conducts himself as lord and master of the whole earth. . . . His productivity was seen in the image of a Creator-God, so that where God creates *ex nihilo*, man creates out of given substance" (139).

24 William Morris, "Art and Labour," in *On Art and Socialism* (London: John Lehmann, 1947), 95. Subsequent references to this collection are noted in the text.

25 For an overview of Greek musical theory, see Carnes Lord, *Education and Culture in the Political Thought of Aristotle* (Ithaca: Cornell University Press, 1982), particularly 203–19; and Andrew Barker, ed., *Greek Musical Writings*, 2 vols. (New York: Cambridge University Press, 1984–89).

26 Aristotle, "Politics," in *Complete Works of Aristotle*, ed. Jonathan Barnes (Princeton: Princeton University Press, 1984), 1340 (hereafter cited in text).

27 Jean-François Lyotard, *The Differend: Phrases in Dispute*, trans. Georges Van Den Abbeele (Minneapolis: University of Minnesota Press, 1988), 167.

28 In a letter from *Arrows of the Chace* Ruskin comes closest to a strictly classical view of the pedagogical value of music when he writes: "No nation will ever bring up its youth to be at once refined and pure, till its Masters have learned the *use* of all the Arts, and primarily of these; till they Again recognise the gulf that separates the Doric and Lydian modes, and perceive the great ordinance of Nature, that the pleasures which, rightly ordered, exalt, discipline, and guide the hearts of men, if abandoned to a *Dis*-order, as surely degrade, scatter, and deceive alike the passions and Intellect" (34: 530).

29 That the *ut pictura poesis* debate acquired a newly pressing cultural significance in the nineteenth century (as opposed to its more limited semiotic significance in the eighteenth) should be clear from even the most cursory glance at Nietzsche's *Birth of Tragedy*, where "through Apollo and Dionysus, the two art deities of the Greeks, we come to recognize that in the Greek world there existed a tremendous opposition, in origin and aims, between the Apollinian art of Sculpture, and the nonimagistic, Dionysian art of music" (Friedrich Nietzsche, *The Birth of Tragedy and the Case of Wagner*, trans. and commentary by Walter Kaufmann [New York: Vintage, 1967], 33).

Assuming the reversibility of this equation, it would appear that the distinction between the musical and the plastic arts serves as a touchstone for social questions that would come to a head in the writings of Nietzsche but that can be traced across European cultures throughout the century. The *ut pictura poesis* debate has been transformed into a debate between the Apollinian and the Dionysian culture-sponsoring values. Returning to Ruskin, though, we realize that within this transformed *ut pictura poesis* debate there operates a more limited debate about music in which it is Marsyas, not Dionysus, who is the antagonist of Apollinian values. If Nietzsche highlights in pointed terms the stakes of the debate, perhaps the illumination he throws on the questions serves to blind as much as it does to enlighten. What will have become, in Nietzsche, an opposition of Apollinian and Dionysian is reconciled, in Ruskin's presentation, as a narrative of maturation.

30 This question of the primacy of language and voice over music will become something of a bee in Ruskin's bonnet. Even though his attitude to music changed significantly across his long career, his early preference for music tailored to the sense and syllables of the text remained, rendering his musical judgments highly suspect.

31 This question obviously goes back beyond Ruskin. Perhaps the most relevant and suggestive contexts in which the question was addressed was in Shelley's "Notes on Sculptures in Rome and Florence" (probably written in 1819), which are so reminiscent of that key text for the eighteenth-century *ut pictura poesis*—Gotthold Ephraim Lessing's *Laoköon*. Confronted with a grotesque sculpture of a flayed Marsyas, Shelley asks: "Is it possible that there existed in the same imagination the idea of that tender and sublime and poetic and life-giving Apollo and of the author of this deed as the same person? It would be worse than confounding Jehovah and Jesus in the same Trinity, which to those who believe in the divinity of the latter is a pretty piece of blasphemy in any intelligible sense of the word" (Shelley, *Complete Works of Percy Bysshe Shelley*, 10 vols. [London: Benn, 1965], 6: 307–32, 325). Of course, Shelley's surprise is itself a little surprising; the result, perhaps, of his rather benign presentation of the sublime in this passage as "life-giving." The sublime, here, lies with Marsyas—and the aesthetic offense lies in his plastic representation.

The Marsyas-Apollo distinction retains its significance for the intellectual tradition I have been foregrounding right into the twentieth century. Thus, we read in Huizinga's *Homo ludens*: "In few human activities is competition more ingrained than in music, and has been so ever since the battle between Marsyas and Apollo" (188).

32 Oscar Wilde, *The Complete Works of Oscar Wilde* (London: Book Club Associates, 1976), 987.

33 Wilde's use of Marsyas in this context is not a one-off case. In an unfavorable review of a series of poems suggestively titled "Rhymes and

Rhythms in Hospital," Wilde complains that "while echo or mirror can repeat for us a beautiful thing, to actually render a thing that is ugly requires the most exquisite alchemy of form, the most subtle magic of transformation. To me there is more of the cry of Marsyas than of the singing of Apollo in the earlier poems of Mr. Henley's volume, 'Rhymes and Rhythms in Hospital,'" (Oscar Wilde, *The Artist as Critic: Critical Writings of Oscar Wilde*, ed. Richard Ellmann [London: W. H. Allen, 1970], 90; originally published as "A Note on Some Modern Poets," in *Woman's World* 2 no. 14 [December 1888]: 108–12).

34 By insisting, for literary historical reasons, on the centrality of organicist tropes even in so thoroughly "artificial" a writer as Wilde, Frank Kermode, in *Romantic Image* (London: Fontana, 1971 [1957]), has effectively homogenized the tradition of aesthetic socialism. Although art represents, for Wilde, the condition of nonalienated labor, his recognition of the liberating value of technology clearly distinguishes him from the tradition of, say, Morris. Wilde begins from the historical condition of rationalization: labor will never again be redeemed by invoking an aesthetic paradigm, and one can only hope, on the basis of technological advances, that it is to cease altogether. Morris's ideal of handicraft, however, depends on the possibility of labor acquiring a redemptive quality through a return to handicraft ideals and use values. Indeed, Morris's particular brand of aestheticism is rigorously utilitarian. The distinction within aesthetic socialist thinking between utilitarian rejections of capitalist exchange (Morris) and "art for art's sake" (Wilde) is not simply temperamental: it can be traced directly to distinct conceptions of labor.

CHAPTER 2 STUMBLING AND LEGIBILITY

1 François Delsarte (1811–1871) was a French teacher of acting and singing. He set up rules coordinating the voice with the gestures of all parts of the body. From 1839 on his advice was sought by great actors such as Rachel. His exercises aimed to render the individual conscious of his body in space. It was the exportation of his ideas to the United States, however—where his thought directly influenced Isadora Duncan and the mother of Ruth St Denis—that greatly boosted his posthumous fame. In Europe, meanwhile, Laban studied Delsarte assiduously.

2 Nordau's analyses of cultural decay enjoyed great popularity around the turn of the century. See Max Nordau, *Degeneration* (Lincoln: University of Nebraska Press, 1993). His attempts to link sociological, cultural, and physiological traits were based on the work of the Italian criminologist Lombroso. See Cesare Lombroso, *Crime: Its Causes and Remedies*, trans. Henry P. Horton, intro. Maurice Parmelac (Boston: Little, Brown, 1911); and Cesare Lombroso and William Ferrero, *The Female Offender*, intro. W. Douglas Morrison (New York: Appleton, 1895).

3 "allein zu gehen . . . außer dem Gängelwagen, darin [ihre Vormünder] sie einsperreten." Quoted in Bernd Jürgen Warneken, "Bürgerliche Gehkultur in der Epoche der Französischen Revolution," *Zeitschrift für Volkskunde* 85, no. 2 (1989): 177–87. Immanuel Kant, "An Answer to the Question: What Is Enlightenment?" in *Perpetual Peace and Other Essays*, trans. Ted Humphrey (Indianapolis: Hackett, 1983), 41–48.

4 See Thomas Hobbes, *Man and Citizen: De Homine and De Cive*, ed. Bernard Gert (Indianapolis: Hackett, 1991); and Johann Heinrich Pestalozzi, "Über Körperbildung als Einleitung auf den Versuch einer Elementargymnastik in einer Reihenfolge körperlicher Übungen," in *Johann Heinrich Pestalozzi über Körperbildung*, ed. Heinz Meusel (Frankfurt am Main: Limpert, 1973).

5 For a consideration of the literary implications of this concern with walking, see Anne D. Wallace, *Walking, Literature, and English Culture: the Origin and Use of Peripatetic in the Nineteenth Century* (Oxford: Clarendon, 1993). Also helpful is the study by Belinda Quirey, Steve Bradshaw, and Ronald Smedley, *May I Have the Pleasure? The Story of Popular Dancing*, ed. Libby Halliday (London: Dance Books, 1976). In this study the relationship between body posture and social dance highlights the ways in which both theatrical and popular dance responded to quite specific changes in fashionable deportment—specifically, a three-centuries-long aristocratic preference for the out-turned toe—to develop new forms of dance.

6 "Ich halte den Gang für das Ehrenvollste und Selbständigste in dem Manne und bin der Meinung, daß alles besser gehen würde, wenn man mehr ginge."

7 "Eine neue, bürgerliche Gehkultur wird in Deutschland insbesondere seit den 1780er Jahren beredet und erprobt. Und es läßt sich mit einigem Recht sagen, daß das bürgerliche Bemühen um einen eigenen Lebensstil und auch eine eigene Körperkultur nicht nur neben vielem anderen eben auch Gehpraxis und Gehstil einbezieht, sondern daß dieser neuen Gehkultur bei der Veralltäglichung eines modernen bürgerlichen Habitus und der Demonstration bürgerlichen Selbstbewußtseins eine eigenständige und bedeutsame Funktion zukommt."

8 Giorgio Agamben, *Infancy and History: The Destruction of Experience*, trans. Liz Heron (London: Verso, 1993), 135 (hereafter cited in the text).

9 Adorno's reflections on walking and promenades are primarily to be found in Theodor Adorno, *Minima Moralia: Reflections from Damaged Life*, trans. E. F. N. Jephcott (London: Verso, 1974).

10 For a comprehensive study of eighteenth-century work on the origins of language, see Hans Aarsleff, *From Locke to Saussure: Essays in the Study of Language and Intellectual History* (Minneapolis: University of Minnesota Press, 1982); and Hans Aarsleff, *The Study of Language in England, 1780–1860* (Princeton: Princeton University Press, 1967).

11 Jean-Jacques Rousseau, "Essay on the Origin of Languages; Which Treats of Melody and Musical Imitation," in *On the Origin of Language. Two Essays: Jean-Jacques Rousseau and Gottfried Herder*, trans. and with afterwords by John H. Moran and Alexander Gode (Chicago: University of Chicago Press, 1986), 1–83, 6.

12 The vigor of Thrasybulus finds its counterpart in an even more violent act: "When the Levite of Ephraim wanted to avenge the death of his wife, he wrote nothing to the tribes of Israel, but divided her body into twelve sections, which he sent to them. At this horrible sight they rushed to arms, crying with one voice: *Never has such a thing happened in Israel, from the time of our fathers' going out of Egypt, down to the present day*" (7). In his celebration of vigor Rousseau overlooks the lack of vigor in the dismembered female body. In its most dramatic example the symbol is already murderous of the very vigor that supposedly motivates it. On the other hand, the body becomes articulate in its very dismemberment: it speaks through its disarticulation. A distrust of meanings made possible only through grammar plays itself out as a murderous attack on a female body—a forcible recuperation of "mimetic" possibilities by a rejection of linguistic and bodily articulation. Furthermore, we would be wrong to ignore the historical setting of the Jews' "fathers' going out of Egypt." Given all Rousseau has just said about Egypt and symbolic writing, what are we meant to make of this singular symbol disseminated in the wake of a "going out of Egypt"? Clearly, the implication would seem to be that any attempt to "reinvigorate" the symbol post-Egypt would consist merely of an autopsy on symbolic language. To attempt to recover pantomimetic language is necessarily to do violence to the body.

13 The gendering of the symbolic body is, of course, very interesting here. Whereas the body of the woman becomes significant through its death and dismemberment, Diogenes becomes a symbol precisely at the point where his body serves to figure his personality through walking. If the symbolic presents and confirms embodied masculine identity, it seems to demand the sacrifice of the feminine.

14 Honoré de Balzac, *Théorie de la démarche et autres textes* (Paris: Albin Michel, 1990 [1833]); hereafter cited in the text.

15 Althusser famously describes interpellation as follows: "Ideology 'acts' or 'functions' in such a way that it 'recruits' subjects among the individuals (it recruits them all) or 'transforms' the individuals into subjects (it transforms them all) by that very precise operation which I have called interpellation or hailing, and which can be imagined along the lines of the most commonplace everyday police (or other) hailing 'hey, you there!' (Louis Althusser, "Ideology and Ideological State Aparatuses," in *Lenin and Philosophy and Other Essays* [New York: Monthly Review Press, 1971], 174).

16 "L'homme social est obligé d'aller continuellement du centre à tous les

points de la circonférence. Il a mille passions, mille idées, et il existe si peu de proportion entre sa base et l'étendue de ses opérations, qu'à chaque instant il est pris en flagrant délit de faiblesse."

17 "N'est-il pas réellement bien extraordinaire de voir que, depuis le temps où l'homme marche, personne ne se soit demandé pourquoi il marche, comment il marche, s'il marche, s'il peut mieux marcher, ce qu'il fait en marchant, s'il n'y aurait pas moyen d'imposer, de changer, d'analyser sa marche: questions qui tiennent à tous les systèmes philosophiques psychologiques et politiques dont s'est occupé le monde?"

18 "Un fou est un homme qui voit un abîme et y tombe. Le savant l'entend tomber, prend sa toise, mesure la distance . . . Il n'y a pas un seul de nos mouvements, ni une seule de nos actions, qui ne soit un abîme où l'homme le plus sage ne puisse laisser sa raison, et qui ne puisse fournir au savant l'occasion de prendre sa toise et d'essayer à mesurer l'infini. Il y a de l'infini dans le moindre *gramen*."

19 "Ici, je serai toujours entre la toise du savant et le vertige du fou . . . Je me place au point précis où la science touche à la folie."

20 "Borelli dit bien pourquoi l'homme, emporté hors du centre de gravité, tombe; mais il ne dit pas pourquois souvent l'homme ne tombe pas, lorsqu'il sait user d'une force occulte, en voyant à ses pieds une incroyable puissance de *rétraction*."

21 "Vous demanderez pourquoi tant d'emphase pour cette science prosaïque."

22 "Ici, ne serait-il pas toujours M. Jourdain, faisant de la prose sans le savoir, marchant sans connaître tout ce que sa marche soulève de hautes questions?"

23 "Je décidai que l'homme pouvait projeter hors de lui-même, par tous les actes dus à son mouvement, une quantité de force qui devait produire un effet quelconque dans sa sphère d'activité. Que de jets lumineux dans cette simple formule!"

24 "Le fluide moteur, cette insaisissable volonté, désespoir des penseurs et des physiologistes."

25 "L'homme aurait-il le pouvoir de diriger l'action de ce constant phénomène auquel il ne pense pas? Pourrait-il économiser, amasser l'invisible fluide dont il dispose à son insu?"

26 "Tout mouvement exorbitant est une prodigalité sublime."

27 "L'âme perd en force centripète ce qu'elle gagne en force centrifuge."

28 "Chercheurs d'autographes, et ceux qui prétendent juger le caractère des hommes sur leur écriture."

29 "Lavater a bien dit, avant moi, que, tout étant homogène dans l'homme, sa démarche devait être au moins aussi éloquente que l'est sa physionomie; la démarche est la physionomie du corps. Mais c'était une déduction naturelle de sa première proposition: *Tout en nous correspond à une cause interne*."

30 We should beware of overstating this shift, however. Balzac observes the manner in which a physiognomic reading of morals from bodily proportions can easily be confused with a reading of gauche gestures. Observing how "an obese man is necessarily obliged to surrender to the false movement introduced into his economy by the belly that dominates him" [Un obèse est nécessairement forcé de s'abandonner au faux mouvement introduit dans son économie par son ventre qui la domine] (62), he concludes that "edifying work and destructive vice produce the same effects in man" [le travail qui édifie et le vice qui détruit produisent en l'homme les mêmes résultats] (63); namely, imbalance.

31 "Pour moi, dès lors, le mouvement comprit la Pensée, action la plus dure de l'être humain; le Verbe, traduction de ses pensées; puis la Démarche et le Geste, accomplissement plus ou moins passionés du Verbe . . . des transformations de la pensée dans la voix qui est le *toucher* par lequel l'âme agît le plus spontanément, découlent les miracles de l'éloquence et les célestes enchant ements de la musique vocal. La parole n'est-elle pas, en quelque sort, la démarche du coeur et du cerveau?"

32 "La Démarche étant prise comme l'expression des mouvements corporels, et la Voix comme celle des mouvements intellectuels, il me parut impossible de faire mentir le mouvement."

33 "Tout mouvement saccadé trahit un vice, ou une mauvaise éducation."

34 "Il est prouvé, par les différentes autopses des personnes royales, que l'habitude de la représentation vicie le corps des princes; leur bassin se feminize."

35 Henri Bergson, *Laughter: An Essay on the Meaning of the Comic*, trans. Cloudesley Brereton and Fred Rothwell (New York: Macmillan, 1911), 8–9 (hereafter cited in the text).

36 There is also an interesting example of this sort in Balzac's *Théorie*. He describes a practical joke where, as a child, he watched his sister pick up a box in which he normally stored heavy coins, but which he had removed unbeknownst to her. His sister exerts a force to lift the box and finds herself tumbling backward because it is now so light. While he links this practical joke to "the chaste and pure sentiment I felt for my sister" [le chaste et pur sentiment que j'avais pour ma soeur] (30), he nevertheless follows it up with another example from which he draws the following moral: "I compared the voyager to the jug full of water that a curious girl was carrying back from the fountain. Busy looking at a window, she is jostled in passing and spills a splash of water. This vague comparison expressed in broad terms the expenditure of vital fluid that this man seemed to have made for nothing" [Je comparais le voyageur à la cruche pleine d'eau qu'une fille curieuse rapporte de la fontaine. Elle s'occupe à regarder une fenêtre, reçoit une secousse en passant, et laisse perdre une lame d'eau. Cette comparaison vague exprimait grossièrement la dépense de fluide vital que cet homme me parut avoir faite en pure perte] (31–

32). The oddly out-of-place remark regarding his own chaste sentiments for his sister is thrown into doubt by this description of the casual expenditure of "vital fluids."

37 It is interesting to note that during a stay in New York, Wilde studied quite intensively with Steele Mackay, Delsarte's primary proselytizer. Delsarte is equally important as a theorist of "posing."

38 Anna Morgan, *An Hour with Delsarte: A Study of Expression* (Boston: Lee and Shepard, 1889), 11.

39 François Delsarte, *Delsarte System of Oratory*, 4th ed. (New York: Edgar Werner, 1893), 392.

40 It might be interesting to trace the movements of "grace" between its aesthetic and its religious connotations in nineteenth-century discourses of the body; see T. Jackson Lears, *No Place of Grace: Antimodernism and the Transformation of American Culture, 1880–1920* (New York: Pantheon, 1981). One should also note the element of muscularity that Morgan does not simply reject and that subsequently forms the basis of popular American "muscular Christianity."

41 This notion is, of course, encountered repeatedly in eighteenth-century reflections on gesture and the origins of language. In his entry on gesture for the *Encyclopédie*, de Cahusac affirms that "*gesture* is and always will be the language of every nation" [le *geste* est et sera toujours le langage de toutes les nations], *Encyclopédie* (Neufchastel: Samuel Fauche, 1765), 7: 651.

42 Genevieve Stebbins, *Delsarte System of Expression*, 6th ed. (New York: Dance Horizons, 1977 [1902]), 381 (hereafter cited in the text). It was Stebbins who was to prove most influential for the direction of modern dance in the United States and who most directly transmitted the work of Delsarte to a generation of dance pioneers. On Stebbins, see Nancy Lee Chalfa Ruyter, "The Intellectual World of Genevieve Stebbins," *Dance Chronicle* 11, no. 3 (1988): 381–97.

43 Althusser's distinctions between mechanical, expressive, and structural causality are most clearly delineated in the essay "Marx's Immense Theoretical Revolution," in *Reading Capital*, ed. Louis Althusser et al., trans. Ben Brewster (London: New Left Books, 1970), 182–89.

44 "Des automates, qu'on auroit démontés et détruits," Chevalier de Jaucourt, "Le Tact," *Encyclopédie*, 15:819.

CHAPTER 3 "AMERICA MAKES ME SICK!"

1 John Martin, *America Dancing: The Background and Personalities of the Modern Dance* (New York: Dodge, 1938), 87–88. Hereafter cited as *AD*.

2 John Martin, *The Modern Dance* (New York: Dance Horizons, 1972 [1933]), 11.

3 Again, we should beware of overstating the intentionality of such shifts. Duncan, for example, would insist: "I hate dancing. I am an *expressioniste* of beauty. I use my body as my medium, just as the writer uses his words" (Isadora Duncan, *Isadora Speaks*, ed. and introduction by Franklin Rosemont [San Francisco: City Lights Books, 1981], 53). Hereafter cited in the text as *IS*. In such pronouncements the relation of subject to body is understood as a mediation—just as is the relation of subject to language. Because Duncan insists that she is an *expressioniste*, however, we also need to understand this mediation in the sense intended by Althusser in his critique of Hegel's "expressive causality"—that is, as the manifestation of an immanent aesthetic and semiotic totality (Louis Althusser, "Marx's Immense Theoretical Revolution," in *Reading Capital*, ed. Louis Althusser et al., trans. Ben Brewster [London: New Left Books, 1970], 182–89).

4 Isadora Duncan, "Dancing in Relation to Religion and Love," in *The Art of the Dance*, ed. and introduction by Sheldon Cheney (New York: New York Theatre Arts, 1928), 125. Subsequent references to this volume are noted in the text as *AOD*.

5 The relationship of religious to cultural and aesthetic puritanism, however, was never simple. Witness, for example, Ted Shawn—cofounder of Denishawn, perhaps the single most important school for dance in America last century—who trained as a Methodist minister but left his calling to dance. He danced an entire sermon before an apparently enthusiastic congregation, but his aestheticized puritanism led him to reject "the Puritan type of mind, which produced its arch type in the late Anthony Comstock [and] found beauty and sin almost synonymous" (Ted Shawn, *The American Ballet*, introduction by Havelock Ellis [New York: Henry Holt, 1926], 80; hereafter cited in the text as *AB*). However, Shawn's own protestantism—an aesthetic puritanism that rejects the religious puritanism of a Comstock—would in turn lead him to be ridiculed. His insistence on the naked body as an affront to social puritanism was seen as prurient and narcissistic by those puritans of the dance.

Ann Daly, *Done into Dance: Isadora Duncan in America* (Bloomington: Indiana University Press, 1995) further traces the link of this aesthetico-religious nexus to a tradition of Wilsonian progressivism. Isadora's invocation of the rhetoric of progressivism allowed her, according to Daly, to move easily from an early high-minded social liberalism based on conservative high cultural values to a more explicitly conservative position at the end of her career. In her late writings, Isadora would then become not just conservative but positively reactionary in her opposition to the perceived depredations of a modern culture that had passed her by. Her very untimeliness, Daly claims, was itself paradoxically timely, resonating with a newly emergent rhetoric of populist nativism in the 1920s. This strain of populist conservatism is exemplified by the popular work by Wilbur C. Abbott, *The New Barbarians* (Boston: Little, Brown and Co., 1925).

6 Daly, *Done into Dance*, 220 (hereafter cited in the text).

7 Not only with regard to bodies in space but also to bodies in time does Martin set up a general model that America seems to defy. Just as, for example, he insisted that art becomes universal by observing its local geographic specificity, so it becomes eternal by insisting upon its own historical situation: "The vainglorious attempt to belong to the ages defeats itself, for unless the artist so merges himself in his own age as to become of its very stuff, history is unlikely to carry him along in any specifically contrived individual compartment of immortality" (*AD* 68). Martin's aesthetic criteria are not—in Hannah Arendt's sense of the word—"eternal" and metaphysical. They are "immortal"—that is, they transcend their own mortality by acknowledging the human condition. Just as American dance, unlike Italian opera or Greek sculpture, will become specific by being general (rather than general by being specific) so it must resist any temporal fixation implicit in the "modern." Indeed, Martin's problem with Wigman and with Duncan's imitators is precisely their attempt to codify as a metaphysic the choreography of the modern. Ballet, likewise, can only be "modernistic" in the sense of an "aping of the legitimately modern" (*AD* 77). Once again, however, Martin will claim that the distinction of American dance is not an idiosyncrasy of American idiom but rather the realization of something intrinsic to dance as genre: its temporal immanence. If dance and America are "here," they are also "now."

8 Of course, the relationship of expression to mimesis is a particularly complex one in the realm of performance. In referring to what he calls "the Duncan-Graham-Cunningham cycloid" in modern dance, Mark Franko, for one, reminds us that "the most salient trait of the modernist narrative is its progress from expression as spontaneity to expression as semiological system to the marginalizing of expressive intent" (Mark Franko, *Dancing Modernism/Performing Politics* [Bloomington: Indiana University Press, 1995], ix).

9 Isadora Duncan, *My Life* (New York: Liveright, 1927): 78 (hereafter cited in the text as *ML*).

10 Susan Manning, "Modernist Dogma and Post-Modern Rhetoric," *TDR* (Winter 1983): 32–39, 36.

11 Amy Koritz argues with specific reference to the career of Martha Graham that her early dances were an attempt to work out and work through an exoticist, international "other" inherited from her early career at Denishawn. Only then could she return to the nativist discourse we examine later in this chapter (Koritz, "Re/Moving Boundaries: From Dance History to Cultural Studies," in *Moving Words: Rewriting Dance*, ed. Gay Morris [London: Routledge, 1996], 88–103).

12 Ramsay Burt, *Alien Bodies: Representations of Modernity, "Race," and Nation in Early Modern Dance* (London: Routledge, 1998), 16.

13 Susan Manning, *Ecstasy and the Demon: Feminism and Nationalism in the*

Dance of Mary Wigman (Berkeley: University of California Press, 1993) (here-after cited in the text as *ED*).

14 Sigmund Freud, "Hysteria" (1888), *The Standard Edition of the Complete Psychological Works of Sigmund Freud*, 24 vols., ed. and trans. James Strachey (London: Hogarth, 1953–74): 1: 39–59. 41. Subsequent references to this work are noted in the text. The vexed historical relationship of dance to hysteria and other forms of medical pathology is examined in Felicia M. McCarren, *Dance Pathologies: Performance, Poetics, Medicine* (Stanford: Stanford University Press, 1998).

15 For an elaboration of the sense in which I am treating "historical trauma," see the account of the concept elaborated in Kaja Silverman, *Male Subjectivity at the Margins* (New York: Routledge, 1992).

16 After using cultural, racial, and national stereotypes to describe the different eras and modes of dance through history, Shawn's study *The American Ballet* seeks to characterize America's characteristic dance form. The "first and voluntary answer" is jazz, but "jazz as the expression of America in the dance is a lie. Jazz is the scum of the great boiling that is now going on, and the scum will be cleared off and the clear fluid underneath will be revealed" (*AB* 7–8).

17 Martha Graham, "Seeking an American Art of the Dance," in *Revolt in the Arts: A Survey of the Creation, Distribution, and Appreciation of Art in America*, ed. Oliver M. Sayler (New York: Brentano, 1930), 249–55, 254.

18 Entertainment is a form of distraction, a distraction from being. (We can trace a similar logic in Ruskin's rejection of *amusia*.) This radical, rather than relative, distinction of popular from aesthetic dance sets up some of the terms crucial to my study, in the final chapter, of American choreographies as read in Europe. It allows us to rethink the strain of exoticism and orientalism in early modern dance as something other than just a novelty—as a reflection, in fact, of the shifting strata of culture at the time. Orientalism in modern dance figured both the desire for an "integrative" culture and the subjection of that desire to the "disintegrating" forces of popular fashion. (Kracauer, as I show in the concluding chapter, would offer the best articulation of this paradox.) By shifting from a referential to a performative model for under-standing ideology, we can see that while orientalist dance is ideological in its appropriation and misrepresentation of putatively "integrative" indigenous cultures, in its playing out of "high" against "low" cultural forms it confronts the ideological impossibility of projecting one's essence into the other. In other words, the striking prevalence of forms of exoticism in American mod-ern dance of the time—for example, the orientalism of Ruth St Denis—is not fortuitous: entertainment is always and structurally exoticist in its cult of distraction, in its deflection of contemplation from the self. The exotic is not simply one form of entertainment, then; it is its very definition. Thus, a

confrontation with low culture will necessarily involve a confrontation with the exotic—and vice versa.

19 While the Native American offers Graham an insight into the possibility of an "integrative" national culture that would oppose the forms of "entertainment" necessitated by immigration, she finds further inspiration in the very geography of America itself: "So the answer to the problem of the American dance on the part of the Individualists who point the way is, "Know the land"—its exciting strange contrasts of barrenness and fertility—its great sweep of distances—its monstrous architecture—and the divine machinery of its invention. From it will come the great mass drama that is the American dance" ("Seeking an American Art of the Dance," 255). The reflexive "know thyself" of the philosopher has been replaced by a new dance exhortation, "know the land." This shift, I will argue, fuses exoticism and ontological thinking: the physical topography of America becomes the (literal) ground of a metaphysics. The geographical physicality of America mirrors the passage of art into the realm of the nonideological, the physical. Whereas earlier dancers turned to an anthropology of some putative racial and cultural "other," Graham's exhortation posits the American landscape as an external that must be known, and yet as something intimately related to the self. Daly argues that Graham's focus on landscape derives from popular tropes in the work of Frederick Jackson Turner, *The Frontier in American History* (New York: Henry Hòlt and Co., 1920 [1893]). She is wrong, however, in failing to differentiate between Graham's rejection of "Negro" culture and her embrace of the Native American.

20 Ted Shawn and Gray Pool, *One Thousand and One Night Stands* (New York: Doubleday, 1960), 11.

21 Julia L. Foulkes, "Dance Is for American Men: Ted Shawn and the Intersection of Gender, Sexuality, and Nationalism in the 1930s," in *Dancing Desires: Choreographing Sexualities on and off the Stage*, ed. Jane C. Desmond (Madison: University of Wisconsin Press, 2001), 113–46.

22 Ted Shawn, "A Defence of the Male Dancer," *New York Dramatic Mirror*, 13 May 1916, 19.

23 Susan Leigh Foster, "Closets Full of Dances: Modern Dance's Performance of Masculinity and Sexuality," in Desmond, ed., *Dancing Desires*, 147–208 (hereafter cited in text).

24 *Berliner Tageblatt*, 4 May 1931. Collected in "Scrapbooks of Ted Shawn and His Men Dancers," at New York Public Library for the Performing Arts.

25 Don Ryan, "Should Men Be Graceful?" in "Scrapbooks of Ted Shawn," New York Public Library for the Performing Arts. Shawn is being paraphrased here.

26 Lucien Price, "All-Man Performance," *Atlantic Monthly*, November 1936, in "Scrapbooks of Ted Shawn," New York Public Library for the Performing Arts.

27 *Atlanta Journal*, 11 December 1933, "Scrapbooks of Ted Shawn," New York Public Library for the Performing Arts.

28 In an article for the *Berkshire Evening Eagle* 27 June 1936, Shawn writes: "We work with pick and shovel, with scythe, axe, two-man saw and crowbar. Then when we come into the studio to create a Labor Symphony, for instance, it is no mere abstraction—the sweat of these forms of primitive manual labor is on our backs, our muscles are sore with it and our hands calloused with it" ("Scrapbooks of Ted Shawn," New York Public Library for the Performing Arts).

29 More broadly considered, dance history has demonstrated how this shift to a thematics of labor itself became a crucial component in choreographic work of the 1930s. For an elaboration of this question with respect to the questions of race being raised here, see Mark Franko, "Nation, Class, and Ethnicities in Modern Dance of the 1930's (Historicizing Bodies)," *Theatre Journal* 49, no. 4 (December 1997): 475–92.

30 T. Jackson Lears, *No Place of Grace: Antimodernism and the Transformation of American Culture, 1880–1920* (New York: Pantheon, 1981).

31 Complicating the modernists' rather neat racial parsing of formal artistic attributes is a contemporary article by Zora Neale Hurston claiming for Negro culture precisely those movements that supposedly purified and integrated the body politic against the forces of "negroid disintegration." See Zora Neale Hurston, "Characteristics of Negro Expression," in *Negro Anthology*, ed. N. Cunard (New York: Negro Universities Press, 1969).

32 Ann Daly has contested the claim that Duncan represents a new democratic form of dance. Acknowledging that Duncan questioned the ideological significance of ballet as a socially rooted form of aesthetic violence, Daly nevertheless claims that Duncan left in place more fundamental structures that reinforced the division of high and low culture, seeking as she was to gain legitimacy for dance by linking it to existing high cultural forms. Significant in Daly's critique of this traditional scenario is the equation (or is it a conflation?) of work as social practice (work, let us say, as production) and work as aesthetic phenomenon (work, we might say, as reproduction). Duncan's aesthetic, Daly will argue, is repressive to the extent that it elides the specificity of work in the artwork: "By constituting a "natural" body as the basis for dance practice, Duncan effectively removed from it any vulgar requirement of *labor*, which would have smacked of the working class; instead, it could be imbued with an aura of the innate—of good taste, which is, by definition, effortless. Something that ballet, constituted as it was by its demanding technique, could not claim" (Daly, "Isadora Duncan and the Distinction of Dance," *American Studies* 35, no. 1 (spring 1994): 18. While there are similarities in this argument to the tradition of Morris—in the insistence on work—the difference, of course, lies in Daly's desire to see work as effort, as the marker of pain. In Morris, work was that which expressed the joy rather

than the pain in labor. In effect, Daly posits an opposition of taste and labor that cannot simply be grafted onto the American scene. As the example of Shawn demonstrates, the conflation of aesthetic and moral purity meant that it was often necessary for American dancers to justify the status of their "work" (particularly in the activist period of dance in the 1930s).

CHAPTER 4 THE SCANDALOUS MALE ICON

1 Feminist scholarship on dance is voluminous and definitive for our understanding of the field. Many of the relevant works have been cited earlier throughout this study. Of note here is Elizabeth Kendall, *Where She Danced: The Birth of American Art-Dance* (Berkeley: University of California Press, 1979), which was important for placing women's work in dance in its social and political background. It was followed by such synoptic works as Judith Lynne Hanna, *Dance, Sex, and Gender* (Austin: University of Texas Press, 1988); Christy Adair, *Women and Dance: Sylphs and Sirens* (New York: New York University Press, 1992); and Lynn Garafola, ed., *Rethinking the Sylph: New Perspectives on the Romantic Ballet* (Middletown, Conn.: Wesleyan University Press, 1997).

More recently, the focus has been on the question of the body—both its representation and its epistemological status. See, for example, Susan Foster, ed. *Corporealities: Dancing, Knowledge, Culture, and Power* (London: Routledge, 1995); Amy Koritz, *Gendering Bodies/Performing Art: Dance and Literature in Early-Twentieth-Century British Culture* (Ann Arbor: University of Michigan Press, 1995); and Felicia M. McCarren, *Dance Pathologies: Performance, Poetics, Medicine* (Stanford: Stanford University Press, 1998). Of particular further interest in the current context are Ann Daly, "To Dance Is Female," *TDR* 34, no. 4 (winter 1989): 23–27; Gabriele Klein, *Frauenkörpertanz: Eine Zivilisationsgeschichte des Tanzes* (Berlin: Quadriga, 1992); Susan Manning, "Feminism, Utopianism, and the Incompleted Dialogue of Modernism," in *Ausdruckstanz: Eine mitteleuropäische Bewegung der ersten Hälfte des zwanzigsten Jahrhunderts*, ed. G. Oberzaucher-Schüller (Wilhelmshaven: Florian Noetzel, 1991), 105–15.

Perhaps the most important contribution to recent work on the male dancer is Ramsay Burt, *The Male Dancer: Bodies, Spectacle, Sexualities* (London: Routledge, 1995), 44.

2 Modris Eksteins, *Rites of Spring: The Great War and the Birth of the Modern Age* (Boston: Houghton Mifflin, 1989).

3 See, for example, the classic study by Lynn Garafola, *Diaghilev's Ballets Russes* (Oxford: Oxford University Press, 1989). In this otherwise excellent work Garafola tends to reduce the figure of Nijinsky to a homosexual narcis-

sist unable to confront the question of the feminine. In a shorter piece, "Vaslav Nijinsky," *Raritan* 8, no. 1 (summer 1988): 1–27, Garafola rightly argues that "the Chosen Virgin is, above all, a creation of twentieth-century male sexual anxiety" (26), but the relation of this anxiety to homosociality—rather than homosexuality—goes unexamined.

4 Rambert's recollection of the incident is recounted by Richard Buckle, *Nijinsky* (New York: Simon and Schuster, 1971), 283. On the question of the sacrifice, see Millicent Hodson, "Sacre: Searching for Nijinsky's Chosen One," in *Ballet Review* 15, no. 3 (fall 1987): 53–66.

5 Vaslav Nijinsky, *The Diary of Vaslav Nijinsky*, ed. Romola Nijinsky (London: Quartet, 1991), 148. Hereafter cited in the text.

6 Jacques Rivière, "Le sacre du printemps," in *Nijinsky Dancing*, ed. Lincoln Kirstein (New York: Knopf, 1975), 164–68. Hereafter cited in the text.

7 Ramsay Burt, *Alien Bodies: Representations of Modernity, "Race," and Nation in Early Modern Dance* (London: Routledge, 1998), 98.

8 See Michel Fokine, *Fokine: Memoirs of a Ballet Master* (Boston: Little, Brown and Co., 1961).

9 René Girard, "Scandal and the Dance: Salome in the Gospel of Mark," *New Literary History* 15, no. 2 (winter 1984): 311–24, 316.

10 Dawn Perlmutter, "Skandalon 2001: The Religious Practices of Modern Satanists and Terrorists," *Anthropoetics* 7, no. 2 (fall 2001/winter 2002).

11 On this question of "grace," see Millicent Hodson, *Nijinsky's Crime against Grace* (New York: Pendragon Press, 1996).

12 Charles Sanders Peirce, *Peirce on Signs: Writings on Semiotic by Charles Sanders Peirce*, ed. James Hoopes (Chapel Hill: University of North Carolina Press, 1991), 238–39; hereafter cited in the text. This definition was taken by Peirce from a definition of "sign" for the *Dictionary of Philosophy and Psychology*, 3 vols., ed. James Mark Baldwin (New York: Macmillan, 1901–5), 2: 527.

13 See Michael Moon, "Flaming Closets," *October* 51 (1989): 19–54 (hereafter cited in the text); and Peter Wollen, "Fashion/Orientalism/the Body," *New Formations* 1 (spring 1987): 5–33. The most recent addition to this literature on Nijinsky's iconic status is Kevin Kopelson, *The Queer Afterlife of Vaslav Nijinsky* (Stanford: Stanford University Press, 1997).

14 On the epistemological structure of the "open secret," see D. A. Miller, *The Novel and the Police* (Berkeley: University of California Press, 1988); and Eve Kosofsky Sedgwick, *The Epistemology of the Closet* (Berkeley: University of California Press, 1990).

15 Jean Cocteau, *Past Tense*, 2 vols., trans. Richard Howard (London: Methuen, 1985), 2: 109 (the entry is for 25 May 1953).

16 For these suggestive, but rather questionable, etymologies, see Lincoln Kirstein, *Dance: A Short History of Classical Theatrical Dancing* (Princeton: Dance Horizons, 1987 [1935]).

CHAPTER 5 FROM WOMAN TO GIRL

1 "Wir amerikanischen Menschen mit dem griechischen Herzschlag"; "Wenn es einem Dichter gelingt, die internationale katharsis, die das moderne Variété auslöst, und damit das vielgestaltige moderne Leben in einen Konflikt des Tragischen oder des Komischen zu bringen, so kann es nur ein deutscher Dichter sein" (Arthur Moeller van den Bruck, *Das Variété* [Berlin: Julius Bard, 1902], 10, 234).

2 For treatments of the feminization of mass culture in critical thought, see Andreas Huyssen, *After the Great Divide: Modernism, Mass Culture, and Postmodernism* (London: Macmillan, 1986); and Tania Modleski and Kathleen Woodward, eds., *Studies in Entertainment: Critical Approaches to Mass Culture* (Bloomington: Indiana University Press, 1986).

3 Siegfried Kracauer, "The Mass Ornament," in *The Mass Ornament: Weimar Essays*, ed. and trans. Thomas Y. Levin (Cambridge: Harvard University Press, 75–86. 77 (this volume is hereafter cited in the text as *MO*). There is copious literature on dance, rhythm, and Americanization within the Weimar Republic; examples abound in Anton Kaes, Martin Jay, and Edward Dimendberg, eds., *The Weimar Republic Sourcebook* (Berkeley: University of California Press, 1994).

4 Walter Benjamin, "The Work of Art in the Age of Mechanical Reproduction," in *Illuminations*, ed. Hannah Arendt (New York: Harcourt, Brace and World, 1968), 219–53.

5 "Nicht die jahnhafte, deutsche Mentalität war der Frau, war dem kommenden Tag günstig, sondern das freie Amerika, das ebenfalls vorerst ideell theoretisch, dann praktisch-angewandt zu einer Körperkultur gelangte" (Fritz Giese, *Girlkultur: Vergleiche zwischen amerikanischem und europäischem Rhythmus und Lebensgefühl* [Munich: Delphin, 1925], 9; hereafter cited in the text).

Friedrich Ludwig Jahn (1778–1852), better known as Turnvater Jahn, was a German pedagogue and patriot who felt that the unification of Germany could only be brought about by healthy and athletically trained young men. He began inaugurating open-air gymnasia in 1811 in Berlin and, after serving in the military in the Napoleonic wars, was a central figure in establishing the German fraternal system of *Burschenschaften* at Jena. Jahn was a politically controversial figure often at odds with the reactionary governments of his time, and he spent numerous periods either imprisoned or exiled. He is seen as the father of a youth-oriented nationalism in Germany. In the quote here Giese is referring to Jahn's ubiquitous pairing of physical and military drill.

6 Peter Jelavich, *Berlin Cabaret* (Cambridge: Harvard University Press, 1993). The historical material in this chapter draws extensively on Jelavich, as well as on my own archival research in Berlin and at the New York Public Library for the Performing Arts.

7 Theodor Lücke, "Gedanken der Revue," *Scene* 16 (1926): 114 (quoted by Jelavich, *Berlin Cabaret*, 169).

8 See Theodor W. Adorno, "On Jazz," in *Essays on Music*, ed. Richard Leppert, trans. Susan H. Gillespie and others (Berkeley: University of California Press, 2002). For a historical contextualization of Adorno's essay, see Evelyn Wilcock, "Adorno, Jazz, and Racism: 'Über Jazz' and the 1934–7 British Jazz Debate," *Telos* 107 (spring 1996): 63–80.

9 It is important to note the various cultural registers of nudity in Weimar Germany—from the primness of popular nudism, through the titillation of the variety theater, to the decadence of theatrical performers such as the drug-addicted and consumptive Anita Berber. An excellent quasi-comprehensive study of dance, body culture, and the cabaret underworld in Weimar Germany appears in Karl Toepfer, *Empire of Ecstasy: Nudity and Movement in German Body Culture* (Berkeley: University of California Press, 1997).

10 From the *Berliner Börsen-Courier* August 28, 1924 (quoted by Jelavich, *Berlin Cabaret*, 176).

11 Claudia Jeschke, "Book Review of Susan Manning's *Ecstasy and the Demon: Nationalism in the Dance of Mary Wigman*," *Dance Research Journal* 27, no. 2 (fall 1995): 35.

12 "Sie waren eben nicht nur Schau sondern Leistung."

13 Steve Neale, "Masculinity as Spectacle," *Screen* 24 no. 6 (winter 1983): 2–19.

14 "Es mag eine männliche und eine weiblich Art des Tanzes geben. Weibliche Art ist das Pflanzenhaft, das sanft sich Auswirkende, das blind Suchende. Männliche Art das Tierhafte, das Ergreifen-Wollen. Wo die erste selig sich ergeht, will die andere triumphieren" (Ernst Schur, *Der moderne Tanz* [Munich: Gustav Lammers, 1910], 18).

15 "Die Idee, eine ganze Schnur von jungen Mädchen in exaktester Gleichmäßigkeit zu bewegen, ist die echt amerikanische Mechanisierung des Ballettgedankens; aber auch eine mechanisierte Form kann vollkommen schön sein, wenn ihre Präzision auf den Schlag bezogt. Bei den Tillergirls ist das gelungen" (Hans W. Fischer, *Körperschönheit und Körperkultur: Sport, Tanz, Gymnastik* [Berlin: Deutsche Buchgemeinschaft, 1928], 207).

16 "Die Revue ist bisher vom neuen Kunsttanz gänzlich unbefruchtet geblieben. Ihre Auflockerung verdankt sie dem engen Bündnis mit dem modernen Gesellschaftstanz."

17 "Das Variété verlangt immer Fertiges, es lehnt Dinge, die erst im Fluß sind, ab. Darum duldet es Kunst nur, wenn sie artistisch ist. In dieser Hinsicht ähnelt es dem Ballett, das ja auch eine völlig nichtssagende, aber blendende Pirouette höher wertet als jeden Gefühlsausdruck, dem die mühelose technische Beherrschung fehlt."

18 "Der Mann prägt sein Wesen darum im Werk, das außer ihn besteht: er ist Schöpfer. Das Weib dagegen ist vor allem Geschöpf, ihr Wesentliches und

Höchstes bleibt in ihr selbst geschlossen" (Hans W. Fischer, *Das Tanzbuch* [Munich: Albert Langen, 1924], 36).

19 Siegfried Kracauer, "Girls and Crisis," *Weimar Republic Sourcebook*, 565–66; (originally published as "Girls und Krise," in *Frankfurter Zeitung*, 26 May 1931).

20 Ramsay Burt, *Alien Bodies: Representations of Modernity, Race, and Nation in Early Modern Dance* (London Routledge, 1998), 92.

21 Gustav LeBon, *The Crowd: A Study of the Popular Mind*, trans. Tom Detitta (New York: Larlin Corp., 1994 [1895]). LeBon was one of the first theorists to turn his attention to the emerging phenomenon of the urban masses.

22 Alfred Polgar, "Girls," in *Auswahl: Prosa aus vier Jahrzehnten* (Reinbek: Rowohlt, 1968 [1926]), 186 (quoted by Jelavich, *Berlin Cabaret*, 180).

23 Walter Benjamin and Bernhard Reich, "Revue oder Theater," *Querschnitt* 5 (1925): 1043; (quoted by Jelavich, *Berlin Cabaret*, 180).

24 On the importance of the concept of cynicism to the understanding of ideology's operation, see Peter Sloterdijk, *Critique of Cynical Reason*, trans. Michael Eldred (Minneapolis: University of Minnesota Press, 1988).

25 "da es ihr oberstes Gesetz bleibt, Symbol, Allegorie, Dilemma zu verneinen, ja selbst die primitivste Handlung fur eine nur triebhaft geordnete Szenenkette zu opfern, stellt sie in ihren Mittelpunkt das Symbol des Asymbolischen, die Allegorie des Chaos, das Urbild der Alogik: die schöne, nur schöne, sinnliche tierhafte Frau" (H. H. Stuckenschmidt, "Lob der Revue," in *Tanz in dieser Zeit*, ed. Paul Stefan (Vienna: Universal Editions, 1926), 63.

26 I do not detail here Bloch's reflections on dance. They are best traced through his writings in *The Principle of Hope*, vol. 1, trans. Neville Plaice, Stephen Plaice, and Paul Knight (Cambridge: MIT Press, 1995).

27 While it would be innacurate to portray Kracauer as a Marxist critic, his analysis nevertheless opens up this category of the mass in a way that would prove important for subsequent Marxist analysis. On the importance of the category of the mass in the development of Marxist thought, see Etienne Balibar, *Masses, Classes, Ideas* (New York: Routledge, 1994).

28 I have in mind the minimalist modernist tradition set forth in the seminal text by Adolf Loos, *Ornament and Crime: Selected Essays*, trans. Michael Mitchell (Riverside, Calif.: Ariadne Press, 1998).

29 In a related essay, "Those Who Wait," from *The Mass Ornament*, Kracauer develops this notion of "hovering" temporally as a waiting or *Verweilen*, while in the essay "Hotel Lobby" he fuses the spatial and the temporal in an analysis of places where people wait.

30 "Die wüsteren Tänze der anderen Rassen sind bloss ihre Volkstänze, auf die stärkste geschlechtliche Form gebracht . . . Im Can Can wird die erste rohe Regung der Masse Ereignis, über die gemeine Wirklichkeit fortzukommen und zu einer höheren hin."

31 Slavoj Žižek, "The Spectre of Ideology: Introduction," in *Mapping Ideology*, ed. Slavoj Žižek (London: Verso, 1994), 26.

32 Slavoj Žižek, "Fantasy as a Political Category: A Lacanian Approach," in *The Žižek Reader*, ed. Elizabeth Wright and Edmond Wright (Oxford: Blackwell, 1999), 89.

33 Fredric Jameson, *The Political Unconscious: Narrative as a Socially Symbolic Act* (Ithaca: Cornell University Press), 98.

34 Honoré de Balzac, *Théorie de la démarche et autres textes* (Paris: Albin Michele, 1990 [1833]), 82.

35 Slavoj Žižek, "How Did Marx Invent the Symptom?" in *Mapping Ideology*, 329.

Index

ANDREW HEWITT

is the chair of the department of Germanic languages

at the University of California, Los Angeles.

Library of Congress Cataloging-in-Publication Data

Hewitt, Andrew
Social choreography : ideology as performance in dance
and everyday movement / Andrew Hewitt.
p. cm.—(Post-contemporary interventions)
Includes bibliographical references and index.
ISBN 0-8223-3502-6 (cloth : alk. paper)
ISBN 0-8223-3514-x (pbk. : alk. paper)
1. Choreography. 2. Dance—Sociological aspects.
3. Movement, Aesthetics of. I. Title. II. Series.
GV1782.5.H49 2005
792.8'2—dc22 2004022037